FIGHT CLUB
True Lies
APOLLO 13
TITANIC

DIGITAL DOMAIN

THE LEADING EDGE OF VISUAL EFFECTS

THE FIFTH ELEMENT
X-MEN

Dr. Seuss HOW THE GRINCH STOLE CHRISTMAS!

T2-3D

PIERS BIZONY

BILLBOARD BOOKS

An imprint of Watson-Guptill Publications/New York

First published in the United States in 2001 by Billboard Books,
an imprint of Watson-Guptill Publications,
a division of BPI Communications, Inc.
770 Broadway, New York, NY 10003

First published in 2001 by Aurum Press Ltd
25 Bedford Avenue, London WC1B 3AT

Library of Congress Card Number: 2001088242

ISBN 0-8230-7928-7

1 3 5 7 9 10 8 6 4 2
2001 2003 2005 2004 2002

Book design, additional 3D work and technical illustrations by TWO:design, London
Originated and printed in Singapore by CS Graphics

CONTENTS

FOREWORD

In 1992, when Digital Domain was first imagined, James Cameron, Stan Winston and I shared a single vision. Our goal was to create a digital studio that would demystify the visual-effects process and empower film-makers, producers, writers and artists to participate more fully in the creative process. We were joined by financial partners IBM and, later, Cox Enterprises, who believed we could make our dream a reality.

The company was formally launched in 1993, and we hit the ground running, so to speak. Within a matter of months, we moved from temporary offices in Santa Monica to our own studio in Venice, California, building up our infrastructure while at the same time starting work on our first slate of projects. Critics thought we were moving too fast and would never make it. We thought differently. We were a start-up that would prove to be the upstart in the visual-effects industry. Our motto? 'Fear is not an option.'

In year one, our features division began work on *True Lies* and *Interview With The Vampire*, while our commercial division worked on an array of distinctive advertisements for some of the best directors in the business. We were also sought out to produce the visual effects for the award-winning Rolling Stones video 'Love Is Strange'. It was the beginning of an often exhilarating, frequently exhausting, but ultimately rewarding adventure. Eight years, five Academy Award™ nominations and two Oscars™ later, we're still producing groundbreaking imagery.

Early in the fall of 1995, we received a call from Piers Bizony, a British writer well-known in our community for his book on Stanley Kubrick's *2001: A Space Odyssey*. Piers wanted to discuss our work on director Ron Howard's film *Apollo 13*. His extensive knowledge of visual effects gave Piers unique insights into our work, and led to the dialogue between us that has endured for the last five years.

In 1996, Piers approached us about writing a book on Digital Domain. We were interested, but the timing wasn't right. Piers diligently kept in touch as we completed our work on *The Fifth Element*, *Dante's Peak* and *Titanic*. In 1998, we began serious discussions, which led to the book you now hold.

The initial intent of our company was to demystify visual effects and to offer film-makers and other artists full participation in the creative process. This book is the logical extension of that philosophy. More importantly, this book also serves to acknowledge the 3000-plus individuals who have contributed so much to Digital Domain over the past eight years. In looking at the various projects highlighted in this book, we pay tribute to those dedicated individuals who devoted themselves to setting a standard of achievement that will last for generations to come.

Scott Ross
Venice CA, 2001

INTRODUCTION

One of the greatest misconceptions about modern movies is that visual effects are generated by computers. Nothing could be further from the truth. Human inventiveness is the most important ingredient and it always will be. Computers offer amazing new possibilities, but the underlying challenges of movie illusions are the same today as they were nearly a century ago when the industry was young. People, not machines, drive the craft of visual effects.

There are two or three major visual-effects companies dominating the field today. All of them are pushing at the cutting edge of digital techniques, but one company in particular knows how to keep the computer in its place – as just one of many appropriate tools, rather than as an end in itself. Digital Domain's artists are the finest and most technically advanced in the world, capable of delivering some of the most photo-realistic effects that the movie and television industries have ever seen, but they are artists first and computer experts second, and this is the key to their success. Painters, sculptors, biologists, cartoon animators, model-makers and photographers bring to the company their expertise and experience of the real world outside the digital realm, and only then are the computers brought into play.

However, there are times when computers truly can deliver images that are beyond traditional artistry alone. It takes a special talent, as much scientific as aesthetic, to coax the best out of the machines on these occasions. Digital Domain has attracted the right kinds of talent. There are NASA scientists, previously responsible for designing and operating probes to Mars, who now believe that the world of visual effects is more stimulating than the dwindling space effort, and they have joined the company. There are areas at the forefront of Digital Domain's research that appeal to physicists and mathematicians on the lookout for new challenges: fluid-dynamics simulations of seas and storms; the growth of artificial digital life forms; the analysis of weather and clouds; the understanding of how animals behave in flocks and swarms; and even the complete re-creation of human movement down to the last anatomical detail. The company's movie effects are now pushing at boundaries of understanding that lie far beyond the world of entertainment alone.

Because computers are just one facet of a company that incorporates so many different skills, Digital Domain is the perfect subject for a book explaining the basics of modern movie effects. My purpose in writing this book was simple curiosity. I didn't quite understand how two very different media, movies and computing, could be physically combined into the final reels of film that we see projected in the theatre. I didn't know how colour, texture, light and shade, and the illusion of solidity were applied to computer images. I wanted to find out how much of modern effects work is purely digital,

and how much is still physical or conventionally photographic. I wasn't sure whether computers were a wonderful influence on movies or an alarming new trend. I searched for a book that would tell me all these things, but couldn't find one written in plain English.

In some stores, I did locate a couple of expensive coffee-table books about movie effects, but these were infuriatingly vague when it came to explaining the actual techniques. In other stores, I found even more expensive books, designed for industry insiders only, that delved into the most abstruse minutiae of software and mathematics. These left me almost as ignorant as before. Somewhat frustrated, I wrote this book primarily for myself, confident that other moviegoers also would be interested to discover how visual effects are conceived and produced in the computer age.

I hope that students contemplating a career in the digital realm might find a few useful general observations here, but this is not any kind of technical treatise. I have largely ignored specific details of software, on the assumption that most of the wide range of packages designed for three or four distinct types of work (compositing, modelling, shading and animation) perform more or less similar tasks at heart. My jargon-free language is aimed at anyone who wants to understand the underlying principles of effects work, using as examples some of the most spectacular and entertaining movies of recent times, with effects created by one of the most significant and influential effects companies in the world.

But why focus particularly on Digital Domain for this book? Much of the answer to that question lies in the promises made to clients and investors when the company was founded in 1993 by Scott Ross (senior vice-president for Lucasfilm, and head of the Industrial Light and Magic company) and director James Cameron, along with make-up and creature effects supremo Stan Winston. Initial backing came from IBM, with further investment in 1996 from Cox Enterprises. For Digital Domain and its investors alike, it was a gamble. How was this new company supposed to be better than, or different from, any others in the field? Size had to be a contributing factor. Many kinds of effects would be facilitated under the same set of roofs. Instead of seeking computer skills from one house, physical miniatures from another, and on-set practical effects from yet another, Hollywood producers could source all the effects required from this one company, and at competitive rates. Operating at this scale would allow Digital Domain to compete at the highest levels. Much more important than this, however, was the special relationship that Ross, Cameron and Winston wanted to forge with movie directors.

In principle, a director's job is to marshal teams of experts to deliver what he or she wants, without necessarily becoming entangled in the exact details of camera operation, lighting, sound recording, and the many other specialisms of raw movie craft. After all, if directors were supposed to handle their own machinery, why would they hire skilled technicians in the first place? On set, or next morning while watching 'rush' prints, a director can check that everyone is performing as required. The live-action arena, with actors performing right there and then, and the scenery visible through the viewfinder of a camera here and now, is a director's natural environment. But difficulties arise when visual-effects experts are called in to create shots that can't be viewed until many weeks or even months later. Effects can be a worry for a director who hasn't used them much before.

Digital Domain wanted non-technically minded directors to be able to manage even the most complicated effects with confidence. In the pitch to investors, the company promised 'to bring the film-maker into the creative loop at every stage, so that directors and producers will feel a greater sense of authorship in areas which have previously been the realm of specialists'. This meant revising the somewhat protective attitude that effects practitioners sometimes display with regard to their hard-won expertise. They don't necessarily want to give all their secrets away to clients. Digital Domain vowed to break down that barrier and provide directors with a 'user-friendly' service.

So far, this approach has worked incredibly well, attracting a wide range of directors and producers who might not otherwise have wanted to take on a large effects commitment. But it doesn't entirely solve the principal economic problem. Only a certain number of effects movies get made each year, and Digital Domain cannot expect to win contracts for all of them. That's why the commercials division, under the stewardship of Ed Ulbrich, is so important. Many people don't realize that the company works on three, maybe four major feature films a year, while contributing effects to (and often completely creating from start to finish) over 80 commercials in that same span of time, for clients whose brands are recognized worldwide. Nor is it widely known outside the trade that a number of essential tools for movie effects, now in use throughout Hollywood, were pioneered in fast-turnaround television advertising projects at Digital Domain.

Meanwhile, the company is busy exploring technologies and creative options that reach far beyond the movie theatre. Several extremely ambitious theme-park projects have already been developed, along with sophisticated advances in three-dimensional stereoscopic photography and computer graphics, allied with new ways of delivering the results to an audience. These are all areas that particularly fascinated James Cameron. With films like *True Lies* and *Titanic*, and themed entertainments based around Cameron's and Stan Winston's *Terminator* concepts, Digital Domain was able to showcase work to a technical standard far beyond what might have been expected from a start-up company in the early years of its career.

In more recent times, with Cameron and Winston pursuing a wide range of other activities, directors including Neil Jordan, Ron Howard, Bryan Singer, David Fincher and the Coen brothers have worked with Digital Domain on films such as *Interview With The Vampire*, *Apollo 13*, *Dante's Peak*, *Fight Club*, *O Brother, Where Art Thou?*, *X-Men* and *The Grinch*. The company's contributions to these, and many other films besides, have helped to reshape the relationship between today's directors and the world of visual effects. Meanwhile, Ross has begun to steer the company towards a broader and perhaps riskier arena: the total production and copyright ownership of movie projects from beginning to end.

That's why Digital Domain makes such a good subject for a book. By delving into any specific area of the company's work, much can be learned about the wider world of film-making today.

THE SAME OLD PROBLEM

The simplest photographic special effect is to **double-expose** a film.

A century ago, when photography was still a young art and its secrets were unfamiliar to the public, unscrupulous photographers would shoot portraits at normal exposures, then as soon as their gullible clients were safely out of the studio they would snap a carefully positioned collaborator, making a brief exposure that left only a faint image on the film. After processing, the client would be handed a positive paper print of herself with a ghostly apparition apparently standing behind her. The photographer concocted a mysterious supernatural explanation and doubled his fee accordingly. Sir Arthur Conan Doyle, creator of the forensically minded detective Sherlock Holmes, was fooled by various photographic tricksters, and after the First World War, many young widows and forlorn mothers and fathers were susceptible to the comforts of ghost photography. The art of special effects was born with an attendant whiff of chicanery and superstition.

A more subtle variation on the ghost trick came into play whenever the client was surrounded by studio props: a writing desk, a vase of flowers, maybe a fireplace. A careful photographer would ensure that only the ghostly stand-in appeared in the second exposure, and not the props, because they might betray themselves the second time around by being all-too-obviously double-exposed over their own originals. The ghost sitter would be photographed with black-velvet drapes masking off the rest of the studio. Film does not 'see' black, because the chemistry in the emulsion is only affected by light. Only the ghost would register in this second exposure.

This was the beginning of what is now universally known as the matte process, whereby unwanted objects in any given exposure are masked in some way and prevented from registering on film. Our conman used a matte in his studio, while more honest artisans used oval-shaped mattes to create soft rounded edges on their photographic prints, but the word came into common use when the **matte box** was invented for movie cameras. The box fits snugly in front of the lens, and a flat black sheet is used to mask off a selected area of the field of view – say, from the top of the frame to the horizon, where a dull overcast sky meets a field of grass. The photographer exposes the field, then waits a few days for the weather to produce a more dramatic cloudscape. Then he swaps his mask to the bottom of the frame and shoots his preferred sky. Although he has double-exposed

1 In Alexander Korda's *Things To Come* (1936), a model of a futuristic underground city's upper levels is double-exposed above footage of live actors, with matte masks preventing one image showing through the other. The dividing line between the live set and the model is apparent, but not so obvious as to ruin the scene.

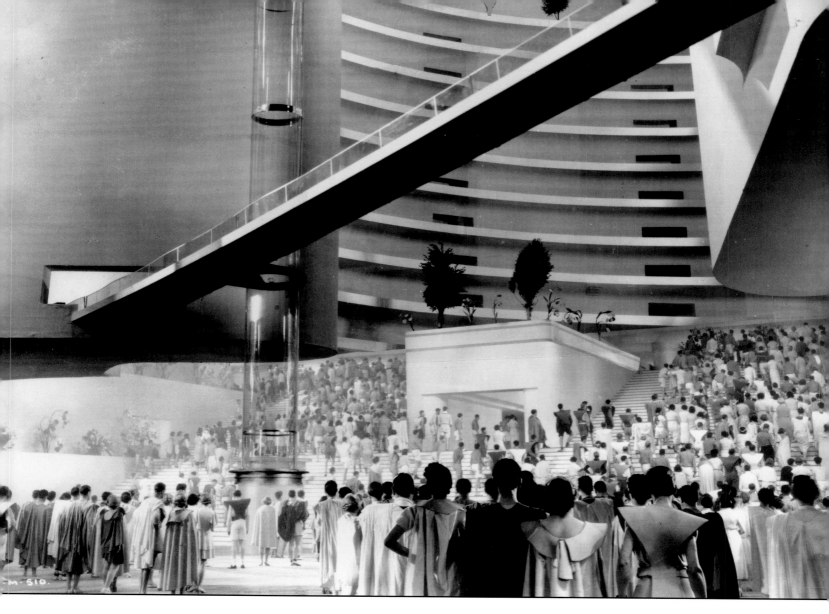

his photographic plate, the separate elements do not actually interfere with each other. The sky does not appear through the field. Matte-box masks come in any number of different shapes, but the more elaborate the shape, the harder it is to ensure that multiple exposures do not interfere with each other and give the game away.

In cinematography, it's not just one frame but many thousands that must be exposed; however, a matte box can still be effective so long as its masks do not have to change shape or position. **Matte painters** created ancient cityscapes and mythical landscapes on large sheets of glass and placed them a few feet in front of the camera. Live action, restless crowds, battling gladiators and so forth were then photographed through the clear unpainted areas in the glass. This technique masked out unwanted areas of the live action and at the same time *replaced* those areas with the painted image, all in one exposure. This process, still occasionally in use today, reached a pinnacle of sophistication in the Hollywood historical epics of the 1950s and early 1960s.

One major drawback with matte paintings was that the lighting and contrast of the painted picture was fixed indelibly on the glass. If the painting was of a fantastic castle in glorious sunshine, but the weather during the live-action photography delivered nothing but rain for a week, there would be an obvious disparity between the matte painting and the live elements. The castle ramparts would be casting sharp shadows, while the live elements would appear duller and more flatly lit. To prevent these costly inconsistencies, matte painters often delivered nothing but black masked-out areas on the glass for the principal shooting. Afterwards, they processed a few feet of film to see what the live-action lighting conditions looked like, then painted the glass accordingly. The exposed but undeveloped live-action footage was wound back into the camera and exposed again, with the painting now dropping neatly into its own black (unexposed) area of the frame. Meanwhile, the areas of the glass that had previously been transparent were themselves blacked out to protect the live elements photographed earlier.

The great remaining problem was the static nature of the matte painting, which could never move in the frame

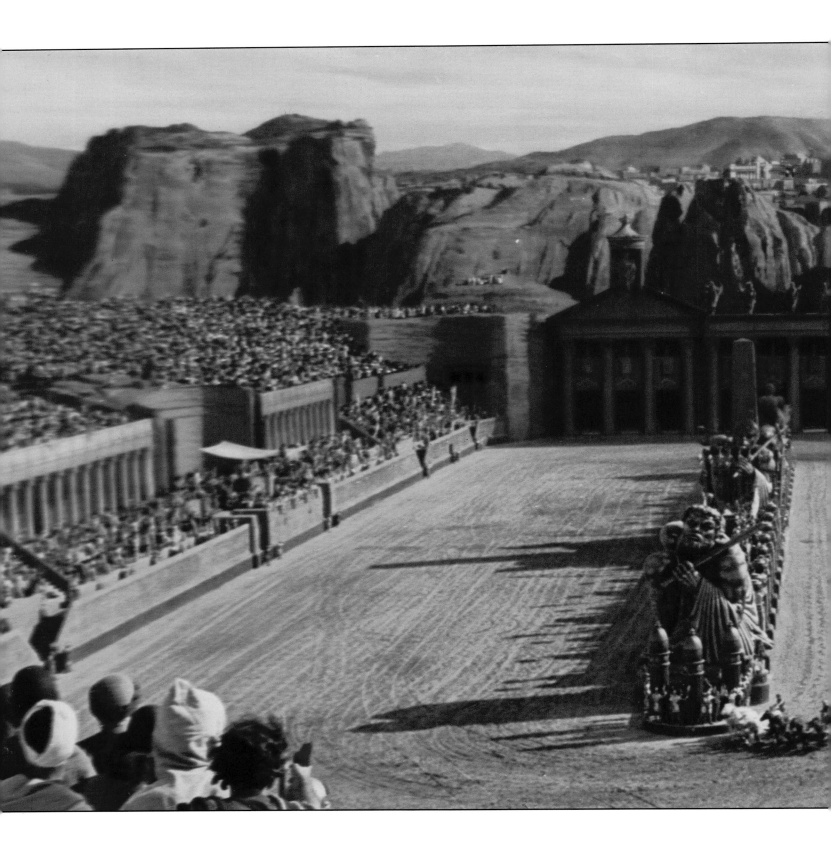

2 In the 1959 version of *Ben Hur*, the arena for the classic chariot race is a live-action set at full scale, and the foreground soldiers and members of the audience are real. The background hills and city rooftops and the crowds in the aisles visible in the extreme distance are derived from a matte painting.

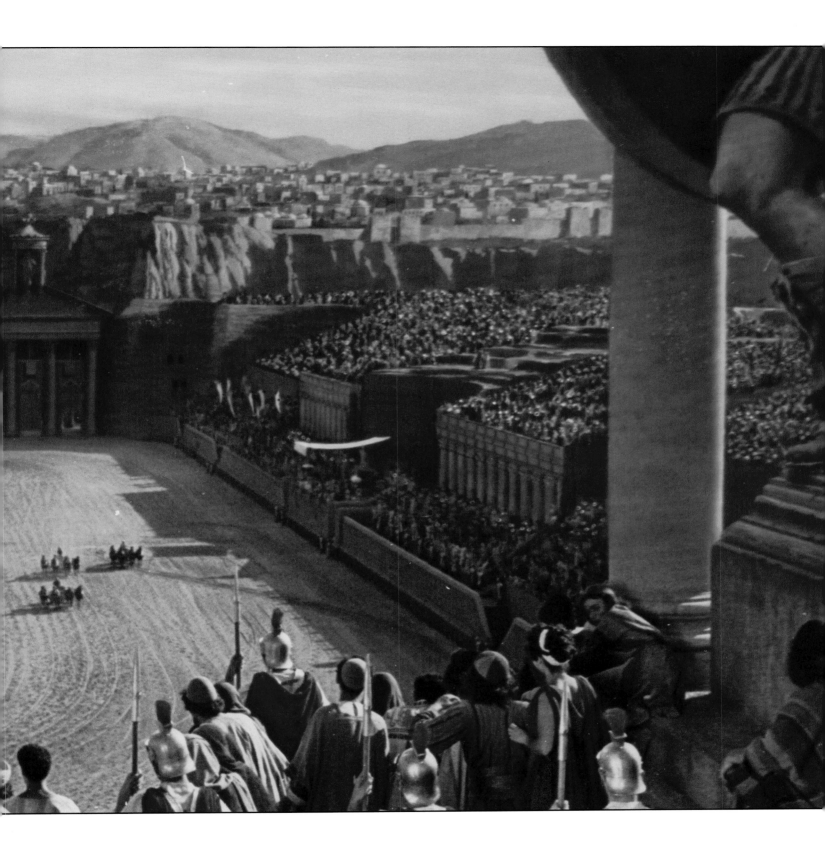

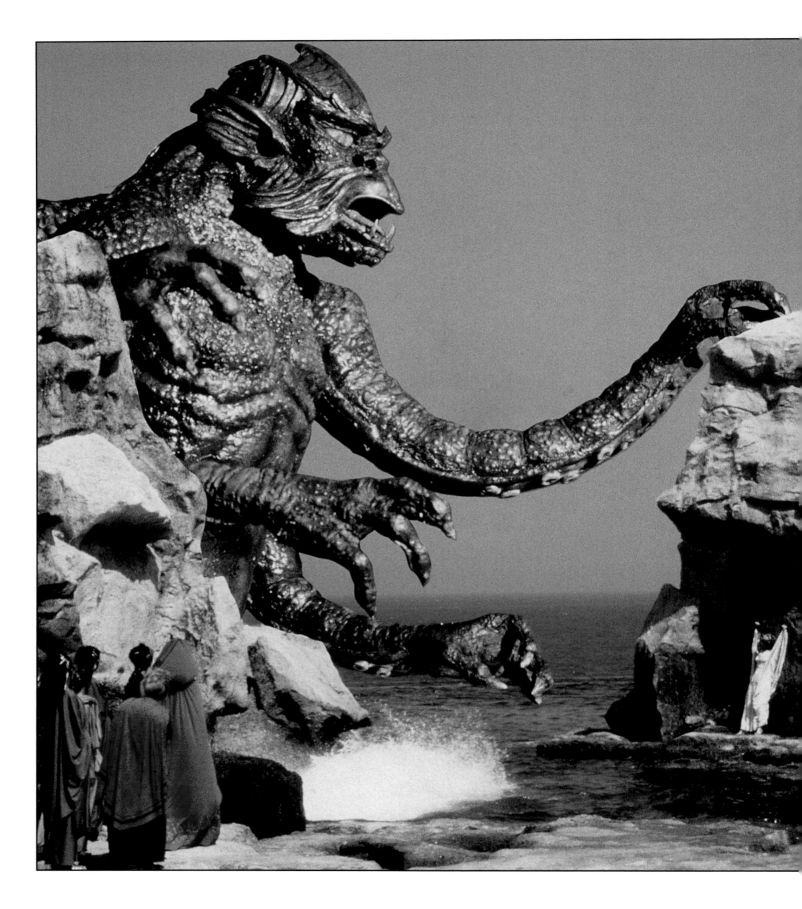

3 Before the advent of digital animation, the legendary Ray Harryhausen created many famous 'stop-motion' monsters, essentially clay and rubber models a few inches tall that were animated by nudging the arms, heads, tails and other appendages very slightly prior to exposing each frame of film. The resulting footage of these tiny giants was then combined with live action shot separately. This is a typical frame from *Clash of the Titans* (1980). Today's digital creatures are much more realistic, but this doesn't in any way detract from the appeal of Harryhausen's work.

because it was literally fixed rigid in front of the camera. What if a director wanted the camera to follow moving objects, or even actors walking across a scene? This was beyond the capacity of a static matte box, and so the **travelling matte** was born: a black mask that changed position, shape and perspective in lockstep with the moving objects it was supposed to block.

An early technique, borrowed from the world of cartoon animation, and still in use in more refined forms, was **rotoscoping**. Back in 1915, animator Max Fleischer realized that most individual hand-drawn sheets or 'cels' in a cartoon were almost exactly like the previous frames, and also just like the ones that would come next. It was only the fractions of apparent movement added to each frame that made any difference when cumulatively viewed on screen at 24 frames per second. Fleischer created a projector (the **rotoscope**) that beamed completed cels onto a fresh cel sheet, so that animators could simply work over the previous cel's outline, thus saving themselves endless flicking between one sheet and the next in the drawing process. It soon became clear that this technique could be adapted to create matte masks.

To rotoscope travelling mattes, processed images from a live-action shot of an actor, say, are projected, frame by frame, onto acetate sheets, so that an artist can trace the actor's outline. This is then filled in with opaque black ink. (Hence the use of acetate for the cels: ordinary paper would warp and deform in the areas dampened by the ink.) The optical system of the projector is converted into a camera and then loaded with black and white negative film. The sheets are put back onto the baseboard and photographed, one by one.

This process delivers a cartoon-like sequence of the actor as a pure white silhouette moving against a pure black background. Next, the negative is copied onto another negative strip. This delivers a black silhouette moving against a white background. There is now a matte to protect footage of the actor, and a 'counter-matte' to protect the background.

The next step takes place in a film-copying system called an **optical printer**. Its magazines and drive mechanisms are built to handle a double thickness of film. The topmost layer, the matte of the actor, prevents the fresh film underneath from registering anything within his silhouette. Footage of the required background is copied onto new film *around* the matte. The result is a copy of that background with an unexposed dark area corresponding to where the actor should appear.

Then this new film is rewound to its start position, and the counter-matte is laid on top, protecting all the background areas. The original footage of the actor can be copied through the actor-shaped white hole in the counter-matte, and onto the new film underneath, where the unexposed actor-shaped area is waiting. When processed, the final result is the actor combined into his background, but without any double exposure flaws.

This complex, tedious process of sandwiching, copying and rephotographing many strips of film in the optical printer to deliver a final strip with every element correctly in place is known as **compositing** – a term that still applies in the modern digital age.

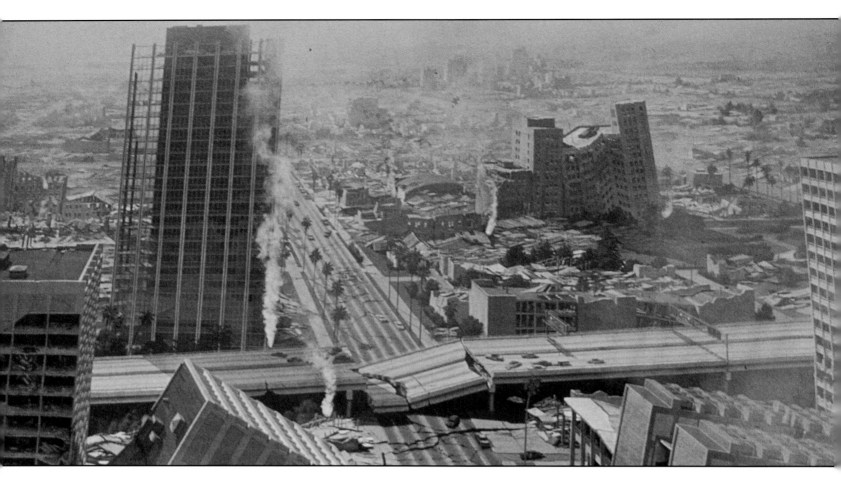

FOREGROUND AND BACKGROUND

It is expensive and time-consuming for artists to rotoscope every frame of a travelling matte, particularly when actors are involved. Arms and legs, hands, fingers and swirling clothes are difficult to trace accurately. In the 1950s, film-makers searched for a way of automating the process. The **blue-screen** technique became a standard, still in use (in an adapted form) today.

In the colour difference process, actors were photographed against an evenly lit blue screen. The colour film was processed and its positive image was then copied, through a blue filter, onto black and white film. Only blue light could pass through the filter, so the foreground actor was darkened while the blue background registered as pure white on the new strip of film. This created the matte. The original colour image was then copied again onto another strip of black and white film, but this time through a strong red filter. Now the actor remained light, while the background blue screen turned completely black. This generated the counter-matte. By using very high-contrast black and white films, with no grey scale, more or less pure black-white mattes were delivered, but only at the cost of losing subtle details such as hairs or cloth fibres.

In the 1970s, the **colour separation process** was developed. This worked by filtrated copying from the original colour negative, where the greatest amount of original information was to be found. The filtration details were far more complicated, and this was not a technique for the timid or the underfunded.

In fact, before the digital age, there were any number of methods for blue-screen shooting, and countless combinations of film stock, chemistry and colour filtration that could be used. The drawbacks were never quite eliminated. Multiple copying and sandwiching of film layers inside optical printers almost always led to some degradation in the image quality; colour films for live action weren't always consistent in warmth, graininess and other characteristics with the film used to shoot the background elements; and the complexity of the process was such that a dozen different strips of film were often required to achieve a single matte. For scenes containing multiple elements (swarms of battling starships, for instance), it was a challenge merely to keep administrative track of the countless separate strips of film: positives, negatives, mattes, counter-mattes, exposed and developed strips, partially exposed but undeveloped strips, filtered, colour-separated, original, copied and recopied strips and so on.

Digital compositing dispenses almost entirely with the need for these intermediate film duplications, and provides matte artists with an ever-increasing range of possibilities. Many different layers of live-action components, model shots, cloud and sky effects, digitally painted artwork and **computer-generated images (CG)**, with their mattes and counter-mattes automatically made available, can be blended in a computer to build up a scene.

4 A devastated Los Angeles in *Earthquake* (1974) is represented by a matte painting. Smoke and fire, shot as live elements, were simply double-exposed onto the painting at key locations to give the otherwise static scene greater realism.

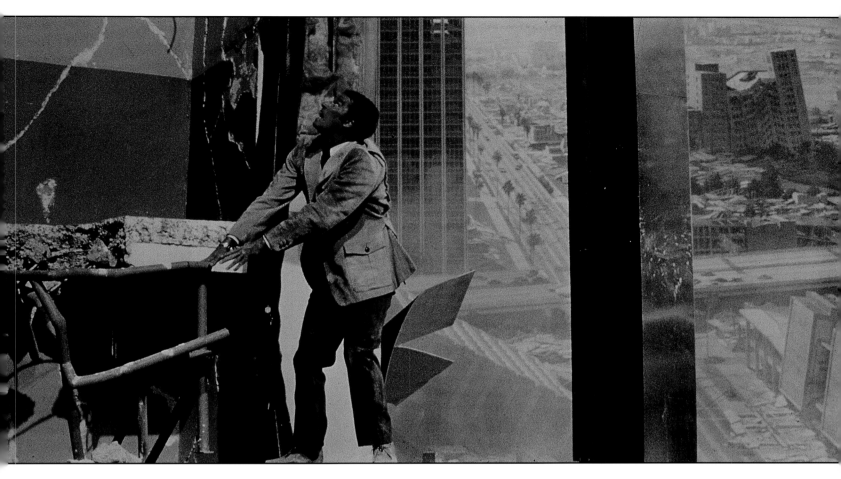

THINKING IN FRAMES

Before serving as creative director during Digital Domain's inception, Price Pethel was a key figure in the invention of a new technology derived from TV video compositing. He collaborated with Quantel, whose famous 'paintboxes' (developed in the 1970s) and other electronic editing tools allowed complex mixing of TV video images by converting the signals into digital formats that could be manipulated by a computer. In 1976, TV coverage of the Montreal Olympic Games featured split screens and multiple camera angles shown simultaneously. That would all seem very tame today, but it seemed miraculous at the time. By 1978, Quantel could take a flat TV image and roll it up like a newspaper, or wrap it around a sphere, thus providing television producers and advertisers with a brand-new set of graphics tools.

Multiple-element compositing for television was made possible with tools like **Chromakey**, working in a way not dissimilar to blue-screen techniques, essentially swapping out blue backgrounds in favour of a substituted background image. (TV weather forecasters began to appear in front of huge maps that weren't really there.) This was fine for combining video images, but problems occurred whenever anyone tried to mix video with film.

Video images work on a cycle of 30 frames per second (or 25 in the UK), while film works at 24. Another difference is that images viewed on a TV screen are built up line by line,

with the images 'refreshing' 30 times per second, whereas movie frames are projected whole, swapping from one to the next 24 times a second. Traditional **telecine** machines copy film onto video tape using various methods of skipping some frames and lingering on others, so that frame by frame the film and tape never quite match, but minute by minute they do. Because the video systems are just copying the film from an adapted optical printing system, there is often some mechanical flutter in the movement. This is quite noticeable in many TV showings of classic movies.

Pethel decided these inaccuracies were intolerable. 'At a company called CIS, I became involved in finding a way of scanning film onto digital media without weave and flutter. Up till then, telecine had been concerned primarily with making movies available for television broadcast, and that was that. Instead of thinking of the movie as a whole, we began to think in terms of respecting and preserving the data in individual frames.' Even as recently as the 1980s, there was only a limited market for frame-by-frame accurate transfer of movies onto digital media, because optical printers were still the byword for compositing. 'You'd have inter-mediate positive copies, intermediate negatives, bi-packed film strips and all those separate elements. Our aim was to get everything loaded digitally, so you could save the image degradation that comes from working with three different

5 In another scene from *Earthquake*, Charlton Heston climbs the side of a small set representing a smashed building, while the matte painting of greater Los Angeles in decay is rear-projected behind a semi-translucent screen at the back of the set, so that the camera can shoot everything in a single take. The lighting and colours of the foreground and background scenes were difficult to match, but projectors were frequently used as an alternative to mattes and compositing in the pre-digital age.

DIGITAL DOMAIN **THE SAME OLD PROBLEM** 19

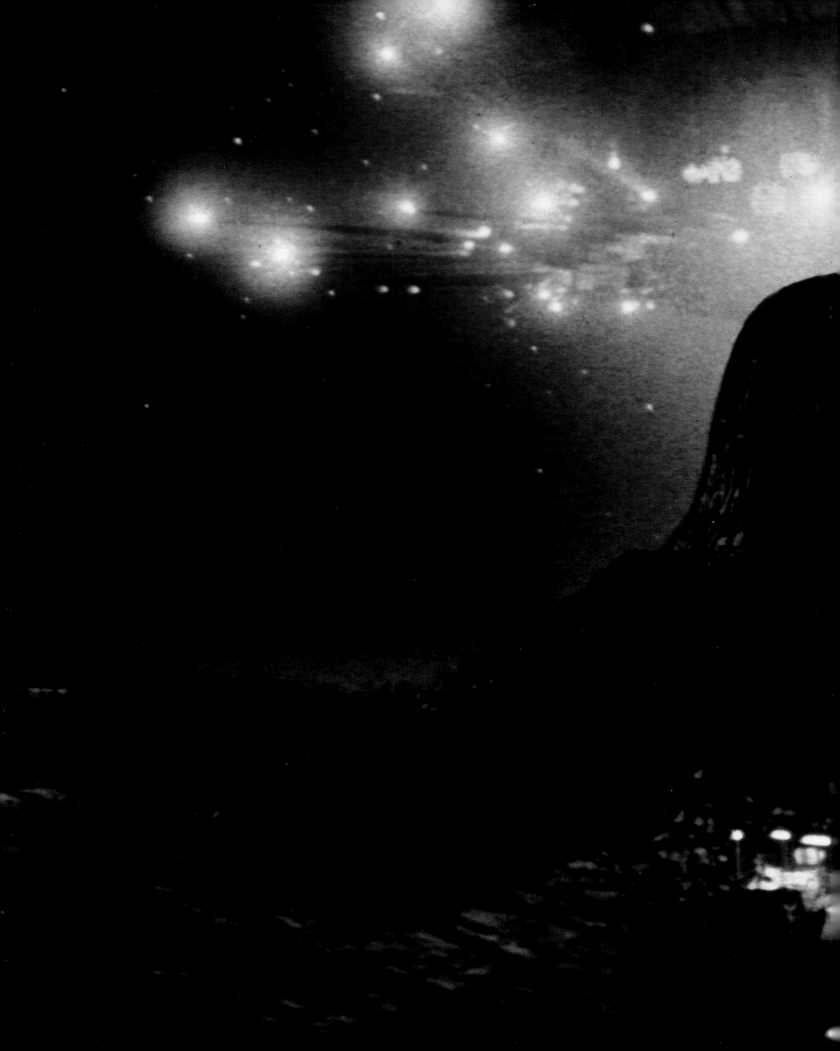

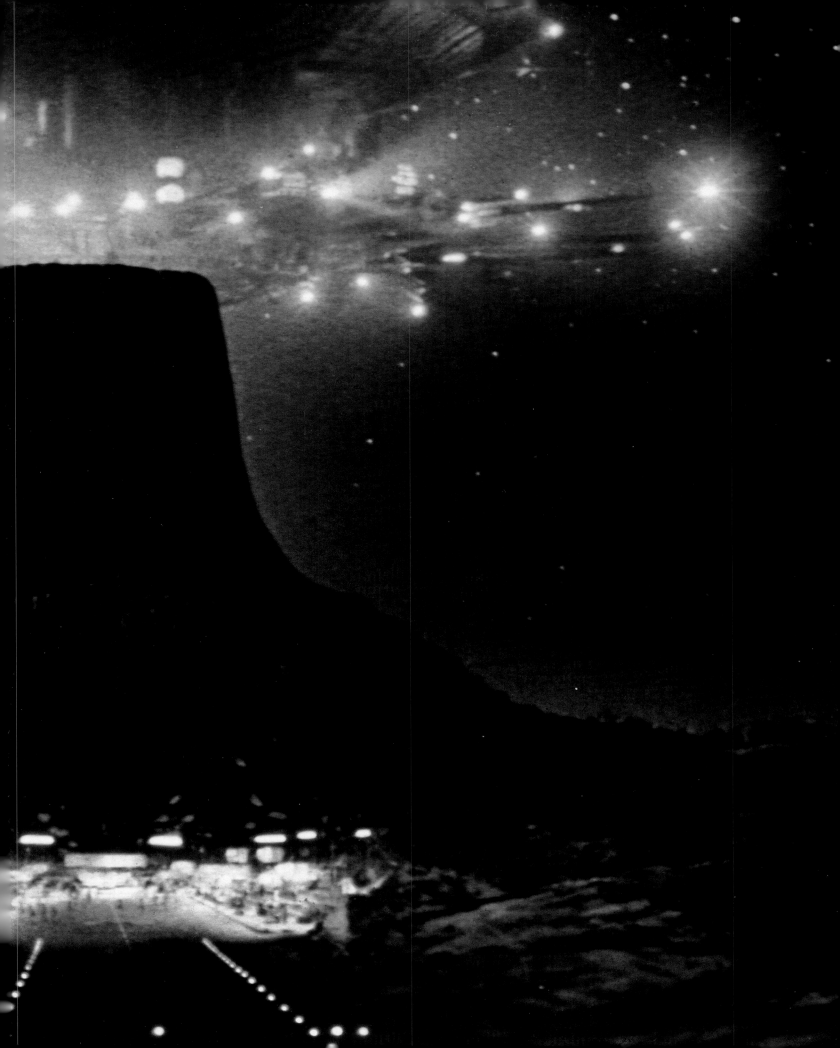

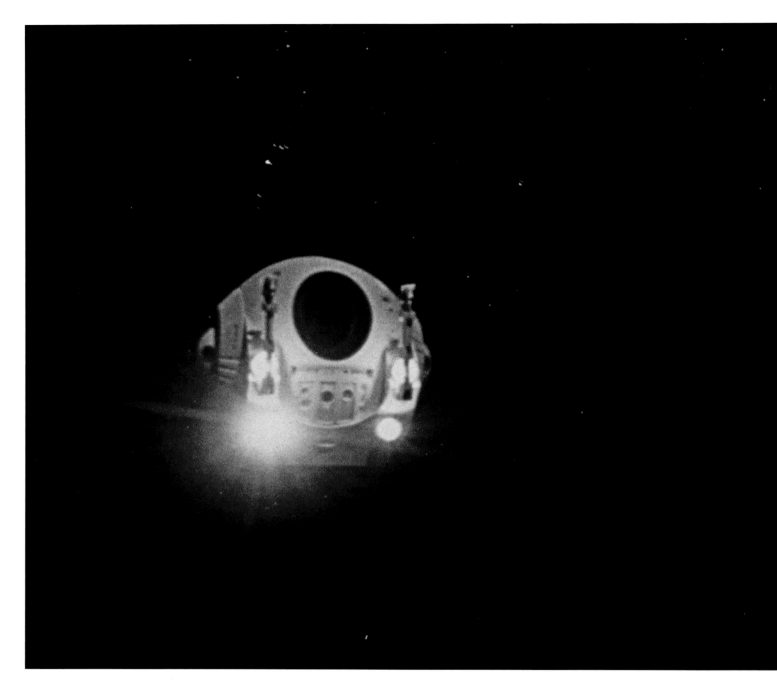

generations of copying one film onto another, and get rid of all the dirt, the cleaning, the mechanical problems, the endless matte and counter-matte strips and so forth. I thought it would make a lot more sense if you could use a mixing desk for movie images just as you would for sound or video.' Among a like-minded group of pioneers, the concept of digital movie compositing was born.

A major advance came along quite independently of the TV and movie worlds. Computer disks became much faster and more powerful, and it became possible to store huge numbers of pictures in one box. Instead of streaming a movie onto video tape and playing it in sequence, each complete frame could be stored as a separate file and accessed separately. This break-through, **non-linear editing**, is now absolutely standard, for television as well as film.

Mark Forker joined Digital Domain from the world of television and video. 'For video compositing in the old days, you might be able to layer ten or twelve different elements, but they came from tape. With a dozen tapes rolling all at once, you had to go with it and hope for the best. Also, with tape, you're winding backwards and forwards forever just to get to the place you want. With non-linear editing and compositing, you can dive in and out of a sequence and grab any frame you want, at any time. Random access computer disk memory allows for that.'

PREVIOUS PAGES
6 In a beautiful non-digital scene from *Close Encounters* (1979), the alien mothership hovers over the official reception site established by a secret group of human scientists. The rock formation and the alien ship are models, but the illuminated science station is a live set composited into the scene. The ship, mountain, night sky and science station all required separate mattes and counter-mattes.

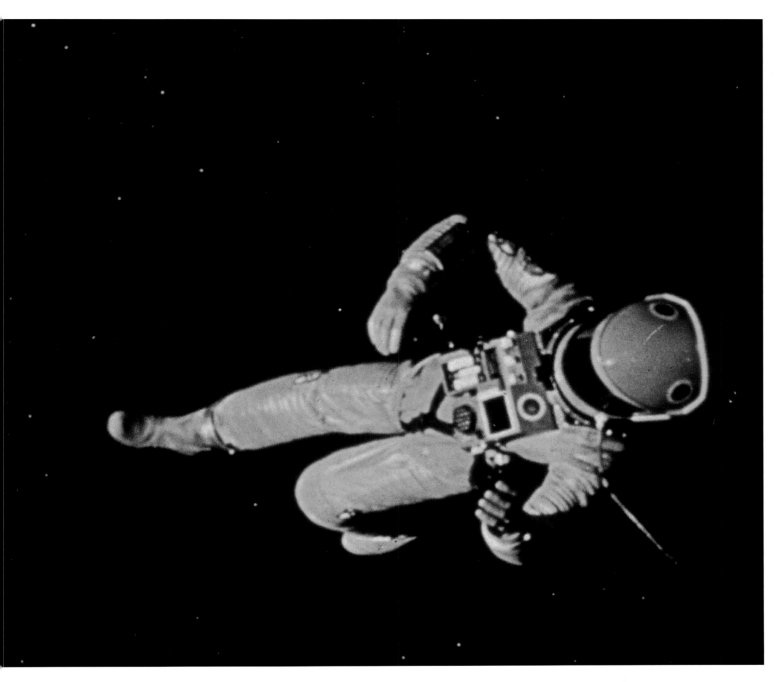

It's no coincidence that Digital Domain chief Scott Ross used to work in the video realm, as head of a major post-production company called One Pass Video. When he was hired by Industrial Light and Magic, he took with him a determination that film-makers should be able to adjust their images on a mixing desk just like videographers, but without sacrificing the image quality normally associated with conventional film stock. Thus one of the founding philosophies for Digital Domain was established.

7 For his 1968 science-fiction classic *2001: A Space Odyssey*, Stanley Kubrick insisted on hand-drawn (rotoscoped) mattes for every astronaut and craft floating in outer space. This laborious old-fashioned technique delivered perfectly crisp effects in every frame, with no fringing or blurring, but as a consequence, *2001* took nearly three years to complete.

A theatre screen can require an image which is comprised of 3 million pixels or more.

a single pixel

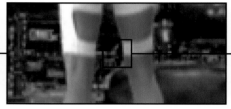

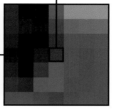

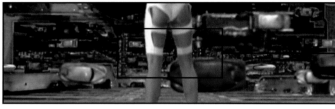

DIGITAL BUILDING BLOCKS

In a digital image, the smallest picture element, universally known as a **pixel**, is created from three electronic channels: red, blue, and green (RGB). The balance between these three signals creates the final colour mix of a pixel. Meanwhile, a fourth 'hidden' channel, called the **alpha channel**, controls a pixel's transparency by varying the RGB intensities. When digital images are layered on top of each other during digital compositing, the alpha channel controls the degree to which one image can be seen through another. The alpha channel is a fundamental tool for creating digital mattes.

All four of these pixel channels have a 'depth' measured in terms of digital 'bits'. An 8-bit depth means that the colour and transparency of a pixel can be described in 32 bits. The finely graduated subtlety of photo-realistic digital images may require a depth of 16 bits per channel during certain phases of work. (The Cineon 10-bit format, developed by Kodak, is used during many phases of digital imaging.)

A digital picture frame is made up of parallel lines of pixels. The quality of the overall image depends partly on the total number of pixels involved. Frames designed for projection on a huge theater screen may require more than 3 million pixels, in a matrix 2048 wide and 1556 deep. Because such an image is made up from approximately 2000 lines (actually 2048), this format is known in the trade as a 2K picture, but 3K and even 4K images are sometimes created. Multiply that by the number of bits that it takes to define each pixel, and the scale of memory required to store and manipulate individual digital frames becomes clear.

The alpha channel is used to drop out the green background.

White areas are visible and black areas become transparent, allowing the figure to be placed on any chosen background.

The grey areas of the alpha channel become semi-transparent.

The depth of the grey determines the level of transparency. The darker the grey, the greater the transparency.

Single digital frame

3 colour channels (RGB)

Alpha channel/matte

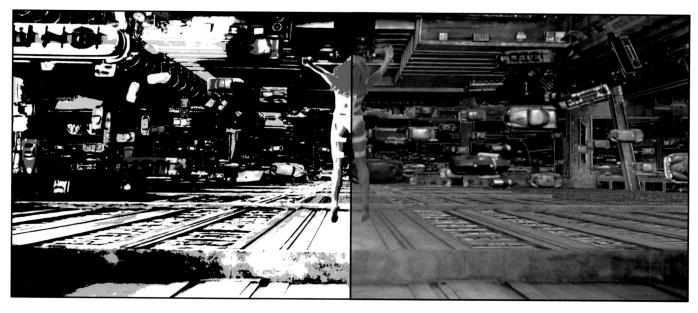

3-bit composite RGB image
1 bit (RED) + 1 bit (GREEN) + 1 bit (BLUE) = 3 bits (RGB)
2 tones x 2 tones x 2 tones = 8 colours

24-bit composite RGB image
8 bits (RED) + 8 bits (GREEN) + 8 bits (BLUE) = 24 bits (RGB)
256 tones x 256 tones x 256 tones = 16.7 million colours

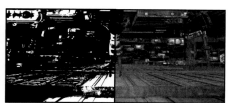

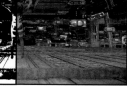

1-bit red channel 8-bit red channel 1-bit green channel 8-bit green channel 1-bit blue channel 8-bit blue channel

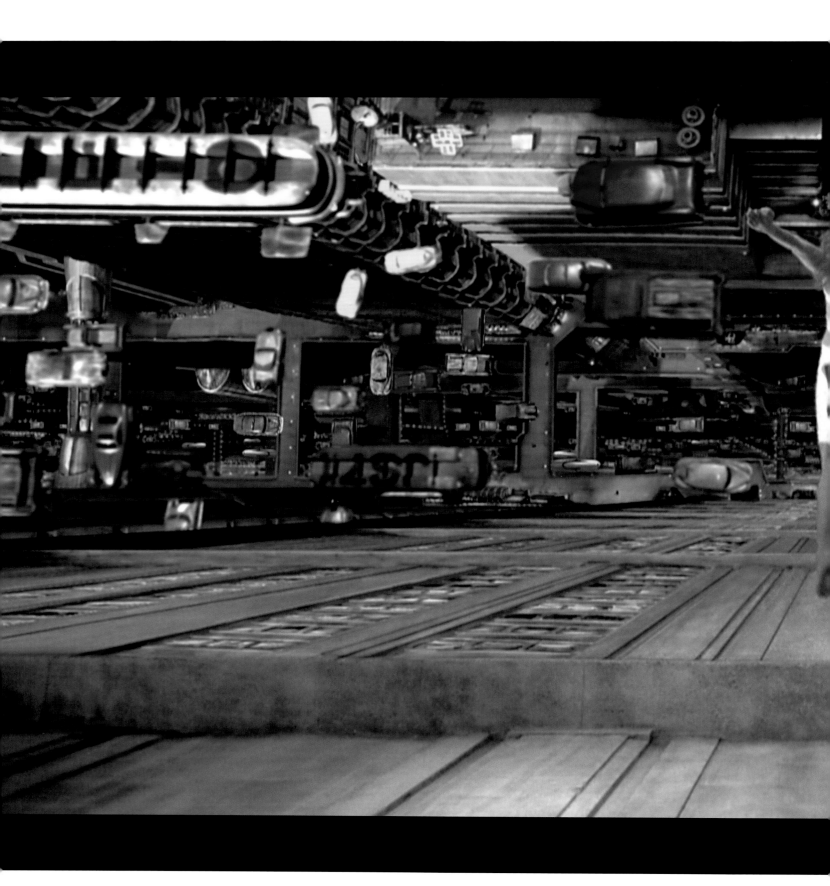

8 A stunt artist standing in for *Fifth Element* actress Milla Jovovich appears to leap into the air and fall hundreds of metres towards the street. In reality, the performer dropped towards a huge green screen suspended over the studio floor.

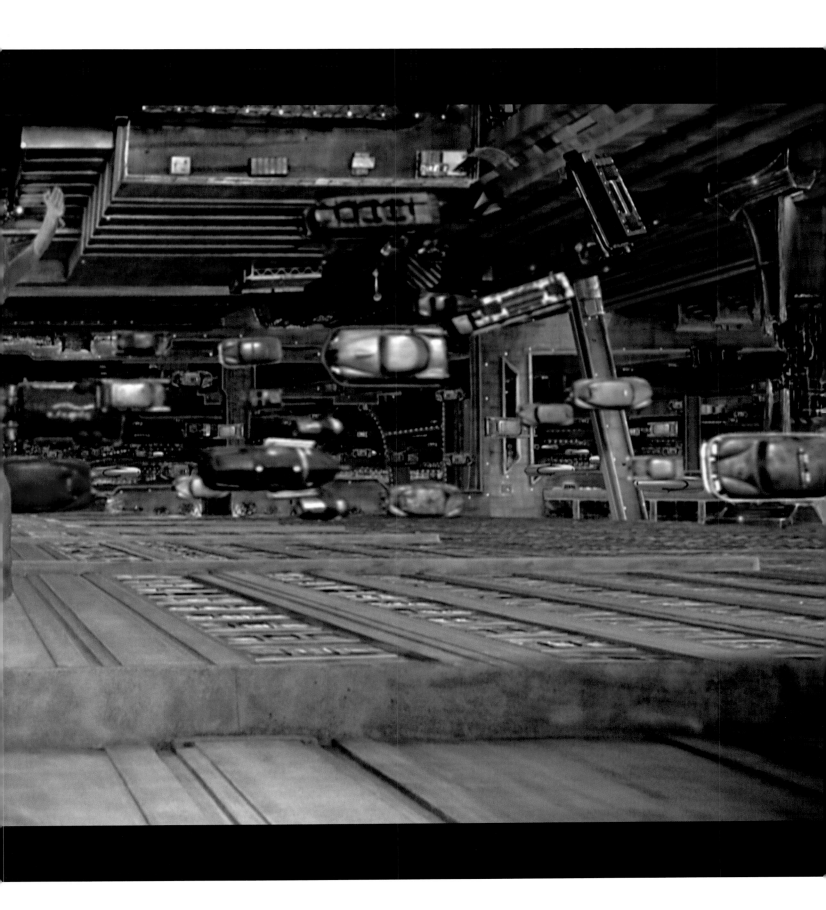

BACKGROUND PLATE CONTAINING MULTIPLE CG ELEMENTS
In *The Fifth Element*, the miniature cityscape is overlaid with moving CG traffic. All the vehicles follow paths controlled by coded particle systems.

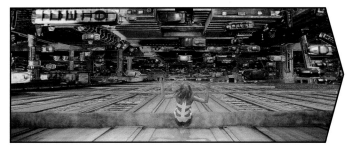

PREVIOUS FRAME
A stunt performer doubling for Milla Jovovich, playing the character Leeloo, prepares to jump into thin air to escape her police pursuers. Although this looks like one live-action take, the scene is actually composed of many elements shot at different times.

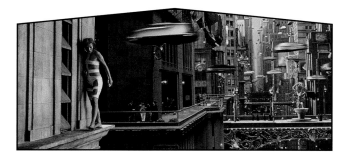

PLOT 'SET-UP'
Leeloo tries to evade capture by walking along the ledge of a frighteningly tall skyscraper, but it seems there's nowhere for her to go. The scene is a complex mix of live-action photography, model shots, CG sky backgrounds and particle-systems traffic.

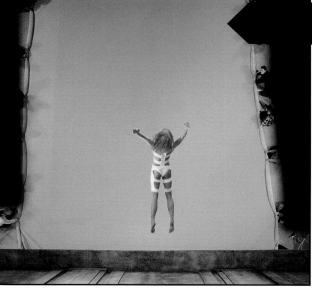

LIVE-ACTION FOREGROUND FRAME
Milla Jovovich's stunt double jumps into space and falls onto a green-screen tarpaulin held by a Digital Domain crew. All the green areas will be replaced later by the appropriate street scenery.

BRIDGING THE DIVIDE

In principle, there are two ways of transferring digital images onto film. The most common method, derived from telecine machines, is to photograph the surface of a **cathode ray tube (CRT)**. Essentially, this is the glass guts of a video monitor, but specially scaled and adapted to work with the front end of a film camera. Even the best CRTs cannot match the resolution of conventional film, so it is common for each electronic frame of a digital picture to be split into the separate blue, green and red components, ensuring that the entire resolution of the CRT screen at any one moment is dedicated to delivering information for just a single colour. The film camera photographs these three colour separations in turn, thereby layering up not just a complete copy of the overall original electronic image, but one that's actually three times sharper than the CRT alone could ever display. The process takes approximately 20 seconds per frame.

There are several variations on that technique, one of which involves removing the glass surface of the CRT and firing its charged electron guns directly onto film. But the most modern systems dispense with the CRT altogether. In a BU **laser scanner**, three beams of blue, green and red light are combined in a series of prisms to create a single beam, mixed to the appropriate pixel colour. This fires onto a rapidly spinning mirror which deflects the beam so that it sweeps across the film frame in a pattern of parallel lines. All the while, RGB channel data pulses the colour lasers on or off at the appropriate millisecond, constantly altering the output beam's colour mix until a complete matrix of pixels is burned onto the film. With delivery times of less than six seconds per frame, laser scanners are fast, hyper-accurate and literally 'laser-sharp'. The only problem is, they can be too sharp. Sometimes a digital image composited into conventional live-action photography looks unnaturally crisp. Computer artists at Digital Domain often spend a good deal of time adding artificial image degradation to their work before outputting it onto film.

The opposite end of the process, scanning film images into digital form, is accomplished with **charge-coupled devices**

COMPOSITE FRAME BREAKDOWN
Many different elements contribute to the finished scene. In a technical sense, everything has to match perfectly, but there also needs to be an intangible emotional cohesion to provide the overall shot with the right 'feel'.

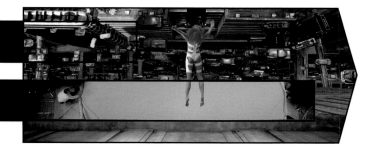

FINISHED FRAME
The street miniature is shot with a motion-control camera rig. Multiple CG traffic elements are composited over this plate. Then the live-action shot of the stunt double is composited into the overall background scene.

BACKGROUND PLATE
Attention to detail is everything. An army of set dressers are employed to make sure every detail is correct.

CG ELEMENTS
Each CG vehicle is a completely modelled 3-D item in its own right, but particle-systems routines and other techniques enabled certain characteristics to be 'dialled in' to the design of many cars at once: for instance, colour, size, rust and dirt, minor impact damage, and other subtleties of overall appearance.

BACKGROUND PLATE WITH CG
The multi-level traffic must fly between buildings, not through them. The various particle-systems layers are programmed around an exact three-dimensional survey of the model buildings. When the CG traffic is composited into the model-shot plates, there are no clashes.

(CCDs), similar in principle to the ordinary photo scanners available for most home computers today. (Similar, but much more accurate and expensive, of course.) Three parallel CCD arrays, one for each of the three colours, scan an illuminated film frame.

In all the above systems, moving components are kept to a minimum. The 'weave and flutter' effect that once vexed Pethel and his colleagues has been eradicated from the frontier where film meets digital. Any remaining problems of unsteadiness must lie within movie cameras themselves: with the very fact that conventional film needs to be unrolled from one reel, straightened out, clawed and cajoled through a camera's innards, and then rolled up onto a second reel. It's not a system synonymous with accuracy. In an age of 'solid state' electronic marvels, a first-rate motion-picture camera is one of the last and most impressive bastions of old-fashioned mechanical precision.

DIGITAL MATTES
Because all the colours and brightness levels of a digital image are described mathematically, the blue background in a blue-screen image can be identified very precisely and swapped for something else: typically, a background scene of some kind. Only the blue pixels are swapped.

Effects artists think of elements shot against a blue screen as foreground elements, and refer to the images that will eventually be swapped for the blue as the **background plate**. The word 'plate' is a fond throwback to the old glass-painting days, but in practice, the background is usually film footage, with each frame considered as a separate 'plate'.

In theory, any pure colour tone in a screen can be swapped for a background plate, but there is a good reason for sticking with blue: it is the least prevalent colour in human skin. Flesh tones feature the red, orange and yellow end of the spectrum, and images of any actor photographed in front of a blue screen will be unaffected when every last pixel of blue in the scene is exchanged for something else. If a red screen was digitally swapped for the background plate, then parts of that scene

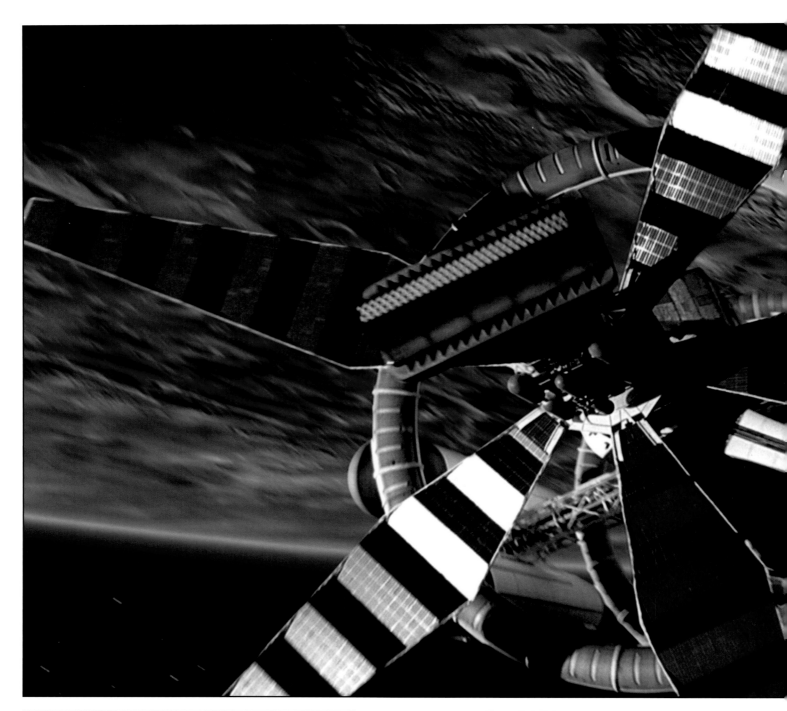

MATTES

In a classic example of matte photography, a model spaceship for the movie *Red Planet* is shot against a green screen.

The green sections can be isolated either through photochemical processes or in a computer to create a matte of the ship.

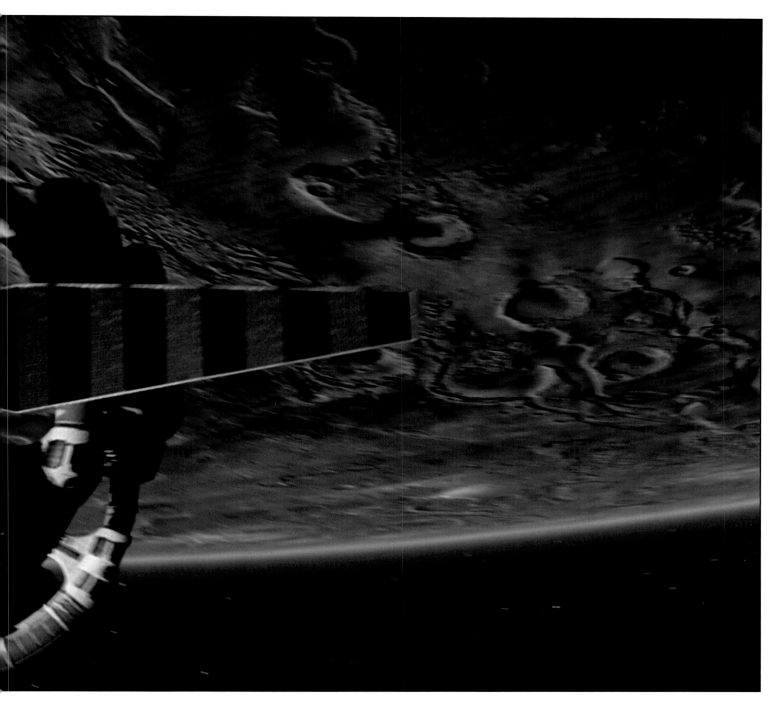

The resulting silhouette matte prevents a separate background shot of Mars from showing through the spacecraft area.

Then a counter-matte allows the original full-colour spacecraft image to be composited into the shot without disturbing the background.

GREEN SCREEN IN ACTION

would appear through the actor's red cheeks and suntanned arms. Since actors are photographed more often than anything else, background-plate separation techniques for live action are based around non-human colours only.

But there's a catch. Movie film contains three layers, each sensitive to different colours: blue, green and red. Different chemical dyes are required to pick up each colour, and as a consequence, the red-responsive layer tends to be sharper than the blue. Another problem is that blue light has a longer wavelength than red, and this creates inherent unsharpness within the glass components of a lens, even when they are designed to compensate. For crisp mattes, therefore, it would be best to shoot against a red screen, but as we have seen, that would be no good for shooting actors. The middle green region of the spectrum is often considered the best compromise, and green-screen photography is just as common as its blue-screen cousin. Digital matte systems are just as happy swapping out green pixels as blue.

Let's explore a perfect example of how green-screen digital mattes are used in the making of a movie. *True Lies*, directed by James Cameron, was Digital Domain's first major venture into feature films. Until now, Cameron had drawn on the resources of Industrial Light and Magic (ILM) to create his effects. ILM designed the water alien in *The Abyss* and the remorseless humanoid liquid-metal hunter-killer for *Terminator 2: Judgement Day*. These movies certainly had the 'wow' factor, using effects that stunned and amazed their audiences.

But for his next film venture, Cameron wanted to showcase Digital Domain's new-born capabilities. In *True Lies*, Arnold Schwarzenegger plays a secret agent working for the government. Just like an American version of James Bond, he comes with all kinds of fancy equipment, but unlike 007, this super-spy is married – the hook being that his wife (as played by Jamie Lee Curtis) is totally unaware of her husband's profession; she thinks he's a computer salesman who has to go away rather too often on long sales trips. Adventure ensues when a gang of terrorists bent on world domination hijack a nuclear bomb. Digital Domain devised many of the film's set-pieces, with stunning visual effects supervised by John Bruno.

In the climactic sequences, Schwarzenegger is flying a Harrier jump jet, trying to save his daughter from the evil clutches of terrorist Art Malik. All three end up clambering on top of the jet while it hovers precariously among the skyscrapers and office blocks of Miami. Digital Domain's task was to make this sequence utterly believable, yet completely safe

9– Shooting *Red Corner* in genuine Chinese locations was politically impossible. Instead, a covert
10 team, posing as tourists, shot major landmarks as stills. A blue screen on a Hollywood backlot
 enabled clever compositing of real landmarks into live-action footage.

11– For an early scene in *Apollo 13*, actors were shot against a green screen on a small foreground set.
12

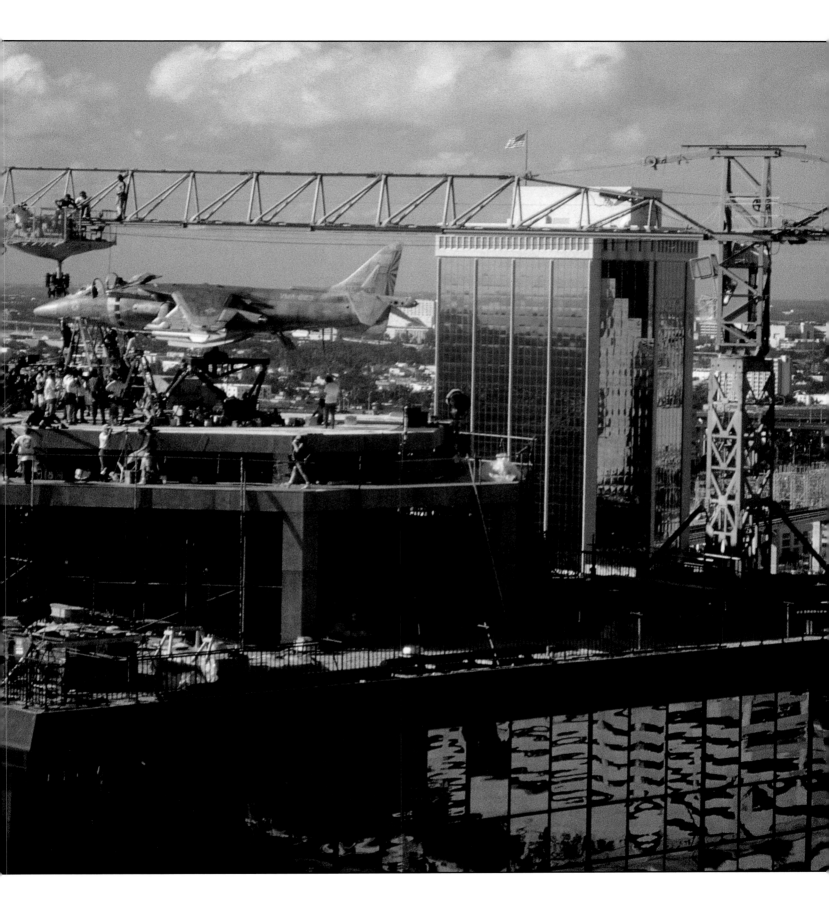

13 During the filming of *True Lies*, for maximum realism, several key live-action scenes of the Harrier were shot on the roof of a real Miami office block, with the Harrier mounted on a hydraulic platform so that it could pitch and roll. The platform was later painted out digitally.

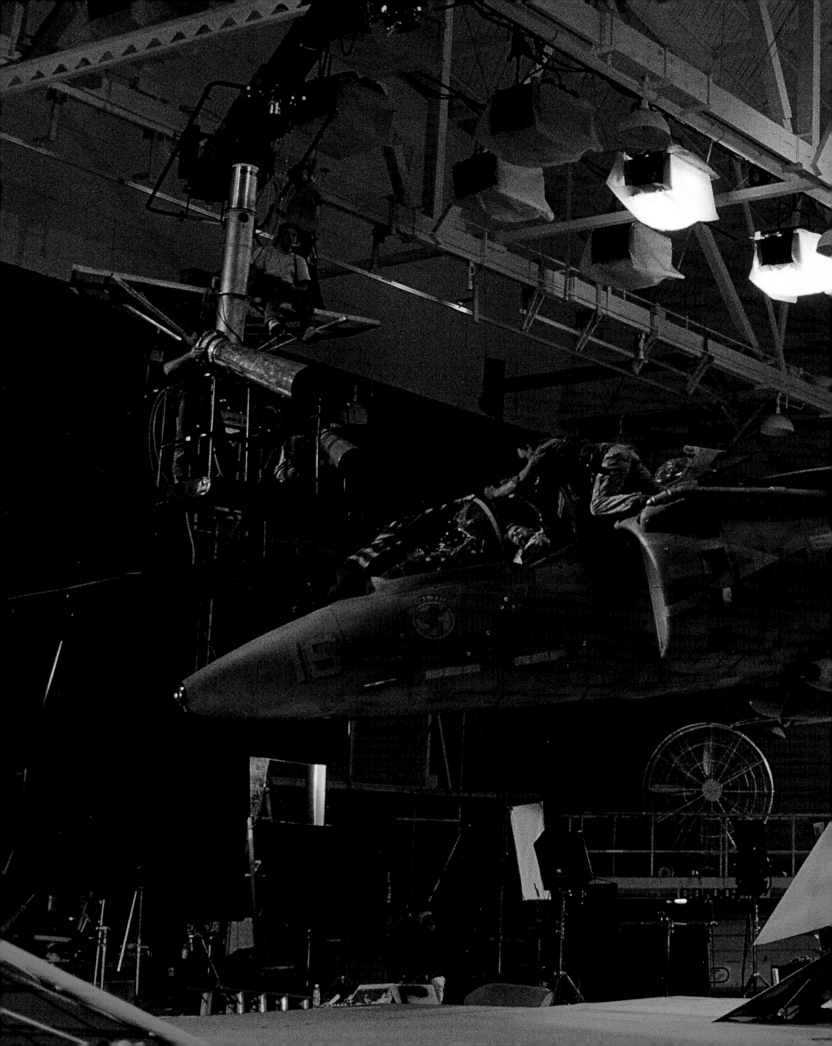

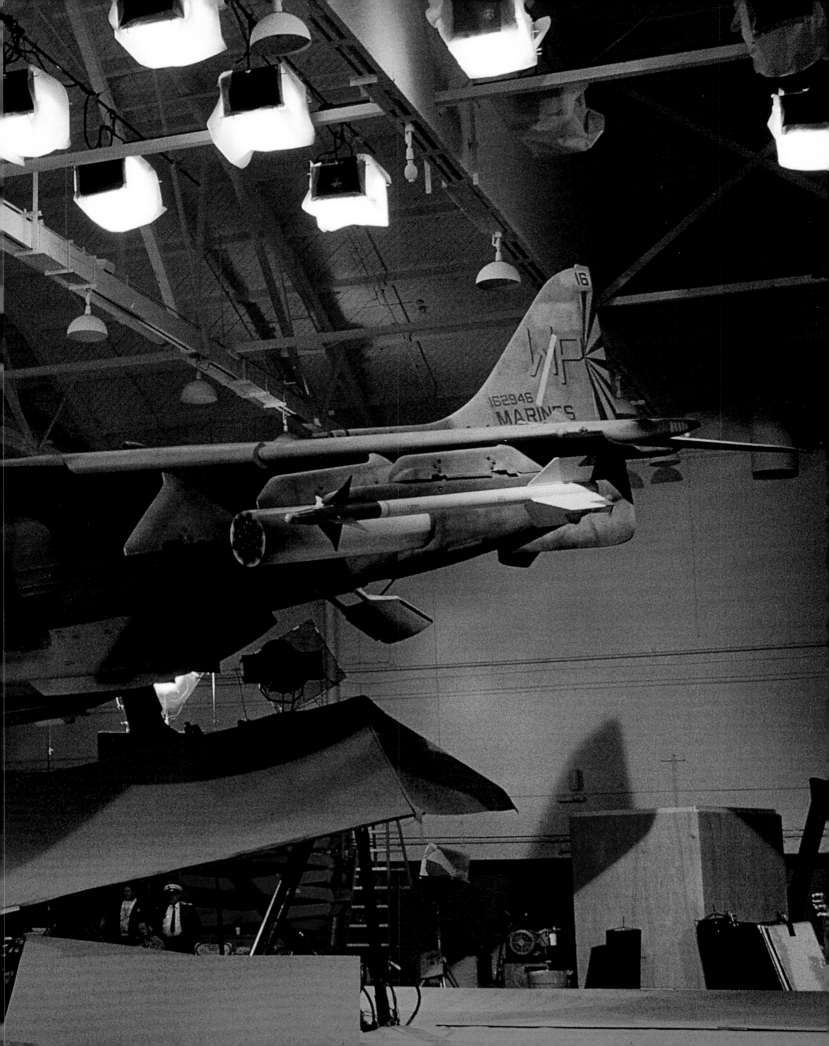

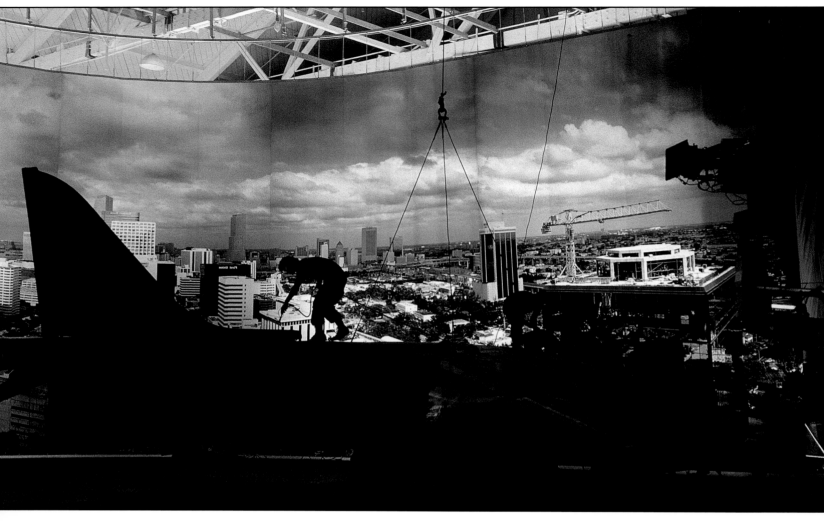

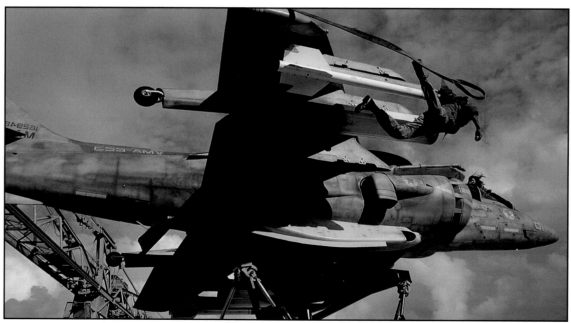

PREVIOUS PAGES
14 A full-size Harrier mock-up at the Van Nuys shooting facility, complete with green-screen base rig.

14

for the actors to perform. Several rooftop scenes were filmed on top of a Miami office block, but the shots looking down onto the Harrier, with the street apparently hundreds of feet below, were deemed too dangerous to shoot live, even for stunt doubles.

Art Malik's terrorist, pushed beyond logical thought by fear and greed (he is the villain, after all), leaps from a tall construction crane and onto the top of the Harrier. At least, this is how the finished shot appears. In practice, stuntman Jimmy Roberts jumped onto a full-scale mock-up of a Harrier, suspended in a studio just a few feet above a green-screen floor panel large enough to fill the camera's field of view. The green was swapped digitally for the background plate of the street scene.

It sounds straightforward, but the 47-foot studio version of the Harrier model, shot with a wide-angle lens, required a green-screen floor the size of a basketball court. A specially converted hangar at Van Nuys airport was hired, large enough to encompass a wide variety of set-ups. For instance, in one scene, our hero (somewhat distracted by having to fight with the terrorist) inadvertently backs the Harrier into the side of a tall glass office building, smashing windows with the tailplane. At Van Nuys, a two-storey panel of glass windows was constructed, and the Harrier, with stunt doubles enacting the Schwarzenegger and Malik roles, was trundled at speed along a steel frame on caster wheels. In real time, it smashed into the glass panels and shattered them.

There were green screens everywhere, but in order to isolate the Harrier and the glass panels cleanly for inclusion in the finished sequence, Digital Domain's artists had to resort to rotoscoping mattes into individual frames to get rid of the Harrier's hydraulic supports and various struts and beams within the surrounding hangar. Digital rotoscoping is barely less tedious than the old system of inking acetate sheets. It requires frame-by-frame manipulation of the initial image with mouse-driven paintbrush tools. If modern audiences (and

newspaper journalists) could see digital rotoscoping for themselves, they wouldn't talk so often about computers 'creating' all the effects in modern movies.

Another problem for the Van Nuys team was that glass is reflective. Matte painter Ron Gress and his partner Suzy Miscevich painted a huge mural of the Miami skyline, which was placed behind the camera and lit so that it would reflect in the glass panels. Of course the camera and crew would also be reflected. Huge flat panels painted up as cloudscapes and sky were placed around the camera, until only the lens was showing through in the glass reflection. (This last little glitch had to be digitally painted out later.)

Scanned and digitized footage of the Harrier smashing into the panel of glass, surrounded by a green screen, with random 'junk' elements rotoscoped out, was now ready for a background plate to be swapped into the green areas. But *what* background, exactly? The Miami office block in question was photographed as a location, from the appropriate angle, with the perspective and scale of the real-life glass panels exactly matching the Van Nuys replica. This background plate was then substituted for the green: essentially fitting an image of the real office block *around* the Van Nuys glass panels and the colliding Harrier.

There was no optical compositing involved. Digital Domain compositors were able to swap out green screens for background plates entirely within the computer. Compositing expert Jonathan Egstad highlights another overwhelming advantage of digital techniques: 'With optical printers, a failure is a failure, and you have to load all those strips of film again and try different exposure settings, colour filtrations and so on. Now we have the option of "iterating" a composite, trying different things much more rapidly, adjusting the values and characteristics of the various composited layers, and we're not putting original film stock at risk. We can experiment. We can see what we're getting by sampling frames along the way, and

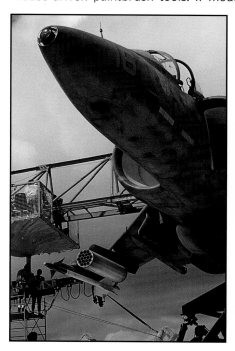

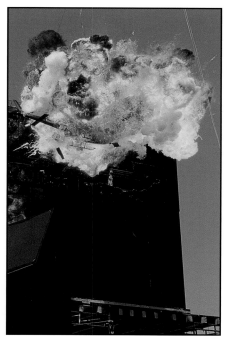

15 A Miami skyline backdrop ensured that any shiny glass or perspex surfaces on or around the Harrier would reflect an appropriate exterior scene.

16– Footage of the Harrier model was mixed with stunt work and exploding miniatures.
18

19 In the finished scene, Art Malik zooms to his death against a composited background.

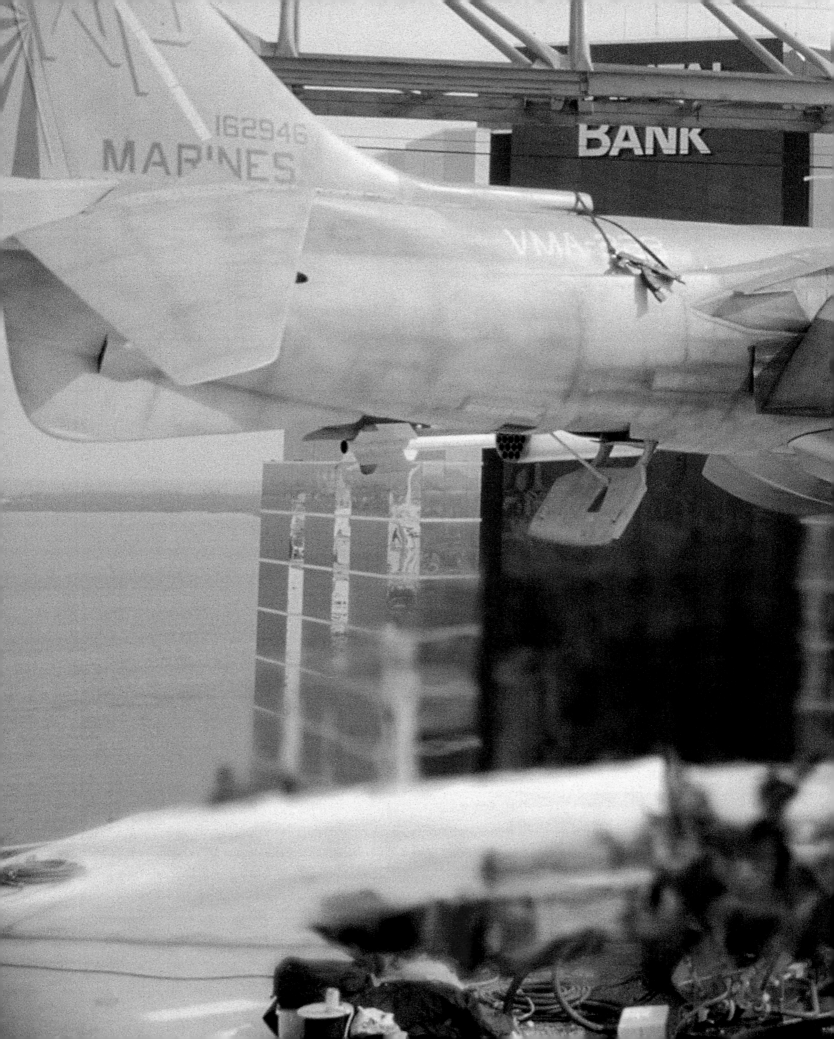

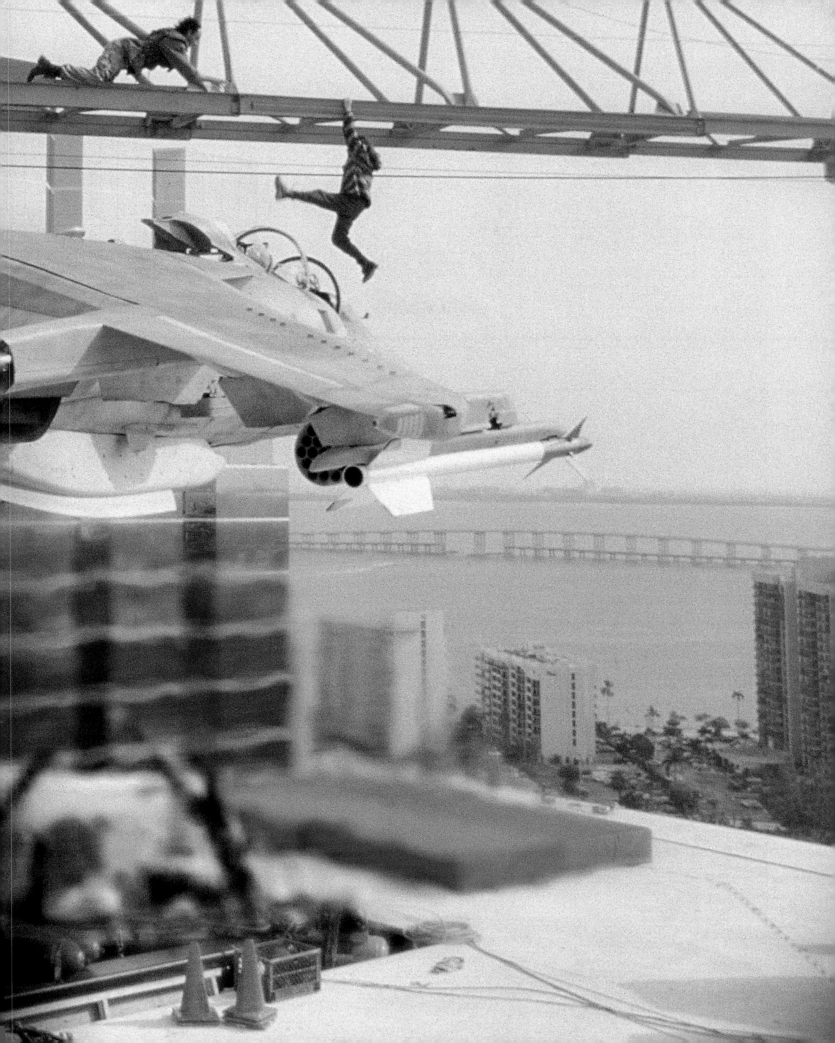

20

PREVIOUS PAGES
20 At the rooftop location in Miami, stunt performers enact the sequence in which Art Malik's terrorist prepares to jump from a crane onto the Harrier.

GREEN-SCREEN LOVERS

In this seductive commercial for Levi's jeans, a young couple are interrupted by a disapproving mum.

The interior areas of the clothes were digitally painted to appear empty, but otherwise, green-screen face masks and body stockings enabled the actors to be removed.

A 'clean' background plate, with no actors in the shot, provided all necessary data about the areas to be swapped out for green. Motion control ensured that the background moved in exactly the same way for the clean shots as for the ones with actors in place.

we're allowed to fail. We're also allowed to make things better, because it's not going to kill us to make changes.'

Mark Forker emphasizes the desire for perfection that is both the blessing and the curse of a digital-compositing system's flexibility. 'With the technology now, you can get 75 per cent of the way there in a day's work. Everybody here is capable of doing that. Then, maybe it'll take another two weeks to get to 95 per cent of how it's supposed to look. But the 95 to 100 per cent range? You can spend four weeks, or eight weeks, desperately trying to get that last few per cent just right. Then, either you run out of time, or else there's a 2 per cent niggle, but you just can't work out what it is, or how to fix it, or even exactly what the problem is – it just doesn't *feel* right – and you have to let the shot go. Of course, what do you expect from perfectionists?'

THE PROBLEM OF MOVEMENT
When a digital compositing system picks out a blue or green screen and swaps it for a background, it does so frame by frame, enabling travelling mattes to be defined just as easily as static ones (even if compositors sometimes have to rotoscope certain tricky areas). But there's more to a travelling matte than just substituting blue or green.

True Lies is a dynamic film full of rapid motion. For instance, in the climactic fight scene, as our view of the Harrier shifts across the film frame, so the background plate of the real Miami office building has to shift in synchrony. We are touching on one of the basic fundamentals of blue/green screen photography: how to keep the background motions of location shots in lockstep with the entirely separate motions from the studio shoot. To put it another way: when the plane in the studio is constantly shifting about in the restless camera's viewfinder, and the Miami background plate is also shifting, it becomes a daunting challenge to predict how the two elements will align when the time comes to composite them, whether optically or in a computer. The solution to this problem is known as **motion control**, and it is a cornerstone of the visual-effects industry.

21

21 The Harrier composited into the final frame with the office block in the background.

MOTION CONTROL

The problem of relative movement between background and foreground elements, exposed at different times, was identified as early as 1914.

In *Flight of the Duchess*, a gallery in an eerie house displays pictures of long-dead family scions. The camera tracks along the floor, examining each picture as a wispy ghost steps out from the canvas. Camera operator Otto Brautigam first shot the gallery set, keeping a record of exactly how many seconds it took to pull the camera (on tracks) between each pair of pictures. Then he swathed the entire set in black velvet, replaced the pictures with rectangular holes that his ghost-actors could climb through, and repeated his original camera move, using his stopwatch data and a cable marked with distance indicators. The result was a fluid shot in which both the 'background plate' (the gallery) and the live-action elements (the ghosts) more or less matched up.

Paramount Studios experimented with a primitive 'motion repeater' for *Samson and Delilah* (1950). In the tragic climax, the hero pulls down the temple of his enemies, and the set collapses around him. The camera pans up to reveal a miniature shot of the larger temple exterior falling apart. Some way had to be found of matching this accurately with the full-size set. Camera moves in the model studio were recorded as photoelectric signals on a strip of film, where the soundtrack would normally register. (An alternative method was to use a phonograph record.) Then, during the live-action shoot, the moves were repeated to create identical pans and tilts. It was essentially a double exposure, with the join between the exposures constantly in motion as the camera moved. Each exposure, or **pass**, had to match the other. During the live-action shot, the areas surrounding the set were swathed in black velvet. Then the miniature was shot with velvet draping the areas that would later be occupied by the live footage. This technique could be thought of as a simple travelling matte, with no need for complex blue screens or optical printing.

Half a century later, similar techniques, logged by pre-digital analogue electronic circuits rather than stopwatches or phonographs, were explored by Stanley Kubrick, Wally Veevers and Douglas Trumbull during the two-year-long creation of the extremely complex effects for *2001: A Space Odyssey* (1968). Kubrick was not satisfied with the precision of the hardware and eventually demanded hand-traced rotoscoped mattes for every element in every outer-space scene. Two dozen artists, nicknamed 'blobbers', worked non-stop for many months tracing all the separate rotoscope elements required for each

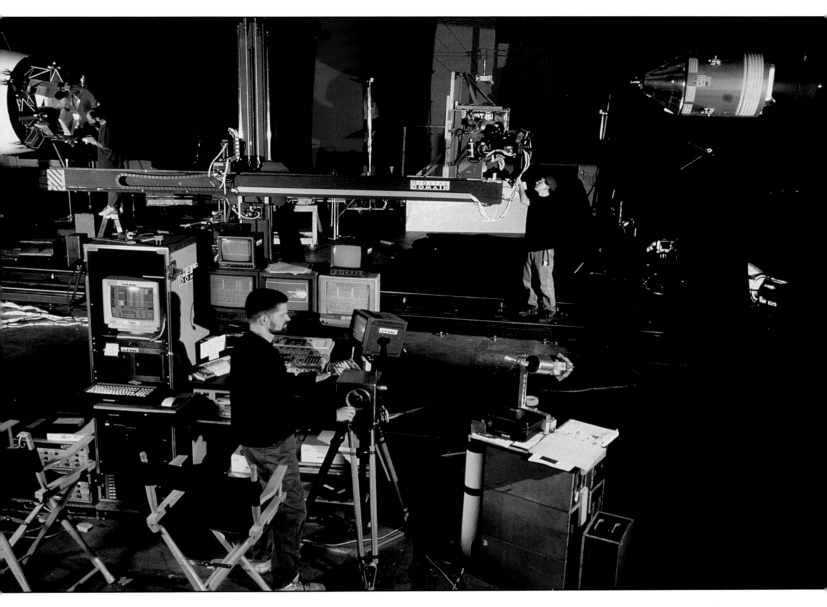

frame: say, the mothership, a repair pod and a drifting astronaut, all individually matted so that the starfields behind them wouldn't show through.

In those days, Disney cartoonists wouldn't have hesitated to hand-draw that many frames, but modern producers on a budget needed to find better ways of creating travelling mattes and multiple exposures for dynamic spaceship scenes. John Dykstra is among those credited with developing a fully computer-controlled motion-control system to shoot spaceship sequences in the first *Star Wars* movie (1977).

Miniatures shot against blue or green screens are used to simulate the ships, because full-size versions (even if they exist in the real world) are too vast and unwieldy to photograph, especially when they have to be seen drifting or zooming into the infinite reaches of cosmic space. Background plates of starfields and planets are then substituted for the screen during the compositing process. But it is difficult for a camera

lens to keep models sharp from end to end. The iris diaphragms in the lenses have to be 'stopped down' almost to the size of a pinprick ($f16$ or $f32$, say) in order to maintain depth of focus. Every stop-down on the iris halves the light passing through the lens. The lighting needs to be very subtly organized for miniature work; turning up the power of the lamps to compensate for the tiny iris aperture is not necessarily the solution. The upshot is that model photography typically requires many seconds of exposure time per frame, with each frame held in position behind the lens until the exposure is complete. To put this in perspective, live-action footage of actors is shot at the normal camera rate of 24 frames per second, with typical exposure times of as little as 1/125th of a second per frame. Until recently, it was rare for a spaceship model to move. The *Enterprise* in the first *Star Trek* movie and even the careening fighters in *Star Wars* were bolted onto sturdy metal poles, completely motionless. It was more practical

1 In the motion-control studio, a camera on the end of the boom lines up with the top of *Apollo 13*'s lunar module.

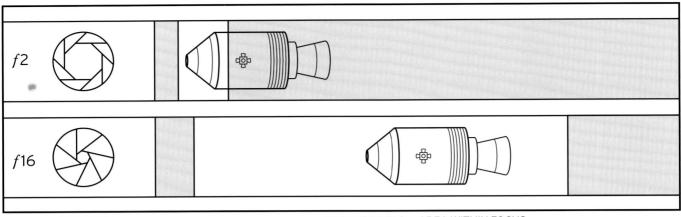

APERTURE DEPTH OF FIELD – AREA WITHIN FOCUS

for the camera to make all the movements, shifting the perspective of the model in the frame so that the viewer was deceived into thinking that the model itself was moving across the screen.

As soon as anything more complicated than a basic 'beauty pass' of a model is called for, the camera has to make more passes. Let's suppose that a miniature spaceship has navigation lights studded around its fuselage. To keep these lights in scale with the model, they have to be very tiny and low-powered. The stopped-down lens of the camera can barely even register these dim glows. After the first model pass, all the lights in the studio are switched off, and the model is in darkness except for the navigation lights, which can just be perceived glowing like distant stars in the blackness. The camera is trundled back to its start position, the film is re-wound, and now an even longer exposure – perhaps half a minute per frame – is made to capture the navigation lights. Frame by frame, the lights have to register in the correct position on film, in accordance with the position of the ship. The slightest misalignment would be obvious in the processed footage, because the ship and its lights would drift apart. This is where the exact repetition of the earlier camera pass becomes essential.

Now for another problem. In the blackness of deep space, illumination comes from the sun and little else. However, audiences don't respond well to pure black shadows, and some minor 'fill' light has to be used to soften them up and show at least some of the details of the elaborate spaceship model to the most glamorous effect, even if this is not scientifically realistic. The soft, gentle shadow-fill lights call for a different shutter-speed setting. The camera must repeat its pass yet again, this time with the main lighting and the little navigation bulbs switched off and only the soft fill lights activated.

The casual observer might notice the camera moving along its rails fairly briskly during the brightly lit beauty pass, with the shutter clicking open and shut every few seconds, and much more slowly for, say, the navigation-light pass, with the shutter staying open for long stretches before the camera is allowed to move on. These different paces of movement have to be co-ordinated. Every quarter-inch that the camera moves along has to be matched by an exact number of film frames exposed. If the mechanical gearing and the camera's frame rate fall out of synch, the model's apparent rate of movement across the screen will look shaky in the processed footage. There needs to be some kind of communication between the motor that moves the camera, and the other motors that fire the shutter and advance the film onto new frames.

Finely geared stepping motors, capable of counting the turns that they make, communicate with other motors in the motion-control rig via computer. 'The motors can operate on the basis of 5000 countable steps per revolution,' says Michael Karp, a valued motion-control expert at Digital Domain before he was lured away by Disney. 'Inaccuracies don't come from them so much as from the slight play in the gearing mechanics, and the momentum of the whole heavy system when it moves.'

The camera itself is mounted on a motorized crane, allowing precise up and down and left and right motions to be plotted and controlled by the computer. In addition, a set of tracks about a dozen feet long can move the entire rig towards and away from the model. Every movement can be plotted exactly in a three-dimensional X, Y and Z co-ordinate system. This data is translated into an exact number of turns (and even fractions of a turn) in the rig's mechanical gearing. The camera operator doesn't have to work out all the mathematics himself in order to create a move. He steers the camera in a first test pass using a joystick. The computer then remembers the gear movements and repeats them later, as often as necessary.

Recently, the pole that holds models in positions has become linked to the motion-control set-up. It is now possible for spaceship and airplane models to make their own limited movements at last, on a **model mover**; specifically, pitch, roll and yaw motions, and modest forward–backward shifts, all timed and repeated to match the camera's passes.

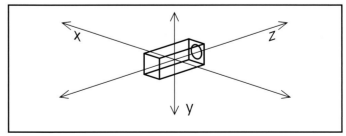

AN X, Y AND Z CO-ORDINATE SYSTEM

2-3 The Mars spacecraft model for *Red Planet* included many delicate struts and spars which were difficult to matte by conventional matte passes alone.

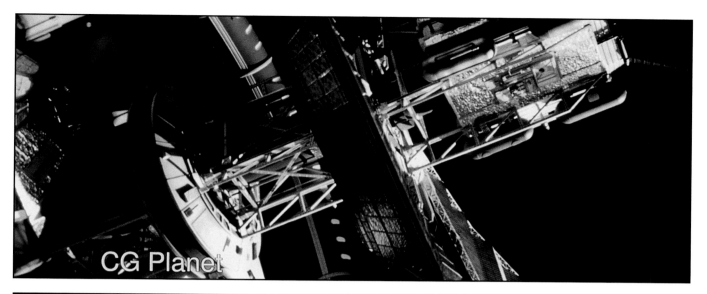

CG Planet

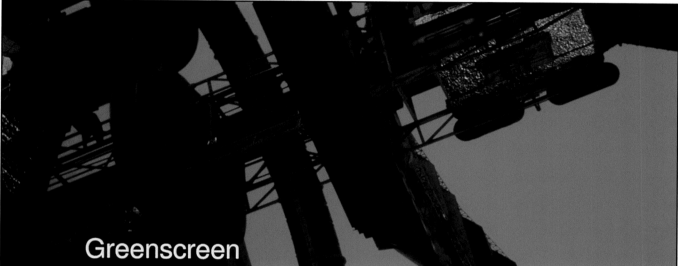

Greenscreen

UNWANTED LIGHT

Once the beauty pass and the navigation-light and shadow-fill-light passes have been squared away, a special kind of matte pass is required to solve one of the most vexing problems in green-screen model photography.

In order to produce an absolutely even colour across its entire surface, a green screen has to be illuminated. The light reflected from the screen floods the shooting area. The surrounding walls of the studio are painted non-gloss black so that they don't reflect any of the green, but the objects being photographed in front of the screen inevitably catch some of the unwanted green tones. This is called **green spill**. When actors are photographed, great care has to be taken to make sure they aren't wearing shiny clothes that might reflect the green. For model work, however, smooth and partially reflective surfaces cannot always be avoided. *Apollo 13*'s *Saturn V* rocket, for instance, was built from semi-gloss white cylinders that were as good as guaranteed to pick up a green tint; and the gantry model was so complex and multi-faceted that reflections from the screen in countless little nooks couldn't be avoided.

The problem with green spill is that the camera sees green *within* the model areas. Therefore, when the green screen is substituted for a background plate in the compositing process, some of that background will show through the model. Typically, an ugly green fringe will appear around the edges of the model, ruining the effect.

An unusual technique has come into use to solve this. A 'black light' pass bathes the model in ultraviolet light invisible to conventional film. A special clear lacquer on the model fluoresces under the ultraviolet and gives off an eerie blue glow: a colour that definitely *isn't* green. This extra matte pass now produces an absolute distinction between the model and the green screen, with no green spill – because the model is, in a sense, illuminating itself, rather than merely reflecting other light sources. The beauty passes and so forth are unaffected, because under ordinary studio lighting, the lacquer just looks completely transparent.

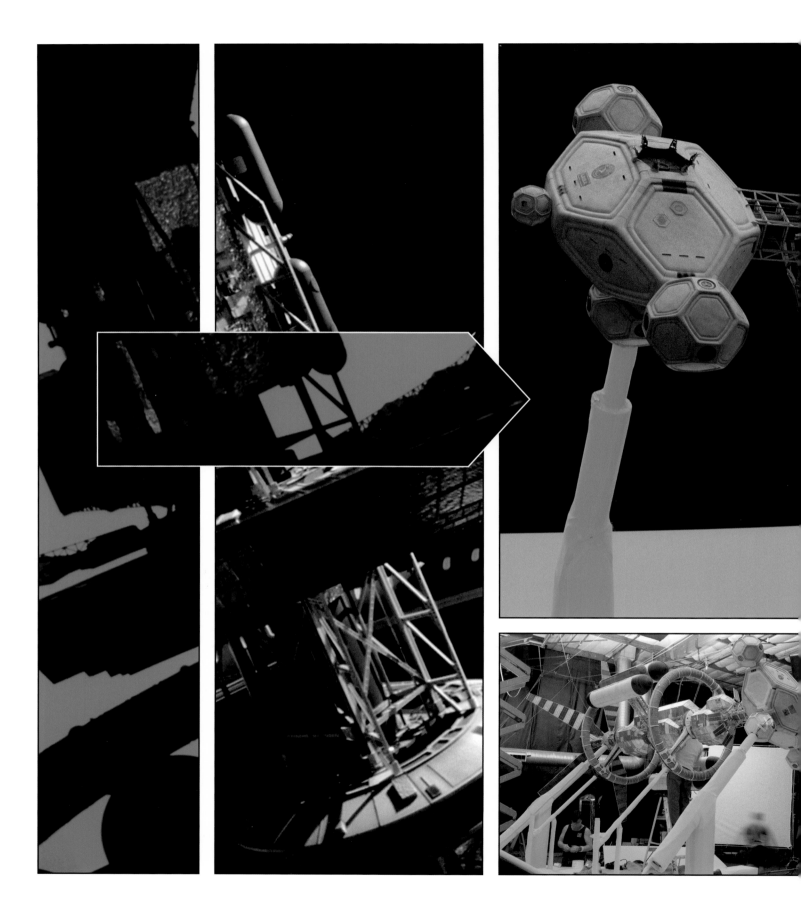

4-5 A close-up shows how extremely delicate details in a model can sometimes edge towards the limits of definition in the colour layers of film emulsion.

6 The spacecraft from *Red Planet* in preparation for a green-screen matte shot. Note the ring-like structure on the model – according to the script, this central section of the ship rotates to provide artificial gravity for the crew.

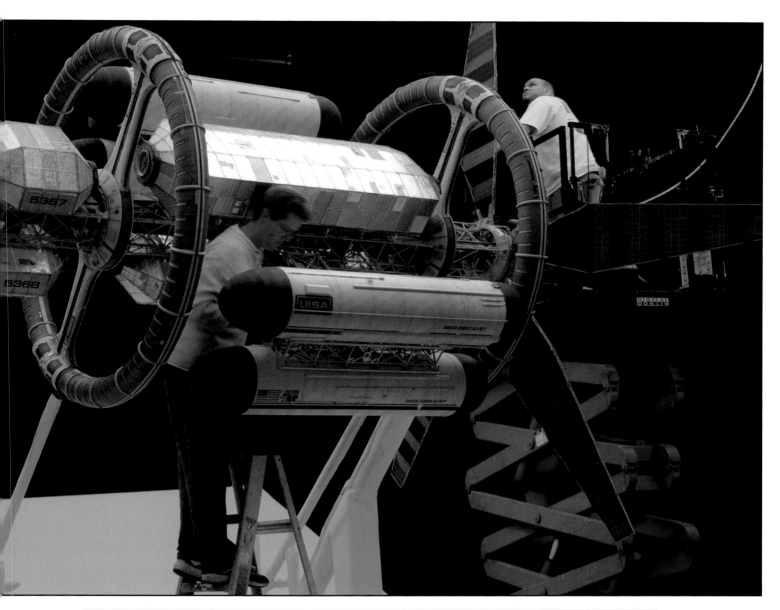

6-7 The motor that drove this part of the model needed to be linked into the motion-control computer system. Key lighting on the shooting side of the ship looks fine, but all is not as it seems. A view of the set-up from the other side shows green light from the screen reflecting onto the model, 'spilling' around corners and curves.

8 Under ultraviolet lighting, special transparent varnish on the model fluoresces, producing a visible blue glow that cancels out 'spill' from the green screen.

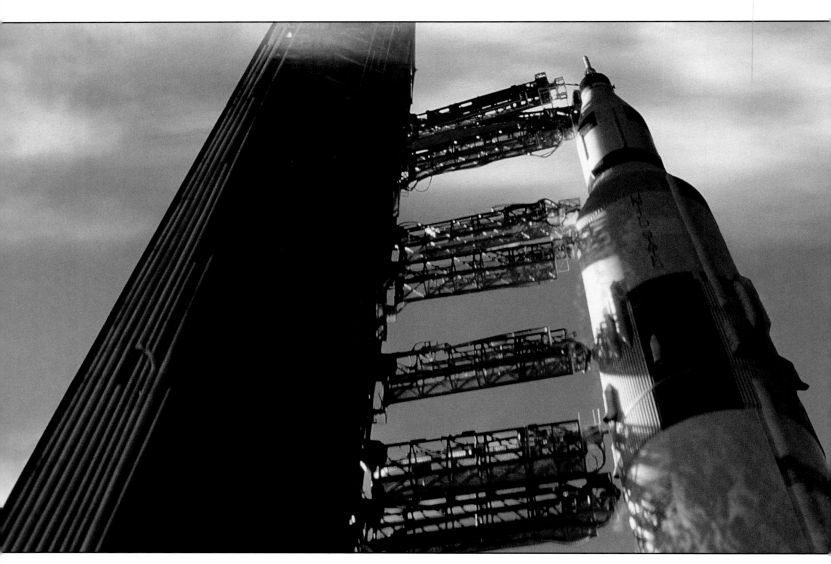

The trouble with the lacquer is that it is incredibly delicate to the touch. Modelshop chief Leslie Ekker warns, 'The number-one rule is, you've got to keep your hands off it, and number two, you have to remember to go in about every couple of weeks and freshen it up because it starts to die off. Number three, you have to get the lacquer into every last corner of the model, no matter how many struts and dongles you have to reach inside the launch tower or wherever. The black-light concept is a pretty good way to go for a stand-out matte, but it's not an easy fix by any means.'

An additional technique is to paint the background screen with a different kind of fluorescent lacquer that glows deep red under ultraviolet lighting. When a red filter is placed in front of the camera lens, only the red screen's light impinges on the film. The blue light emanating from the model can't get through, and it registers as a pitch-black silhouette – a perfect matte. (As discussed earlier, red screens can't be used for matting when actors are involved, but they can work well with spaceship models.)

Having gone to all this trouble to obtain a sharp register, there are times when the edges may need to be deliberately smudged, as Price Pethel explains: 'The movement in a

9–11 The *Apollo 13* rocket illuminated for a beauty pass, with the lighting adjusted to match afternoon daylight in Florida. A matte for the rocket is then derived from an ultraviolet ('black-light') pass.

12 The rocket as it appears in the completed sequence, composited into a background plate of sky and clouds. Steam and vapour around the rocket were added digitally to the master shot.

13 The rocket blasts off.

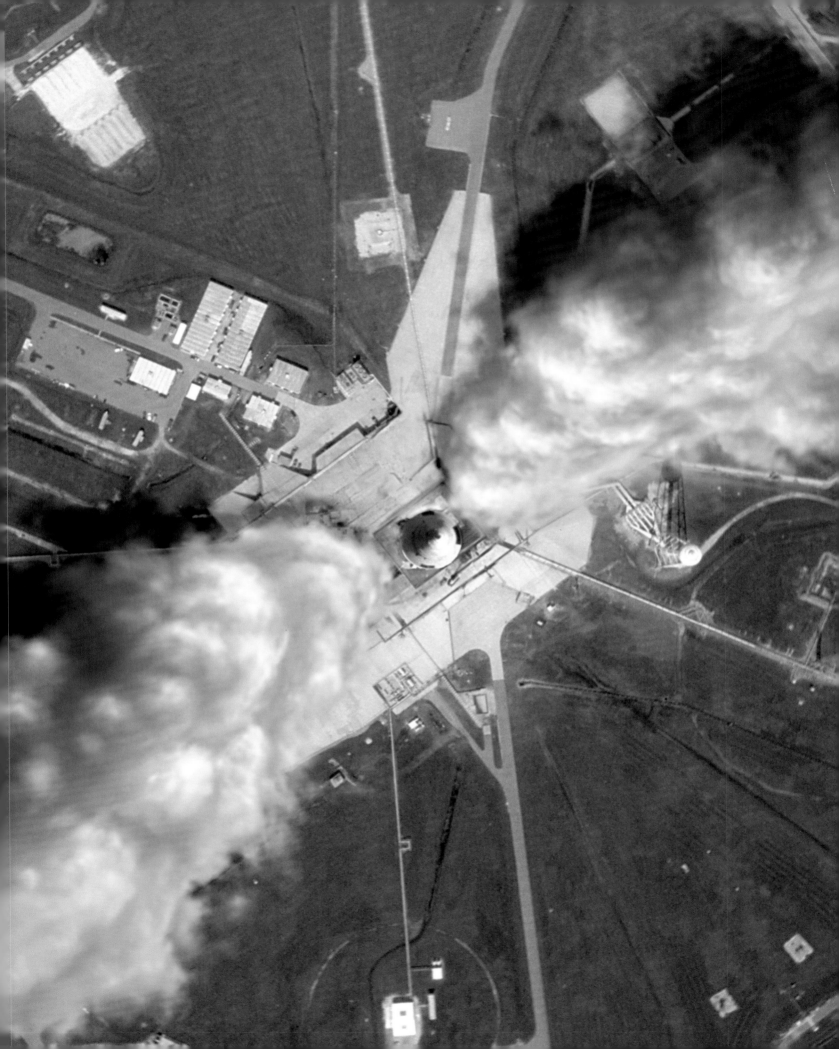

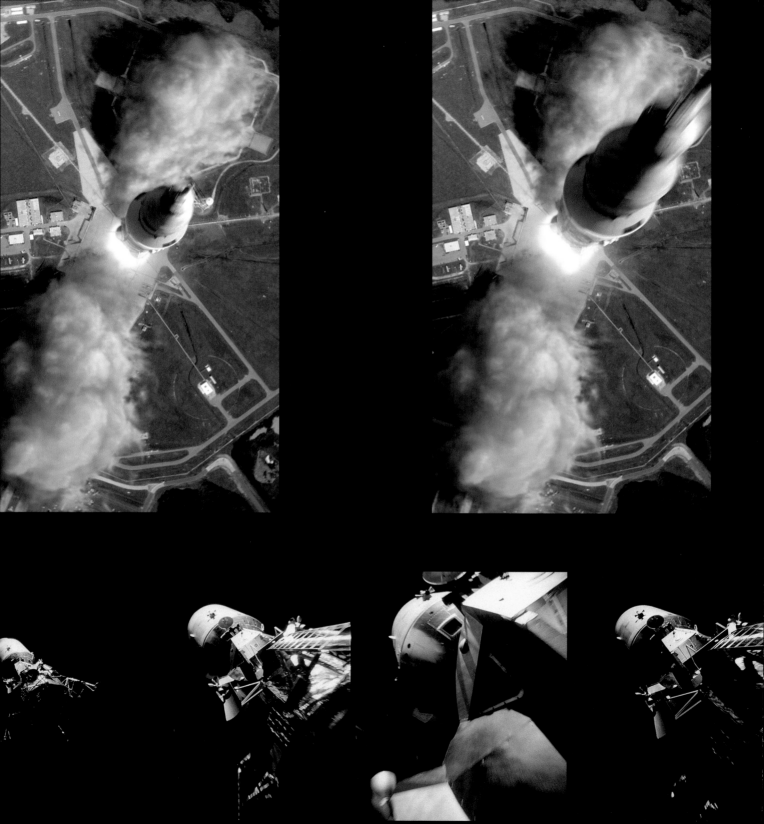

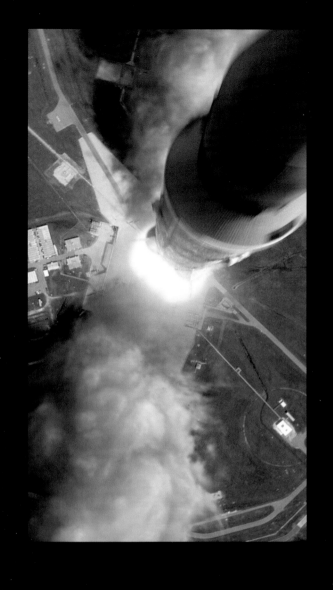

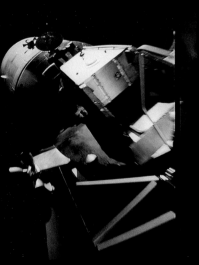

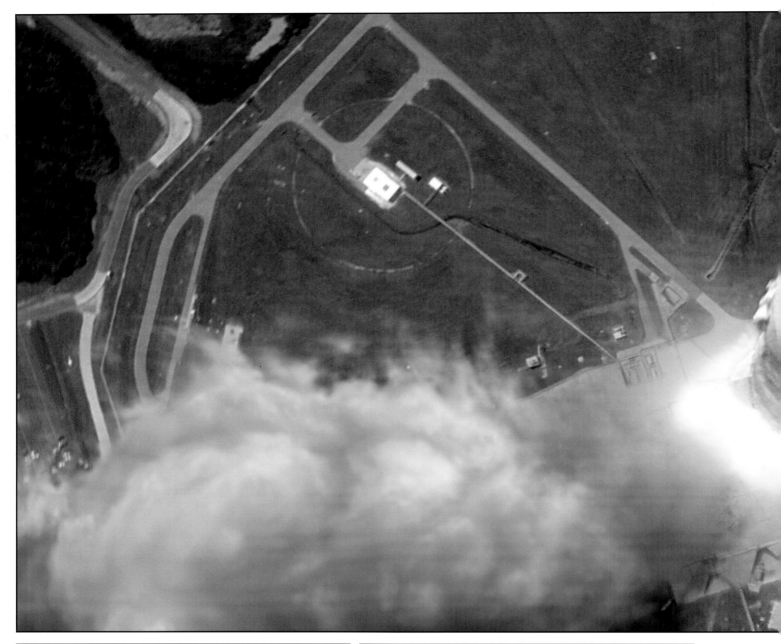

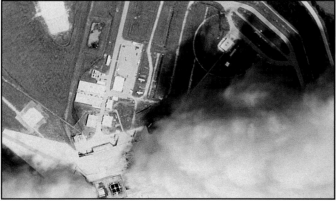

PREVIOUS PAGES

14 *Apollo 13*'s *Saturn* rocket swoops up from the launch pad in a stunning and emotive sequence that impressed many NASA veterans.

15 Actor-astronauts photographed separately in the live-action set appear in the windows of the spacecraft model.

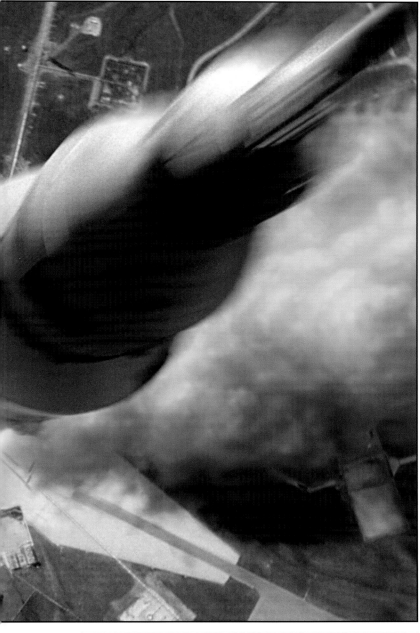

model shot often requires blur to give it a sense of immediacy. Motion control now is so sensitive, you can get a perfect match between motion blur in the beauty pass *and* the matte pass, and the machinery will handle it.' The blur is created by allowing the camera shutter to open up a little longer during each frame, so that the model smudges very slightly across the field of view.

Finally, one of the most common elements for a spaceship shot is window action, where actor-astronauts can be seen punching buttons on their control panels, or staring moodily out into the cosmic void. In these shots, the model's window area will be blacked out during every pass to prevent the film from becoming exposed in that area of the frame. Separate live-action footage of the full-scale window set is designed and photographed so that it matches with the model passes. *Apollo 13* effects supervisor Rob Legato outlines the challenge: 'It's easy enough to shoot actors against a green screen and shrink them down to fit a blank space in the model shot. The problem comes when you want movement in three dimensions. You need to shoot the actors with motion control. Unfortunately there's a big difference between 6-foot actors standing in a window set compared with 6-foot spaceship models fixed to their mounting poles. You can't do multiple passes on actors because they don't stay still, so you have to get everything you need first time. And you can't get anyone to act at two frames per second for long exposures, so you have to use normal live-action shutter speed. In other words, you have to motion control in real time.' And that's not traditionally what such a highly specialized rig is built for. Whizzing the heavy camera along a rig at speed means braking it to a stop at the end of the pass, and this can shake the rig out of alignment. Even getting the camera to move in the first place requires a certain amount of pushing against its inertia when at rest. Legato says, 'In real time, with all the lag and the momentum problems, you're lucky to get a few seconds of smooth footage somewhere in the middle of the pass.'

The end result, then, is a model shot overlaid via multiple exposures with running lights, fill lighting and so forth, plus a black-light matte, and a window-action pass shot in another studio. Everything now needs to be composited with the background plate. Typically, for a spaceship sequence, this would be a beautiful artwork (digital or otherwise) of a planet against a starfield.

ADVANCE WARNING

One of the most common causes of doomed motion-control composites is that the procedure simply doesn't deliver the shot specified by a director, at which point, expensive film is wasted, time is lost, tempers fray and blame is apportioned. Sometimes the motion-control rig itself simply gets in the way.

At Digital Domain, **previsualization techniques** ('previz') are used to map out a shot as a rough sketch, showing how a model will appear to move across the screen when the sequence is completed, and even delivering a crude approximation of how the lighting will look when reflected off the model's surfaces. Then the data is translated into a different viewpoint – not what the camera would see, but how the required motion-control move would appear from the perspective of someone sitting up in the rafters of the studio. The studio's dimensions and those

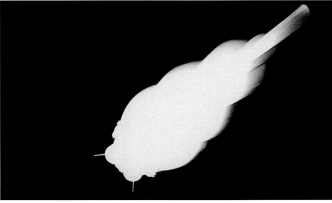

16–
19 A beauty pass of the rocket apparently ascending, and the associated matte. The motion blur has been precisely duplicated by the motion-control rig.

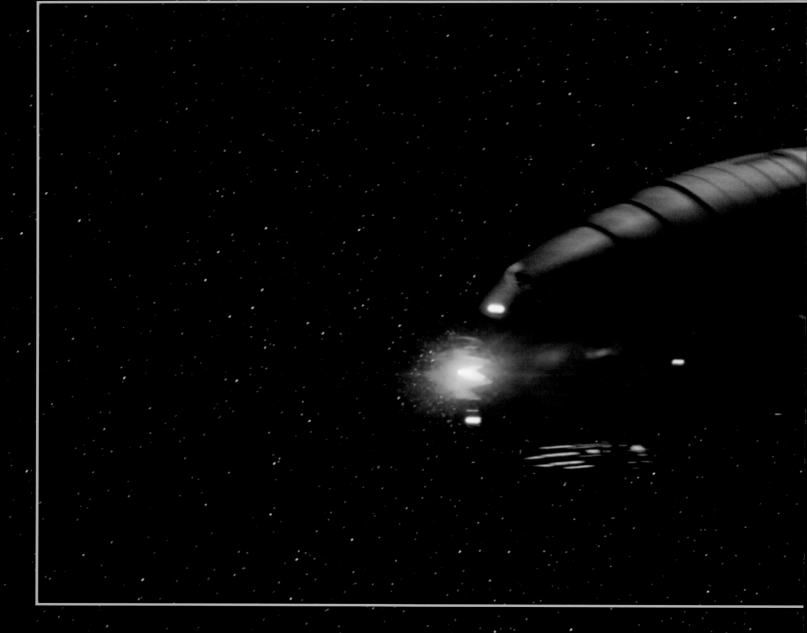

SuperNova ground glass 1

20 A previsualization frame from *Supernova* shows the *Nightingale* miniature on its support, along with the motion-control rig itself, and the green screen, all as rough wireframe elements.

21 This previsualization view is an approximation of how the model and support should look when viewed through the camera.

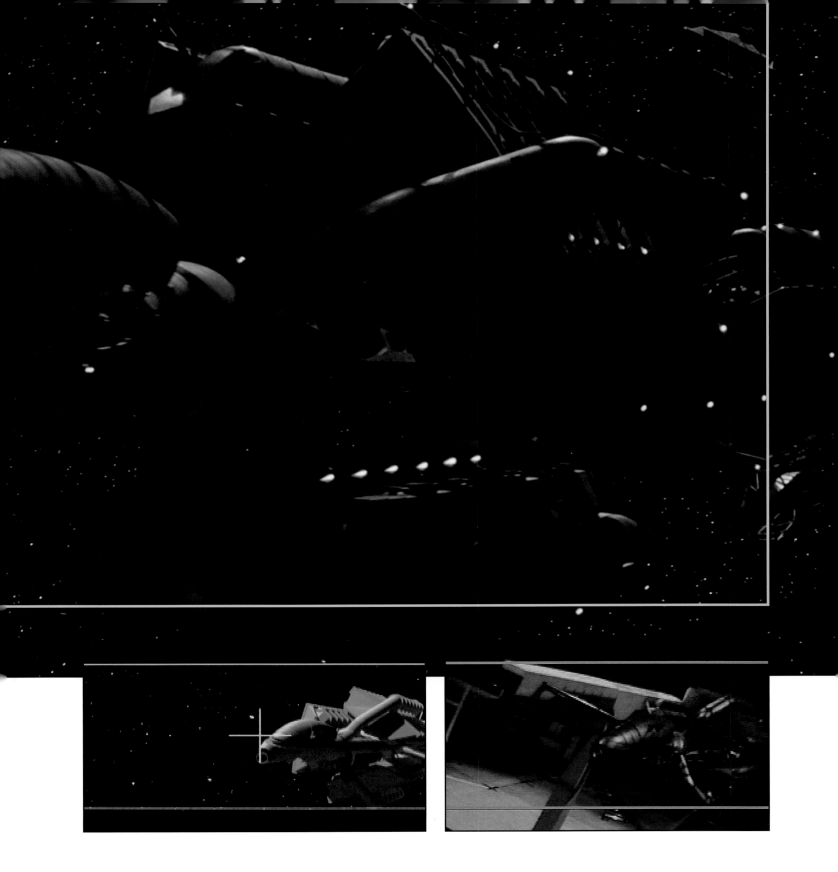

22 If required, the director can cut this more polished simulation (composited into a rough background) into the film as a temporary guide until the actual effects shot is completed.

23 A more detailed simulation of the completed shot, dependent upon a specified focal length lens and frame ratio.

24 The final composited shot.

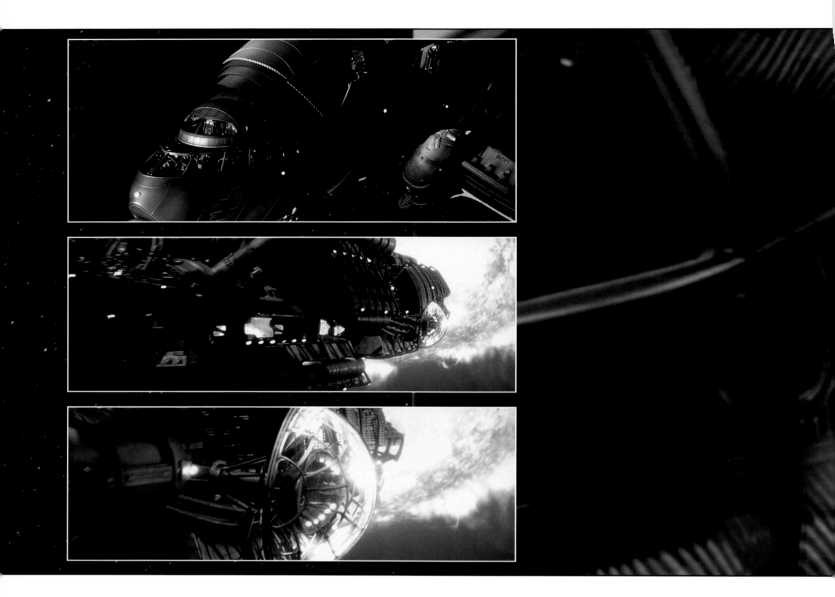

of the motion-control rig are all visible in the computer model. If an intended move, model size and lens characteristic won't combine, the previz software displays the impractical physical side of the set-up before anyone goes to the time and expense of actually installing the model and rig in the studio. It's not uncommon for previz simulations of supposedly wonderful model shots to prove that the rig would drive the camera into the studio walls, or else tangle the camera with the poles supporting the model. In the past, real money has been wasted (though seldom at Digital Domain) by crews fighting to make their rigs deliver impossible shots.

Supernova effects supervisor Mark Stetson identifies another advantage of previsualisation. 'Besides allowing us to have a blueprint for our own work, it gives movie directors something they can temporarily cut into their existing live action, so they get a good idea of pace and style for the overall movie. It solves a wide range of editing and style problems ahead of time.' Another benefit of the previz motion-control

elements is that, on the monitor, they can be overlaid on top of existing background-plate footage to check, in real time, that all the movements will match when it comes to the actual shooting. This is just a simulation, and nothing gets locked down unless it has to.

Even with previz sequences promising perfection, the actual motion-control photography can still be time-consuming and frustrating. *Titanic*'s visual-effects director of photography Erik Nash supervised shots of a superbly realistic model of the ship's wreckage lying at the bottom of the Atlantic. The studio was flooded with smoke to create the effect of a deep underwater murk, a technique known as 'dry-for-wet'. It was mainly a question of achieving one smooth pass that could deal with the long exposure times per frame in this gloomy low-light scene. It should have been fairly simple. But the problem was that two small submarine models in the scene (on thin poles attached to model movers) each had tiny searchlights that illuminated portions of the wreck as the subs roamed around it.

25	
26	
27	28

25– The completed motion-control sequence, with additional effects, reveals the *Nightingale* drifting
28 across the screen, finally closing in to an observation bubble, where a pair of lovers are enjoying weightlessness. The footage of the actors was inserted separately in a live-action session that took into account the motion-control moves for the spaceship model.

Nash couldn't make a separate pass for those lights because they were creating distinct beams *through* the smoke. This type of lighting was too subtle to double-expose later as a separate pass. 'We needed lights that were tiny and to scale with the model subs, but still bright enough to register during the beauty pass. In the end, we did find these little bulbs that could do the job, but we ended up with exposure times of 30 seconds per frame. That was a six-hour pass for the overall shot. Often a bulb would blow after three or four hours. We couldn't simply stop the pass, replace the bulb and start where we'd left off, because the new bulb wouldn't generate exactly the same intensity or width of beam as the old one. We had to start the whole thing over. You could lose a day's work in an instant. In the circumstances, our camera operator Jim Rider made a great job of imparting fluidity to those shots.'

This tiresome story is absolutely typical of motion control. No amount of precision hardware, nor even the fastest computers, can absolve the need for endless human patience.

LAZY EIGHT

For all the modern sophistication of the tools at hand, many motion-control rigs include cameras that are antiques from a long-vanished era of movie-making.

In a normal 35mm film, each frame is as wide as the film itself, barring the four sprocket holes on either side. In 1954 Paramount Studios released *White Christmas*, photographed in a widescreen process called **VistaVision**. Instead of running film through a camera vertically, it was flipped horizontally, so that frames were exposed lengthwise rather than across the film's width. VistaVision generated frames eight sprockets long – twice the normal area. With the film lying sideways along those perforations, VistaVision was often nicknamed 'Lazy Eight'.

Only a handful of movies were released in the VistaVision format – most notably, *The Ten Commandments* (1956), with a stern Charlton Heston as Moses, and *North by Northwest* (1959), Hitchcock's masterful comedy thriller. After 65mm-width film was developed in the mid-1950s, VistaVision was

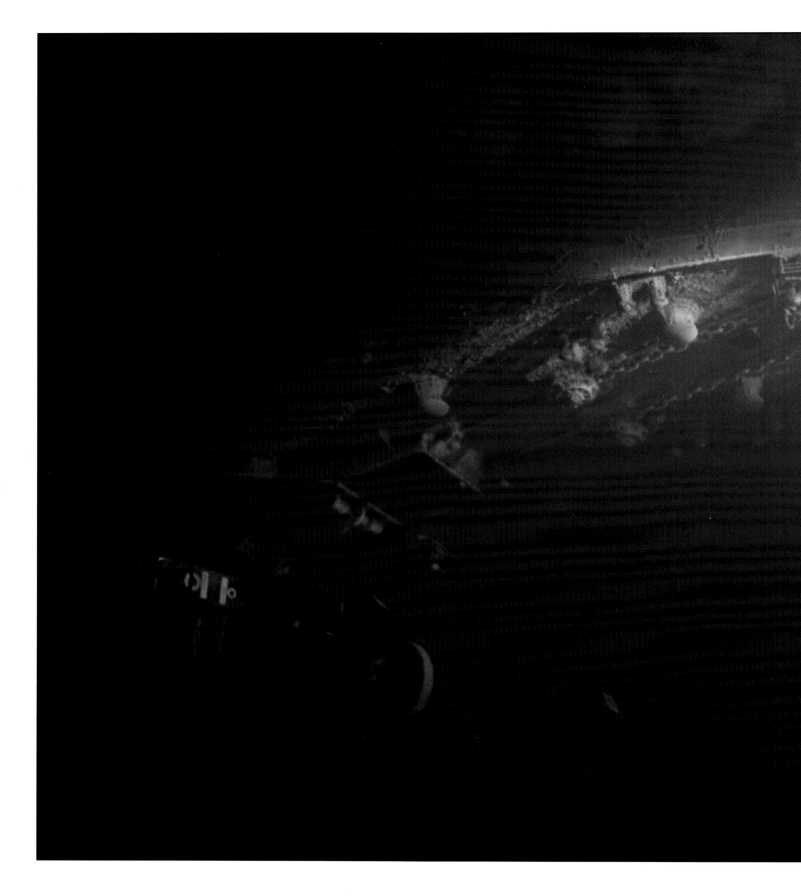

29 During photography of the *Titanic* wreck-exploration sequence, the studio was flooded with smoke to simulate the dark, dank waters at the bottom of the Atlantic. The poles supporting the mini-submarines had to be painted out digitally after the footage had been processed and scanned, but otherwise the shot was achieved in a single pass.

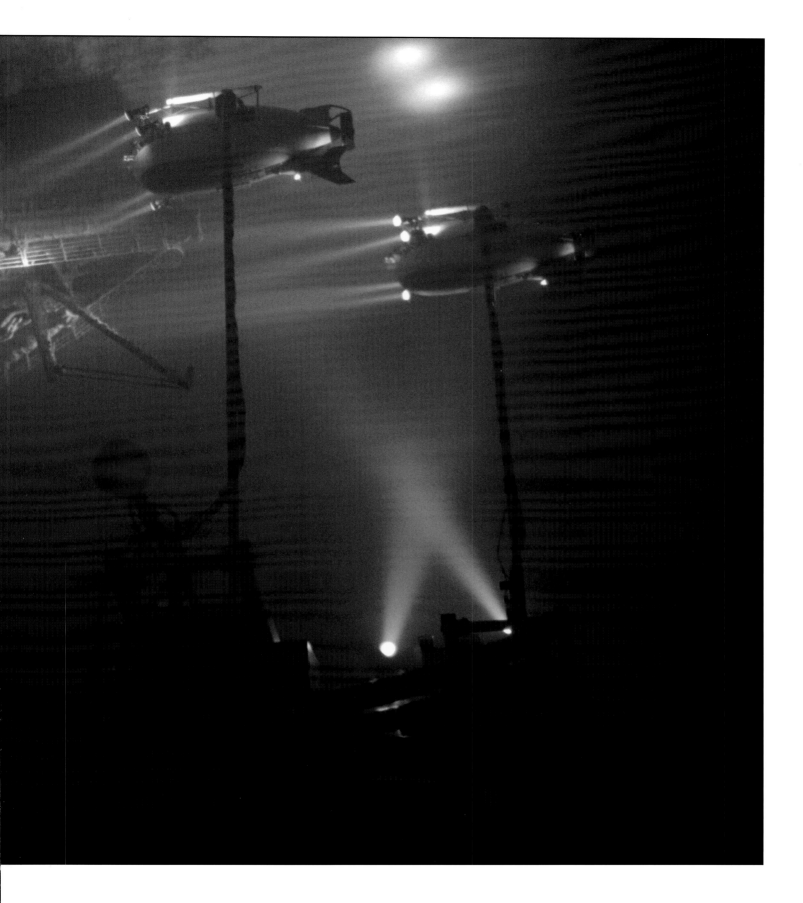

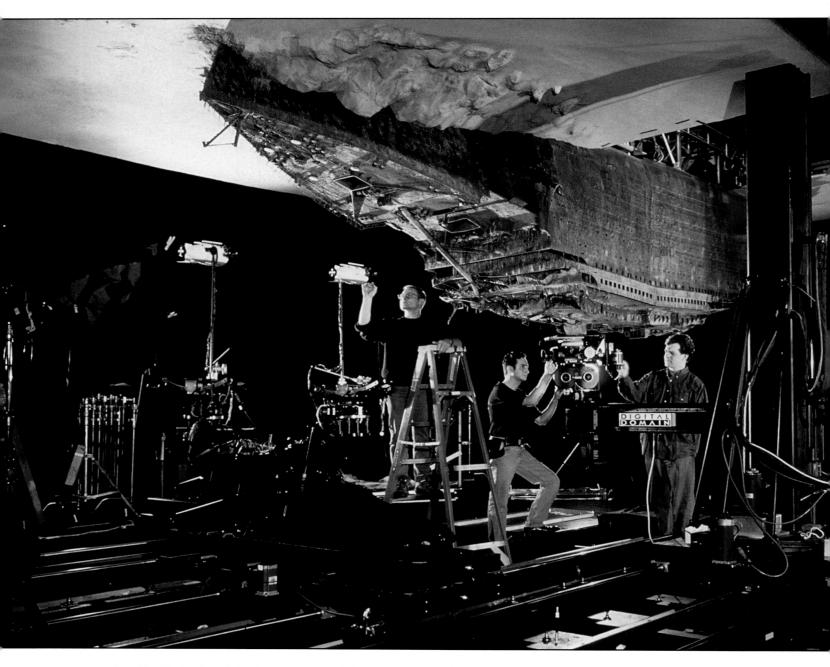

scrapped, and for the best part of 20 years, the special cameras lay in warehouses gathering dust. It was *Star Wars* effects supervisor John Dykstra who gave them a new lease of life.

The optical compositing of multiple elements is a precise business, requiring mechanical tolerances of 0.001 of an inch. The larger the film frames, the more accurately the various elements can be registered on top of one another. Stanley Kubrick used large-format 65mm film throughout the production of *2001*, effects, live action and all. In the mid-1960s, his budget of $10 million afforded him huge studio resources, but a decade later, George Lucas's $10 million for *Star Wars* didn't stretch quite so far, and he had to shoot on conventional 35mm stock. (It's not just that large-format films need more

expensive cameras; they also cost far more to process in the chemistry labs.)

Dykstra wondered how he could find a larger frame to work with in the effects studio without actually changing the film type. He realized he could change the camera instead. Not wanting to give away his intentions, he discreetly bought up all the old VistaVision gear he could find, at bargain-basement prices, and developed his motion-control rig around the larger, horizontal frame. When the effects shots were safely completed, they were 'printed down' onto a normal 35mm format to match the live-action sequences. This might seem a waste of the VistaVision's superior definition, but there was a subtle advantage in the print-down. Non-digital effects for *Star Wars*

30 The model of the *Titanic* wreck was constructed upside down because the studio floor was covered by the motion-control rig's heavy tracks. From the camera's viewpoint, this odd arrangement made no difference.

31 *Titanic* effects supervisor Rob Legato is hazed in smoke.

required so many copies and reprints of elements that the grain and sharpness in the various images tended to deteriorate along the way. Printing the VistaVision frames back down onto the smaller format for the final cut tightened the grain again, so that it closely matched the quality of the live footage in the rest of the movie.

By the time *Star Wars* was released in 1977, the cat was out of the bag. Prices for antique VistaVision equipment reached a peak as 'Lazy Eight' special-effects fever hit Hollywood. Now that technicians and manufacturers have recognized the demand for this format, today's VistaVision effects systems are often custom-built, but at Digital Domain, Michael Karp regularly used some genuinely ancient gear. 'We had Mitchell

VistaVision cameras built more than half a century ago, with retooling done over the last ten years by the Fries Engineering Company. Then we had computers and video assists to go with it. So it's sort of like in Terry Gilliam's movie *Brazil*, where you have very advanced technology mixed with incredibly retrograde gear. And those Mitchell cameras are fast running out today. Most of them were destroyed years ago.'

Fortunately, modern motion-control rigs, coupled with digital tools, have become so accurate that conventionally framed 35mm cameras can also be used today with little fear of misregistration. One day, in the not-too-distant future, there won't be any film at all in the cameras, and even now the mechanical rigs themselves are being phased out for certain

types of shot. Kevin Mack outlines the uncertain future of *Star Wars*-style motion control. 'Suppose you have a big scene with a sweeping camera move, and there's a huge set and a bunch of actors, and you need to put something in the scene that's behind the characters but in front of the set: in other words, a middle layer between the foreground and the background. This happens all the time. Normally, you need to do multiple passes with motion control to be able to composite those elements together, all with the exact-same camera moves. But we're getting to the point where we can reconcile the actors and the other elements with just approximate hand-controlled movements of the camera. Most straightforward shooting set-ups involve multiple takes of a given movement anyway, to get the acting and the framing right, so the crew are already pretty well rehearsed at making reasonably accurate camera moves by hand. The reconciliation between passes may not be as exact as in a motion-control rig, but the computers can analyse the set-ups frame by frame and overlay them. In the very near future, there may be no need for conventional motion control any more.'

FREEING THE CAMERA

Planning a motion-control sequence costs time and money in pre-production and tends to limit a live-action crew to stilted, preconceived camera movements.

Inevitably, the real world, with its windy days, bumpy roads, wobbling sets and unforeseen obstacles, tends not to deliver background plates to specification. In poorly executed composite sequences of models with real outdoor shots – particularly of aircraft against real skyscapes – there is often a jarring mismatch between the background and the models. Until recently, no motion-control system in the world could deal with the great outdoors as anything except rephotographed static shots or cleverly conceived matte paintings. By the time *Apollo 13* was made, Digital Domain had created techniques that freed them from these constraints in many situations. Instead of surrendering to the shackles of motion control, they rewrote the rules until the technique fitted their needs, rather than the other way around. Model photography could thus be combined with the most dynamic outdoor shots.

Apollo 13 told the story of a real-life 1970 space disaster. In April 1970 a NASA spacecraft blasted off for what was intended to be a routine mission to the moon for its three astronauts, Fred Haise, Jack Swigert and mission commander Jim Lovell. When the crew switched on a mixing fan inside one of their oxygen tanks, faulty wiring sparked an explosion in the tank, putting the ship and its frail human occupants in mortal danger a hundred thousand miles out in space – and heading away from the Earth.

Director Ron Howard and effects supervisor Rob Legato initially considered blending original NASA footage from the real mission into their film, but on inspection, Legato recalls, 'The real shots turned out to be on all kinds of different film stock, from different missions, with varying formats, frame rates and degrees of fading over the years. It was clearly impossible to achieve a consistent effect.'

The other problem was the **storyboards**, cartoon-like sketches which film-makers use to map out the general pattern of a movie prior to shooting. Most of the space-hardware shots had been dealt with in the storyboards in terms of close-up work. This approach turned out to be completely inappropriate. When Legato visited the real Cape Kennedy launch centre, 'it opened our eyes. We just knew we had to convey the awesome scale of the whole operation. We had to open up the rocket-preparation and launch shots to include the gigantic assembly buildings and other facilities in and around this vast, sprawling complex.'

1 The *Saturn* and its gantry faultlessly composited against a real Florida sky.

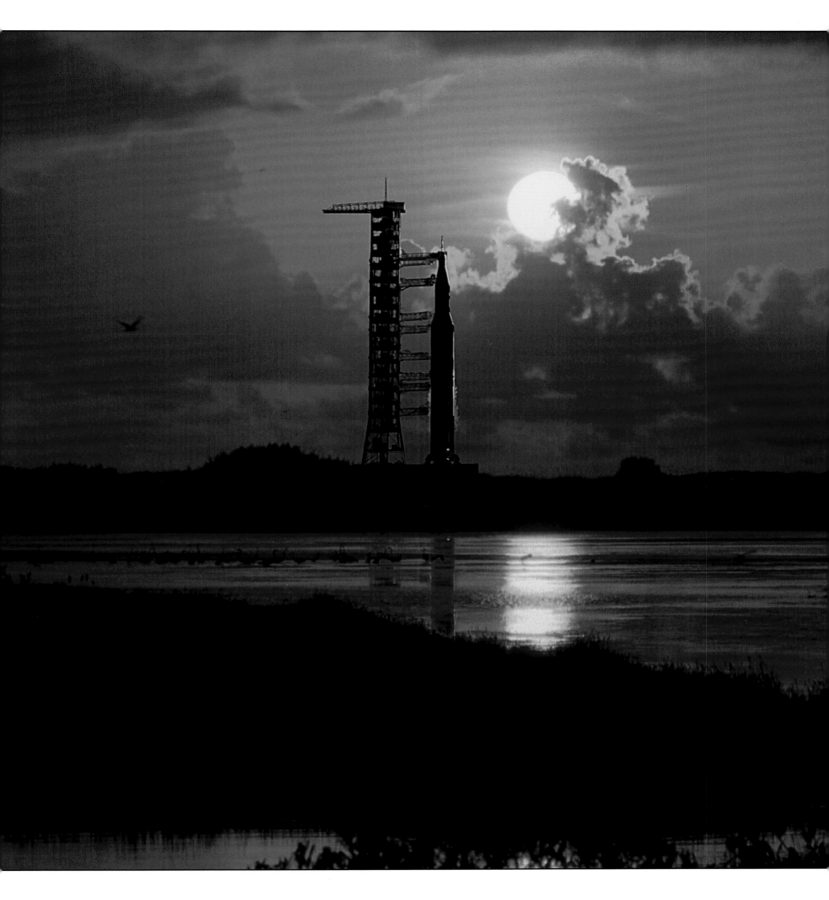

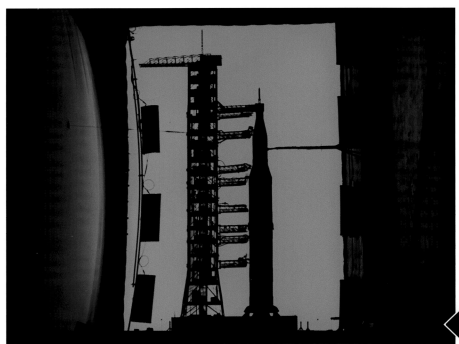

MATTE SHOT
In order to produce an absolutely even colour across its entire surface, a green screen has to be illuminated without 'spilling' green tone onto the foreground model.

LIVE BACKGROUND SHOT
The Florida sunset is a real scene, photographed on location.

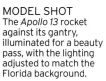

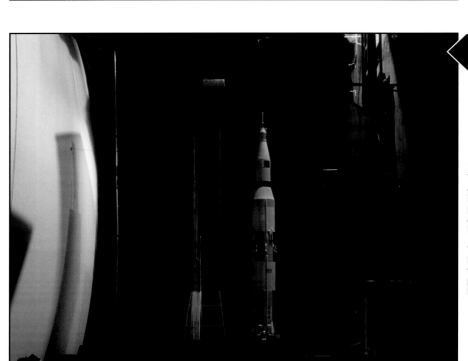

MODEL SHOT
The *Apollo 13* rocket against its gantry, illuminated for a beauty pass, with the lighting adjusted to match the Florida background.

The surrounding studio is swathed in black velvet to prevent pollution from irrelevant light sources.

Howard and Legato embarked on a daring change of plan: no original launch footage whatsoever was used. Every moment of the ignition and take-off was shot as fresh footage, using a highly detailed 18-foot model of *Apollo*'s *Saturn V* booster nestling against a 20-foot gantry. Then the model was seamlessly combined with the real landscape surrounding the Kennedy centre. A very advanced form of motion control was essential to achieve this blend.

A beautiful sequence presents us with a leisurely vertical pan down the flanks of the *Saturn V* moon rocket, with the Florida horizon clearly visible in the background, and also through gaps between the many struts of the gantry. At Digital Domain, the rocket and gantry model was mounted horizontally for green-screen shooting, because it was more practical to keep the camera at floor level throughout rather than sending it 18 feet up into the rafters.

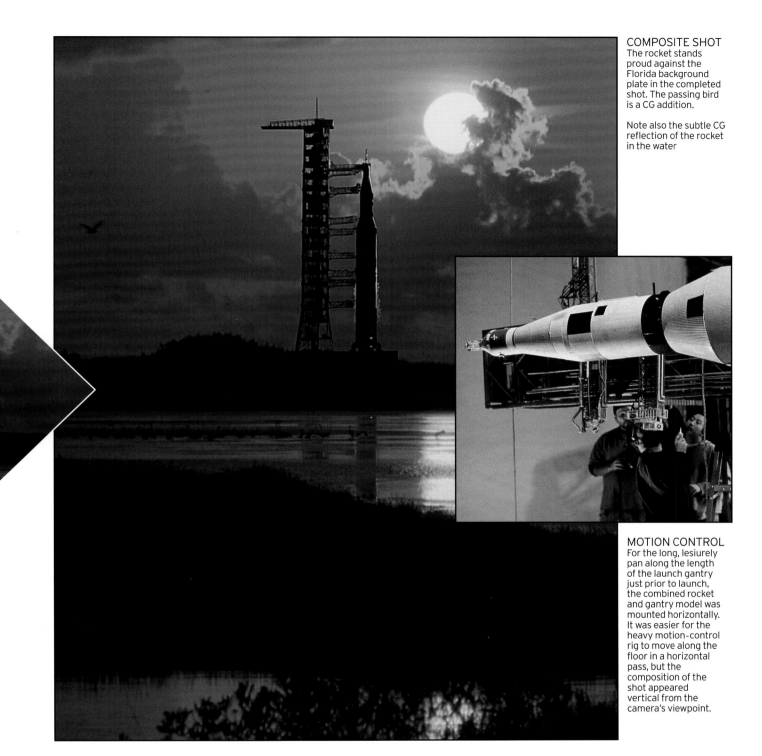

COMPOSITE SHOT
The rocket stands proud against the Florida background plate in the completed shot. The passing bird is a CG addition.

Note also the subtle CG reflection of the rocket in the water

MOTION CONTROL
For the long, lesiurely pan along the length of the launch gantry just prior to launch, the combined rocket and gantry model was mounted horizontally. It was easier for the heavy motion-control rig to move along the floor in a horizontal pass, but the composition of the shot appeared vertical from the camera's viewpoint.

Theoretically, in order to 'match-move' the real horizon with *Apollo 13*'s 18-foot rocket model, a 365-foot vertical move at the Florida location would have been required, because that was the height of the real rockets. The view of the horizon at the top end of the background scene would only have looked correct from 365 feet up. Digital's matte artist Martha Snow Mack chose a very different route. 'I took elements from a range of stills photographs taken from a helicopter. In the computer I blended the shots together like a collage to create three huge panoramas. We could then blend those panoramas to get the overall background data.'

This technique, called **pan and tile**, requires a stills camera that can rotate through 360 degrees, taking dozens of photos in different directions. A complete panorama of the ground and sky is captured. Then a computer program loads these pictures and maps them onto the inner surface of an

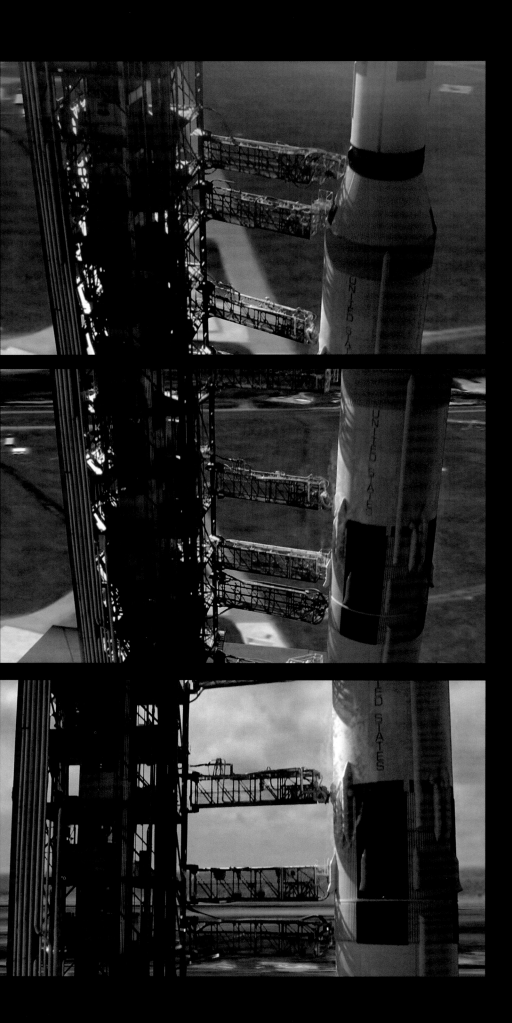

imaginary sphere. From this data, any shift in perspective of the far horizon, as seen from ground level to 365 feet up, can be simulated by the computer, so long as the original stills photography is undertaken with reasonable common sense. For instance, photographing a flat landscape from absolute ground level would produce a thin horizon bereft of any great detail, but a helicopter shot from around 200 feet will capture enough details on the ground so that the computer can interpret and stretch their perspective as if seen from different heights. By selecting different heights to shoot the *Apollo 13* horizon stills, all bases were covered.

Pan and tile frees the background-plate crew from worrying about what might happen weeks or months later in the motion-control studio. Best of all, data from the motion-control rig can be combined in the computer with the pan and tile environment, so that the background perspective shifts automatically to match the motion-control moves.

Other techniques pioneered by Digital Domain allow conventional live-action footage of backgrounds to be incorporated into motion-control work almost regardless of the style of photography. No one needs to log any camera moves on location, and they can even hand-hold their shots.

2-4 Motion control, along with pan and tile background elements, delivered a tremendous panning shot along the flanks of the rocket and gantry.

5 This shot is a combination of live action, model effects and CG.

6 The gantry tower is a maze of delicate struts. A fluorescing red screen in combination with blue-fluorescing varnish on the model delivers an extremely precise matte, with no spill.

MARKERS IN THE SNOW

At Digital Domain, Doug Roble devised **motion tracking** software (called 'TRACK') that allowed live-action camera crews to be more spontaneous and not so worried about what might happen later at the computer workstation or in the motion-control studio. Instead they could concentrate on their immediate real-world problems. 'I was right out of school, and this was my introduction to the visual-effects business,' says Roble. 'I was one of the first 30 people that Digital Domain hired. My program was based on some of the theoretical stuff I had been working on in my PhD at Ohio State University, but at that time, no one had tried to apply this kind of approach to an actual project.'

Roble's ideas were put to the test in Digital Domain's first-ever professional assignment. In the TV commercial *Jeep, 'Snow Covered'*, 1994's newest model burrows its way under the surface of a vast ice pack like an eager mole, completely unconcerned by the rough going. The audience enjoys this spectacle from the vantage point of a helicopter swooping overhead. Leaving a trail of excavated snow in its wake, the Jeep only brakes when it suddenly encounters a stop sign, the only other man-made object in the entire snowbound landscape. The message is clear: Jeeps can drive through anything except the traffic regulations.

Shooting *Jeep, 'Snow Covered'* as a piece of live action was never an option, because the storyboard required a slightly cartoon-like element of humour and character in the Jeep's movements, without actually creating the look or feel of a cartoon. Digital Domain chose to create a computer-generated (CG) Jeep-shaped disturbance ploughing through a CG tunnel of snow. These elements could then be manipulated to behave in a humorous way.

The only serious challenge remaining was how to combine the CG tunnel with a wider snow-covered landscape seen from an aerial perspective. Should this also be a CG construct? The budget and schedule ruled this out. A real landscape would have to be found and shot as straightforwardly as possible in the space of a few days.

By its very nature, aerial camerawork is unpredictable and not suitable for matching-up with motion-control work. The perspective shifts from frame to frame and the horizon never stays still in relation to the camera. Roble said he could deal with this problem, and the live-action crew should get out there, find a landscape, shoot it, and leave the rest to him and Digital Domain's CG team. A pristine ice sheet in British Columbia with snowcapped mountains in the distance was selected and a helicopter despatched. Roble's only proviso was that the landscape had to be mapped before shooting began. His notion of mapping wasn't particularly arduous. He required no more than a couple of dozen reference points scattered more or less evenly around the perimeter of the ice sheet.

The ice wasn't safe to walk upon, so the team used the helicopter to drop empty 55-gallon barrels at intervals of a few hundred metres. Next day, the chopper overflew the barrels, while a brave crew member leaned out of a hatch and touched the top of each one with a survey rod. The instant he did so, a radio message was transmitted to surveyors standing safely on a nearby hill with a laser theodolite. They lined up on the rod and clocked off the direction and distance. Gradually, an accurate survey of all the barrels was made.

'I was feeling a little nervous because this was the first big program that I had written for the company,' Roble recalls. 'I was at a party down in Hollywood, and it was nice and warm, and I was thinking about our effects supervisor Jay Riddle, freezing cold somewhere in British Columbia in the dead of

7-9 Background plates of the ice sheet and terrain were photographed from a helicopter.

10 The burrowing Jeep's trail of ice and snow was constructed entirely in CG.

11 The Jeep stops for nothing – except a stop sign.

winter. And at that moment I got a call from him. He said "I'm standing in this little dinky-town in the middle of nowhere. I'm shivering. And I'm using an outdoor payphone because that's the only one they have. Tell me this is going to work." And I assured him it would.'

The next task was to photograph the site for the background plates. The helicopter, this time with the camera crew on board, flew a variety of paths over the ice, based on a storyboard of how the finished sequence should appear. The pilots had to pretend that they were following a real Jeep, so the helicopter's speed and rates of turn had to be more or less consistent with this imaginary game – but only more or less. As Roble had promised, the camera crew was free to concentrate on mood and style rather than precision flying.

Back at the Digital Domain studios in Venice, California, the processed film footage yielded beautiful swooping vistas of a pristine ice sheet, with at least three marker barrels always kept in shot somewhere discreetly towards the edge of the frame, where they could be easily cropped or digitally painted out later. A wireframe model of the entire array of 24 markers was created in CG, derived from the initial survey measurements. There was no need to try to recreate every detail of the actual landscape in the computer. Processing power could be reserved purely for the ice tunnel and its immediate surrounds.

At this stage, the focus of the CG animation remained firmly on the humour and characterization of the Jeep's apparent movements under the snow and ice, rather than on ensuring any exact fit with the original background photography. Just like the helicopter pilots, the CG animators also had some freedom of movement to play with.

The interim result was background footage on film, including at least some marker barrels at the edge of every shot, and an ice-tunnel animation in the computer, moving among digital markers. The two elements, real and CG, shared an overall mood and pace, yet corresponded only approximately from frame to frame. It didn't matter. When the CG and film frames were finally superimposed, Roble's motion-tracking program altered the perspective of the CG model until its markers overlaid the real barrels, and so on with subsequent frames. As long as there were at least two or three barrels visible on film, the CG markers could be aligned with their real counterparts. Because the ice-tunnel animation was already 'locked' onto the CG markers, it also shifted in lockstep.

At least, that was the plan. Roble had to nudge the CG markers with a mouse and keyboard every few frames to force-fit some of them onto their correct barrels. 'When the match doesn't happen automatically, you think, "Is it the program? Is there a mistake in the survey data?" But we discovered that even the most perfect camera lenses are never *that* perfect in what they capture, and you do get some distortion in the perspective. The lens on the scanner that reads the film and loads the images into the computer also has minor aberrations, no matter how perfect the lens equations are supposed to be. Inevitably, what you see in the frame doesn't always quite accord with the survey data. But it's close enough that motion tracking is still an incredibly powerful tool.'

Powerful indeed. The implications of this technique sent a shock wave through the entire movie industry, especially once TRACK's contribution to *Titanic* was recognized. In 1998, Roble won an Academy Award for Scientific and Technical Achievement.

FOLLOWING PAGES
12 Doug Roble's TRACK software was essential during the making of *Titanic*, especially when multiple elements had to be reconciled to generate the appearance of smooth, swooping shots of the ship at sea.

12

DIGITAL DOMAIN **FREEING THE CAMERA** 73

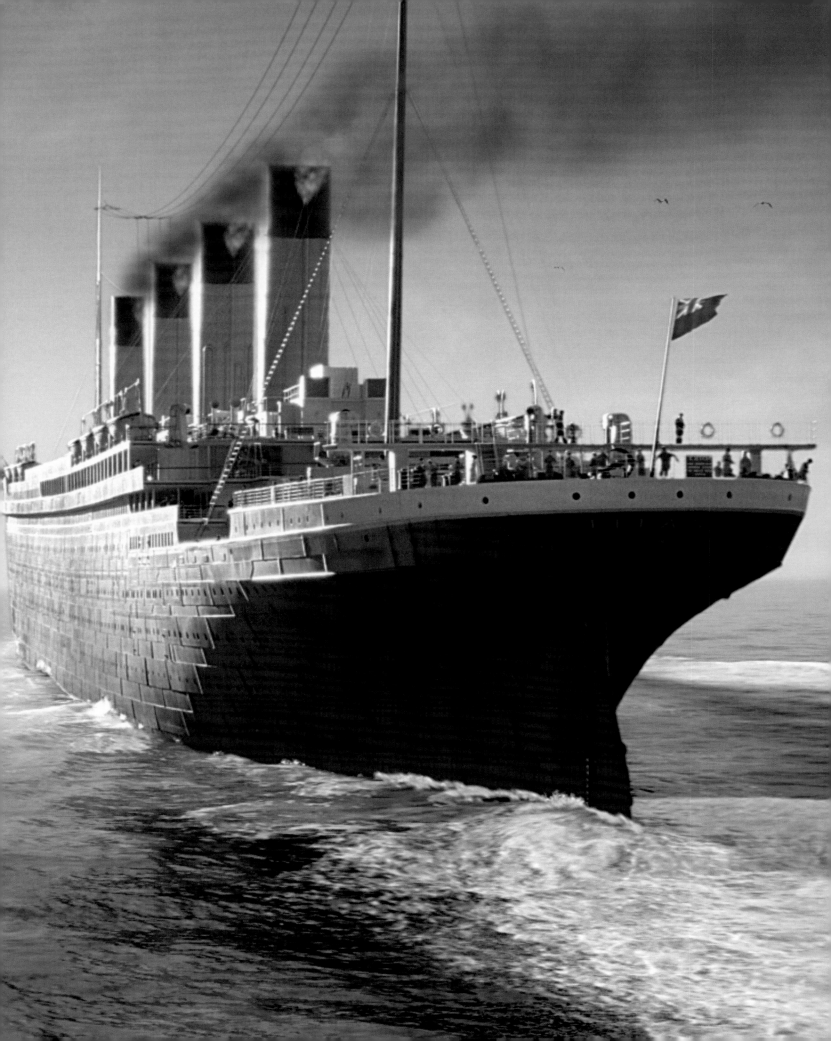

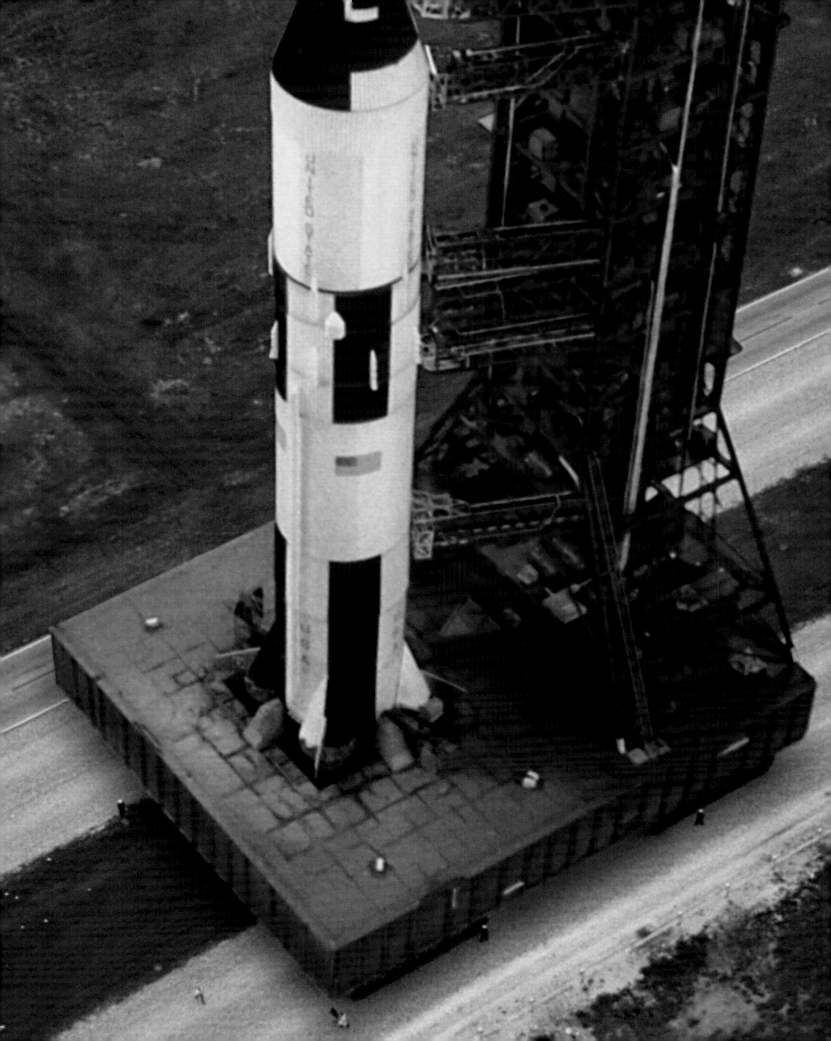

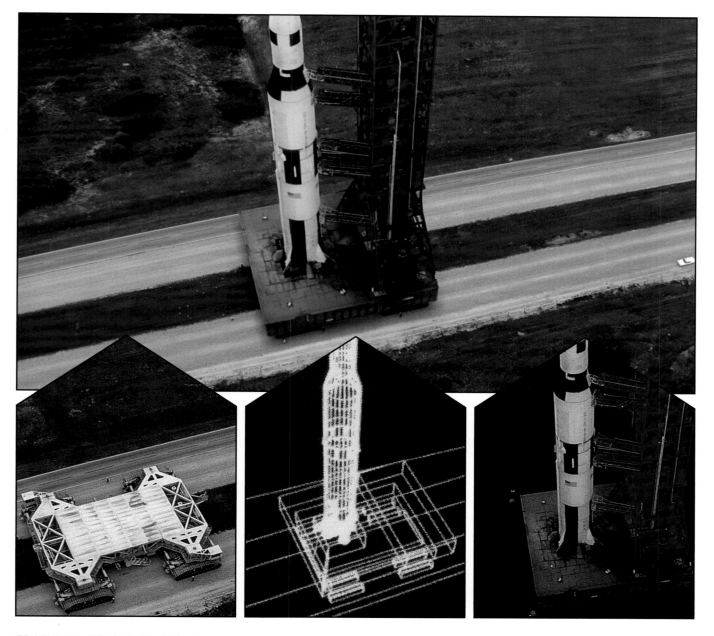

TRACKING WITHOUT SURVEYS

A giant crawler, built in the 1960s to transport *Saturn* rockets to their launch pads, is still used to move space shuttles into position. Sadly, moon rockets haven't burdened the crawler during the last 30 years. For *Apollo 13*, TRACK's task was to combine a helicopter shot of the unloaded crawler moving along its special gravel track with the 18-foot *Saturn V* miniature. This time the task was more subtle than for *Jeep*. Mapping the surrounding terrain was of only limited value, because future elements had to be added to the crawler, not the landscape, and the crawler was itself in constant motion, trundling along its gravel track. So there were no fixed points ('marker barrels', so to speak) anywhere in the landscape for the motion-tracking program to lock onto as an absolute frame of reference. Instead, digital artist Judith Crow searched

for the next best thing – the hard edges and corners of the box-like crawler – and built it as a simple CG wireframe model, with no colour or texture information. She had to check, frame by frame, that her version of the crawler exactly overlaid the real one.

At this point, a CG version of the *Saturn V* rocket and gantry could safely have been locked onto the crawler. In fact, Judith did build an approximate CG model of these machines, too. By the time she had finished, the wireframe crawler and a minimally detailed wireframe rocket and gantry were all moving along as a perfect match. The trouble was that a wholly convincing CG launch tower would have taken months to create at the appropriate level of detail. The many hundreds of delicate steel struts would have taxed the most powerful of

13 The *Saturn* rocket on the crawler.

14– The real rocket transporter is photographed from a helicopter as a master background plate. Judith Crow's
16 simple wireframe CG of the rocket and gantry model is overlaid onto the crawler's movements. The fully
 detailed rocket miniature is photographed under motion control, using moves derived from the wireframe.

17 In the completed shot, the real crawler and the miniature rocket appear to move as one combined object.

programs. It was decided, well into production, that the tower needed to be a conventional miniature. The rocket, consisting largely of simple cylindrical shapes, would have been relatively simple to construct in CG, but its relationship with the gantry was so intimate that no one wanted to take that route. Matters were not improved when Universal Studios, in a fit of marketing enthusiasm, announced in mid-production that the film's release date should be brought forward by four months. Physical model-making was suddenly the *only* option for creating the rocket and gantry hardware on time.

Data from Crow's wireframe of the rocket, now moving smoothly in lockstep with the real crawler, was loaded into the motion-control rig's computer, and the 18-foot rocket miniature was shot against its tower with passes that automatically matched the perspective of the crawler background plate frame by frame.

A similar set-up showed the vast Vehicle Assembly Building (VAB) as a beautiful, sweeping aerial shot (captured by David Norris in a helicopter) with a half-stacked *Saturn* booster visible in the giant doorway. In reality, the doors were shut. Crow had to paint a digital opening onto the background plate before motion-control photography of the booster miniature could be inserted.

18	19

18– In the 'Love is Strong' video, the Rolling Stones – and some glamorous girls – appear like
19 giants wandering through the streets of New York.

2-D TRACKING

A simpler variation on motion tracking, **pixel tracking**, doesn't require any mapping whatsoever of the background-plate locations. As long as the depth perspective of objects in the frame doesn't alter, it is a surprisingly simple and effective procedure.

For David Fincher's 1994 Rolling Stones video 'Love is Strong', the storyboard described the rock stars as giants looming King Kong-style over the concrete and glass canyons of New York. The background-plate photography was shot freestyle (often hand-held) over the space of a few days, with absolutely no attention to measurements or surveys, and barely a passing glance at the storyboards. The resulting footage was edgy and spontaneous, perfectly in keeping with

the characteristic pace and drama of New York. Fincher then edited these shots as briskly as he wished, in time to the beat of 'Love is Strong'. The Stones hadn't even appeared in front of the camera yet, but Fincher knew that he would have no trouble fitting them into his scenes.

In Ontario, Canada, while preparing for the next leg of their *Voodoo Lounge* tour, the Stones were photographed against a green screen. By now, with his rough cut of the New York scenes completed, Fincher knew which buildings and landmarks he wanted his stars to interact with, and he directed them to move or pose appropriately. This time the camera was securely locked off, and the frame never altered.

At Digital Domain, the green screen around the Stones was

20 Keith Richards achieves gigantic stature in a surprisingly simple 2-D effect.

20

FOLLOWING PAGES
21 Mick Jagger walks a treadmill, while a reverse tracking shot of a New York street is composited behind him.

21

substituted for the New York backgrounds. But how could the locked-off rock stars be matched with the shaky hand-held footage? It was precisely because the Stones were shot with a locked-off camera that the illusion works. Even as they twisted and gyrated in time to their music, they made sure to keep their feet within a set target area in front of the green screen. The pixel-tracking software located a small but absolutely unwavering element within each frame: a discreet set of crosshair markers on the green screen. Then, in the background plates, a distinct and easily identifiable group of pixels was tracked: the edge of a window frame, for instance, or the corner of a roof. From now on, wherever that pixel group went in the frame, an appropriate marker from the Stones footage was forced to follow. The end result was that the Stones appeared to move with the buildings, no matter how shaky the scene.

Digital Domain's effects supervisor Fred Raimondi was delighted with the relative simplicity of the procedure. 'There were no miniatures or models, no motion-control rigs, no survey mapping, and there were many shots where we only had two elements to worry about. There was a Rolling Stones foreground and a street-scene background, period.'

Having said that pixel tracking works best for elements that don't change in depth, some simple techniques appeared to break this rule. In one shot, Mick Jagger seems to be striding down a street towards us. In reality, he was photographed pacing a treadmill, never actually changing in scale or altering his distance from the green screen. Meanwhile, the background plate was a simple reverse tracking shot down the street. It's New York that moves, not Mick. The key point is that the pixel-tracking procedure was really linking two-dimensional shapes all along. No warping or distortion of depth perspective was called for. Compare this with the *Jeep* commercial, where the depth perspective of the CG jeep and ice tunnel had to be adjusted, frame by frame, to match the shifting real-life perspective of the 24 barrels in the ice sheet.

However, Raimondi and Fincher realized at one point that they weren't always creating a satisfying illusion of depth, precisely *because* of the two-dimensional 'cardboard cutout' nature of the elements they were playing with. Raimondi explains: 'We didn't always have the right foreground objects to "sell" the effect of gigantic scale to our audience, so in many cases we added them. Using straightforward two dimensional mattes rotoscoped from the original plates, we took buildings and street lamps out of the background and brought them to the front. It was amazing how something simple like that could make the scene.'

22 Leonardo DiCaprio and Danny Nucci enjoy the exhilaration of standing on *Titanic*'s prow.
In reality, only a small section of the deck was photographed at full size.

22

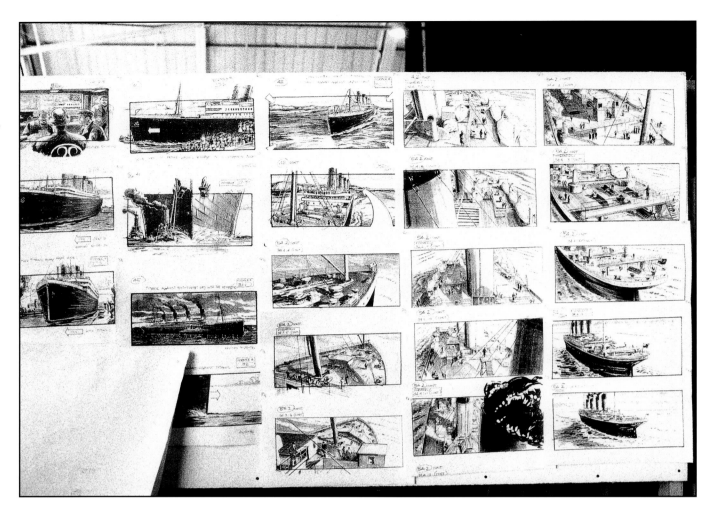

TOTAL CONTROL

A spectacular scene in James Cameron's *Titanic* represents a crowning moment in the art of motion control, both real and computerized. Impressive though it was, the almost life-size Titanic replica that was used for live-action deck scenes never sailed. Constructed in a giant open-air water tank near the Mexican seaside town of Rosarito, it was mounted on hydraulic jacks alongside access gantries and supporting studio buildings. The set-up was fine for quayside scenes and deck close-ups, but, being fully detailed only on the starboard side, the set wasn't suitable for long-shots of the liner on the open sea – particularly since the entire port side of the ship was missing, in order to allow technicians access to the interior scaffolding and lighting rigs.

But Cameron wanted an 'impossible' establishing shot of the ship at sea, as effects supervisor Rob Legato explains. 'When you're dealing with a massive ship like this, and you have to combine models with full-size portions of the set, you normally cut between a wide view of the model that's so wide you can't see any people, and a close view of the set that's so close you don't capture its relation to the ship in its entirety. But today, people have this idea of ocean liners from commercials that show the ships from sweeping helicopter shots. That's what we wanted to do with *Titanic*.'

CG supervisor Judith Crow breaks the problem down into its separate challenges. 'Much of the time, we were combining both full-scale and miniature photography with a wide variety of other elements. In a typical hybrid shot, motion-control data from differently scaled ship models was combined with full-scale actors against green screen, and dramatically enhanced by a multitude of CG elements, including water, the ship's wake, smoke from the funnels, CG characters and even CG birds. We had to find a way of marrying all these elements together so that they looked like the result of a single camera view.'

Doug Roble puts it another way: 'Without the data from each element matching data from all the others, the full-size prow set wouldn't fit onto the miniature, the CG people's feet wouldn't touch the deck, and they wouldn't walk through doorways or lean over rails, the CG ocean wouldn't wash against the hull and the CG smoke wouldn't billow out of the top of the funnels.'

It wasn't artistry that helped solve these logistical problems, so much as disciplined management of the many different shots in an elaborate on-line filing system. The shot begins with a close-up of two young men (Leonardo DiCaprio and Danny Nucci) on the prow of the colossal ship, and transforms

23 These beautiful storyboards for *Titanic* outline the swooping aerial view required to establish the scale and grandeur of the ship on her maiden voyage.

24- *Titanic* sails on a CG sea. Neither the full-scale ship sets or the miniature model ever set sail,
26 and no real aerial photography was involved.

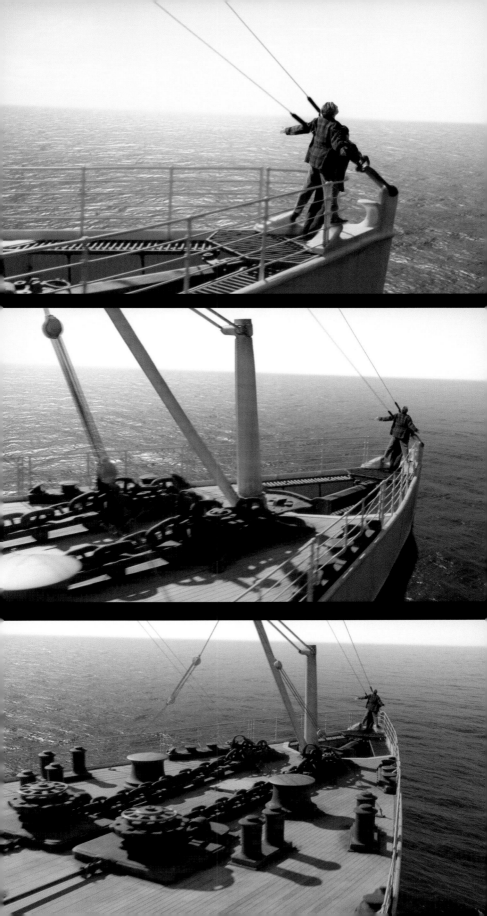

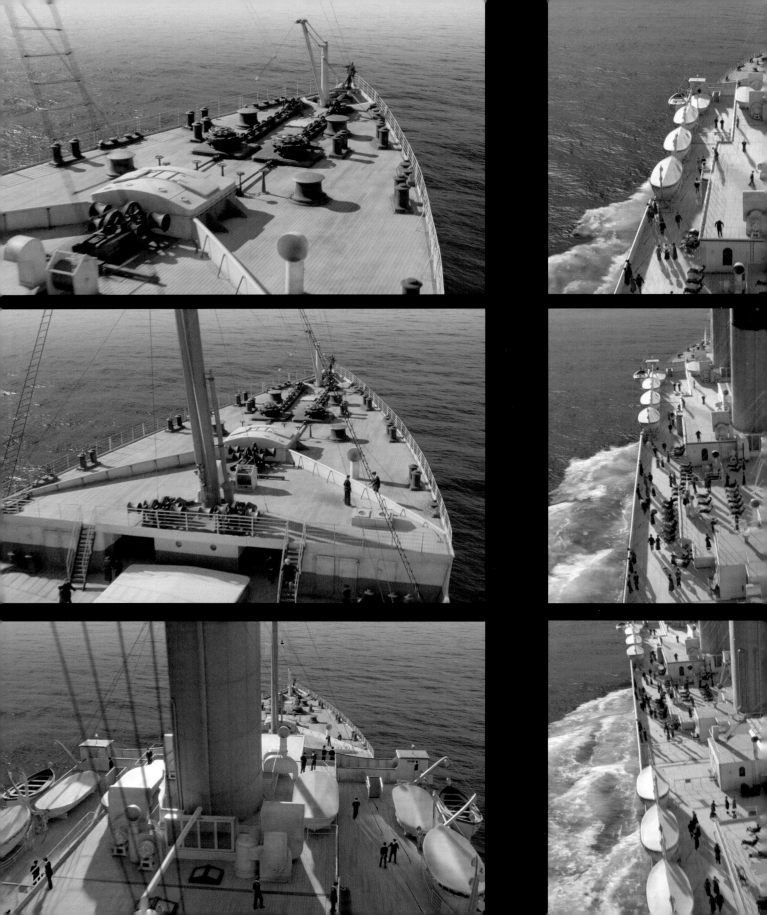

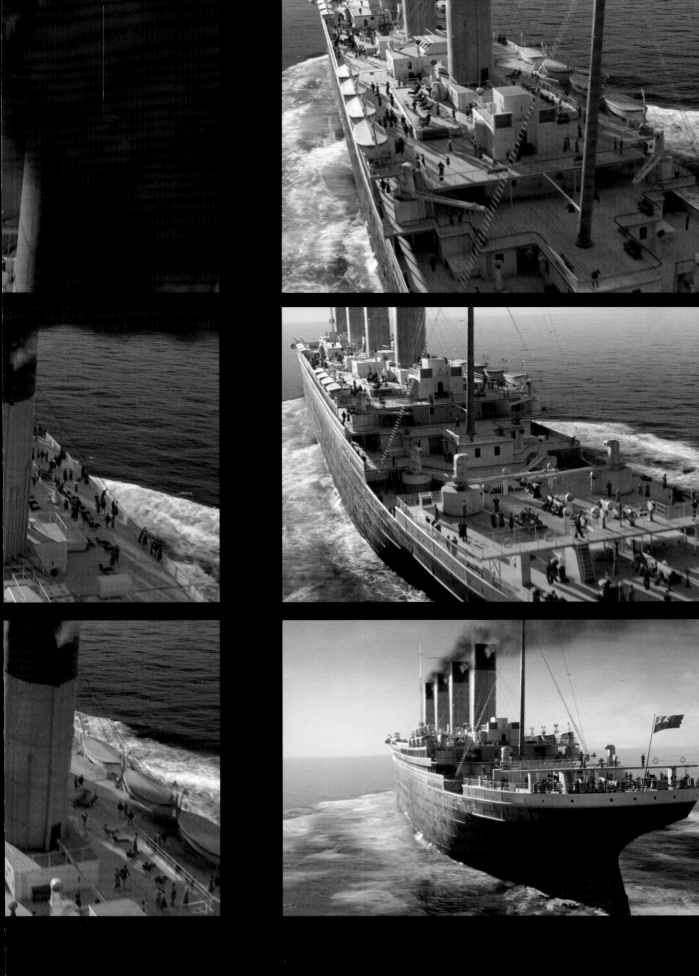

into an ever wider, ever higher shot, spanning the length of the vessel, then swooping away and looking back 'over the shoulder' as if from a helicopter, with the ship disappearing into the distance, surrounded by an endless expanse of ocean.

Digital Domain 'peopled' the miniature ship model shots with computer-generated crew and passengers, and morphed the two actors on the prow into CG miniatures as the viewpoint receded. The problem was to ensure a smooth transition between the live actors and their tiny electronic counterparts – and also to make sure that no one could tell when the full-size prow section merged into the studio-shot miniature of the ship as a whole. The motion control of every element had to be absolutely consistent at all speeds and scales. The completed sequence was one of the most sophisticated combinations of live action, model work, motion control, motion tracking and digital effects ever achieved.

But at the end of the day, what's really changed in these modern times? The technology, for sure, but not the nature of the underlying task itself, as *Titanic*'s co-compositing supervisor Michael Kanfer points out. 'We're still taking a lot of different people's work, from different disciplines, from the studio, or from the modelshop, or out on location, all shot at different scales, at different times, and getting them to tie together in the final image. People have been working on that very same problem since the dawn of cinema.'

Price Pethel is philosophical about the brilliance of all these techniques, despite the fact that he has contributed so much, in his long and distinguished career, to their fruition. 'We can matte individual strands of hair. We can get flawless motion control without a rig. We can build anything the human mind can conceive as a computer image. But let's not get carried way with how smart we are. One of my favourite movies is John Huston's *The African Queen*, and if you look at that, there are any number of old-fashioned blue-screen shots where they're holding out [matting] individual droplets of water. And that was half a century ago. You look at those shots, and the worst thing is that the movements of the background don't match the composited foreground. Plus, there's a little fringing, but so what? You have to look at the shot in the context of the time, where audiences read the images according to the expectations of the day. Maybe in the next half-century, people will look at the work we're doing right now, and will have to put *our* flaws in historical context, because the visual media in the year 2050 will be so much better than today's. But that won't stop people of the future enjoying our work on its own terms.'

27	30	33
28	31	34
29	32	35

PREVIOUS PAGES
27– The camera pulls back to reveal the miniature ship model, plus a huge cast
35 of CG passengers and crew.

DIGITAL MODELLING

The basic unit of many three-dimensional computer-generated (or **CG**) objects is the **polygon,** a flat shape defined by at least three points, or **vertices,** linked by straight lines, or **segments.**

Triangular polygons are the simplest shapes with which more complicated forms can be created. A pyramid can be made from six triangles, and a cube can be built from twelve. (Think of each square face with a diagonal line running between opposite corners.) The positions of the vertices in a **polygon** are defined in a classic Cartesian X, Y and Z co-ordinate system that defines three-dimensional locations in space. X defines the horizontal location, Y the vertical, and Z the depth.

A CG object often begins as a **wireframe mesh**, with no surface details apart from corners and edges (the vertices and segments). The mesh is assembled from measurements taken from a drawing, or else scanned in from a physical structure in the real world: a car, say, or any other artefact that will fit sensibly into a scanning studio. A needle attached to an armature acts in a similar way to a motion-control rig, logging movements in terms of gear rotations or other clearly quantifiable data. When the scanner's probe is pushed gently against the car's body-work, that point of contact is recorded in the computer as an X, Y, Z co-ordinate in three-dimensional space. When enough points on an object have been logged this way, a CG mesh of the entire car emerges. The more data points that are logged, the more accurate the mesh. Straight edges need only to be logged at each end, but the undulating curves that make cars so distinctive require many finely spaced intermediate points.

Laser scanner systems, rather like supermarket barcode readers, can take some of the manual drudgery out of this procedure. Beams intersecting from different directions create a reflected mesh on an object's surface, and the data can be interpreted more or less automatically from that, in combination with a laser theodolite-style routine that measures the time taken for the beams to reflect back to their source, and therefore the varying distances they have travelled.

The difficult route is to create a CG object entirely from scratch, with no external references, using computer drawing tools alone. To save unnecessary repetition, basic three-dimensional objects like cubes, cylinders, cones and spheres are usually available as **primitives,** so that they don't necess-arily have to be drawn from scratch every time. More complex objects can be assembled from an amalgam of various primi-tives, although many vertices in the resulting mesh may need to be manipulated at finer scales to create detail.

In the 'procedural' approach, objects are derived from a

1 A car is digitized to create a wireframe mesh. Adhesive-tape marks on the car act as a guide for positioning the probe.

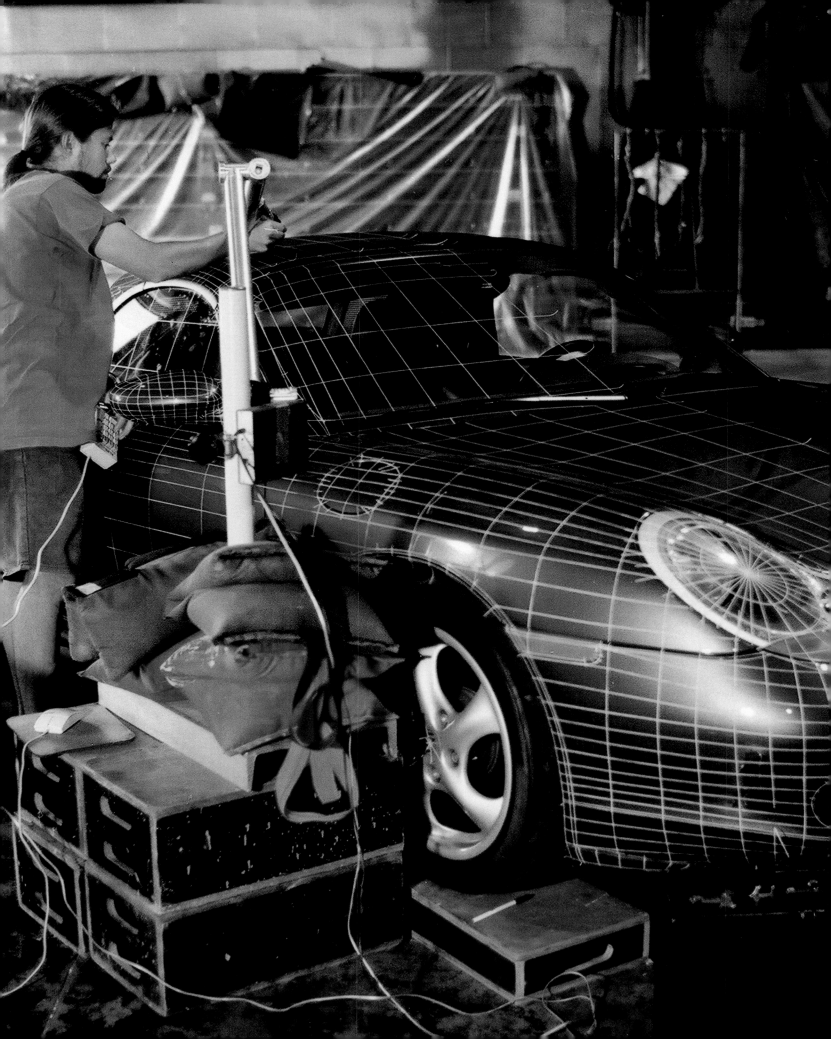

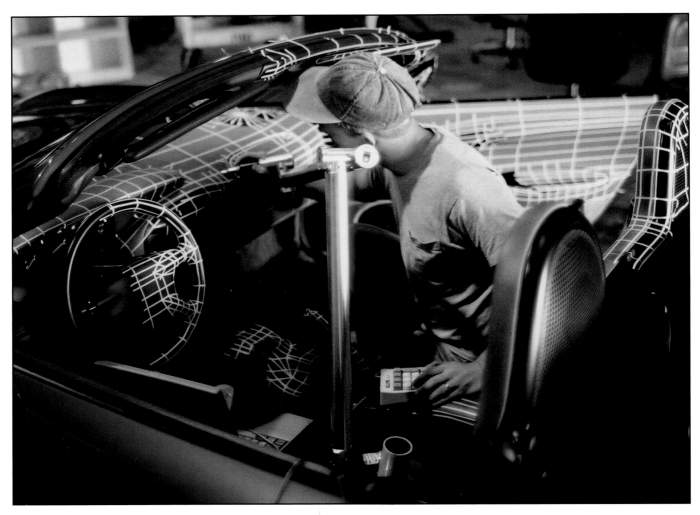

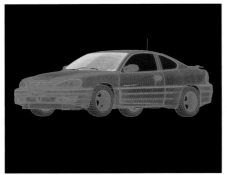

computer code that defines their shape mathematically. For instance, to define a sphere, one central point is assigned, and then the computer is instructed to create a mesh in which all the vertices are equidistant from that point. The beauty of the procedural approach is that simple changes to mathematical values in the lines of code can alter or completely redefine an object without requiring the artist to begin again from scratch.

In their turn, many of these more advanced assemblies become part of a growing back catalogue. Alan Faucher says, 'At Domain we have a large enough library of primitives that we

can plug just about anything together from models created before. But you always know – especially in the space vehicles and other weird stuff – that at some point, you're going to run up against shapes no one's ever conceived before.'

SURFACE GEOMETRIES
Polygons are a great way of capturing the essence of machines and vehicles, with their regular geometrical shapes and easily measured symmetries. (The CG model of *Titanic*, for instance, was created from a mesh of close to a million polygons, under

2-5 Once the real car has been 'digitized' and its wireframe produced, the geometric mesh is tidied up and smoothed out. Surface details are then derived from a multiple set of 'maps' that define colour, texture and other characteristics, including the appropriate reflections from the background.

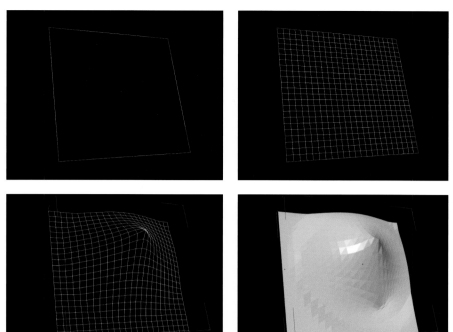

CG CARS

Fred Raimondi: 'About five years ago, I was discussing a car campaign where the director wanted a dramatic movement. The car's supposed to jump into the frame, almost as if from a trampoline. The director said, "I think we need to shoot the car with a motion control rig." Then the specialist car photographer on the job said, "We should put the vehicle on hydraulics." So I said, "How about we make the car entirely in CG?" And it was like I'd said I was sleeping with their wives. Anyway, being Italian, I made 'em an offer they couldn't refuse, and at Domain, we made a test.

'Most car photography isn't about the lighting. It's about controlling reflections from all those shiny surfaces. We decided to do our test as though the car was illuminated only by huge reflecting white cards. We didn't apply any virtual lights. And it looked great. They bought it.

'Then there was a conventionally shot campaign with a sports vehicle going along a forest road, and a year later the company came to us and said, "We've made a few changes to the front headlights. Can you change the car by painting on a few CG patches?" As it turned out, the door handles were also different, and the fenders too. I said to them, "Why not let us create the whole car as a CG, and superimpose it over the old one? Then, in another year's time, when you've made another bunch of changes, we can dial them in for very little additional cost. That's now an important marketing tool for car companies that come up with countless variations on standard models.'

the direction of Richard Payne and Fred Tepper.) They're not so good at capturing more complex undulating surfaces, human faces especially. A face made entirely from polygons looks clunky, with its array of flat facets putting the viewer in mind of a robot rather than a person. One option is simply to add more vertices and more polygons to create a smoother-looking face, but there are drawbacks. The more vertices a CG mesh contains, the more computer memory is needed to define and store it. This affects the speed of the processor, and as a con-

sequence, CG modellers try to use the absolute minimum possible number of polygons at all times. (Scanned meshes will be 'cleaned up' to take away any unnecessary polygons, while leaving the overall model intact.)

Computer artists on the lookout for soft organic shapes, defined by as few data points as possible, often turn to **NURB** surfaces instead. NURB stands for 'Non-Uniform Rational B-spline'. On screen, the graphic representation of a NURB surface can be pulled, dragged, stretched and distorted into complex

6– A rectangular plane is defined in 3-D virtual space as a NURB 'patch'. A mesh then defines the patch as a set of points. In this example,
10 one point is selected, using a mouse, and 'dragged' out of the patch. The overall NURB surface distorts accordingly. Complex NURB models are often assembled from many patches. An approximate 'skinning' process makes the patch look more like a real surface, but the level of textural detail is minimized during initial modelling.

curved shapes. Undulating ripples, egg shapes, even perfect spheres can be created from a NURB without having to build everything from countless separate polygons.

NURBs start off as rectangular 'patches' rather like chequerboards, criss-crossed with vertical and horizontal lines – the 'splines' that define the contours of the surface. If one of these splines is pulled into a curve, the entire patch will deform accordingly. Think of the chequerboard as if it were made from a sheet of rubber, with puppet strings pulling it out of shape. A few carefully judged tugs at certain strings, and a complex undulating surface can be created.

Control vertices are the 'strings'. They act on the points where horizontal and vertical splines intersect. When the artist moves a vertex with a mouse tool, the appropriate point is dragged along in space, and both the splines that pass through that point change shape. By assigning a 'weight' to this intersection point, other points where splines intersect can also be affected, to a greater or lesser degree, without requiring separate control vertices to be pulled manually for every last point. A sphere, for instance, can be pulled into an egg shape using just one control vertex acting on one point. The weighting of that point on others around it will make the difference between an egg with a sharpish peaked tip, or one that is more rounded overall.

NURB patches can be pulled and stretched into the most amazing curves imaginable, just as long as all the separate spline curves remain mathematically consistent. The difficulty arises when an artist wants to put fine detail between splines: into one of the blank squares on the chequerboard, so to speak. If there are no splines at that point, there won't be anything for a control vertex to act upon. The only option will be to add two more splines, one vertical and one horizontal, thereby creating a new point on the patch to manipulate. The more small-scale detail that is added, the more splines have to criss-cross the NURB. Bearing in mind that a change to any single point on a spline must affect the entire shape of that spline, along with all the splines that intersect it, it's easy to see how NURBs can get out of control.

A final snag is that, even when wrapped into the shape of a perfect sphere, a NURB is still really a flat rectangular patch that's been stretched and wrapped into a spherical shape. One wrong tug on the wrong control vertex and the places where the original edges of the patch have been joined together will tear apart. And once torn, they're not easy to repair.

On the other hand, individual vertices of a conventional polygonal mesh can be adjusted without distorting huge areas around them – just those few polygons who share that particular vertex. When looked at closely, even the softest human faces contain a surprising number of sharp corners and indentations, and these are sometimes best modelled polygonally. Consequently, NURBs are sometimes inserted, where appropriate, into a more densely detailed polygonal mesh. As so often in digital imaging, no single device is ever adequate on its own.

Another modelling tool, a **subdivision surface**, combines the benefits of polygonal detail with NURB-style smoothness, as CG supervisor David Prescott explains: 'A subdivision surface allows you to build a wireframe, and you can add new vertices anywhere you want, and just at those places you want, without interfering with the rest of the wireframe. Subdivisions will automatically give you a smooth model by looking at the finished array of vertices and calculating where to put more points in between them to create smoother contours. The big secret is, the smoothing-out only happens at the very *end* of the modelling process, when it's time to output the final version [the 'render' phase]. Meanwhile, you can work on a low-resolution mesh without slowing down your processor.' The disadvantage of subdivision surfaces is that sometimes a modeller needs to see in very exact form what a shape is going to be during the modelling phase, and cannot afford 'approximations'.

The latest and best CG modelling tools allow swapping and conversion between all these surface types during the process. There's not necessarily an either/or choice that has to be made.

A FRAME OF REFERENCE
In order to display a CG model, the artist must select a point of view. The image on the screen constitutes the picture as seen through the lens of a **virtual camera**. You can look at a CG model as a plan view, in exact profile, or from any angle in between. The virtual camera doesn't necessarily appear on the main screen image, but without it, the computer cannot define which of an infinite number of views you want to see. Virtual cameras include lens equations that zoom into the main image or widen out, according to requirements. These days, there's an ever closer relationship between the CG simulations of lens characteristics and the actual qualities of movie cameras, although the complex edge-of-frame distortions from real glass optics remain a tough challenge. In general, there has to be a match in perspective when combining CG objects with real-life background footage. If a live sequence of a New York skyscraper has been photographed with a very wide-angle lens, then the invading alien CG spaceship skimming across the

11– Points (vertices) in a NURB patch can be variably 'weighted' so that they influence other points
13 around them to greater or lesser degrees. In this example, some points have created sharp spikes when dragged, while others have acted more subtly on points around them to produce gentle undulations.

foreground will need an equivalent wide-angle distortion.

On a separate part of a CG artist's working screen, a small **orthogonal display** shows the theoretical spatial relationship between the CG model and the virtual camera. A smooth spline curve can be drawn through the orthogonal space, controlling where the artist would like the camera to travel. It can be made to trawl slowly around the CG model, or swoop high up into the air as if carried by an invisible helicopter. The artist can match a motion-control move from an existing live-action plate, or use the virtual camera as a creative tool in itself.

COLOURS AND TEXTURES

The surface appearance of a CG model is generated by a code that determines various characteristics derived from a number of different but corresponding sources of information.

A materials editor can be used to select how the surface of an object should appear: its colour, how rough or smooth it seems, how granular or matte, and so forth. If light were to hit the object and bounce off cleanly, that would be characteristic of a shiny surface. On the other hand, if light is scattered in all directions when it bounces off, that suggests a rougher surface.

For additional detailing, a flat two-dimensional **texture map** is often created. Adobe Photoshop, Amazon Paint, or any number of two-dimensional graphics packages can be used to 'paint' the required effects. This map is then wrapped around the model, rather like paper around a Christmas gift. The best way of imagining this concept is to think of a flat cutout paper kit of an airplane or a car that becomes a three-dimensional model after it's been folded and glued together.

The wrapping isn't physically literal. Pixels on the CG model are defined for the relevant colours after referring to the texture map. In X, Y, Z spatial terms, the referencing process can be dauntingly complex. What kind of a flat texture map will fit, say, a human head?

One particular advantage of NURB modelling is that the splines on a patch can act like map co-ordinates. Similar left–right grid references on a texture map can be made to align themselves on top of the equivalent NURB splines, automatically stretching and distorting to follow the NURB curves. It's not quite so easy to do this with polygonal meshes, especially when flat maps have to be nudged into folds and indentations. In practice, it makes more sense to generate a flat map of the model wireframe first (which the computer can do automatically), and then paint or apply texture details to that, in the sure and certain knowledge that everything will wrap correctly around the model when reapplied.

If a CG object is supposed to simulate something in the real world – a house, say, or a helicopter – then detailed plan and profile photographs of the real thing can be used as texture maps, thus saving a great deal of time. Failing that, even fantasy CG objects can be detailed with metal plating, rivets or whatever, photographically sampled from reality.

Recent software advances allow artists to 'paint' directly onto a 3-D model, but as so often with wonderful new tools, there's a downside: in this case, a debilitating drain on computer memory.

Next, how rough or how smooth does the surface of the model need to be? Think of the dimples on a golf ball. A **bump map** would use a grey-scale map to apply the two-dimensional illustration of varying height or depth, as if small shadows had been generated by oblique lighting. The dimples can be implied by crescent-shaped shadows and opposing highlights. Alternatively, a **displacement map** can literally distort the surface geometry of the golf-ball model to create the dimples.

Another important aspect of surface detail is translucency, controlled by an **opacity map**. The outer surface of an aircraft, for instance, might be smeared with **semi-opaque** oilstains, through which the military decals can be partially observed, while the perspex windscreen of the craft needs to be entirely translucent so that the interior cockpit modelling is visible.

14 A draft render of a CG spaceship composited with real-life background footage, using a virtual camera wide-angle lens.

15 A flat texture map, defined as a simple grey scale, defines the degree of distortion applied to all the points on a previously distorted NURB patch.

LIGHTING AND REFLECTIONS

Lighting is one of the most important qualities determining a CG model's appearance. Is it supposed to be in dazzling sunlight or in deep shadow? A **virtual lighting kit** can be positioned around the model, and shadows and highlights appear accordingly, but again this is a strange and complex illusion derived from a kind of mapping process. The 'lights' can be manipulated as little icons on the screen, but they do not necessarily mimic real studio lights.

According to Karen Goulekas, 'There are certain things that virtual lights have a hard time doing. Soft light is tricky, because, in reality, the diffusion effect is in the atmosphere rather than in the light itself. In the computer model, atmospheric conditions are a whole separate problem in themselves. You never really get the feel of true stage lighting just by putting the virtual lights where you think they ought to go. It's still kind of voodoo, and it doesn't yet look right.'

CG artists need to understand real photographic lighting in every detail before they can even begin to use the computer's frustratingly non-intuitive simulations. As an example, imaging supervisor Mike Kanfer recalls the famous sequence where *Titanic* is seen as if from a swooping helicopter. Many different motion-control and CG elements were composited into the shot. 'Everything is in glorious broad daylight, but there are actually seven suns dotted around the sky. Of course you don't see those extra suns. They are implicit within the virtual lighting. If you look at small details on the ship, CG passengers,

flagpoles, railings and so on, you might spot that the shadows don't always point in the same direction, as they would if it was just the one sun illuminating that shot. But it took seven separate virtual suns to make the ship overall look naturalistic. The all-round fill light, essentially sunlight reflected from a huge, soft blue sky, is the hardest thing to recreate in a computer. And yet that's the kind of lighting we all live under.'

Reflections are the next challenge, since every object in the world (with the possible exception of a black box swathed in black velvet, viewed at midnight) reflects some light from the surrounding environment. Supposing a CG model is intended to represent a silver coffeepot: what will it reflect? The hard solution is to build other CG objects into the environment, just out of view of the virtual camera, and then calculate the reflections cast in the pot by a process known as **ray tracing**. Literally, every pixel that defines the image of the pot has to be calculated by tracing the rays of light that, in theory, would bounce between the reflected world, the pot, and the view-point of the virtual camera. It's a mathematically intensive task.

Environment mapping (or 'reflection' mapping) is slightly simpler. Photos or artwork of the surroundings are used, rather than actual 3-D models. The viewer would be hard pressed to tell the difference from ray tracing. Typically, environment maps are built onto the inside surfaces of a six-sided cube, or onto the inside of a sphere, after an entirely flat original (derived, perhaps, from a relevant panoramic

16 A virtual lighting kit defines the illumination of a sphere.

17 A low-resolution version of the sphere enables the lighting to be approximately checked.

18 A flat texture map is 'wrapped' around the sphere to produce an earth-like globe.

photo) has been appropriately distorted. Think, again, of the orange-peel segments of a flat map of the earth before it is glued onto the ball of a geographer's display globe. Now think of gluing that map to the *inside* of the globe instead. That's an environment map.

When CG objects are included in a previously shot live-action scene, environment maps need to match specific real-world surroundings. Stills photos of the relevant movie set, digitally joined together as a collage, often suffice as source data, but Digital Domain now uses a much faster procedure. A mirror-smooth chromium-plated sphere, known as a **light probe**, is placed on the set and photographed. The real-life reflections on the sphere are then enlarged to fit directly inside the computer's environment-mapping sphere, with negligible distortion. Just as significantly, the hottest highlights on the metal sphere, created by studio lights and other bright sources, help the virtual-lighting designers to match a CG object's illumination with the real lighting on set. Another approach is to shoot the set using an extremely wide-angle lens with a 180-degree field of view. This eliminates the problems of inadvertently capturing a reflection of the camera itself.

As CG supervisor David Prescott explains, a digital camera is often used. 'The position you're shooting from doesn't necessarily change, but you take multiple exposures. With each exposure stored away as separate levels of data, you capture different types and intensities of lighting information. One pass will pick up the highest intensities from the studio lamps. In another pass, you'll set the exposure characteristics of the camera to pick up subtle, diffuse reflections from surfaces, walls, floors and other objects on the set. Another pass will be attuned to pick up detail in the deepest shadow areas. No single exposure on any normal film camera will get the full range of information that's out there. That's why we call this multiple-pass approach **High Dynamic Range** or **HDR**. When we're shading a CG object and building environment maps and lighting it, we're using the fullest possible information.'

This is not an easy technique, and the development work (pioneered by Paul Debevec at the University of California, Berkeley) has some way to go before it is ready for routine use. Prescott sees a great future. 'You'd be amazed at the difference it makes to get the subtleties of lighting on the CG exactly right, to match the real environment. I can see this becoming a full-blown effects tool.'

OUTPUTTING THE RESULT
The colour and intensity of each pixel in a CG image will be the sum total of all the influences described above. **Rendering** is the technique that calculates and outputs the pixels, one by one, until a complete image is created. It burns up a colossal amount of processing power and can take anything from a few minutes to several hours per frame, depending on the scale and complexity of the model.

Throughout most of the construction phases of a CG object, whether as polygons or in NURB surfaces, rendering is kept to a minimum so that everything can be manipulated in rough form at practical viewing speeds. Fully rendered models cannot yet be manipulated in real time, because computers simply aren't powerful enough to cope with the workload.

Another severe problem with rendering is that it logjams

19 The complete interaction between the texture maps and the virtual lighting will only become
 apparent after a full high-resolution render.

20– A metal sphere helps the virtual-lighting designers match the real lighting on set. In fact, the
21 information is more computationally extensive than these images suggest, and every extra piece
 of information helps Digital Domain's animators.

an entire computer – in fact, *most* of the computers in the CG departments. There's nothing their human custodians can do except wait and twiddle their thumbs. The practical solution is to render at night, when the artists are away from their desks and the computers can crunch their pixels in peace. At Digital Domain, **render farming** distributes individual frames of a required CG sequence to different processors (using custom-built company software called 'RACE'). As soon as employees log off and go home, their workstations automatically accept a frame to work on, allocated according to urgency by a net-worked queuing system. At night, as many machines as possible will always be working simultaneously on rendering, with not a human in sight.

This helps to soften the impact of render delay times. Suppose a frame from a certain sequence takes six hours to complete. If a dozen machines work a 12-hour night shift, then what will the CG artists find when they return in the morning? At six hours per frame, divided among 144 machine hours, that'll be 24 frames rendered and ready. One second's worth of footage. Sensible render times can only be achieved using hundreds of processors at a time.

And at render time, some nasty surprises may still need fixing, particularly when many separate elements are involved, as Karen Goulekas recalls: 'In the shot of *Titanic* breaking apart, we had maybe 200 layers, and every time you wanted to reach in and change something, there was a ripple effect across all the other elements, and a lot of memory used up, and a lot of waiting for the changes to kick in.'

THE PROCEDURAL APPROACH

Kevin Mack points out that all these separate CG techniques, so neatly defined a few years ago, are merging into each other as the latest software packages become more complex. 'The shading, texturing and rendering components are becoming hard to distinguish, in some cases, from the under-lying raw geometry of the model.'

Mack prefers to model 'procedurally'. In other words, he likes to work at the most abstruse progamming level. He doesn't draw so much as *write* a shape. Pointing to a land-scape picture on his wall, he says, 'Everything you see can be described in terms of mathematical functions. All the colours, shapes and textures. The more you rely on a generalized graphic interface, the less fine control you get over your work. I'd say that a computer artist should know the software inside out, but I understand if traditional artists don't always want to get into that level of expertise.'

Mack presents for inspection an eerie fantasy image of monolithic rocks floating in a blue sky, with clouds and drifts of fog adding to the scale. The grey rocks are pitted with age, and the overall effect is flawlessly realistic. 'I didn't draw or sketch this. I wrote the procedure knowing pretty much in advance what it would deliver.' Along with many of his colleagues, Mack can 'see' in computational mathematics in the same way that classical composers can 'see' the shapes and emotional heights of their works in the musical notation.

General-use software packages are somewhat easier to work with, consisting of tool palettes and icons in a 'user-friendly' interface, along with some procedural shortcuts that can be selected from menu bars. The deeper workings of the software are hidden from view unless specifically called up. The strength of these packages is that artists with drawing skills can make their ideas come alive as three-dimensional models, using tools that allow for an intuitive way of working direct from a low-resolution but quickly adjustable screen image, with just a few sample frames occasionally rendered in detail to check progress along the way.

However, there remain many dynamic motions, structures and textures that are best suited to purely procedural approaches. For instance, what if no one is quite sure what an object should look like? What if the object is too subtle or complex to be visualized in advance? There are many natural phenomena that cannot easily be drawn in detail because humans don't have the gift of understanding certain types of complex structures in a preconceived way.

Sometimes it is better to *grow* an object than to draw it. Creating the right kind of digital 'seed' is strictly a procedural challenge for software experts only, and not for the faint-hearted. But if you really know what you're doing, then complex CG objects can be derived from surprisingly simple programs. In *What Dreams May Come*, Robin Williams enters an afterlife realm where his beloved late wife's artworks are translated into a three-dimensional landscape apparently made of oil paint. Under Mack's supervision, David Prescott and Matthew Butler created a beautiful sequence in which a tree suddenly sheds its leaves at the point when Williams realizes that things aren't entirely right in this apparently wonderful afterlife world. Mack says, 'The tree wasn't constructed as a preconceived model, but actually grown organically, from what you could call a mathematical "gene" set.'

Genetic code (DNA) is often referred to as the 'plan' for life, but this analogy is not quite appropriate. A plan of a house or an aircraft shows all the components in relation to each other, as they should finally appear. The DNA molecule does not contain any such forward-looking blueprint for how a natural organism should eventually look. What it does contain is actually more like a recipe than a plan: manipulate a given set of ingredients a set number of times in a certain way, and – provided that none of the instructions contain errors – a healthy organism is guaranteed to emerge.

Starting with a single cell that divides into two, four, eight, 16 and so on, the growth of a natural organism is based largely on instructions to build new layers of tissue onto existing layers, or branch out fresh structures in a pattern not entirely dissimilar from what's already there. There is no need for DNA to encode any information about the desired length or weight of a completed structure. It only has to dictate that spurts of growth should be triggered, or 'iterated', a certain number of times. Deceptively simple chemical instructions can produce complex organisms, and the tiniest variation in any of the instructions has a tremendous effect on the end result. (The difference in the instructions encoded within human and chimpanzee DNA amounts to less than one per cent of variation in the chemistry.)

Since software designers are always keen to make efficient use of computer memory, it's not surprising that they have tried to learn from nature's example. We are a long way yet from fully understanding how DNA generates its instructions to make animals, but in 1968, botanist Aristid Lindenmayer

22 The L-systems tree for *What Dreams May Come* as a wireframe, combined with a template of the NURBs landscape surface for reference.

23 A DNA molecule – the original inspiration for the L-systems program.

24 This diagram shows how Digital Domain farm out frames to different processors for rendering.

FOLLOWING PAGES
25 The fully rendered tree, complete with surface textures and foliage.

25

realized that the growth of trees, at least, could be analysed with simple rule-based language. A computer parallel is now available. Named after the first letter of Lindenmayer's name, **L-systems** is a 'branching' program that creates CG trees.

Starting out, say, with a single vertical trunk, the topmost end might be instructed to sprout three new branches, all pointing in different directions but sharing a common root at the tip of the original trunk. Each new branch then sprouts a trio of fresh offshoots in the same way, so that nine additional branches appear – and so on. After just five iterations of the program, the original trunk has sprouted a tree-like canopy with 243 branches. The simplest adjustments to the initial program will result in very different trees being delivered; maybe a gentle curve applied to each branch when it is first sprouted, or an instruction to make new branches sprout from halfway along old ones rather than from the tips.

Trees in the real world do not adhere to such simplistic rules. Branches vary in size and texture, with older branches the thickest and most gnarled and the latest season's new shoots the thinnest and smoothest. Length also depends on age, because most branches continue to grow during a tree's lifetime. If L-systems is to deliver something genuinely tree-like in appearance, its instructions need to affect not just new shoots but the entire tree during each iteration. The program needs to store data about all previous generations of branches and apply an appropriate ageing and growth process to them, as well as merely adding new branches to the outer layers of the canopy. As an L-systems tree grows, so the program becomes slower, because of the exponentially increasing population of branches that it needs to remember and manipulate during each iteration. Just as in nature, L-systems will iterate its growth cycles a certain number of times and then stop, before the entire computer memory is swamped with data from an out-of-control tree with billions of branches.

A good L-systems routine can mimic natural tree growth with uncanny precision, but the trouble with any program based on rules – even the most subtle ones – is that nature often throws away the rulebook altogether. For instance, why is it that most of a real tree's branches carry on growing, but some do not? To a software designer sitting at a workstation, surrounded by computer hardware, the answer might not seem obvious at first, until she goes out into the nearest park and actually looks at a tree and observes that a few large branches have died years ago but haven't yet fallen off. What's more, the death of these branches may be only partial, with a few fragile shoots stemming here and there from some regions where nutrients and sap are still in supply. Parasitic infestations often affect trees in this way, sporadically blocking or hijacking the flow of sap through a branch. As trees get older, they become increasingly prone to random natural events, and the symmetry of their early years is increasingly degraded.

Mack and Prescott's L-system program was, in a way, the simplest aspect of creating their *What Dreams* tree. The hard part came at the end of countless experimental growth cycles, when they ended up with trees that somehow didn't quite look right, for all the subtlety they had tried to work into the program. Prescott describes the dramatic solution to their problem. 'We grew a tree that looked pretty close to what we needed, and we weren't going to get it all that much better. But still it wasn't right in some indefinable way. So we had this moment of inspiration. We literally reached into the completed structure and inflicted massive random damage on it. We tore a huge branch off, in the assumption that there would have been storm damage at some point in the tree's past life. Once we'd done that, we had a tree that looked like a tree.'

As Prescott says, 'It's not enough to know about computers, or how to animate CG elements and so forth, no matter how smart you are at the technical level. Truly good computer artistry requires you to go outdoors and look at the natural world, to really observe it and see how it behaves.' For example, observation of anatomy has drawn Mack to the conclusion that all vertebrate mammals are essentially the same. He has developed a procedure that automatically creates an animal template, a head, torso, four legs and so forth. 'Really quite minor variations to some of the procedures can turn a mouse-shaped CG model into a man.'

INSTANCING

Fight Club opens as its highly disturbed, chronically depressed anti-hero, played by Edward Norton, prepares to blow himself away. In the depths of his brain, a cluster of cells generate electrical signals, firing like dim lightning in a gloomy cavern of nerves and dendrites. Our viewpoint pulls back to reveal Norton's gloomy 'thoughts' – weak pulses of electrical energy moving listlessly around his brain. We twist and yaw our way through the temporal and frontal lobes and out through the forehead, along a single hair follicle, then down between beads of sweat to Norton's upper lip, and finally along a gigantic smooth metal groove – the top of the gun that he has rammed into his mouth. From the audience's point of view, the bravura effect looks like a single, seamless shot, more than a minute and a half in duration.

Medical illustrator Katherine Jones worked for a year with *Fight Club*'s director David Fincher, delivering a detailed and eerily beautiful sketchbook of the brain's anatomy at different scales. 'Although he's an edgy visual person, I was impressed by how much he cared about the anatomical accuracy of the scene. He really wanted to know what the brain structures look like. He knew that the best results come from looking at what's really there, rather than somehow making things up. You can't *really* pull a camera through someone's brain, and we had to simplify the density level of some structures to clear a path, but apart from that it's an accurate scene.'

David Prescott led the modelling team for the brain interiors, and once again, L-systems was pivotal. 'We were dealing with organic natural structures, so, like the tree in *What Dreams May Come*, we wanted to grow rather than model this brain. The dendrites that we grew are the communications structures that route electrical signals between the neurons, the actual brain cells. Neurons have strands of axons, which receive signals from other neurons and dendrites, and you have, essentially, a dendritic forest, which creates what we know as "thinking". But I'm not an expert on how the brain works.'

Kevin Mack supervised Digital Domain's effects for *Fight Club*. 'When we grew the tree for *What Dreams*, we stored the entire

26– The gloomy interior of a deranged mind is revealed in *Fight Club*. Director David Fincher wanted
29 the shot to give the impression of a night dive in deep, murky waters, with the scene lit as if by
 the weak spotlights of a tiny submarine.

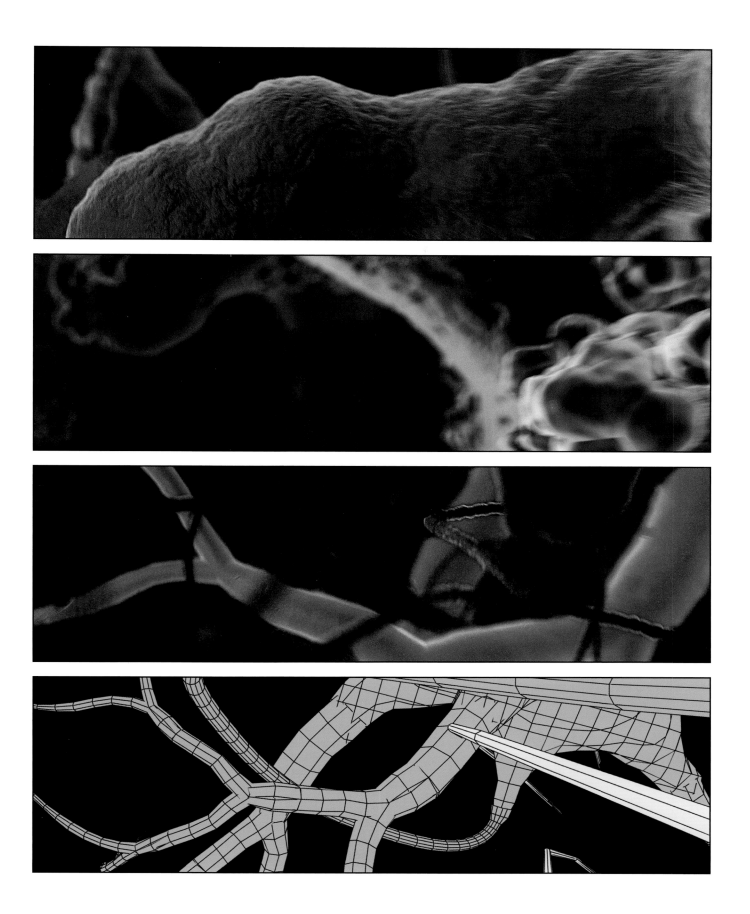

structure in the computer as a fully completed model. This time, we were dealing with an overall modelling universe much more complex than the tree. We had dendrites, membranes, arteries and the subarachnoid spaces, and the convoluted chambers that distribute cerebrospinal fluid through the brain.' Mack rattles off these biological terms with loving care. 'The point is that the final overall model is so large that we couldn't have loaded it into a computer all at once.'

The solution was **instancing**, a technique that allows the computer to call up only those structures that it needs for any given frame, without necessarily referring to a grand overall model. In addition, structures that repeat many times (like the dendrites) only have to be calculated once, no matter how many of them appear in a scene. 'In what looks like a vast tangle of dendrites, you essentially have the same ones every

time,' Mack explains. 'The computer only has to do the hard modelling maths on, say, half a dozen of them. You see them rendered many times, but from different angles, and this gives the impression of a much more varied population. That saves greatly on computer resources.'

Just as well, as Prescott points out. 'If you tried to build the entire brain environment as a complete model, then no matter how many terrabytes of storage we have at Digital Domain, and no matter how many processors and workstations, you just wouldn't be able to store or manipulate something like that. You have to split the workload some way, and just build the part of the brain that you need at any one moment. You never have a complete brain model accessed by the system at any time.'

Matthew Butler was CG supervisor for *Fight Club*. 'We knew

30 A complex *Fifth Element* digital matte painting shows New York in the 23rd century. Some buildings appear brand-new, others 300 years old.

the trip through the brain would be a smooth pull-back, rather than a jerky forward-looking rollercoaster ride, because when you're going in reverse the audience can't see what's coming up next behind them, and that heightens the anxiety. But other than that, it was a difficult scene for us to visualize in advance, because you never really get a grip on the entire environment that you're dealing with.'

In fact, neither does the audience. As Mack explains, 'David Fincher wanted to create the mood of a night dive, with low light apparently coming from the camera's point of view, as though you were relying on the weak headlights from the front of a submarine. Also, because this is the inside of a brain we're talking about, and not some vast cavern, the sense of microscopic scale was conveyed by creating a very shallow depth of focus.'

The lighting problem was dealt with surprisingly simply. Objects facing towards the virtual camera were instructed to render as if illuminated, and everything else was in shadow. There were no offscreen virtual lights or ray-tracing calculations to worry about. The defocusing of images also occurred during the render process, as shader expert Johnny Gibson explains. 'A virtual camera can be programmed with a focal plane, just like a real lens. In other words, if objects are too far forward or too far back from that plane, they'll defocus. At render time, you can instruct pixels to get "noisier" the further away they are from the plane of focus. They become clusters of pixels that land increasingly randomly around where the single pixel was supposed to be. The overall image then appears less sharp.'

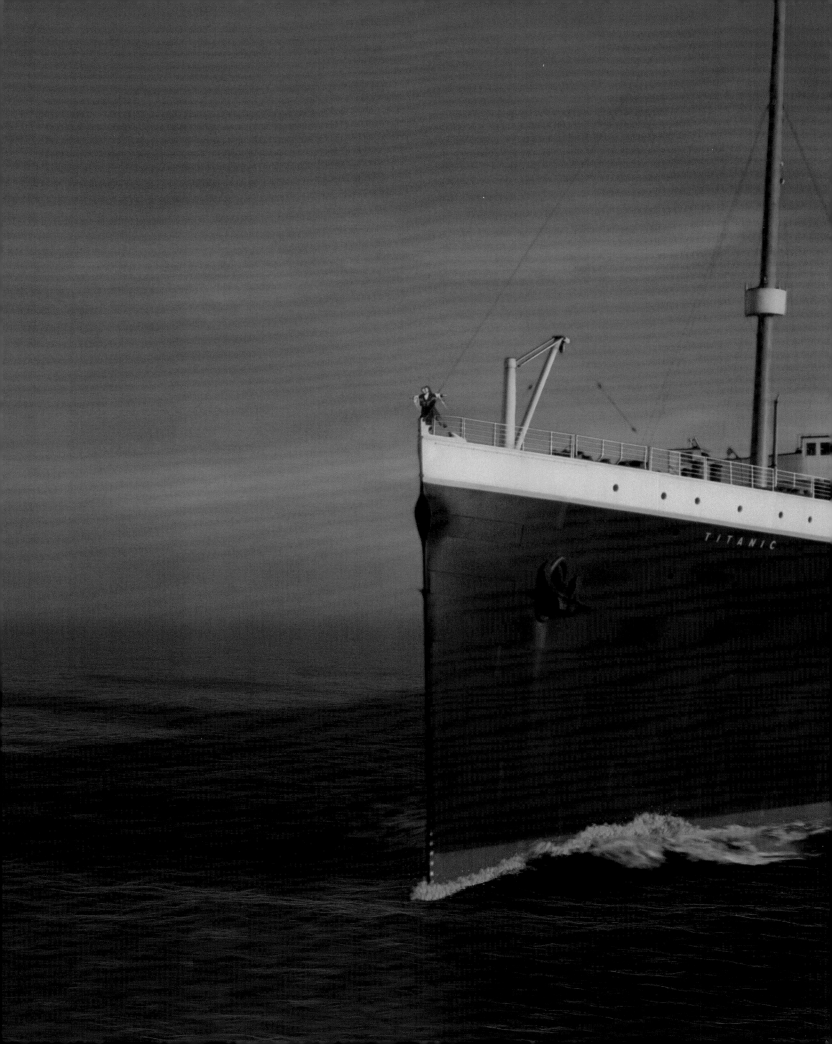

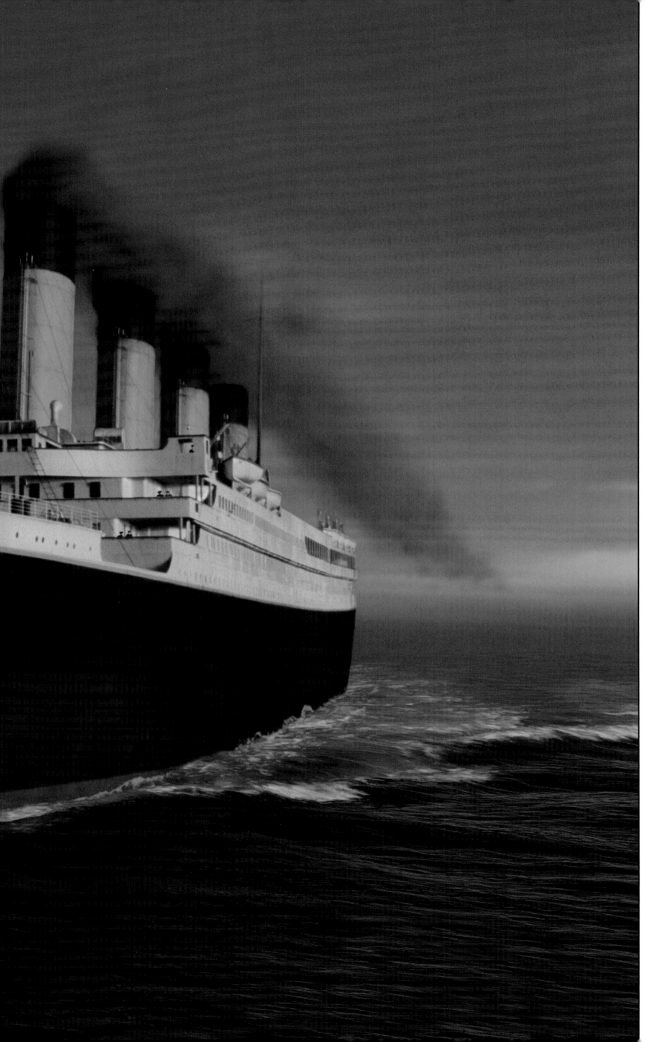

THE GREAT CG OCEAN
Water is one of the most 'computationally expensive' natural phenomena to model. Waves are not as consistent as they might seem. Variations in temperature, plus wind eddies and conflicting currents make real ocean surfaces unimaginably complex.

The underlying geometry of a CG ocean is a 'height field' consisting of many points on a flat plain. Complex displacement routines then sweep across that field, moving points up and down. Rendering the resulting wavy surface is a huge task, especially given the texture and reflection mapping requirements.

White water – the many places where waves break into foam and droplets – is so mathematically intensive that, until recently, it was seldom attempted in CG. In this shot, the ocean as a whole is CG but the *Titanic*'s wake, and the places where her bow cuts through the waves, are live photographic elements composited on top of the CG water. (A ship with a similar bow shape and size was photographed from many angles to obtain the white-water elements.)

THE UNBIASED EYE

Meshes, NURBs, shaders, procedures, instancing, pixel noise: ultimately, the judgement of a CG image's success or failure owes less to any of these technicalities than it does to common sense. Sometimes it's a good idea for someone 'outside the loop', as it were, to look at a CG image and see if it feels right intuitively, rather than merely from a technical perspective. As often as not, compositing artists who eventually assemble many different elements, live and CG, into the same frame will have an opinion on what looks good and what doesn't.

For instance, on science-fiction subjects, effects supervisor Mark Forker, who came to the company from a compositing background, sometimes has to warn his contributing CG artists that they're aiming for the wrong kind of perfection, and the overall scene when composited just doesn't feel right. 'Every-body knows that if you're making CGs of everyday objects like houses, you have to "dirty" them down. The problem comes when building futuristic environments, and everything comes out brand-new, as if designed by a single person. The people of the future aren't going to build their world in a day, no matter how high-tech they may be. There'll be a passage of time that you have to represent. There might be week-old spare parts on a five-year-old spaceship touching down on a ten-year-old landing pad. This is probably the most common error that computer artists make. The great thing about Digital Domain is that you have people from so many different creative backgrounds, and there's always someone available to put real-world truth into virtual CG constructs.'

DIGITAL ANIMATION

Animation is one of the oldest techniques in cinema. For every second that a cartoon character cavorts on screen, the movement is broken down into 24 separate moments, frozen on flat acetate art sheets. Then the sheets are bundled up and photographed by a movie camera that shoots only one frame at a time.

Cheap television cartoons often appear jerky because the budgets won't stretch to a separate hand-crafted cel every 1/24th of a second, and the backgrounds are often simple cutouts moved across the field of view, rather than properly drawn elements with perspectives that shift as the scene progresses. As a rule, the higher the quality of the cartoon (say, a major feature from Disney), the more separate cels per second of footage have to be drawn.

Background artists and colourists are incredibly skilled, yet it's the character animator who is to some extent the star of the show. To understand what a rabbit hopping across the screen should look like when broken down into 1/24th-second slices, the animator needs to understand everything about rabbits and animal movements in general. Good animators watch the living world around them and come to recognize the difference between a horse's trot and its canter, or the way a dog's backside swings when he's wagging his tail, or how a cat hunkers down close to the ground before pouncing on its prey. And no one watches the movements of human beings more closely than an animator: the way we shake hands; the way our feet fidget as we get into position for a golf swing; how we laugh, smile and register subtle emotion by flexing hundreds of individual muscles in our faces.

In CG animation, the overwhelming advantage is that modern software can create fully rounded three-dimensional models, rather than the flat artworks of traditional cartoons. Faces can be made to smile or grimace by adjusting control vertices at the corners of the mouth and around the eyes. The nose can be crinkled and the ears can be wiggled. And the intensity of the various expressions will depend on the weighting attached to the clusters of points that are concentrated around the main control vertices.

Alias Wavefront's Maya software combines NURB and subdivision modelling and animation tools with friendly mouse-driven controls. For the first time, animators with traditional hand-drawn artwork skills can use computer techniques without having to learn every last detail of the software's innards. A wide range of basic shapes, or **primitives**, is available as a starting point. A mouse body, for instance, can quickly be cobbled together from a big sphere for the belly, a smaller one for the head, couple of shallow discs for the ears, four thin cylinders for the arms and legs, and so on.

THE 'PRIMITIVE' MOUSE

A mouse is modelled in simple subdivision geometry. On command, the subdivisions are smoothed out to produce a more refined model. This simplistic level of detail is best for initial animation purposes.

Any reasonably talented artist could build a crude cartoon animal in the computer after a couple of days' tuition.

To save an animator having to define surface-control vertices point by point, they can be manipulated *en masse* with something similar to a texture map. A grey scale can determine areas where vertices need to be heavily weighted in order to produce substantial deformations, and other, lighter areas where the vertices need have only subtle effects. It is possible to 'paint' weighting areas onto an emerging model. Suppose the jaw of a human head is instructed to move. The animator need focus only on getting the overall motion correct, while the painted-on weighting map will help deform the surrounding skin in the appropriate way.

However, it's not enough merely to define the outward appearance of an animated CG character, or the way in which the skin should flex. Like real creatures, a CG entity usually needs an internal skeleton to define what it can do and, just as importantly, what it *can't* do. Human knee and shoulder joints should bend one way but not the other. A head should be able to turn so far to the left or right, but not swivel 360 degrees around. Necks can crane and stretch an inch or two, but no further than the links between individual vertebrae will allow. Comedy characters may be afforded an outrageous flexibility of movement, but any simulation of real life requires a CG skeleton to behave just like a human or animal one.

A CG character can be constructed with a **hierarchy**, so that movements of the surface skin (an array of 'child' components) are driven by changes of position of the interior bones (the 'parent' components). When an animator drags the foot of a character forward, as though making a step, the hierarchical information flows through the entire model, making sure that the leg bones move properly, that the hip is displaced the right way, that the spine changes position, and the head and arms adopt the pose of a character balancing naturally in its stride. This approach, known as **inverse kinematics**, saves an animator a huge amount of effort tweaking every last fraction of the character to get a movement looking right.

But just as some talented proceduralists think that it's better to 'write' a CG object rather than draw it, so some animators prefer a more challenging mode: going into every ball and socket joint of the skeleton, tweaking the joints one at a time, and deriving the external movement of the character from the inside out, with no automated shortcuts. That's **forward kinematics**, a technique that can be as hard and slow as the famous stop-motion animations of Ray Harryhausen prior to the computer era. The benefits are that the most subtle movements can be minutely controlled. Just as a NURB patch is a handy shortcut to achieving complex curves while creating a model, but can sometimes be frustrating when working on fine details, so inverse kinematics sometimes locks animators into preprogrammed, robotic modes of movement that they may not want.

Quite apart from these small individual motions, the overall action of a character across time needs to be determined. **Keyframing** harks back to a time when traditional cartoon animators drew the first frame in a sequence in perfect detail (say, a car at the beginning of a roadway), then the last frame (the car at the other end of the road), and maybe

AN INTERNAL ARMATURE
A simple interior skeleton allows an animated model to maintain an appropriate shape at all times. By setting limits on the degrees of joint rotation, for instance, or the amount of 'stretch' allowable between one bone and another, animators can ensure that their models are unable to contort themselves in completely unrealistic ways. Alternatively, by throwing away these rules, wildly comic movements can be achieved.

INSTANT CG CHARACTERS

CG animators usually have to create their characters from scratch. To save time in creating hundreds of animated extras for *The Grinch*, Digital Domain created a plug-in to use with Maya animation software, nicknamed the 'Who Construction Kit'.

Procedural routines affect certain aspects of a template Who. Many different values throughout its geometry need to be altered simultaneously in order to change the character's overall shape. However, a simple graphic interface with 'sliders' instantly applies the changes. Each slider controls an easily understood superficial concept: height, fatness, age, nose length, mouth mood, and so forth.

Animators can 'dial up' a new Who character without having to access the underlying procedural codes. An extensive library of texture maps provides the clothing, whose contours automatically conform to the character, no matter how fat or slim their build.

The hard work was in creating the initial template, with all its variabilities. Advanced versions of this technique may soon apply to the creation of most CG characters, perhaps becoming a standard feature of animation software. Kevin Mack is already working on a system that can just as easily deliver a CG man or a mouse from the same template.

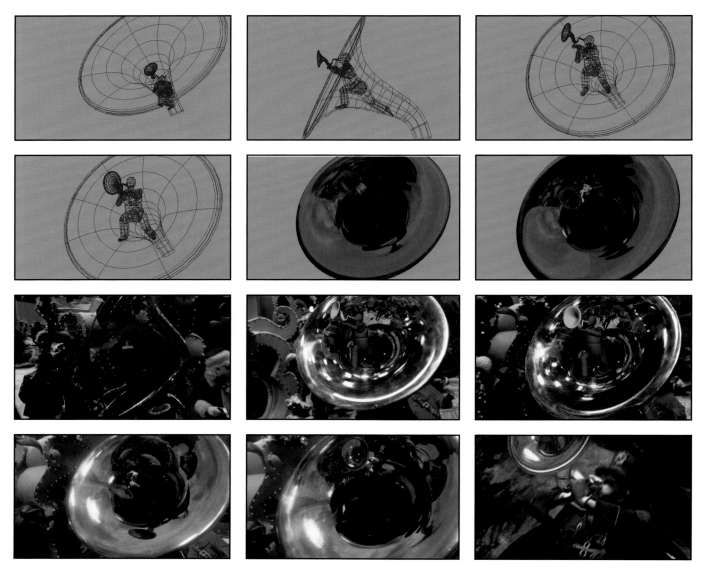

another frame somewhere in the middle of the sequence, to build an overall sense of where they were going, and in how many frames (i.e. for how long in movie time) before they committed themselves to the many dozens of other frames in between. Digital artists often keyframe by hand, while allowing the computer to create the intermediate positions. Inverse kinematics will move a CG character from one pose to the other in the assigned number of frames. Keyframing is not an easy cheat. It takes years of experience for an animator to understand which ones to select in the first place. Forward kinematics are much more demanding to keyframe because the start and end positions of each joint in the skeleton may need to be set by hand.

A very small CG Who musician pops out of a CG trumpet bell. Notice the complex reflections of the CG character appearing on the surface of the larger trumpet (and a completely different set of reflections in the smaller instrument).

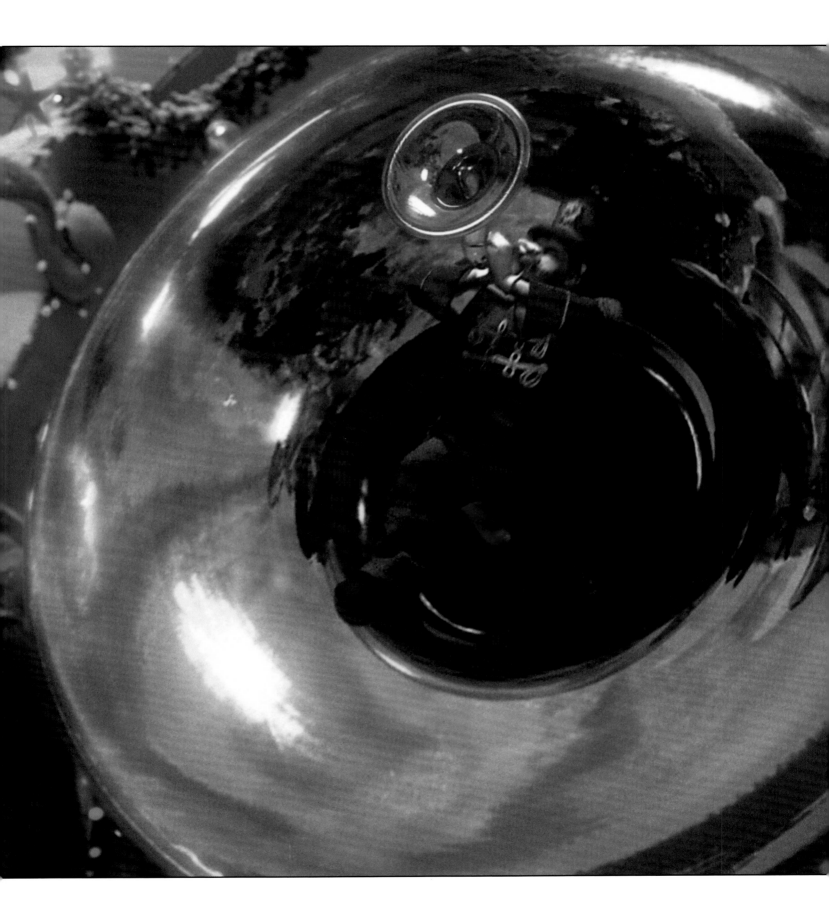

1 The final render of the Who trumpet-player.

1

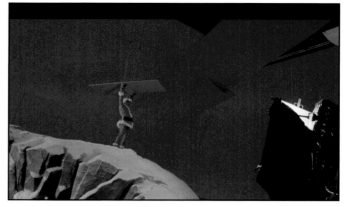
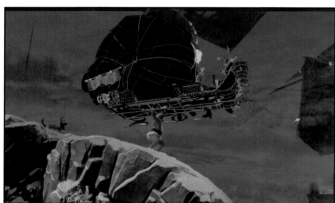
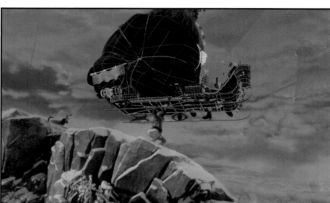
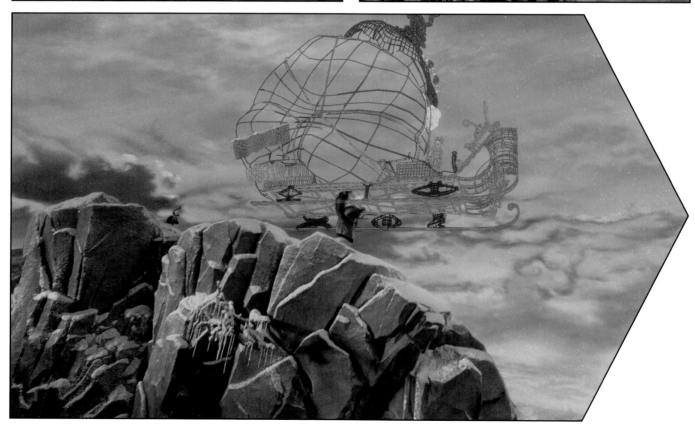

A CRAZY CHRISTMAS RIDE

At one point in this sequence the Grinch holds the entire sleigh above his head. Shots of Jim Carrey in the studio, holding a lightweight plank in the air, were composited with a CG sleigh and a complete wintery background.

The wireframe geometry defining the huge red sack incorporated routines to simulate the apparent shifting of different-sized presents inside, as if responding to the sleigh's lurching movements.

The correct physical dynamics were delivered semi-automatically (and slightly exaggerated for comic effect). Conventional animation would have required hand adjustments of every single crease in the sack.

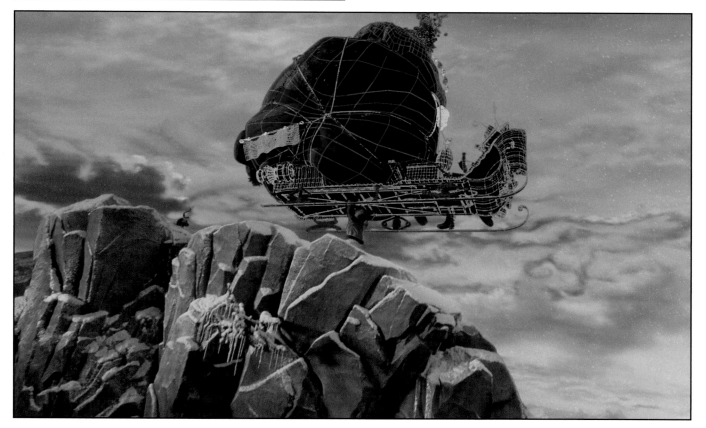

OBSERVING NATURE

There are some aspects of character animation that are too subtle or complicated to be achieved by shortcuts. The ill-fitting skin of a rhinoceros, folded into deep, heavy creases that sway like pendulums as the creature walks, is a case in point. Texture mapping and rendering the skin is difficult enough, but even the underlying mesh must contain shapes that are not easy for an animator to predict, or to build out of primitives. The alternative, laser-scanning a good clay model of a rhino, is not a complete solution, because a CG model built for animation still needs to include the weighting and dynamic data for *moving* various parts of the model relative to the others. Every step a CG rhino takes means, effectively, a change in the entire model. A further complication is that the swaying of a real rhino's skin is only partially constrained by movements of the skeleton, because, in nature, the connection between bone and skin is so loose.

In 1996, Digital Domain needed to build not just one rhino but an entire thundering herd for a Mercedes advertising campaign. The premise was that the Mercedes car in question was tough enough to withstand the rigours of busy down-town traffic; the rhinos, stomping through the city streets and bashing into cars as they went, were intended as a metaphor for the rough driving conditions. Animation supervisor Randall Rosa recalls, 'For maximum control, we'd build the legs and the torso as separate components and put them together, but when you animated the movements overall, the creases between them tore apart.'

For a while, putting character into the rhinos took second place to the problem of simply keeping them in one piece every time they took a step. 'Then we came up with a quick and dirty fix of not even bothering to fix the tears at all. We just hid them behind other convenient creases. We learned that it was important to separate out these technical problems so that animators who were trying to concentrate on character and narrative didn't have to stop every few frames to fix tedious technical glitches.'

In those long-ago days of the mid-1990s, rhinos were a substantial challenge for animation software, and each animal took up a lot of memory. 'It was hard to visualize scenes with a dozen rhinos because the computers would only let us manipulate two or three at a time before it would start bogging down,' says Rosa. 'Even playing a hundred frames of the rhinos in raw mesh was painful, because the meshes alone were so complicated that you had to burn up render time before you could see what was happening. There's a scene looking at the horizon from a balcony, and there are maybe a hundred rhinos. We had to handle and render them in small groups. There had to be a natural-looking rhythm and flow to the entire herd, and it was tough working on just small groups at a time.'

Today, specialist computer houses maintain libraries of animals and plants, created with the most efficient tried-and-tested wireframe meshes, thus saving animators the time and trouble of building complicated flora and fauna from scratch. But that's all the specialist suppliers can do – supply the right kit of parts. Giving a CG animal some semblance of life requires extensive animation experience that the technical experts can only support, not replace.

SYNTHETIC MISTREATMENT
In the Coen brothers' film *O Brother, Where Art Thou?* a car knocks down a CG cow discreetly inserted among a group of real animals. Along with expert character animation, artificial motion blur and film grain have achieved a perfect photo-realistic blend between the digital animal and its live counterparts. The American Humane Society lodged a formal complaint, and needed to see a breakdown of the shot before they could be convinced that no animals had been harmed during the shoot. The Society was impressed, and at the same time slightly puzzled about what to do. They opted to add a new phrase to their familiar disclaimer at the end of a film involving living creatures: 'No animals were harmed ... some scenes are simulated.' Domain's animators took the Society's intervention as a backhanded compliment.

Digital Domain chief Scott Ross says, 'It would be wrong if only computer geniuses could make CG animations. So many of the skills we need come from the non-computer world. We have people who are fascinated by the way animals move, or artists who are spectacularly good at human anatomy, and they're not too much up to speed on technology. We have folk who know everything there is to know about landscape painting, but they don't know how to write software for computers. There are any number of brilliant old-fashioned cartoon animators out there that we can learn from. Well, fine. Let's get them a tool that enables them to cross the divide between art and computers so that they can work with us and not feel strangled by the machinery.'

Having come from a traditional film background prior to joining Digital Domain, Rosa certainly works by this philosophy. 'To computer experts, I'm a cross between an acting coach and a choreographer. I might say, "Your movement arc isn't right there, or you've got to do a little more anticipation here," and if they've come from an engineering or science background, they'll look at me blankly. The grammar of film

and animation is a different language, and my job is to translate it. That's one difference between being an animator and *supervising* the animation.'

He cites as an example a rhino gesture so insignificant that audiences of the Mercedes ads might easily have missed it, diverted instead by the spectacle of the stampede as a whole. 'Coming from a traditional background, you learn to go the the zoo and spend hours breaking down your character just like an actor prepares for the part he's playing. There's a point where you actually sit down and think, "Well, why's this rhino behaving this way? What's he thinking?" A lot of the time he's thinking, "There's an insect bugging me", or, "I have an itch". So he'll flick his ear, and when an audience sees that, it helps sell the shot. But you have to stare at rhinos for a long time before you know how these small, barely noticeable actions bring them to life. When I say they're barely noticeable, an audience would sense instinctively that something wasn't right if those actions weren't included in the CG. So it's definitely up to us as animators to notice them.'

PREVIOUS PAGES
2 Keen observation of real rhinos enabled DD artists to give their CG rhinos that extra something in realism.

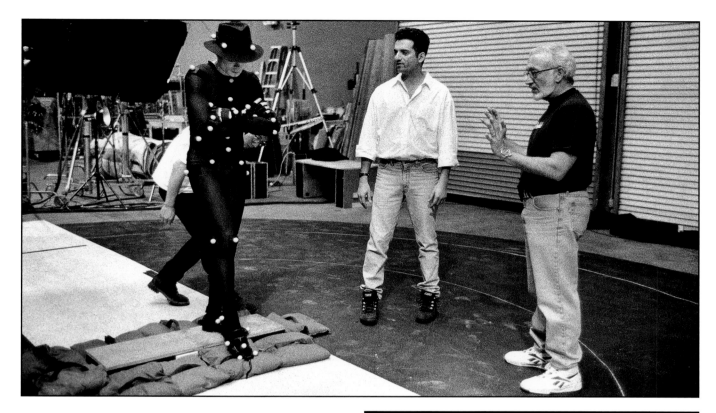

CAPTURING THE ESSENCE

Despite the increasing levels of trust between old-school and new-school animators, some traditionalists remain disturbed by a fast-growing trend. **Performance capture** is a process that attempts, often with incredible success, to semi-automate the naturalistic animation of CG characters by using real animal and human performances as a template.

In principle, optical performance capture is straightforward. An actor with an appropriate size and build performs the required physical actions. Attached to her feet, shins, knees, hips, elbows, shoulders, wrists, hands and head are little white markers that fluoresce under ultraviolet light. Special electronic cameras are attuned to record only in that frequency of the spectrum, totally ignoring conventional visible lighting. Each camera transmits an ultraviolet beam, then shoots images of the reflected white markers. The result is a digital record of the markers' every move against a black background, with no extraneous detail.

Then a CG mesh is created, similar in proportion to the original performer. A basic wireframe skeleton is contained within the mesh. The markers on the actor now correspond to a precisely similar set of points in the CG construct, incorporated at appropriate points in the skeleton. The motion-capture data then drives the CG markers to move in lockstep with their real-life counterparts. The CG character automatically follows the actor's original movements.

The snag with visually cued motion capture is that the cameras can't see through the performer. For any given frame, there will be some doubt about the exact position of markers obscured by the performer's own body. Animators can intuit where the unseen markers *probably* are, but computers don't

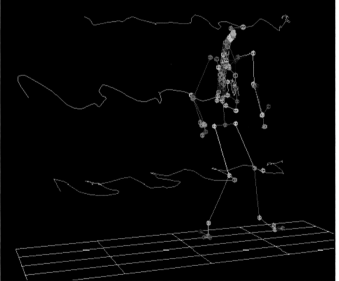

3 Michael Jackson prepares to dance for his 'Ghosts' video.

4 The approximate wireframe figure is activated by Jackson's original dance moves.

5 An animation screen shows Jackson as a simple wireframe. Notice the orthogonal displays that allow the virtual camera's point of view to be selected.

6

6 A fully rendered skeleton mimics Jackson's dancing style.

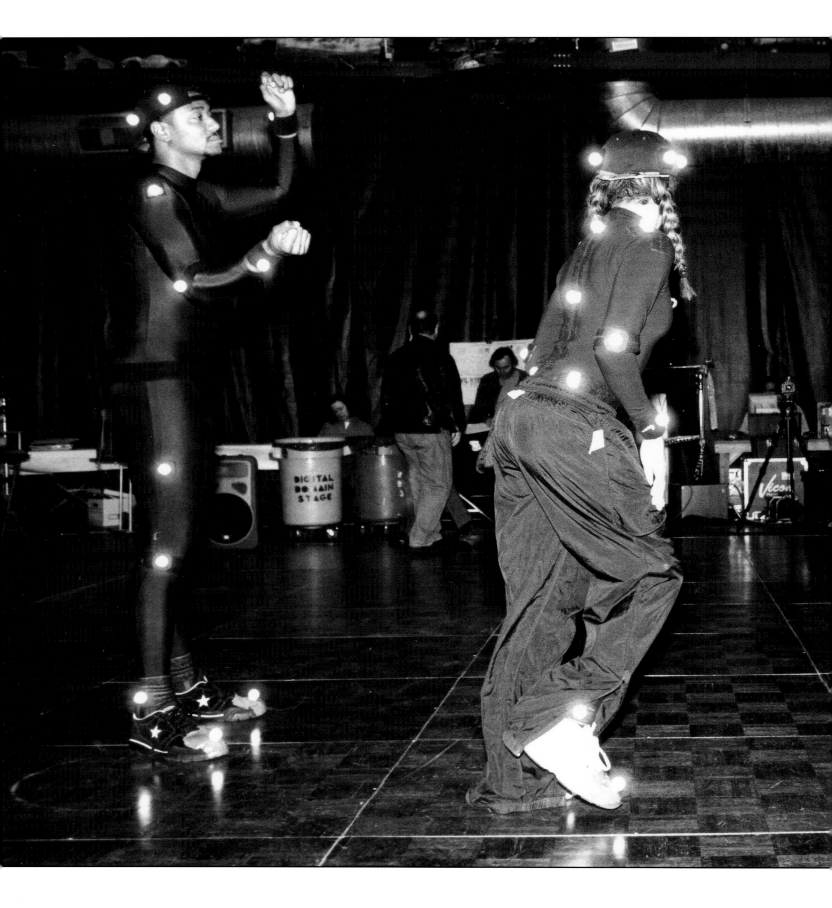

7 Jazz dancers are performance-captured for the Coca-Cola *Jitterbug* commercial.

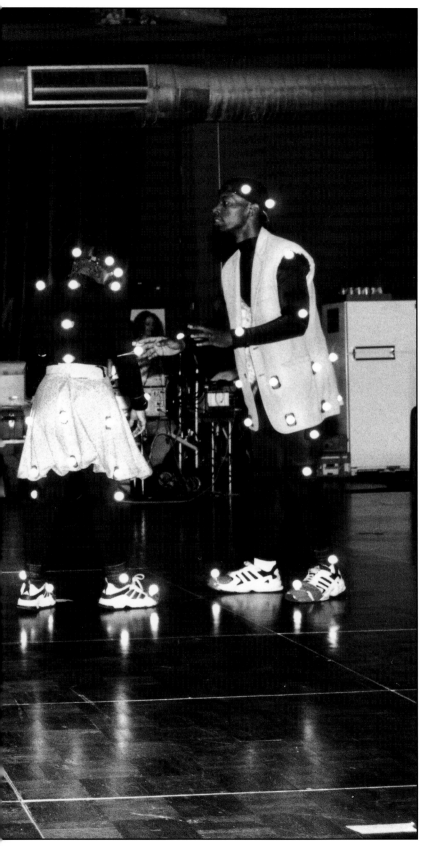

like ambiguity, and the missing markers won't trigger their equivalents in the CG model. Animators usually have to keyframe a lot of data points before a performance-captured character can complete its simulation of the original movements. Shooting with multiple cameras helps to obtain the most complete set of data.

There is an alternative. Instead of recording the markers optically, it's more accurate to 'sense' them instead. Changes in magnetic fields allow a performer to be tracked even in the dark, with almost perfect reliability. The downside is that she has to wear a cumbersome electrical harness, and has to confine her movements strictly to within the bounds defined by a clunky magnetic sensor array in the studio. It's not the best way to record freestyle jazz dancers, that's for sure.

Quite apart from the pros and cons of the various motion-capture techniques, a more wide-ranging argument has rippled through the movie industry in recent times. Who is ultimately responsible for the wit and humour of a CG character's performance: the digital animator or the human performer? Ever since 1915, when Max Fleischer invented the rotoscope, traditional animators have felt threatened by any hint of automation. Although the rotoscope proved valuable for creating hand-drawn travelling mattes, one of its original purposes was to trace over the outlines of human and animal performances from live-action film frames so that they could be translated into cartoon characters. This was supposed to make animators' lives a little easier, but it also imposed questions of creative ownership. Money also came into the equation. Some of the less philanthropically minded studio bosses saw a way of leveraging yet more frames per day out of their already poorly paid animators.

At Digital Domain, these vexed questions hardly arise. It doesn't make sense for digital animators to feel threatened by their own computers; and as for the artistic credit, this is more a partnership between animators and performers than a rivalry. Anyway, the division between animation and performance capture becomes still more blurred when the capture data is used merely for reference, rather than to steer a CG character's every last movement through every last frame, as animator Andy MacDonald explains: 'We tend not to use performance capture to drive our CG models directly. Instead, we'll often digitally rotoscope the capture data on top of our CG character at useful intervals, and then animate the intermediate frames ourselves.'

When performers as renowned as Michael Jackson offer themselves to be rendered as detailed animations, no one quibbles about the balance between keyframing and performance capture. For his music video 'Ghosts', Jackson performed one of his distinctive high-energy dance routines. Data from the capture reflectors all around his body was transferred to equivalent markers on a fully detailed CG skeleton similar in size and proportion to Jackson's. When the skeleton repeated Jackson's dance, there was no doubting the star performer's trademark signature in the steps, even though most of his moves were keyframed onto the skeleton, rather than slavishly imitated frame by frame. Animators may have been doing much of the work, but their aim was to deliver a purely Jackson dance routine.

WORKING THE CROWD

Performance-capture expert André Bustanoby once worked with a cast of 800. Actually, he captured performances from about a dozen Digital Domain staff members, plus their partners and children, to 'people' the deck of the *Titanic*. A specialist company nearby, House of Moves, facilitated the captures under Bustanoby's direction. The capture computers, linked to video cameras, could track at least 120 markers at a time. By placing 50 or 60 markers on each performer, the interactions of two or three people could be captured all of a piece, which was perfect for creating little action vignettes. 'When you're watching folk move, ideas come to mind, and it's no longer just an effect you're getting,' says Bustanoby. 'You can achieve a truly lifelike shot. We had characters on deck shaking hands, someone pointing, two guys in steerage fist-fighting, a man tipping his hat, a woman adjusting her shawl, a father and son playing kickball.' When a real mother picked up her equally real young child, the mother's body instinctively relaxed when the youngster was safe in her arms, and the performance-capture system picked up on a subtle nuance that even the most experienced traditional animator might have found hard to create from scratch.

With a more predictable kind of subtlety in mind, *Titanic* visual-effects supervisor Rob Legato asked that the performance-capture artists should wear costumes appropriate for 1912, because 'I wanted to encumber their movements as much as I could. Men in formal Edwardian suits and ties and women in stiff corsets and full-length skirts don't move anything like as freely as modern folk in casual T-shirts and jeans.' Bustanoby was more than happy when markers attached to the costumes, on the fringes of dresses and jackets, swayed naturally in step with the heavy materials. 'We got the physics of the fabric movements for free, without having to do too much secondary clothes animation by hand.'

Individually, or in groups of two or three, the volunteers were captured performing a wide variety of actions, and a vast library of capture data was stored away. 'From any one of these vignettes, the animators could create variations, flipping the characters, altering their speed, changing their costumes and so forth. From a dozen archetypes, we peopled the deck with 800 distinct passengers and crew.'

After a while, Bustanoby noticed something eerie. 'You'd look, weeks later, at these little digital people, and you'd suddenly recognize a work colleague's distinctive way of walking. And then you see these little versions of your friends plunging to their deaths over the sides of the ship. It makes you forget, for a moment, about the nit-picking technical details of shadow, clothes rendering and composition and so forth, and you think instead about the humanity that you've captured.'

There are some actions that even the most dedicated performance-capture volunteers couldn't be expected to make: for instance, hurling themselves over a 400-foot drop as the *Titanic*'s stern rises ever higher out of the water after the waterlogged bow has been dragged under the waves. Even if maniacal stunt artists had volunteered to shoot falls from such great heights, their safety postures on landing wouldn't have matched the panic-stricken flailing and body language of ordinary people dropping from the rails of a doomed ship. Even dropping from lesser heights proved hazardous. An embargo

8 Digital passengers occupy the decks of the *Titanic*.

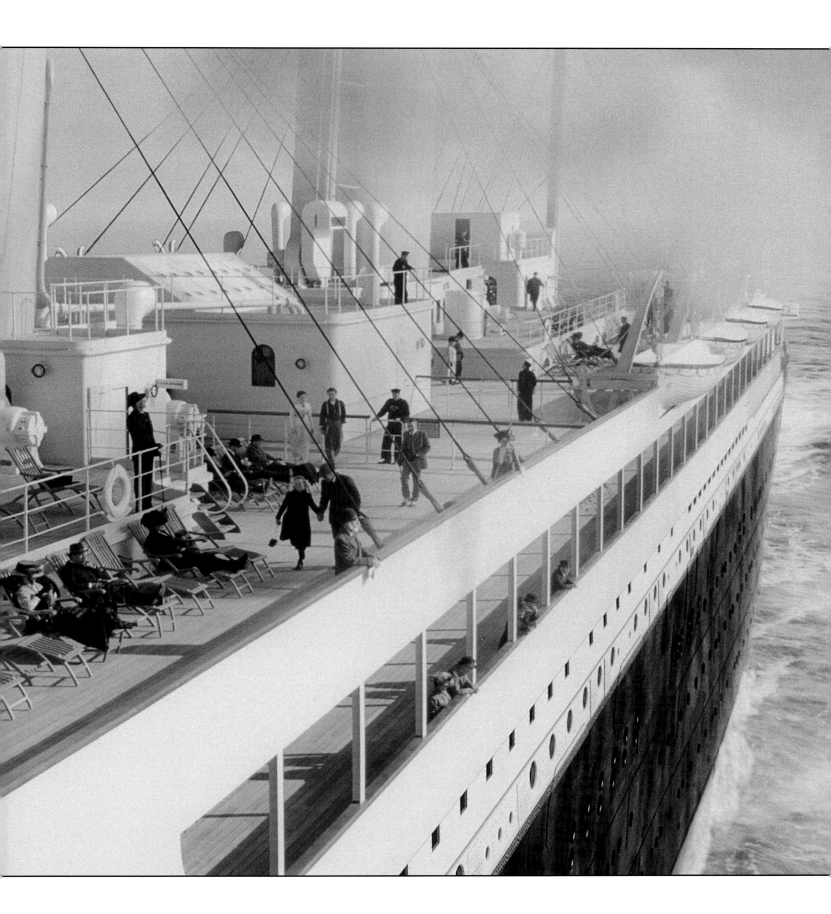

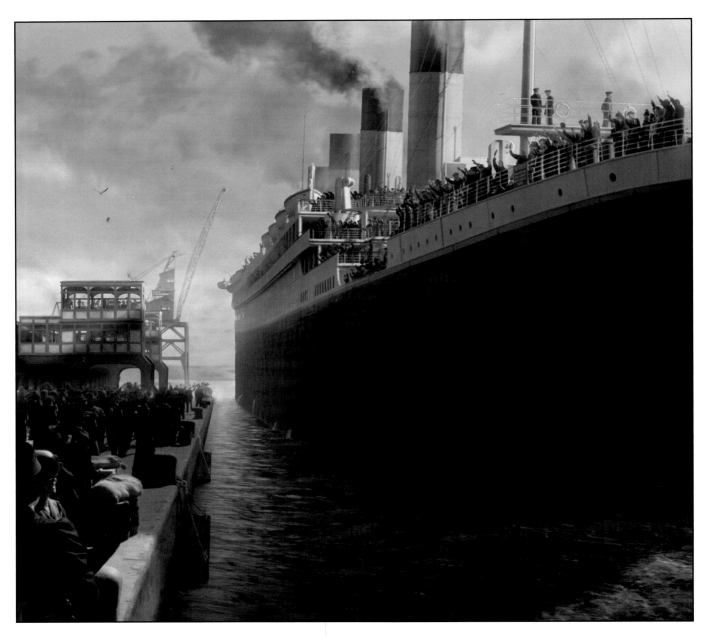

was placed on stunt falls from above a certain minimum safe height, and keyframe animation was brought into play.

Stunt artists dropped over a ledge, but not at such a great height that they might injure themselves when they landed on the safety mats. These were the opening keyframes. In a different set-up, they were filmed falling into a padded mat after being dropped in a more horizontal posture, with enough safety margin in the padding so that they could imitate haphazard landings without worrying about injury. These were the closing keyframes. Animators then digitally rotoscoped these extremes of action and simulated the inter-mediate CG motions of the capture points in order to link and blend the opening and closing keyframes.

From Bustanoby's point of view, it wasn't always an easy blend. 'It's very difficult for animators to have to deal with maybe 120 performance-capture markers on an individual and push those markers to get a good action. The whole point of performance capture is pretty well lost if animators have to do the bulk of the work themselves. We developed a hybrid system that combined performance capture with keyframe animation, but all the same, some very talented animators created a wonderful variety of character-in-distress moves using keyframe alone.'

Rob Legato was amazed by the library of CG passengers and ship's crew assembled by Bustanoby's team. 'We found we could put them together in combinations that we'd never dreamed of. We could add all kinds of falling people to a scene that Jim Cameron had already shot with live actors. This was almost a new kind of film-making.'

9 This long shot of the *Titanic*'s stern, populated by miniature CG characters, appears entirely realistic. Today, CG people can be viewed in tight close-up with no loss of believability.

10– In *Tightrope*, the skin textures for both characters were derived in part from real human faces.
13 Skin areas were selectively photographed and manipulated, then flattened as texture maps and wrapped onto the CG heads.

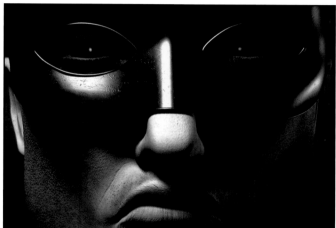

PURE ANIMATION

One showcase project at Digital Domain proved what the company's animators could do without any help from human actors. *Tightrope* was the result of an in-house competition, kicked off by Scott Ross, who pledged to fund and produce the best idea. The brief was for a short film, four minutes in duration, in which two interesting characters would play off against each other in a beautiful yet abstract landscape that wouldn't divert too much attention away from the characters. The film had to be amusing or striking in its own right, while simultaneously showing off the best and most realistic character animation the company's artists could possibly deliver. Within a tight budget, the winning team had to promise total completion of the film inside a year. Using performance capture of human actors as a shortcut in any of the animation was absolutely not an option.

Daniel Robichaud, animation supervisor from *The Fifth Element*, came up with the eerie scenario of a rope hanging in a seemingly endless sky, with no ground in sight even when looking down. Two characters walking along the rope meet face to face and the problem arises: how do they get past each other? One character is a mischievously attractive jester of uncertain sex, wearing a flamboyant outfit, while the other is a sinister masked man in a dark suit. He has a long tightrope walker's pole for balance, but the Jester gets by

on charm and magic. The two characters meet head to head. Who will surrender the right of way? Trying to force the issue, the masked man pulls a gun. The Jester responds by deploying a magic yo-yo and a pair of scissors. The literal-minded Suit character can't defend himself against the bizarre anti-logic of the Jester's magic tricks. He quickly loses his grip on the situation, along with his balance on the rope.

The characters are hyper-realistic, but they weren't designed to look completely human. As Scott Ross wearily admits, 'We went through a phase with *Apollo 13* and other projects where it wasn't obvious to audiences that we'd done such marvellous work. Even some veteran lunar astronauts, who maybe should have known better, congratulated us on having cleaned up NASA archive shots so beautifully, which, of course, is not at all how we did that movie. The effects were absolutely real-looking, and that's what you want, obviously, but you'd like the professionals in the business occasionally to be able to acknowledge what you've done, and especially at Oscar time! With *Tightrope*, we put in a few clues that these characters were animations and not actors, because we really wanted to showcase what we could do with pure CG character animation.'

The 'clues' were in the facial textures – almost human but not quite; and in the proportions of the characters' bodies – again,

FOLLOWING PAGES
14 An eerie pair of contrasting characters come face to face on the highwire in *Tightrope*.

DIGITAL DOMAIN **DIGITAL ANIMATION** 131

14

almost human but not quite. Robichaud says: '*Tightrope* has a stylized realism. There's a lot of attention to detail, but it's an invented reality rather than an exact copy of the one we know so well.'

Despite the fantasy element, Robichaud knew that the characters' physical behaviour had to look realistic, because audiences would compare their movements subliminally with those of real humans. 'We had a team of 15 animators overall, but I wanted to give specific control of the characters to the two people who I thought would best bring them to life. For "The Jester" I chose Stephane Couture, a very joyous, outgoing guy. For "The Suit", I chose Bernd Angerer, a more reserved guy.'

Couture and Angerer created their characters in Softimage 3D, with a fascinating plug-in, an addition to the off-the-shelf software written by Couture, which enabled facial features to be controlled with mouse-driven sliders and knobs. 'It's like a set of dashboard controls on the screen,' he explains. 'Each control vector pulls along a cluster of other points, each one weighted with a different percentage of reactivity. When you slide the main control vector, a graduated deformation ripples through the others. You push up the corner of a mouth, and the surrounding skin and lips react in proportion.' (Couture and Angerer sometimes videotaped themselves acting out scenes

so that they could study their own facial expressions.) The movement of clothing was animated in a similar way, after Angerer developed a variation of the facial sliders that allowed keyframing of the clothing movements. Robichaud says, 'It was faster doing it that way than developing physically or dynamically correct calculations, which would have involved much more complex programming.'

The level of detail in the characters was such that it was impossible to animate anything like fully rendered versions. Low-resolution 'proxys' could be manipulated so that the animators could see what they were doing, but when it came to rendering, each frame took up to four hours to process.

The dream-like mood is enhanced with complex virtual-lighting effects in the skyscape (another heavy drain on render time), and an artificially grainy texture applied to completed frames. Couture says, 'After we'd spent all that time getting the most perfect results we could, Daniel spent a lot of time adding artificial grain, so that everything looked like it was shot on film rather than built in a computer.'

15– In a dazzlingly realized scene, the Jester snips the string of the magic yo-yo. All the lighting
20 was ray-traced, with the inclusion of complex atmospheric haze effects. Notice, also, how the virtual camera delivers a close-up shot of the Jester's face, and then what appears to be an extreme wide-angle view of the yo-yo. No real lenses are involved.

REAL ANATOMY

Kevin Mack sees the day fast approaching when CG characters can be directed rather than animated. 'The ideal is, you tell them, "Walk", "Bend over", or "Pick up that object". Better still, you say, "Now walk with more anger, more flamboyance." When you can direct these guys, you won't need keyframing or performance capture. The only problem will be when the CG characters get too smart and say they just don't want to do it any more.'

In 1994, soon after joining Digital Domain, Mack and collaborator Caleb Howard initiated the Human Animation Research and Development project, otherwise known as HARD. Mack chose this appropriate acronym deliberately, after all his colleagues told him that his crazy ambitions were too difficult to achieve. He wanted nothing less than to equip anatomically detailed skeletons with procedurally controlled muscles and tendons, so that characters could produce their own realistic movements internally, from a complex forward-kinematics hierarchy, without an animator's helping hand. Mack's aim was to ally HARD with an artificial-intelligence program, perhaps running on a new-generation 'neural net' parallel computing system.

Howard never pretended this was going to be easy. 'We realized we'd have to gather a huge amount of information about musculature that even the medical profession doesn't have. They dissect dead people to learn about anatomy, but we wanted to understand how people move when they're alive.' Meanwhile, from a purely business point of view, Mack knows that the further development of HARD is difficult to justify to movie-makers merely concerned about the surface appearance of things. 'The visual advantages of doing things the HARD way are subtle. You can keyframe or use performance capture to get an overall impression of a CG character's movements, but then you don't get the sliding and rippling of 18 different muscles under the skin of a forearm, or the flexing of the Achilles tendon at the ankle. It becomes an issue of time and expense.'

No matter how complex they may be, movie effects are just illusions. So far, there has been no real market for putting interior truth into CG animations. As long as they *look* good, they'll do. However, the time is coming when Mack's dreams of genuinely interior-driven animated characters may have a wider application in the world at large.

The first hint of things to come is apparent in a recent commercial project for Motorola, with CG animation supervised by Fred Raimondi. It's a TV campaign for a new virtual communications service, featuring an attractive female representative who's not *quite* human. 'She's a visual representation for a synthetic voice cyber-assistant called "Mya"' Raimondi explains. 'I think that's a sort of play on "My Assistant". You can pick up the phone and say, "Mya, read my e-mail messages to me," or "Mya, dial my office, or dial my agent," and she'll do that for you. It's a virtual assistant that performs tasks from your spoken instructions.'

Mya started life in a series of live-action shots, with model Michelle Holgate standing in for the cyber-assistant, and actress Gabrielle Carteris providing the voice on soundtrack. 'We could have used a human throughout the show, but Motorola wanted Mya to look so nearly human it was uncanny, and at the same time appear very obviously a computer construct. It suited the mood of the commercial. In fact, our first iteration was so close to human in appearance, the clients asked us to make her more obviously artificial.'

Performance capture wasn't the appropriate starting point for this project, because it would have constrained the eventual CG Mya in her movements. Raimondi knew that Motorola's art directors might want to make changes. 'Instead, we used an old-fashioned method, hand-rotoscoping our CG Mya over the real girl where appropriate, and then deleting the girl.'

The CG model drove the cloth on Mya's dress, rather than the animators. 'We hung the dress on her, and we said to the computer, "Figure out what this dress should be doing, based on the movements of the girl." You have to let that bake, because it's a complex calculation of physics. The other problem is that the style and fabric of the dress that the clients chose – well, they couldn't have gone for a more difficult thing. It's multi-layered, transparent, and it really pushes at the calculation time, even for the low-resolution simulations, never mind the final rendering. For 150 frames of low-res walking, it took about six hours to see five or six seconds' worth of movement. The first time the calculation of those movements is made, you can only use one computer because each frame is a dynamic consequence of the last. For rendering, you essentially have all the instructions you need for each frame, based on the completed simulations, so at that point you can farm out different frames to lots of different machines. But rendering something as complex as Mya takes forever, and we crashed the machines several times.'

Because Mya had to be rendered frame by frame, and because rendering cannot at the moment be completed in moment-by-moment real time, she is forever locked into the particular animated sequence delivered to the clients at Motorola. But computers will become faster. Software will become smarter at creating shortcuts in the calculation processes. The HARD techniques will eventually find their true role outside the limited requirements of visual illusion.

Imagine an entity such as Mya coming to life as part of an Internet service. If artificial-intelligence software could be linked to a HARD animation routine in a sufficiently fast computer, it's likely that a cyber-personality could be seen in real time, as well as heard. Her body language would adapt, moment by moment, to the needs and expectations of the user, and to her own ever-changing speech patterns. A 'special effect' would become something much, much more.

21 'Hiya! I'm Mya!' A cyber-personality introduces herself.

22 In this shot, Mya's image is deliberately downgraded and broken into exaggerated scan lines so that she appears as if on a television screen.

Mya in action for the Motorola commercial: almost human, but not quite. The chat-show host is real.

ANIMATING THE INANIMATE

It's not just human or animal characters that need animating. Their surrounding environment may include clouds, rain, snow, dust storms, rocket exhaust, smoke trails and other complex but essentially inanimate phenomena. The 'motivation' for these kinds of movement comes not just from an animator's creative instincts, but rather more from the purest expressions of Newtonian physics.

In *Apollo 13*, there's a scene where the astronauts dump their urine overboard into the vacuum of space through a small valve on the flank of their capsule. A swarm of golden CG droplets was created by Laura Di Biagio. Spurting out of the valve, they needed to fan out into space, becoming more widely spread as they went. (The cloud as a whole also needed to marry up with the motion-control movements of the model capsule.) Even before the droplets were created, their movements were determined by **particle systems**, a procedural

23 Andre Agassi is turned into a realistic digital double for a Nike campaign.

24 NURBs modelling for a *Fifth Element* sequence in which heroine Leeloo is genetically reconstituted from a fragment of forearm.

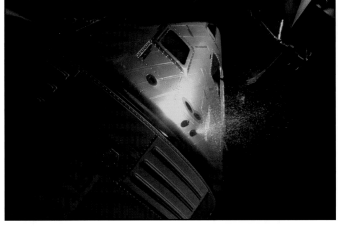

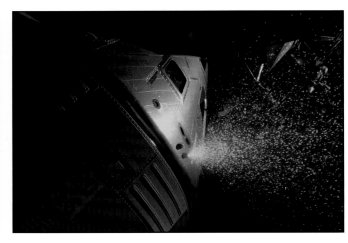

animation technique specifically designed to handle swarms of objects. A cluster of points was instructed to move as a cloud. Rules mimicking the behaviour of droplets in a weightless environment were applied. From now on, each droplet had to go where the mathematics of its particle-system point took it.

Unlike the animation of a character, particle systems doesn't require the artist to keyframe the movements. All that's required is for the start points to be programmed correctly. What's more, according to Karen Goulekas, you don't necessarily need a great many particles to achieve an effect that mimics nature – especially when it comes to smoke and steam. 'If you tried to match the actual number of vapour droplets and soot particles in smoke, you'd go crazy. A lot of people make the mistake of using too many particles. In *True Lies*, a pair of Harrier jets shoot at a truck crossing a bridge, and you see the missile trails whooshing off. We used surprisingly few particles, with a lot of visual "noise" round them. Sometimes you only need a few dozen to make a swirl of smoke.'

Much more complicated CG objects, like cars for instance, can also be manipulated by particle systems. All that's required is that the points should control a wider range of movement – pitch, roll and yaw *around* the point – as well as merely the direction and speed of travel. Goulekas describes the traffic regime for *Fifth Element*: 'We had maybe 80 cityscape shots with CG cars hurtling around, and you couldn't

animate them all by hand because there were just too many of them in each scene. Sean Cunningham was in charge of these sequences, and he attached each car to a particle and he'd say, "What speeds do you want? What percentage of cop cars? What percentage of cabs and private cars?" When the cars turned a corner, the velocity changes were automatic, so the animators didn't have to worry about that. They just planned the moves in a very blocky way, and the mathematics smoothed out the rest.'

Unlike urine droplets, the *Fifth Element* cars needed rules of motion derived not just from natural dynamic forces, but also the behaviour of vehicles in a modern urban society. The particle-systems software was given a 'map' of the city, and instructed to send particles up and down the appropriate streets and avenues and around the correct corners. At intersections, one flow of particles would halt for a while, as if at a set of lights, and allow another set to flow. When the CG cars were mapped onto the particles, the results, on screen, looked tremendously busy, but if anything the underlying instructions were less dynamically complicated than they'd be for a swirl of CG smoke or a stream of water. The layering of different sets of particle-systems traffic, one on top of another, added to the bustle. It helped that the cars were, supposedly, capable of flying through the air, creating traffic many lanes deep as well as wide.

25– The *Apollo 13* command module dumps urine droplets into space. The droplets were generated
28 by particle systems.

29 Hectic aerial traffic in *The Fifth Element* was steered by particle systems.

30 Korben's punctured taxi cab is a model, but the other traffic is CG in this typically energetic scene.

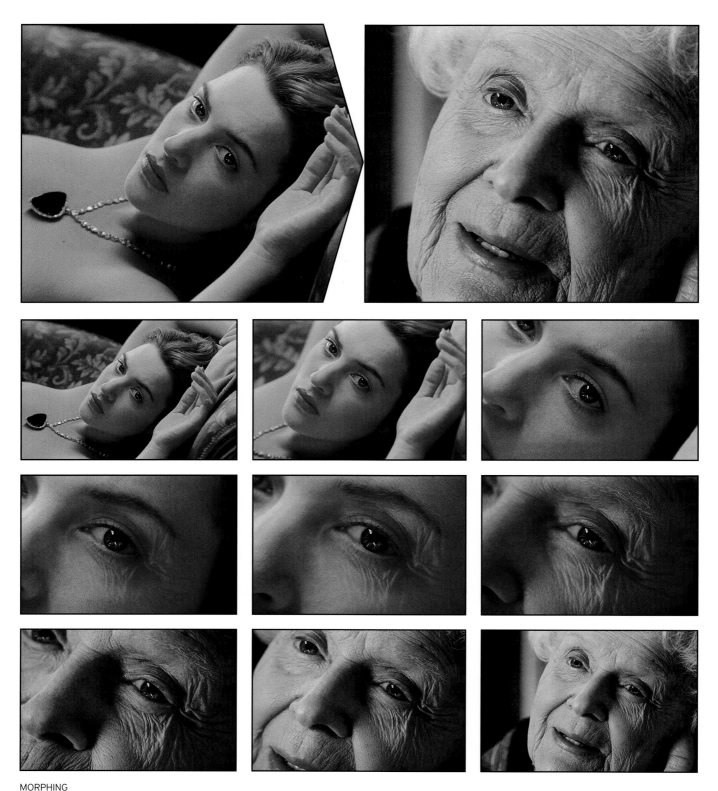

MORPHING

A proud but otherwise seemingly unremarkable grandmother tells the story of how, long ago, she was the young and beautiful lover of a wayward artist aboard the *Titanic*. Lead morph artist Christine Lo 'aged' Kate Winslet so that she appeared to become actress Gloria Stuart, playing the heroine 85 years later in modern times.

Lo used Elastic Reality software. Frames from two separate shoots, with wide variations in lighting and colour, had to be digitally aligned, but the real problem was the eyes. Winslet's were different in colour and shape from Stuart's. The solution was to use Winslet's eyes for both faces, thus making the transformation appear that much smoother.

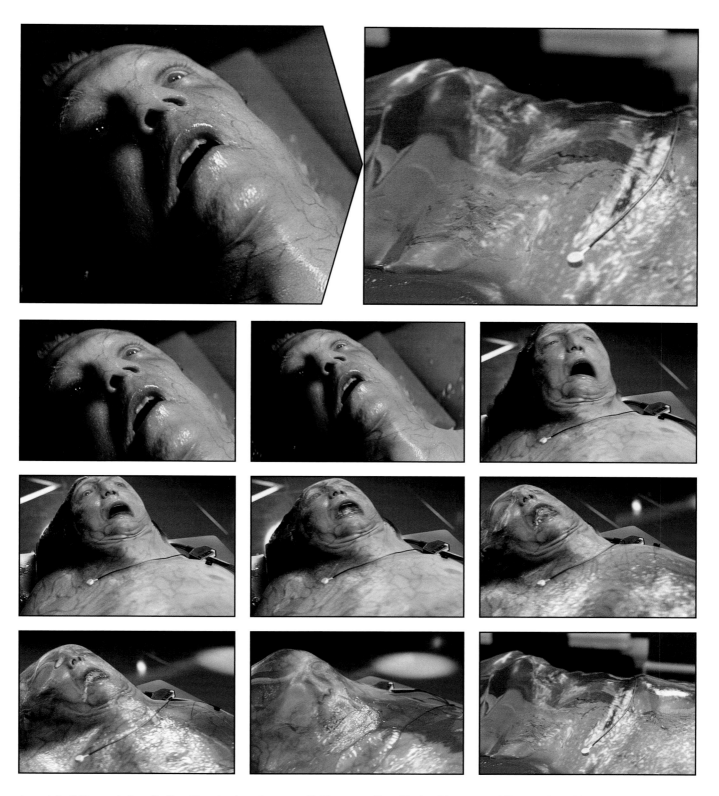

A morph for *X-Men* was just as effective, although not nearly so romantic. The prejudiced Senator Kelly, played by Bruce Davison, has been affected by a gene-mutating machine, and he dissolves under the strain. (Water makes up most of our body mass.) According to Sean Cunningham, 'There were many digital layers: water without refraction, water with murkiness, skin with and without highlights, skin with goo in it. When rendered together, it took 39 hours per frame.'

Lead compositor Claas Henke used image-warping techniques to segue live action of Davison into a more gelatinous CG form. This in turn was morphed to match additional live elements of transparent water bags bursting on the couch, for the moment when Kelly disintegrates entirely and spills onto the floor. Motion control enabled the three separate elements – Davison, his CG counterpart, and the repeat shot of the couch flooded by water bags – to match up.

'We thought of showing some of Kelly's internal organs halfway through the transformation,' says Cunningham, 'but that seemed too gruesome.'

Having said that particle systems are perfect for the dynamics of non-living subjects, individually animated characters can be attached to the points to create football crowds, flocks of birds, colonies of insects, and other phenomena in which living things mass together and behave like complicated swarms. Each bird in a flock, say, can be instanced onto a particle so that it flaps its wings in generic flight behaviour, but the embedded particle can switch on and off more subtle, lifelike characteristics according to certain rules, without the animators having to manipulate every bird individually. If birds come very close to each other, they may turn their heads to discuss right of way; if they actually blunder into the same airspace, they'll take avoiding action, and so on.

But is this flock a challenge for computer wizards or wildlife experts? Leaving aside, for a moment, the example of live geese, Randall Rosa invites us to think instead about apparently non-living, purely scientific pieces of hardware. 'Let's say you have a squadron of jets, and they're diving into a dogfight. Is that a particle-systems job, or should a character animator do it? The particle people would say, "These are machines that fly according to well-known aerodynamic rules." The character animator would argue, "Well, there's a human pilot driving each of those planes, so they need individual quirks." It won't look natural if all the planes are behaving in similar ways. The big-ego pilot's got to wiggle his wings after he's shot down an enemy. The inexperienced rookie pilot has to lose his place in the formation and catch up. There are no mathematical rules to lay out these things. In the end, CG animation is all about a close co-operation between technical and character people. It's a union of art and science. Or should that be science and art?'

WORLDS IN MINIATURE

In 1927 silent comedian Buster Keaton made a film called *The General*, during which he somehow found the budget to have two railway locomotives collide head-on at maximum speed.

The resulting smash was absolutely spectacular. By 1952, even the flamboyant director Cecil B. De Mille wasn't prepared to destroy real rolling stock. In *The Greatest Show on Earth* he delivered a fine rail crash using models running through a miniature landscape.

To simulate Atlanta under siege, David O Selznick burned down an entire studio backlot for *Gone With the Wind* (1939), but no one was in any great rush to copy him. As a rule, producers think twice about destroying expensive real-life artefacts, preferring to use cheaper, smaller-scale duplicates instead. Miniature cars, ships, rockets, planes, houses and even entire cities have long featured in movies when scenes call for a level of mayhem that can't sensibly be financed in the real world. More sedate visions have also called for models, especially when fantasy environments are required. In Alexander Korda's *Things to Come* (1936), a huge community of the future, 'Everytown', was simulated with miniature exteriors and interiors, including trees, walkways and elevators that actually moved. Building Everytown as a functioning live-action set at full scale would have been impossible.

Today, zealous believers in computer technology are convinced that the time is soon approaching when no actual physical models will be required to create these kinds of illusions. The planetscapes, council chambers and underwater cities of *Star Wars: Episode 1 – The Phantom Menace* were created almost entirely as CG, but many critics argued that the human performances suffered as a result. It's hard for performers to develop mood and character while acting day after day against nothing but blank green screens.

Today's audiences are often under the impression that CG modelling has taken over from human craft, but nothing could be further from the truth. For instance, modelling vehicles familiar to audiences from countless TV broadcasts, whether CG or as physical miniatures, is a research task beyond any computer's ability. Pat McClung and Leslie Ekker took charge of the principal miniature construction for *Apollo 13*, supervising an eight-strong team of model-makers. 'We put in a huge effort to get the hardware details historically accurate,' Ekker says. 'Given the time constraints, I think we did pretty well. The markings and decals on the *Saturn V* weren't exactly right for that particular mission, and we had six little ullage rockets on the side instead of the correct three, but you'd have

1 The *Saturn*'s engine exhausts positioned over a miniature flame trench. Pyrotechnic explosive charges and kerosene flames delivered an 'impossible' view of the moment of ignition, as if seen from directly underneath the rocket.

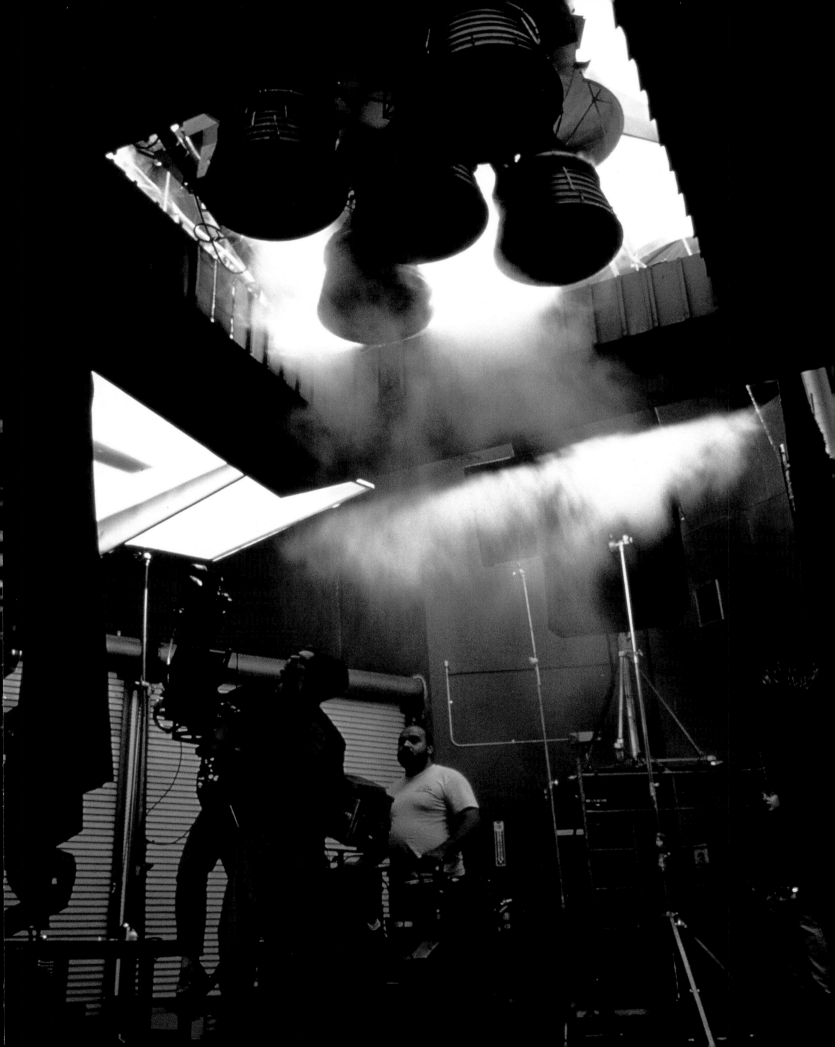

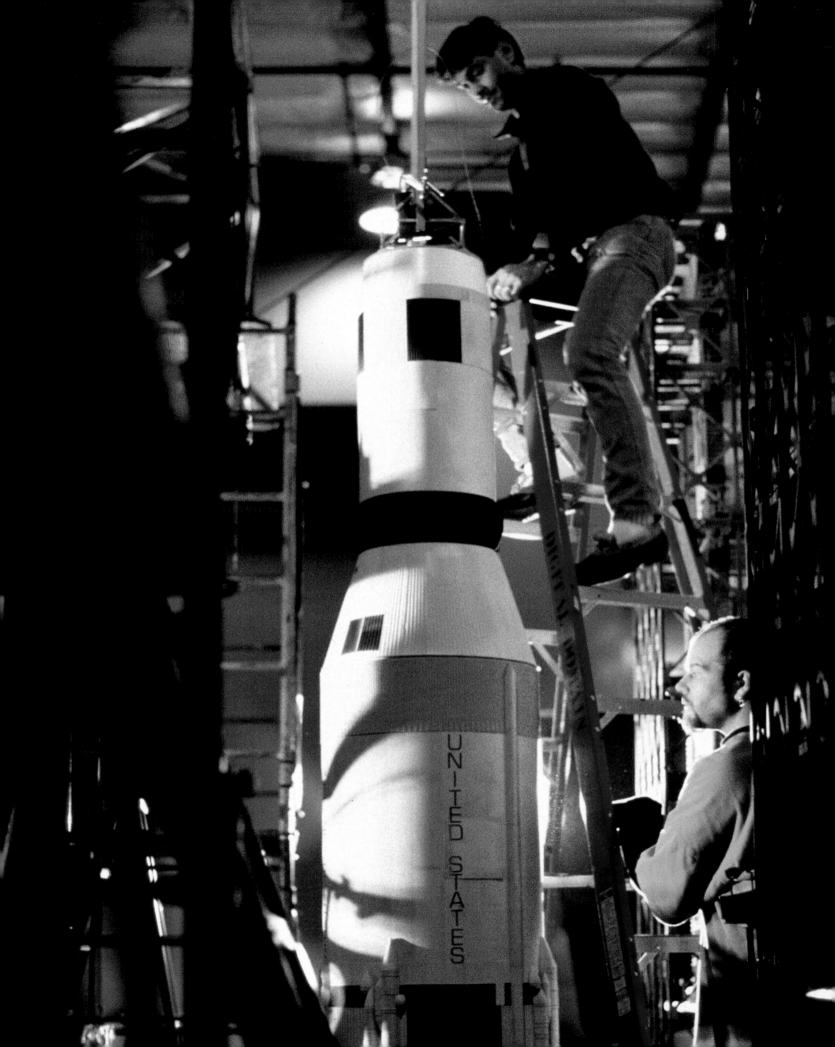

to compare our model with photographs of the real rocket on the launch pad to spot the differences.' NASA archivist David Portree dug up hundreds of drawings and documents for Ekker's reference. 'He was fantastic, and I ended up with a ton of material. After a while, everyone else was asking me how long the rockets were supposed to fire, or exactly where the urine dump output was on the command module.'

The ship from *Titanic* was an even more challenging job of research. Although audiences couldn't be expected to have familiarized themselves with the ship ahead of time, director Jim Cameron was determined to recreate her as faithfully as possible. The starting point was a set of original plans from the Harland and Wolff shipyard which built the real *Titanic*. Model chiefs Gene Rizzardi and George Stevens committed themselves to a 1/20th-scale version, 44 feet long. Stevens says, 'Right away we hired some real boatbuilders out of Santa Barbara to shape the hull, because of the "sheer" – the banana-like bend that most ships have. There's not a single straight line anywhere on the hull, and it's a very difficult shape to model.'

Templates representing cross-sections of the hull at intervals were cut and shaped from Baltic birch plywood, then joined with lengthwise spars or 'stringers' to create a skeleton hull. Flexible sheets of laminated wood were then stapled onto the frame, creating a smooth hull shape. Small sheets of plastic were cut and glued onto the hull to simulate the steel plating, and the interior of the assembly was then reinforced on the inside with tubular steel.

Meanwhile, at the other end of the shop floor, teams of modellers were making the decks and superstructures. Stevens recalls: 'With the tight schedule, we had to build countless substructures all at once and hope they'd fit together properly. Because of the sheer, and the curves on the hull and so forth, we often couldn't lay things down on a flat surface to work on, and that made life pretty hard sometimes.'

Contractors were hired to take some of the load off Digital Domain's crew. There were lifeboats, davits, cranes, air ventilators, portholes, railings and countless other small repeating details to be fabricated. It turned out that the holes in the hull for the thousand-plus portholes couldn't all be created as uniform circular shapes – again because of the hull's sheer. The cuts ranged from near circular to very ovoid, depending on the degree of curvature in the hull.

A 50-strong crew worked on the ship, and as one voice, they all complained about the same nightmare: rivets.

'The usual way of dealing with that kind of thing is to make repeating patterns or as castings of dozens at a time,' says Stevens. 'Again, the sheer in the hull meant there was never a straight flat line to deal with, and the spacing and curvature of the rivet lines constantly altered. We had a notice pinned up in the shop, attributed to Thomas Andrews, who built the *Titanic*: "It takes three million rivets to build a truly fine ship." A good many rivets in the real ship were buried somewhere inside, so we didn't have to worry about those. But we still had to hand-drill 100,000 tiny holes into the hull and put these little pins in that looked like rivets. It took a week to do the holes, and two weeks for eight people to attach the pins.'

2 The 18-foot rocket is stacked vertically for a locked-off shot, ready for inclusion in the hangar scenes.

3 Effects supervisor Rob Legato inspects a large-scale model of *Apollo 13*'s *Saturn* rocket engine block, with umbilical fuel and power connectors.

DIGITAL DOMAIN **WORLDS IN MINIATURE** 149

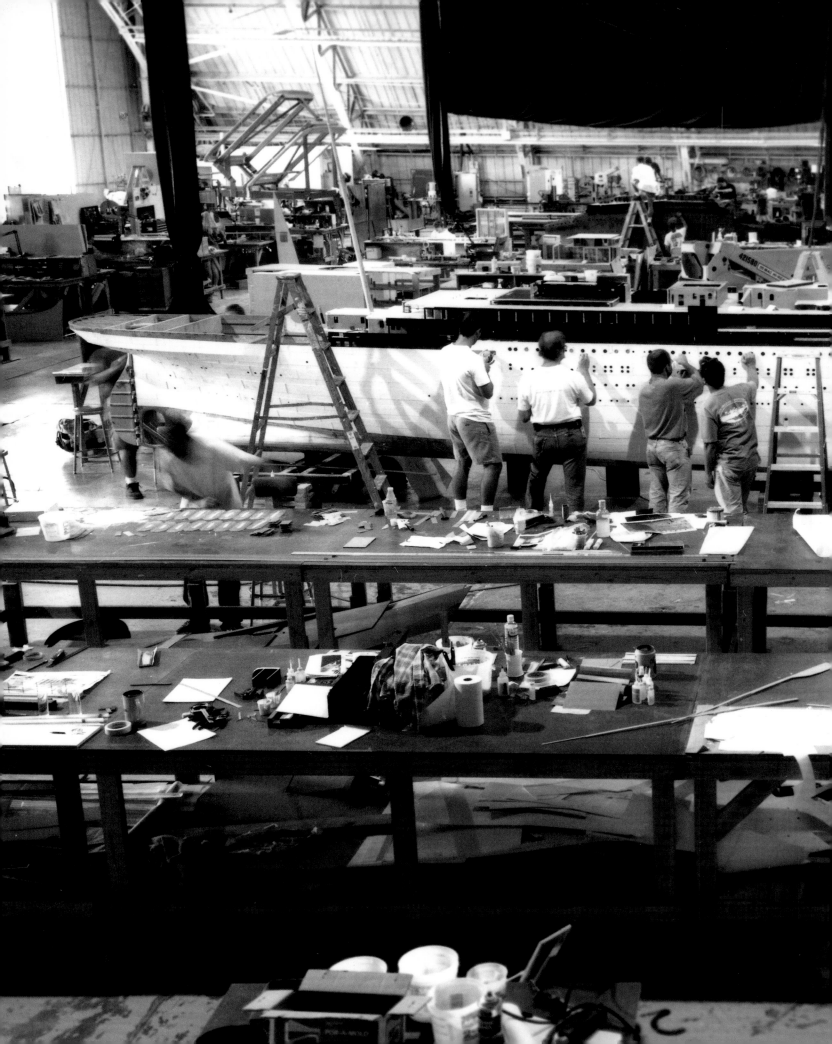

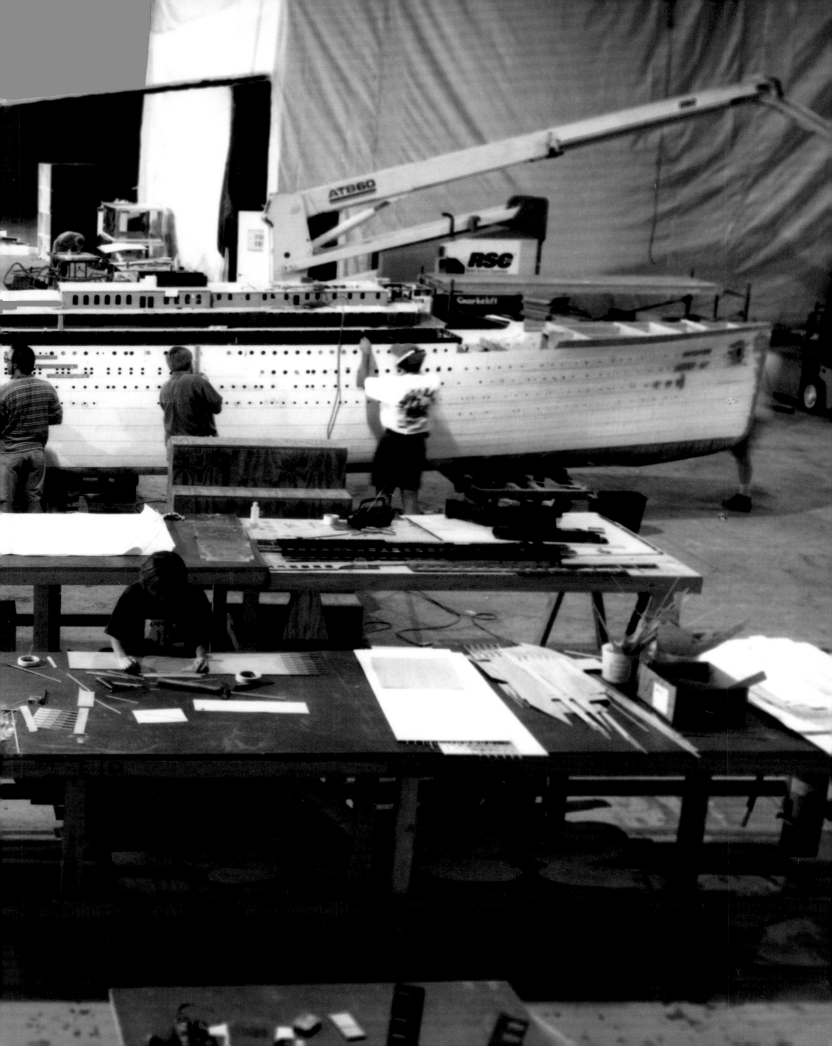

HYBRID SOLUTIONS

At Digital Domain, the emphasis is on creating a mix of real sets, models and CG. No single technique is ever a total solution. Alan Faucher says, 'It's just so much easier and faster to build a physical version than to CG something from scratch. Then, in the paint process, a good spraygun artist can add fantastic realism to the surfaces. Detailing and rendering CG surfaces that well takes time and money. Traditional model-makers still have the edge.'

However, Faucher concedes that CG work has its role to play. 'Our physical model is what you should start out with, but then it can be scanned into the computer, saving digital artists all the work of drawing up a design, putting it into wireframe and so forth. When you want to see your huge spaceship or whatever apparently shooting off from the foreground to a point half a mile into the scene, motion control in a studio doesn't necessarily apply, because you can't track a camera along those kinds of distances. Going to CG for certain extreme effects is better. For close-ups, I don't think we can be beaten yet on detail and believability.'

Leslie Ekker points out the importance of 'dirtying-down' skills, long familiar to model-makers. 'The *Apollo 13* Saturn rocket was so pure white and factory-fresh that it was impossible to get the audience to take it seriously unless we dirtied it down. In reality, space equipment at launch time *would* be super-clean, straight out of the manufacturer's box. It's an audience expectation that dirt reveals the scale of a model, because it outlines and separates panels and access hatches. Dirt makes machines look like they have some kind of a life. If you have an 18-foot model rocket and you're trying to fool the audience that it's as tall as a skyscraper, you have to use every trick available. CG models still look too clean, too perfect to be believable, even when some attempt has been made to paint on dirt digitally. You're often better off putting real grime and dirt stains onto a real model.'

If computer techniques can't quite match the subtle dirtying-down skills of physical model-makers, there are a few 'cheats' that can be applied. In MGM's space adventure *Supernova*, a medical spaceship called the *Nightingale* makes a spectacular debut as a magnificent 20-foot model. However, some shots required the ship to be seen from such a great distance that the motion-control rig couldn't cope, and a complete CG version was required. Mark Stetson, Digital Domain's effects supervisor for *Supernova*, describes the procedure. 'Scott Schneider and his crew in the modelshop built the ship and gave it a beautiful finish that made it look as if it was made out of aged metal. We then photographed it in detail, and mapped the paint finish as a texture map onto a CG model using Lightwave software.'

Inevitably, the relationship between physical and CG models is becoming more of a marriage than a battle, as Stetson explains: 'To design the *Nightingale*, we went back and forth between the computers and the modelshop. We started with sketches and drawings, scanned them in, then exported the data to laser cutters so we could mass-produce the finely detailed components of the model. Then we shot this beautiful vessel and mapped additional CG elements onto it for the final composites. We had this incredible zigzag back and forth between the real and the CG worlds.'

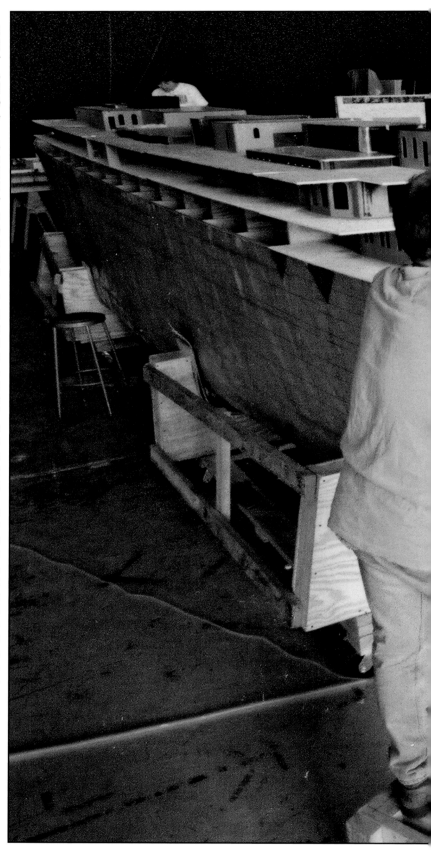

PREVIOUS PAGES
4 The principal *Titanic* model takes shape as a wooden hull, created according to genuine shipwrights' procedures.

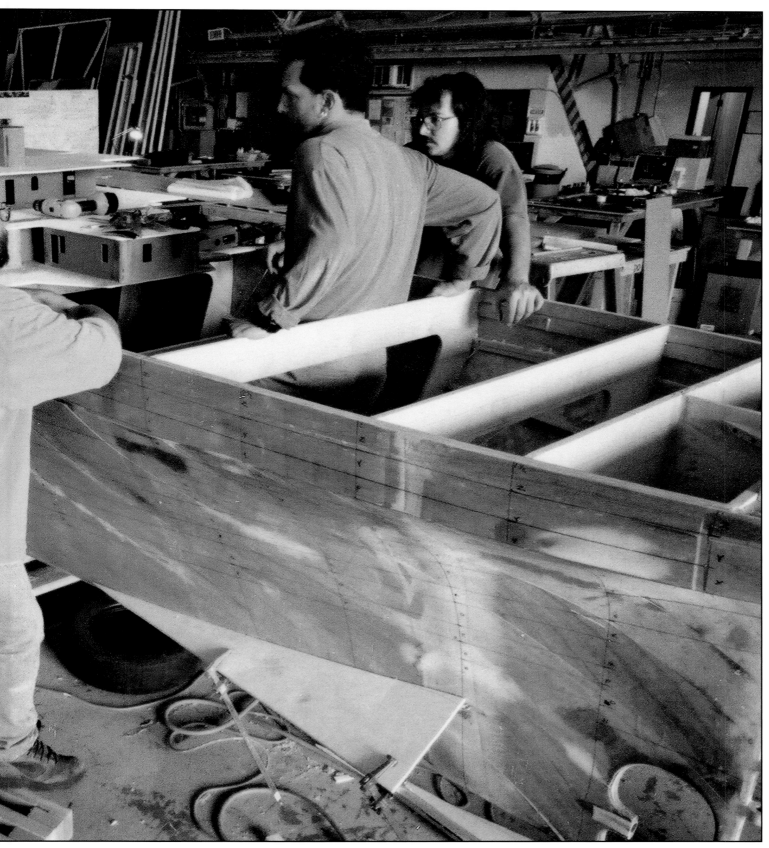

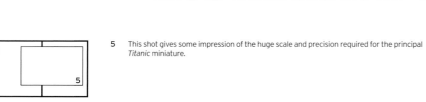

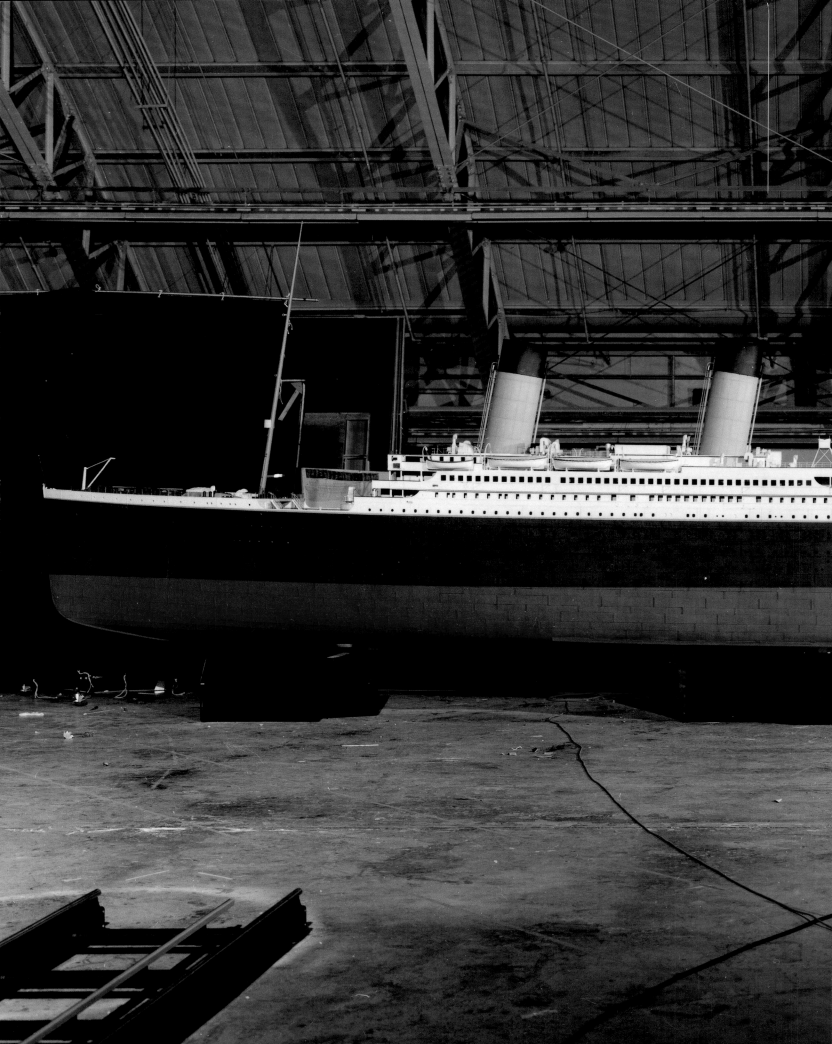

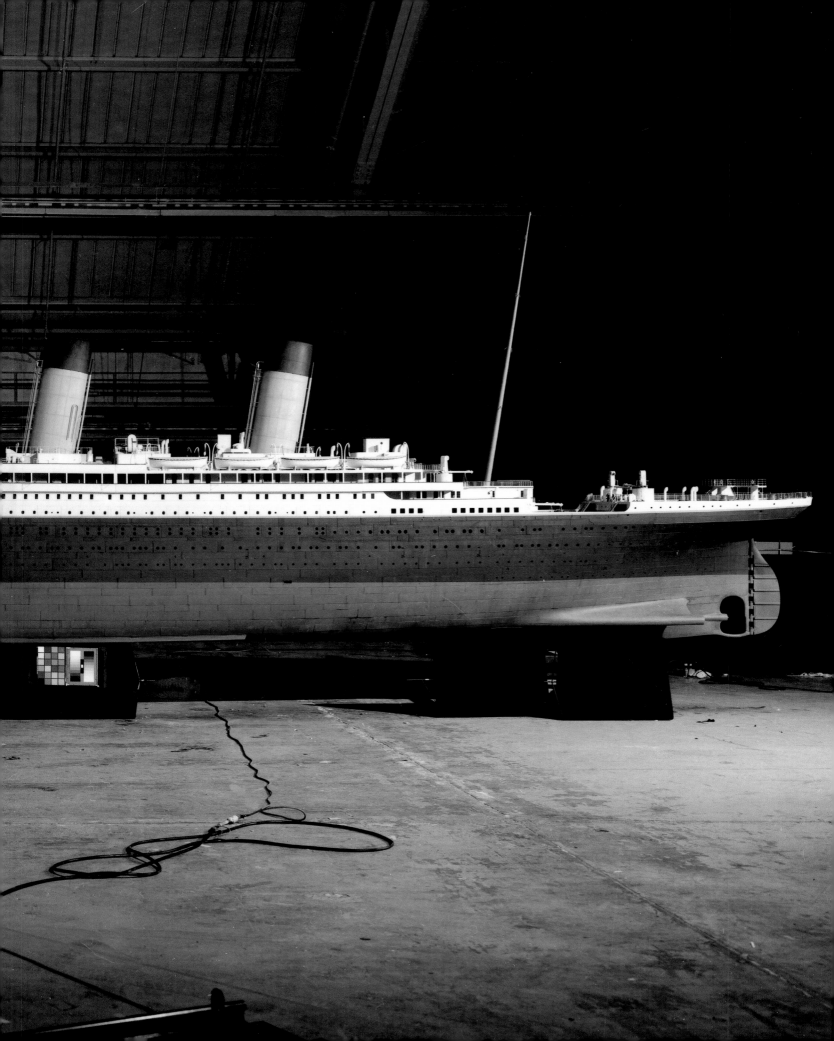

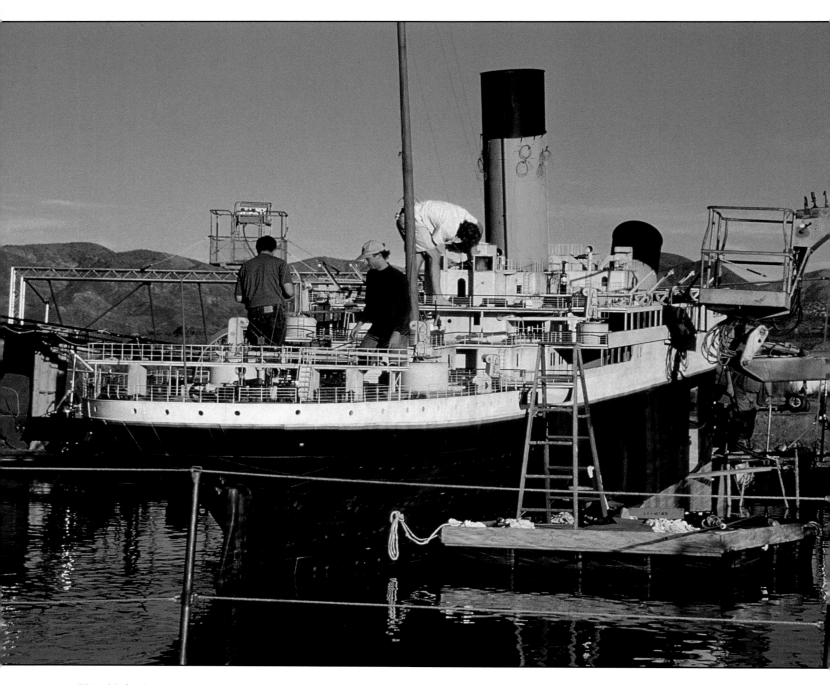

The 20-foot model performed perfectly in front of the motion-control rig for the closer shots, but there were still certain characteristics of the ship that couldn't be created physically. They had to be added later as CG elements. An armoured shield above the main cockpit module slides back to reveal an excursion pod; and further along the ship, the design called for antennae and solar panels that were too nebulous and delicate to build as physical models. They wouldn't reliably have stayed in their correct positions from pass to pass.

The definitive screen version of the *Nightingale* was a modern cross-breed between real and virtual ways of modelling, with neither version ever quite sufficient without the other.

Life-size mock-ups of large craft can also be melded into smaller motion-control models of the same vehicle, although a certain amount of creative chicanery is sometimes required, as Mike Kanfer explains. 'In *True Lies*, there was a shot of Schwarzenegger in the full-sized Harrier cockpit, and the camera pulls back and back. But you can only go about 30 feet before you run out of places to go. The shot needed to pull much further back than that, so we had to morph onto a motion-control shot of the 1/5th-scale Harrier model. We shot the model to make sure that its pitch and roll movements matched the live plates. But the two versions of the plane were slightly different, so we added CG heat shimmer around the

6

PREVIOUS PAGES
6 The completed *Titanic* model, showing colour calibration card underneath the hull.

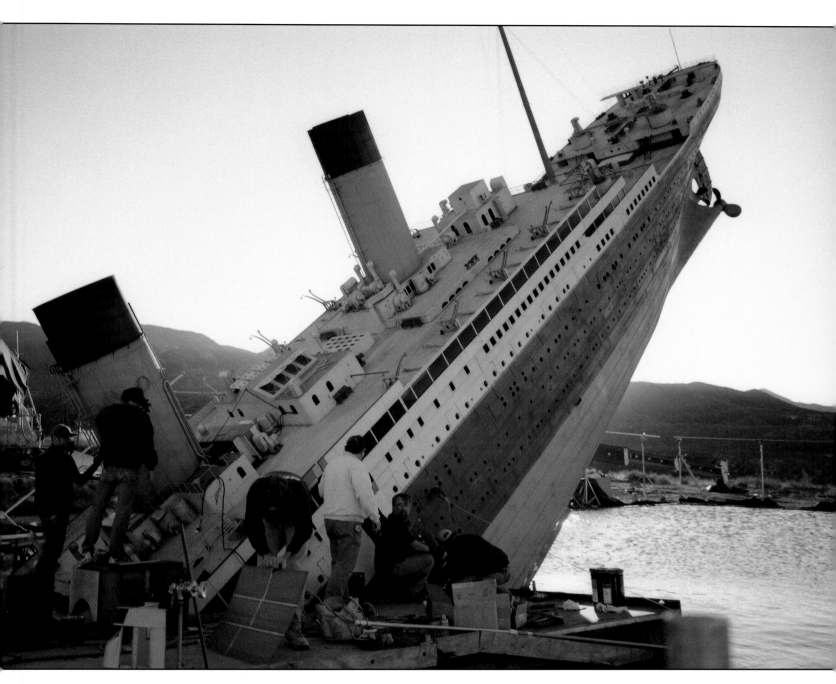

whole thing, as if from the engine exhausts, which helped conceal the morph transition from full-size to model plane. I don't remember anyone planning for that in advance. It was just a neat way of solving a problem that also looked appropriate and added to the shot as a whole.'

Far worse complications arose with the *Titanic*. George Stevens outlines the worst problem his crew faced – even more harrowing than the rivets. 'We were building our 1/44th-scale miniature version from the original shipyard's blueprints, and then there was the CG model created by Richard Payne and Fred Tepper, which was an exact reproduction of our miniature. The problem was that the live-action set of the

Titanic at Rosarito had sections missing, or shortened, to facilitate certain camera positions and to save on some resources. It was basically 10 per cent shorter than the length of the real ship. The spaces between the funnels weren't quite right, and there were a number of other factors that were unnoticeable for the live action, but for us and the digital guys, it was a real problem. When shots of the set had to be combined with the model or the CG, it was like trying to fit Cinderella's glass slipper onto her stepsister's foot.'

Even in the most carefully planned movies, something isn't going to fit somewhere along the line.

7 The 'breakaway' stern of the *Titanic* is detailed prior to being raised on a hydraulic jack.

8 Once raised, the stern can be dropped repeatedly into the water.

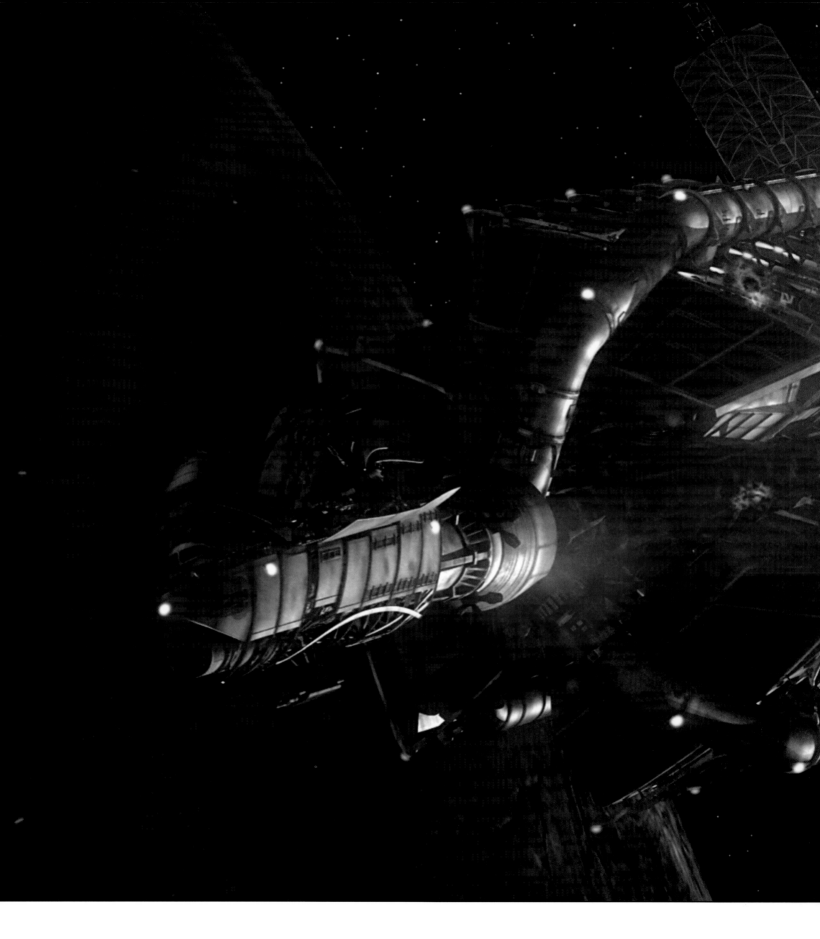

9

PREVIOUS PAGES
9 The *Nightingale* craft from *Supernova* is prepared for motion-control photography.

10 Dark forces are at work in the universe, and the *Nightingale* seems doomed. Multiple elements composited into this shot include an alien planet, an android hand, a CG explosion and a starfield.

10

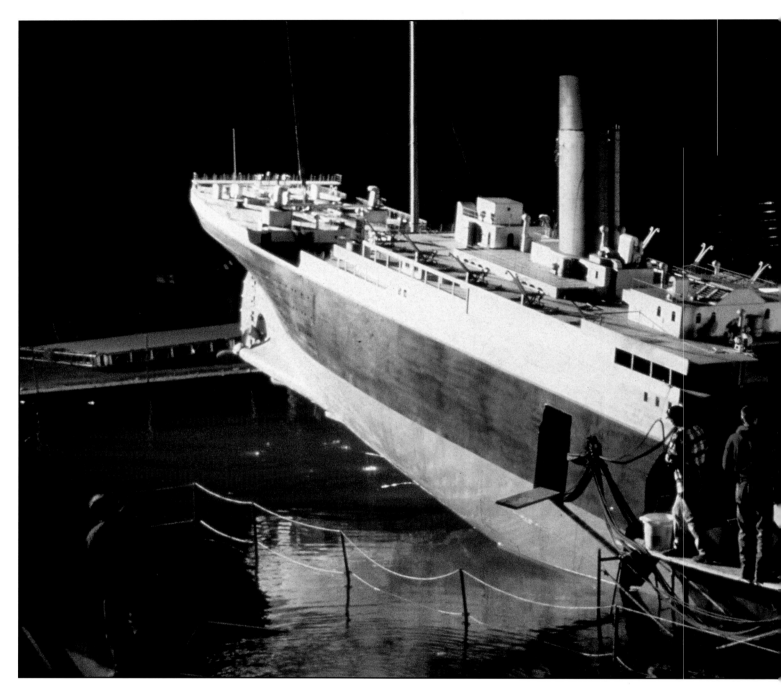

THE BIG SHIP

Titanic had, of course, sunk a few times on screen before – most notably in a modest but moving British film *A Night to Remember* – but Jim Cameron wanted his version of the doomed liner to sink as realistically as possible. After consulting with marine shipping experts, and even visiting the real wreck's resting place at the bottom of the Atlantic in a Russian submersible, he had absorbed the very latest analyses of the wreckage. Now he was determined to show the way that the huge hull had split in half in the last moments before it disappeared forever beneath the waves.

It soon became obvious that more would have to appear on screen than just the hull breaking up. Just think of the *Titanic*'s many inner decks being revealed as the split in the hull opens up; all the furniture and fittings tumbling out as the cabin walls are ripped apart; and above all, hundreds of terrified passengers and crew spilling out of the great gash, or else clinging for dear life onto anything within reach.

The wide shots of the *Titanic* breaking apart were created using a 60-foot 1/8th-scale model (made by Donald Pennington) representing the bulk of the hull from midship to stern, mounted

11 Testing the *Titanic* rig in preparation for a night shoot.

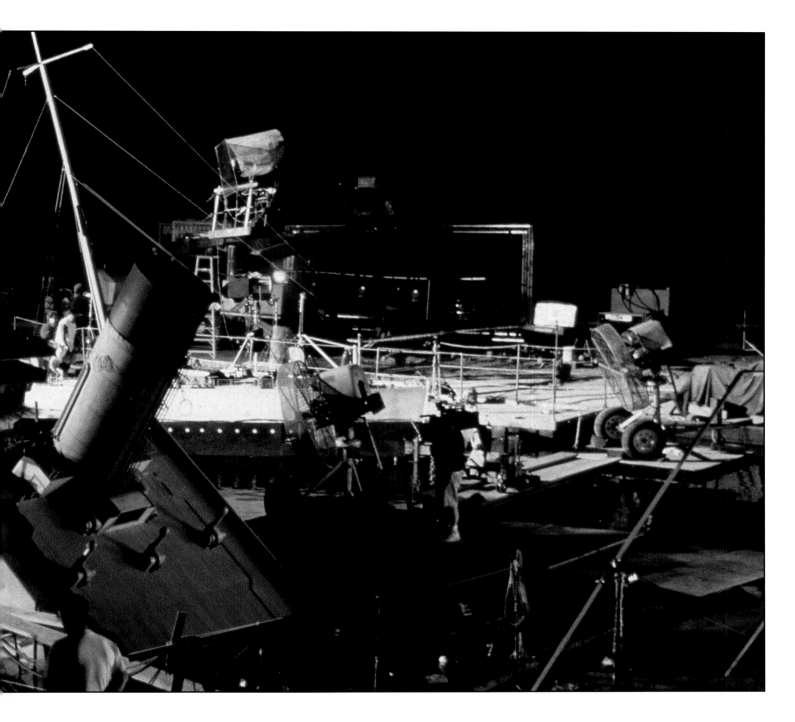

on hydraulic motion platforms, and immersed in a huge water tank. The size and weight of the model ensured that the ripples and waves in the surrounding water wouldn't give the game away by being too obviously out of scale. (So often in movie effects sequences, natural elements such as water and fire don't appear to be on a scale appropriate to the miniatures they are consuming.)

The hydraulic rig was built so that, on cue, the stern hull section could free fall into the water. Additionally, a rotational twist was built into the rig. Cameron insisted that such a massive section of hull tearing away wouldn't fall straight and neatly in real life, but would carry with it all the random stresses of the uneven rupture. (The hull model was built around a sturdy steel cage, strong enough to withstand the several takes required for Cameron to achieve what he wanted.) The inside of the model was also dressed to reveal a realistic interior when it actually ripped apart. Wires and tubes were also inserted among the dressed decks, to send out sparks and belch steam during the break-up.

For close-up work, the model's interior at the split was

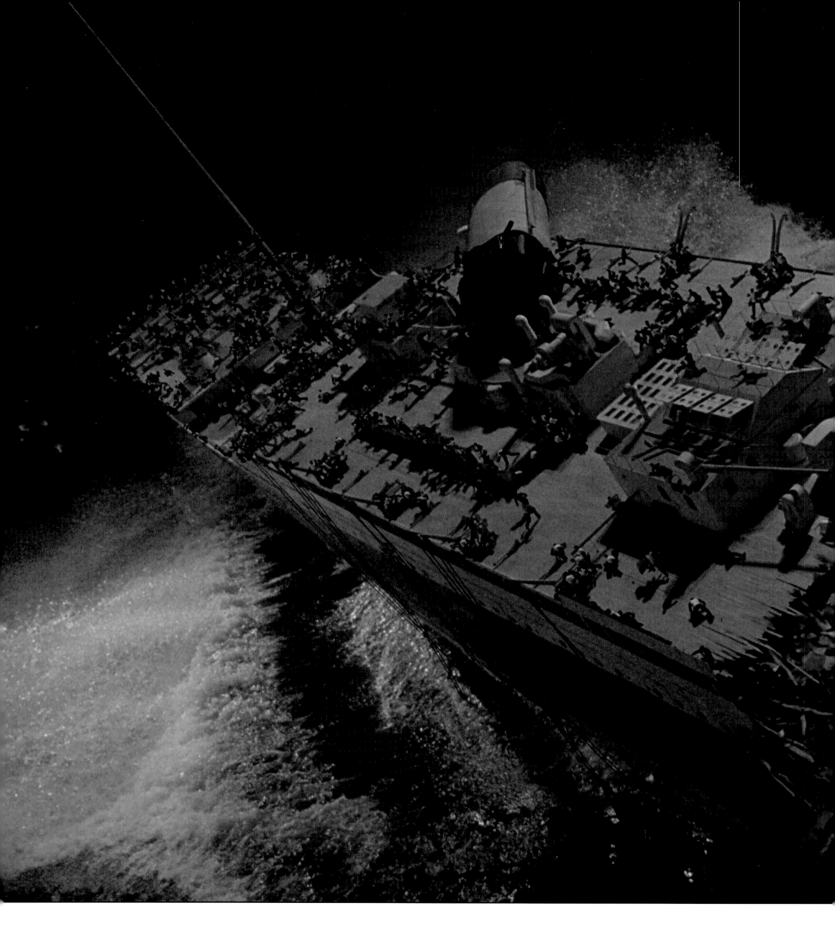

12 The *Titanic* rips itself apart.

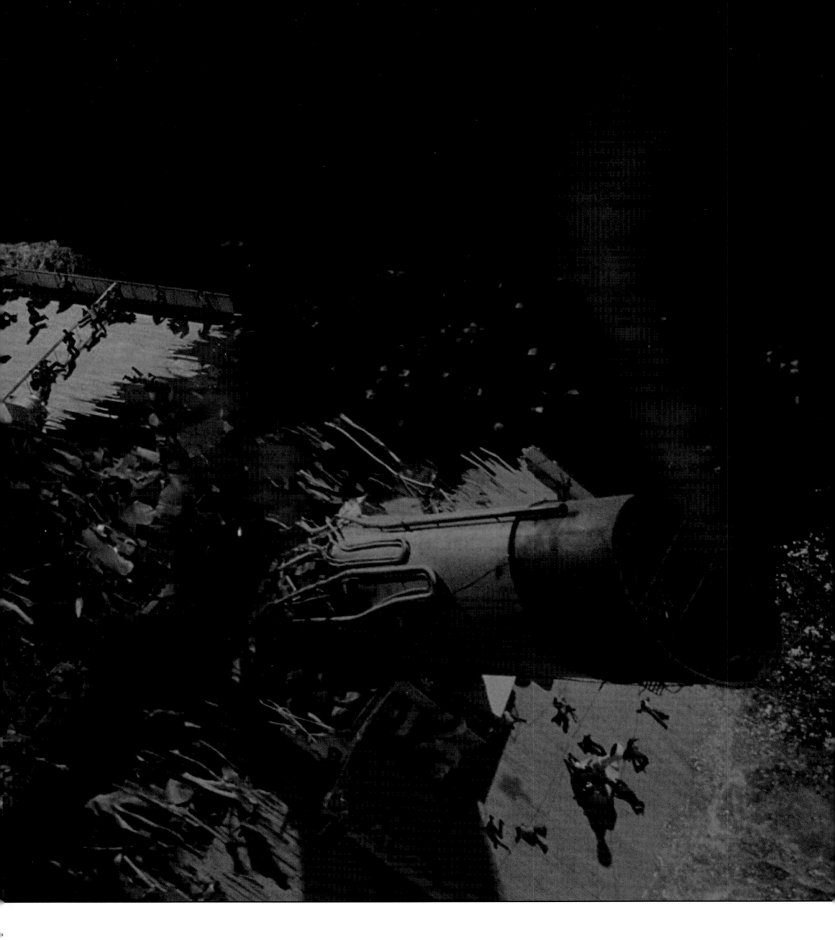

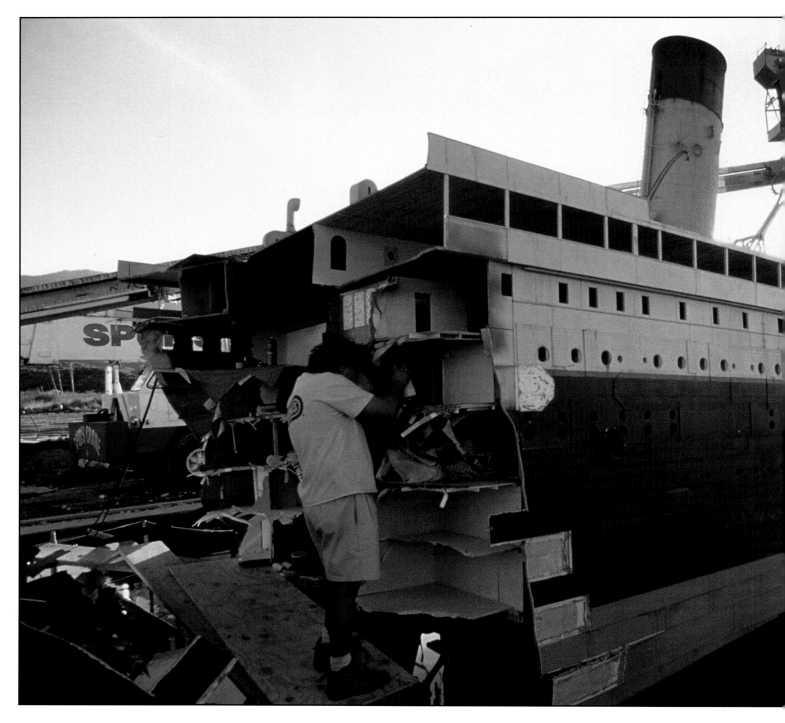

further detailed with cabin fixtures, dolls'-house-sized furniture and other debris. Dozens of miniature explosive charges, known in the movie trade as 'squibs', were timed to go off in the right sequence and scatter all the miniature props on cue. After each take, everything had to be put back in place, and the squib sites reloaded.

Legato says that he found it difficult creating the night-time ambience for the break-up scene. 'By this time in the disaster, the ship's lights had all blown out, and there was no moon.

Then there was the fact that the live-action material for associated scenes was weeks away from being shot, so I had no reference material from any live work to match against the effects. I had to attempt to match what Jim Cameron and [director of photography] Russell Carpenter would be creating weeks later, with no way of knowing what that might be.'

Legato also had to contend with the fact the hull model needed a great deal of light, not only for depth of field, but also for exposure, especially as the break-up had to be shot in slow

13 The interior decks of the breakaway section, ready for the addition of miniature furniture and other loose debris.

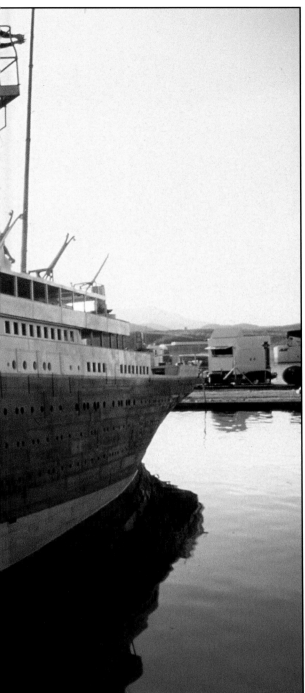

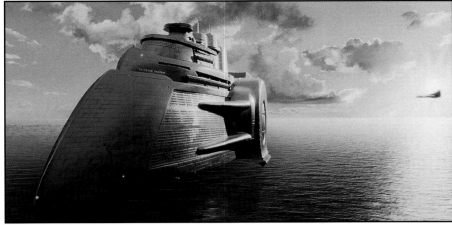

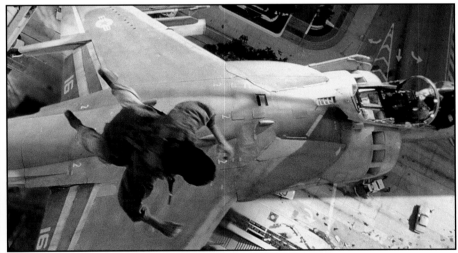

motion. The trick with slow motion is that the camera actually shoots at a *faster* rate than normal, so that when the sequence is replayed at normal projection speed, the action appears slowed down. But as Legato points out, 'The faster the frame rate you're shooting at, the less exposure time you have per frame, so we were shooting what was supposed to be a night-time scene with a lot of light, to keep the camera shutter speeds as short as possible. The night-time mood had to be created by colour-filtering the lights properly, and pointing them carefully. Not by turning them off!'

Despite the incredible detail of this breakaway model, digital artists added 200 subtle layers of what they call 'sweetener' to the scene: smoke, fine debris, shattered planking and, of course, panic-stricken people from Bustanoby's performance-capture library.

14 A luxury cruise liner floats above an alien ocean in *The Fifth Element*.

15 For extreme long shots of the *True Lies* Harrier, a small version of the plane was constructed, complete with miniature puppets sitting in for the performers.

16 In the final sequence model work was combined with live action and CG elements.

HOT ANTI GRAVITY GAS · WARM PLASMA GENERATORS · COLD GYROS
HOVER REPAIR CENTER

GARAGE
DAILY · MONT

CITYSCAPES

There are some illusions beyond the capacity of computers (for now, at least) that only a modelshop can deliver. Although *Fight Club*'s instancing of L-systems dendrites created a seemingly endless brain interior, this won't work if a setting requires many *different* kinds of structure, because instancing relies on replicating similar objects. You couldn't, for instance, make a CG of an entire city, because countless individual buildings would require their own unique architectural styles and detailing. You would have to model them individually, and force the computer to remember each one in specific detail. Office blocks aren't the same as theatres; car-parking lots are different from gardens; a roof terrace isn't the same as a verandah. The computers would overload – or, at the very least, render times per frame would make the task impossible. When Digital Domain was called upon to create a sprawling city of the future, they turned the job over to the modelshop.

Luc Besson's *The Fifth Element* is set in the 23rd century, in a highly stylized futuristic version of New York. For the film's many cityscape scenes, Besson asked Digital Domain to produce wild and busy images full of movement and colour. Up to now, the company had built its reputation on work that was subtle and naturalistic. This time, Besson wanted a style that was obvious in its unreality. In his New York of the future, the sea level has dropped 300 feet as the result of a colossal off-world colonization scheme and the export of water to other planets. He also demanded that most of his film's action should take place in broad daylight. He was tired of the dark subterranean spaceship passageways and dimly lit planets of recent science fiction and wanted a brighter look, cheerfully crazy rather than gloomily realistic. His specific inspiration was the famous French fantasy magazine *Metal Hurlant* (Heavy Metal), in particular, the distinctive and exuberant universes of comic-strip artists Jean 'Moébius' Giraud and Jean-Claude Mézières.

The plot is also baroque. In the year 2259, humanity comes under threat from a giant sphere of 'Pure Evil', heading at breakneck speed towards Earth. A benevolent race of aliens, the Mondoshowans, need to gather all five elements of a protective crystal combination at a special temple on Earth if disaster is to be averted. Four of these elements have been in place for many centuries, but a Mondoshowan ship containing the vital 'Fifth Element' is attacked and destroyed before it reaches Earth.

The effects supervisor for the project was Mark Stetson, who had joined Digital Domain barely a fortnight before the *Fifth Element* effects contract was finally agreed. 'This movie was custom-made for me. I'd been involved with building miniature versions of New York on at least six previous projects, from *Ghostbusters* to *The Hudsucker Proxy*.'

Stetson quickly understood Besson's shooting style. 'He tends toward formal compositions, very symmetrical, with the perspective vanishing point bang in the middle of the screen. New York is built on a grid system. When you're staring straight down an avenue, you're seeing architecture all the way to the far horizon. In bright daylight, that's a lot of detail in the shot. Maybe we *could* have made the city in the computer, but we hit a practical limit of memory and processing time. It was just so much easier and more flexible for us to build it as a set of models.'

17 Attention to detail is everything on the set of *The Fifth Element*.

18 A finished frame from *Fifth Element* includes the detailed cityscape models.

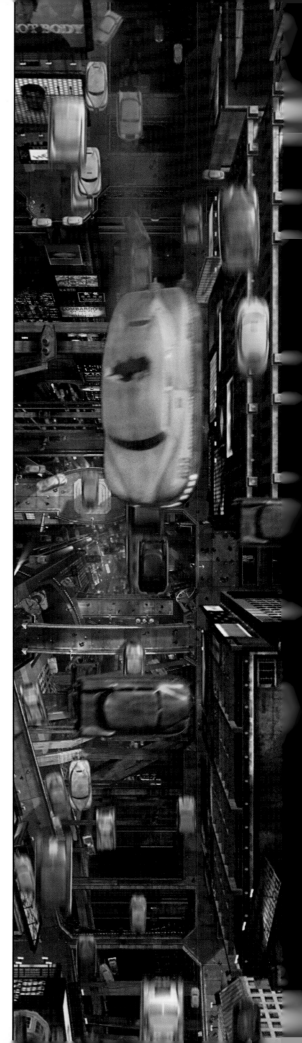

19 A full-size flying restaurant and its owner composited into a background of models and matte paintings.

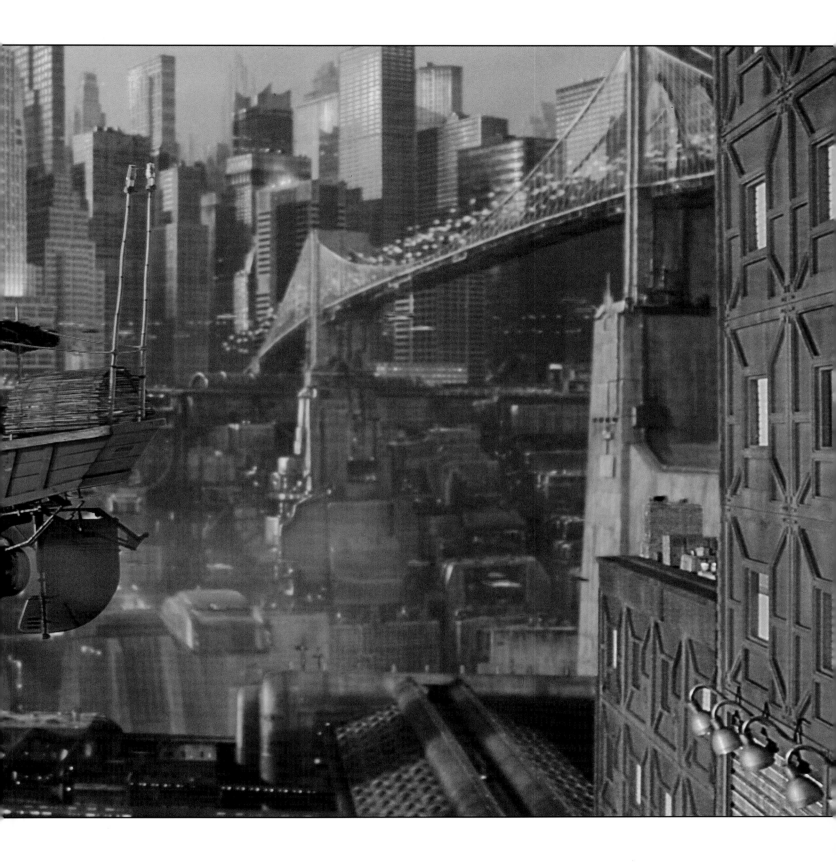

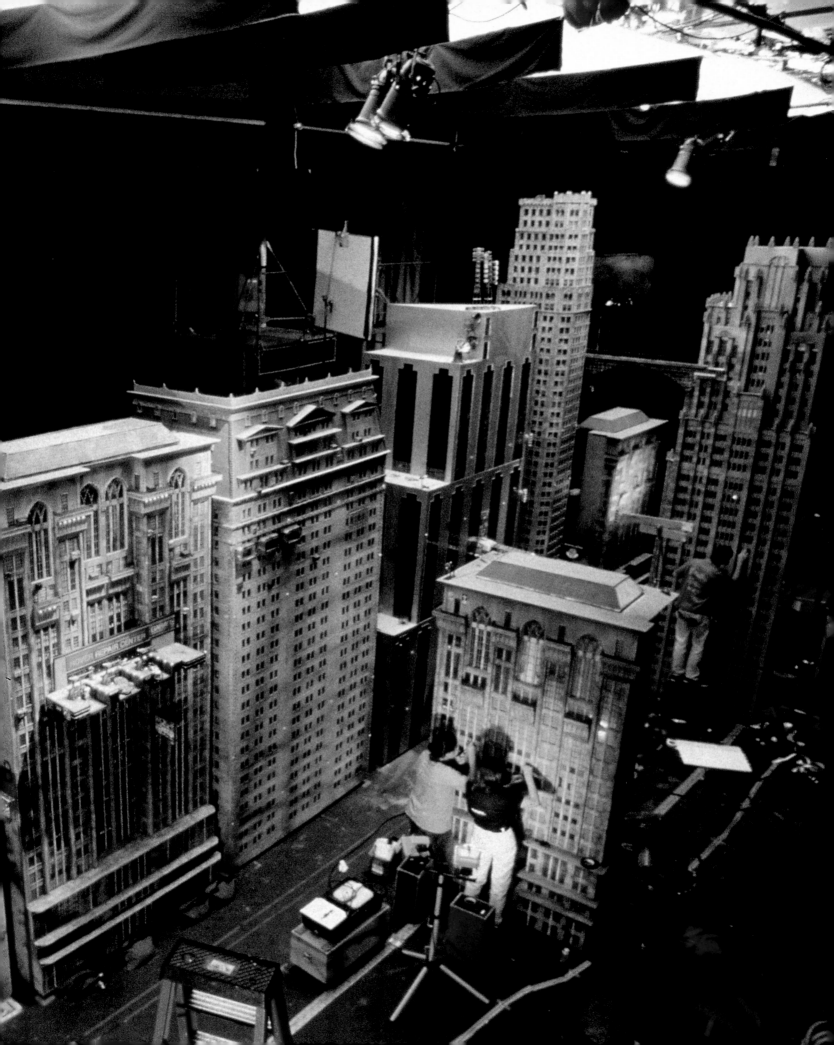

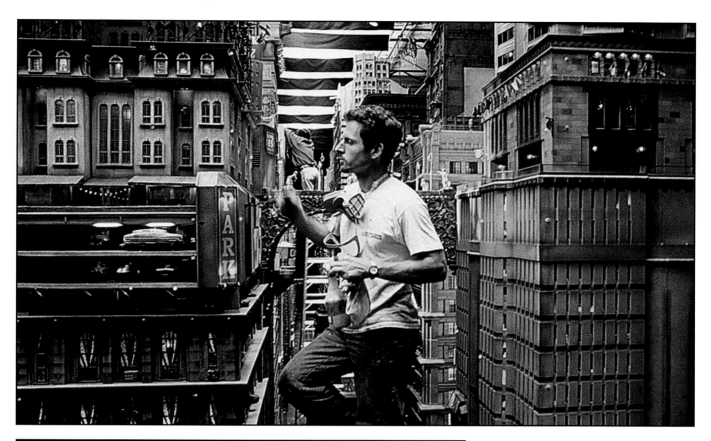

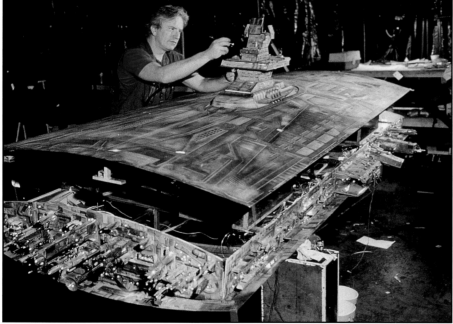

Dozens of apartment blocks were constructed at 1/24th scale, along with 25 skyscrapers, 'miniatures' as much as 20 feet high. An 80-strong team worked for five months on the models, supervised by Leslie Ekker. 'Don't forget all the windows in these buildings. I don't know how many times we had to add little details behind them: desks, tables, furniture, Venetian blinds. Niels Nielsen put small lightboxes behind the windows, with tiny pieces of flat artwork to simulate the interiors. We Xeroxed thousands of copies of various designs. From the camera's viewpoint, they read as three-dimensional.'

20– Adding detail to the cityscape model for *The Fifth Element*.
21

22 After weeks of work, a space battle cruiser is prepared for its brief appearance on screen.

GIANT MINIATURES

Then there are those occasions where only a life-size model will do. For *True Lies*, Donald Pennington created a one-to-one scale Harrier jump jet so that actors and stunt doubles could clamber on top of it. He had 13 weeks to complete and deliver the model. 'I visited the Marine Corps Air Station at Yuma, Arizona, where they let me look over an AV-8B Harrier on the ground and in flight. Then they put this $23 million airplane back in the hangar just for us, and we got to work.'

Pennington's team painted the entire plane with a removable wax to protect the body and paintwork. They then overlaid fibreglass resin sheets, carefully rolling them into place to eliminate air bubbles. When the sheets dried, they were pulled away in 24 discreet sections. 'Then we found a maintenance depot and got a cockpit from a Harrier that had made a bad landing a few years before, plus a real ejection seat. But all the interior cockpit detail we had to create from scratch. We got lucky and found a glass canopy, plus some main landing-gear components, and for the nosewheel we found the gear from an F-8 Crusader, which we modified to match.'

Before leaving the Marine Air Corps in peace, Pennington went to the flightline and photographed the entire surface of an on-standby Harrier. He was looking for the weathering details, exhaust smudges and dirt patterns baked into the plane's blue-grey finish. When the full-size Harrier mock-up was at last assembled from fibreglass castings taken from the 24 moulds, spraygun expert Ted van Doren painted the model to match Pennington's photos.

Meanwhile, Leslie Ekker's team had to build a model bridge in the Florida Keys. Even at 1/5th scale, it was more than 200 feet long. The term 'miniature' hardly applied.

The shot in question called for the villain's truck to explode under aerial attack and tumble off the side of the bridge. This was no throwaway moment but part of the movie's climactic set-piece battle between hero and villains. It had to be spectacular, and the modelwork needed to match live-action material already shot on a real bridge. Harry's wife Helen is a hostage in a limousine escorting two trucks across the bridge. A pair of marine Harriers must destroy the trucks because they contain nuclear warheads. Meanwhile, Harry, chasing the evil convoy in a helicopter, has to get his wife out of the limo and off the bridge before the marine jets fire their missiles. A lot of this sequence was stunt work shot at full scale on an old decommissioned bridge, but the climactic missile attack and explosion had to be done with miniatures, so as to protect the *new* bridge running alongside the old one.

There was no choice but to build the model bridge in the water. At first, effects supervisor John Bruno struggled to find a way of keeping the model within the more or less controllable confines of a studio backlot, but it was not to be. 'There was a big water tank at Universal Studios, but even that wasn't big enough. And there's something about the light at the Florida Keys that's impossible to duplicate anywhere else. So we had to take the model bridge to the Florida Keys.'

The Keys are environmentally protected, and when rumours began to fly that the *True Lies* team wanted to blow up a bridge, the suspicions of the authorities were aroused. Permission to build the model on location was finally granted, but only after

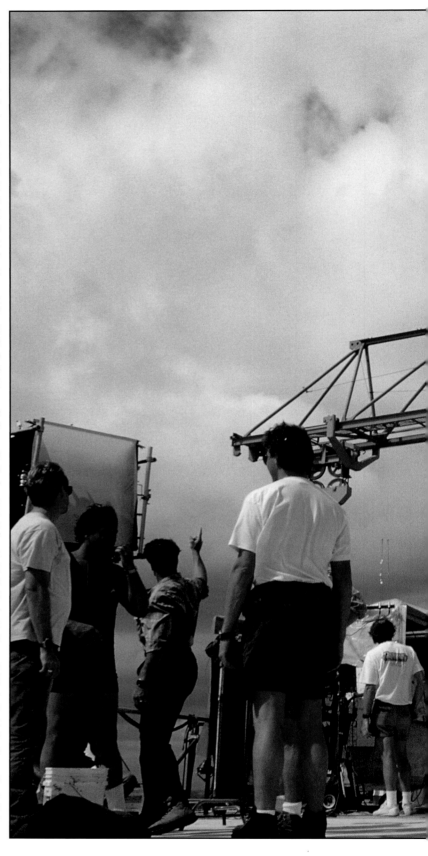

23 Donald Pennington's life-sized Harrier model was indistinguishable from the real thing – except for the empty air-intake nacelles, which were augmented later with digitally spinning fan blades.

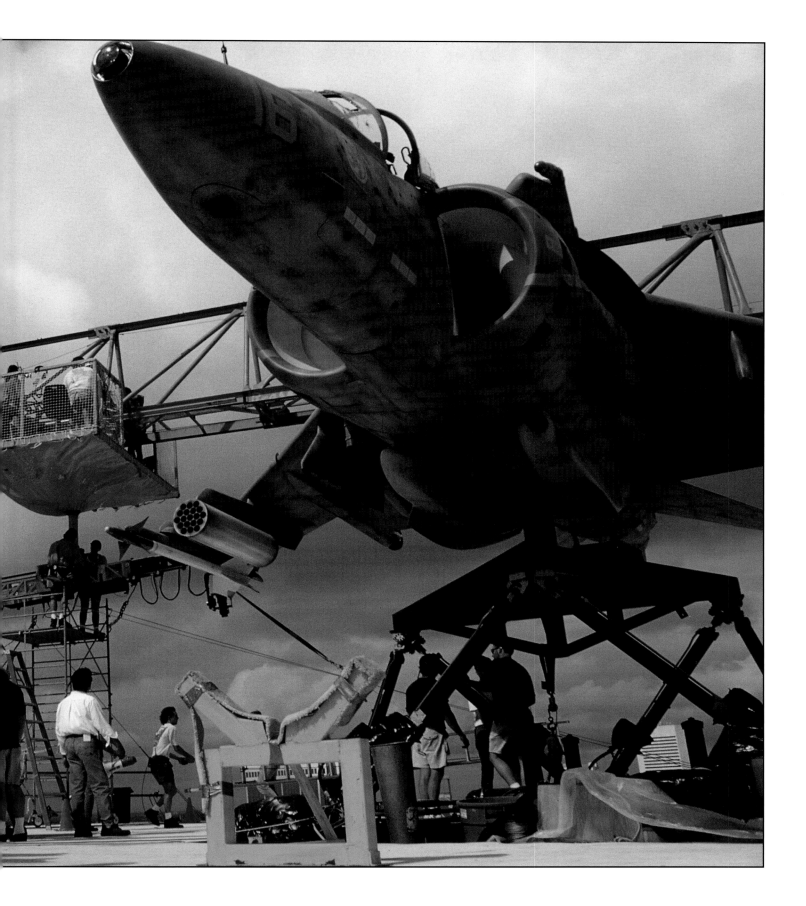

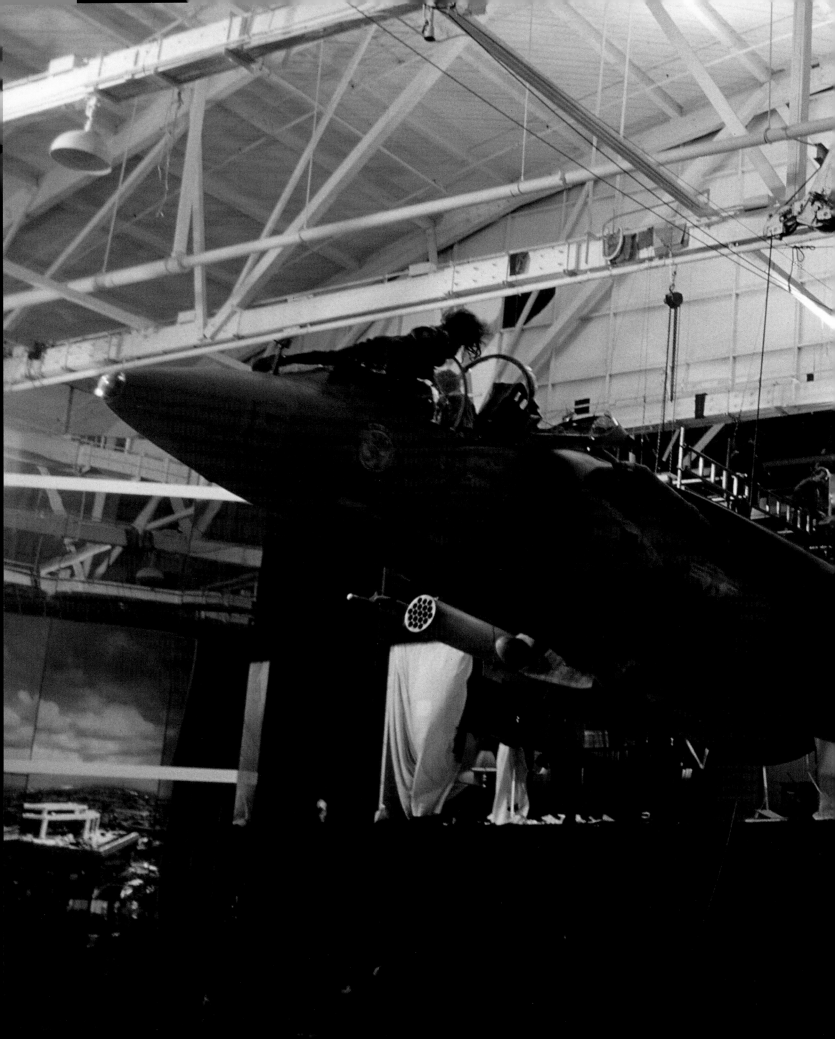

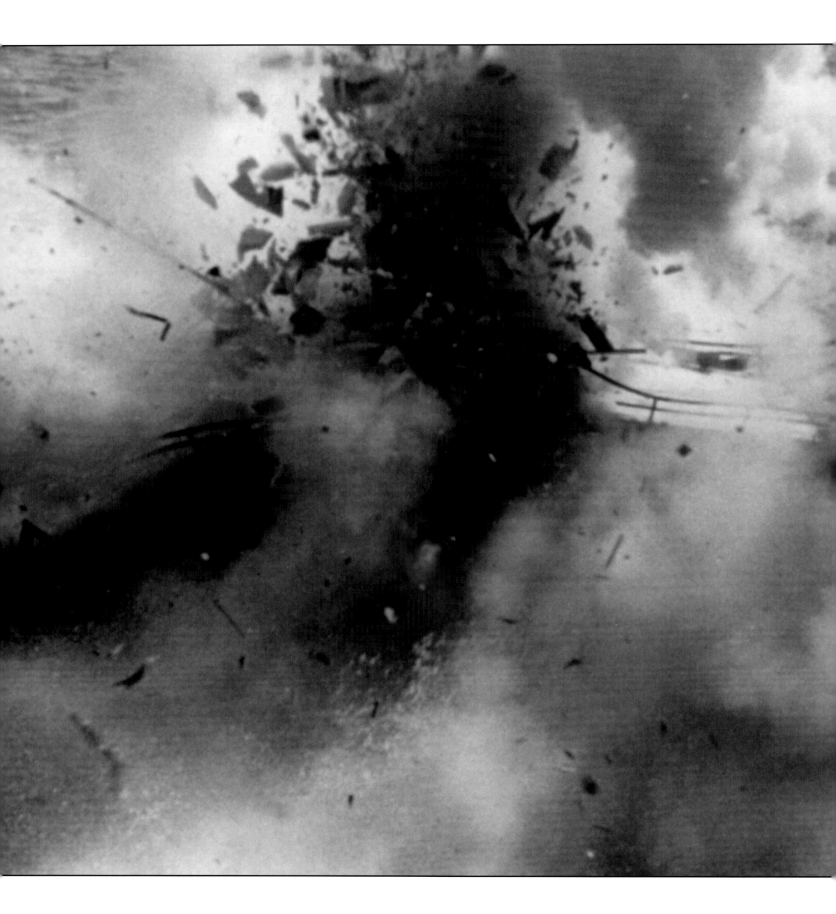

PREVIOUS PAGES
24 At Van Nuys, the full-scale fibreglass Harrier model is prepared to back into a glass office block
mock-up. The crane and other elements were digitally painted out of the final shot.

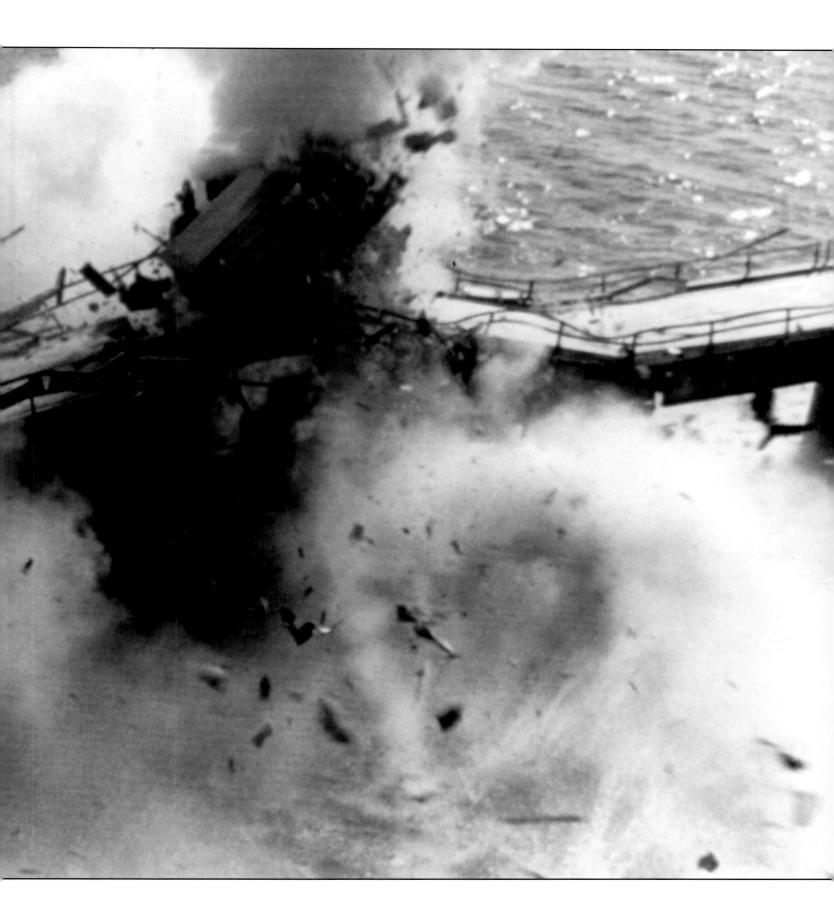

25 The destruction of this bridge miniature in *True Lies* generated countless shards of debris, all of which had to be recovered from the shallow bed of these environmentally sensitive waters.

25

25

the most stringent precautions were put in place to protect the shallow seabed from damage.

Working closely with Stetson Visual Services, miniatures supervisor Pat McClung and modelshop crew chief Leslie Ekker took on this unusual challenge. 'Our bridge needed to be made out of plaster, because fibreglass and other materials don't blow up and fragment in the same way as the concrete of a real bridge,' Ekker explains. 'But when you blow up plaster, you get a cloud of dust and fine debris. We had to promise, under legal obligation, that we'd pick up every last fragment from the seabed when we were finished.'

Prefabricated sections of the bridge were assembled at Digital Domain's craft shop. 'Then I had to work out a way to transport those pieces to Florida, unload them, get them onto a boat, get the boat out to the location and lower the slabs carefully onto the framework which had been built onto the bottom of the Key. We had eight different boats to support people working along the edges of the model. There was not a single slab broken.'

The Floridian authorities watched carefully while Ekker's crew swayed and wobbled in their boats. 'Anything to do with water is tricky, especially when your boat keeps moving relative to the model. We'd clamber out so we could stand on the shallow seabed. We spent 12 hours a day, six days a week, in water up to our eyebrows. It was just deep enough to be a pain in the ass, and it was very cold, too.'

When the set-up was finally ready for filming, the miniature truck failed to behave according to plan. 'We disabled the steering mechanism because we didn't want to blow our last take. No one could be sure how quickly it would steer. In the film, the truck goes up into a beautiful half-roll backflip and lands on the opposite side where John Bruno had placed a camera just in case something cool happened down there. That was an accidental shot; it wasn't supposed to happen.'

Attuned to the unexpected, Ekker had placed another model *inside* the model truck, beautifully constructed but never seen. 'I made a bomb casing to match the one they use in a film, a big solid case made out of wood, so it couldn't break. I felt that if the truck broke open in the explosion, you'd need to see something convincing come out of it. It was a little prop, just in case.'

And then the environmental authorities collected their dues. 'The clean-up process was exhausting because we had to take scuba equipment and get down on the bottom and pick up every bit of plaster we possibly could. That alone took us three days, working non-stop.'

THE WIDER VIEW

There is a tendency among some film producers and directors to think of special effects as part of the post-production process.

In other words, model photography or CG elements can all be dealt with later, after the much more important and highly 'artistic' business of shooting famous actors and marvellous sets and beautiful exterior locations is finished. Two types of effect tend to emerge from this at best sloppy and at worst patronising (or cost-cutting) kind of thinking.

In the first and most often employed approach, actors are filmed on location, wide-eyed with amazement at some off-screen spectacle – a huge flying saucer appearing over a Nebraska cornfield, say – and then the film editor cuts to what the actors are supposedly looking at: a CG of the saucer, created weeks or even months after the actors have departed from the film set, and with nothing but empty sky as a backdrop. Audiences can sense the lack of connection between the live performances and the effect.

The second, and somewhat better, approach is to get the CG artists to integrate their effects into the live-action plate so that the actors, the cornfield background and the saucer all appear in the same frame. No matter how good the CG artists may be, some subtle detail may still escape them if they're forced to work after the fact, so to speak. Perhaps the lighting on the actors' faces is warm in tone, and the CG saucer appears too cool, because the live-action crew kept no record of their lighting set-ups, and the CG virtual-lighting team is running on guess-work. Perhaps the shadow areas of the saucer don't match the hazy blue shadows on the farm buildings and grain stores on the far horizon, because the CG team was 'out of the loop' on important information about the director's chosen film stock and processing regime. Maybe the actors' line of sight can't quite be made to match where the saucer is coming from, but it's far too late at this stage to shoot the live-action plate again. A fundamental lack of communication between the director and his effects suppliers, coupled with a flawed attempt by a producer to 'simplify' costs, has created a failed shot.

Effects supervisor Fred Raimondi certainly found this to be the case, and it took a lot of the fun out of his work. 'Before joining Digital Domain, I had my own effects facility for about six years, and our niche happened to be TV commercials, because the money was good. But the big frustration was that the production companies would shoot their stuff independently of your efforts and then dump it in your lap and say, "Fix it". And that was terrible! I spent about 90 per cent of my time

1 A complete exterior environment is created in CG for *The Grinch*.

1

correcting errors, reconciling different elements, and about 10 per cent of the time actually coming up with something that looked cool. I wanted to get out of the office and onto the set, or out on location, so that I could get involved creatively, instead of just acting as a repairman.'

Judith Crow has seen the Hollywood film world make a definite adjustment in its thinking. 'If a movie is put together properly, there really shouldn't be any such thing as "post-production" anymore. The studios used to believe that if an effects team wanted to get in on day one of pre-production, that was just a way of bumping up the number of weeks on the show, and asking for bigger fees. I'm glad to say people have learned to see things differently.'

Many modern directors and producers understand the need to treat their effects teams as a fundamental part of the creative mix, rather than just as hired hands brought in at the last moment to solve post-production problems. Despite the additional costs, it is best for effects supervisors to be involved with a movie from the very beginning, helping the director and camera crew to plan the live-action shots to integrate seamlessly with effects shots that will be supplied not later, but in parallel. At Digital Domain, this is standard philosophy, and nothing illustrates it better than a movie the company worked on about an angry volcano.

HEAT AND DUST
In May 1980, small earthquakes shook the flanks of Mount St Helens in Washington State. The local people didn't pay it much attention. Geologically, the Pacific NorthWest region was regarded as completely stable. These minor rumbles were about the most exciting thing that had happened around there for a long time, but it wasn't the end of the world.

On May 18, the mountain exploded, and half the entire peak collapsed and fell 15 miles into the valley below. A cloud of super-hot pyroclastic gas and ash hurtled along a 17-mile-long swathe of territory like a nuclear shock wave, burning and choking everything in its path.

Fifteen years later, Universal Studios realized this was a great inspiration for a movie. In *Dante's Peak*, Pierce Brosnan plays vulcanologist Harry Dalton, despatched to a small mountain community after a US Geological Survey team reports some unusual tremors in the area. Linda Hamilton plays single mother and local mayor Rachel Wando. When the mountain overshadowing her peaceful little town suddenly erupts, the scene is set for an action-packed romance.

On the lookout for exactly the kind of integration that successfully melds effects work with live action, executive producer Ilona Herzberg took director Roger Donaldson to Digital Domain after seeing *Apollo 13*. 'Right away we realized that this was a company large enough and diverse enough to handle all our needs – everything from models to computer animation to practical effects on location.' Pat McClung was appointed visual-effects supervisor.

The effects load called for an entire town, as well as the surrounding forests and mountainsides, to look as though they were covered in grey volcanic ash; a vast plume of smoke to rise into the sky; a terrifying pyroclastic cloud to roll down a mountainside and engulf the town; and molten lava flows to menace the actors and engulf houses and cars. At the other end of the temperature scale, a major river was required to run out of control after the volcanic disturbances smash a huge dam. To reinforce the drama of this subplot, a bridge with cars and trucks was to be swept away by the huge force of the water.

The live-action photography was shot in Wallace, Idaho, a small mining town which had served as a location for the notoriously expensive *Heaven's Gate*. At first, the production team's impact on the town seemed modest enough. A few gaily coloured awnings were set up to replaced faded real ones, some window frames were repainted, and a few lawns and flower borders were freshened up to make them as delightful as possible. This all helped to establish a carefree, happy mood which the approaching catastrophe would soon sweep away. Live-action shots of Hamilton and her neighbours enjoying their peaceful life were then accomplished without much difficulty.

Physical-effects supervisor Roy Arbogast put up some new buildings (at least, their realistic façades) to mingle with Wallace's existing period architecture. The walls concealed hydraulic ramps and air pumps. 'We were literally going to shake those buildings to pieces. It was better than placing explosive charges, because everything would take much longer to disintegrate and fall down.' In fact, on the one notable occasion when pyrotechnic charges were used to help topple the steeple of a church, the collapse was so explosive that it didn't give the required impression of a collapse brought on by deep geological ground movement. It looked like what it was: an explosion. (Digital Domain's CG artists eventually removed unwanted flying debris from the shot.)

In the first two weeks of photography, Arbogast's impending explosions and collapses seemed a world away – until the time came for producer Ilona Herzberg to remind the local inhabitants, 'You understand we're now going to cover your town in ash?' Nobody batted an eyelid. When Mount St Helens erupted, Wallace suffered a gentle but prolonged, sinister snowfall of grey ash, even though the source of the explosion was more than 300 miles away. 'Just make sure you clean up before you leave,' the citizens of Wallace said.

Under Arbogast's supervision, several tons of grey paper were ground up to make 'ash', and loaded into blowers normally used to throw insulation into roof and wall spaces. The entire town was covered. For live-action shots requiring ash to fall from the sky, air mortars scattered the material across a quarter of a mile, to settle on rooftops, cars, trees – and actors. All day long, the mortars fired prior to each camera set-up. It wasn't long before the gathering clouds became almost as bothersome as the real thing.

For wide shots, however, it wasn't remotely practical to cover dozens of square miles of Idaho in ash. Compositing supervisor Gary Jackemuk came up with a method of draining the colour from distant background forest and mountainside scenery to match the drab grey tones of the townscape. Because those foreground elements were already made grey by the fake ash, Jackemuk needed to leave them untouched. They were protected, painstakingly, frame by frame, often with digitally rotoscoped mattes – a reminder that high-speed computers don't necessarily take the drudge work out of visual effects.

The ash clouds are just a forewarning of worse to follow. Eventually, the super-hot shock wave of volcanic destruction will sweep across the town. And then the lava.

2-4 To simulate the moment when a volcano blows its top, pyrotechnic explosions are photographed as live action for *Dante's Peak*. These shots were then composited with foreground street scenes shot at full scale.

5-6 Foreground buildings in Wallace, Idaho, were covered in fake ash. Background trees and hillsides were digitally altered during compositing.

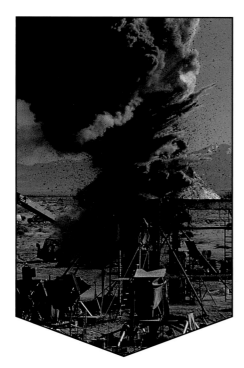
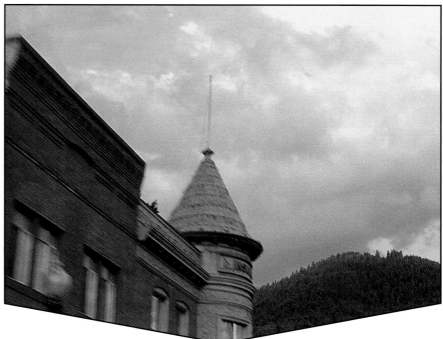
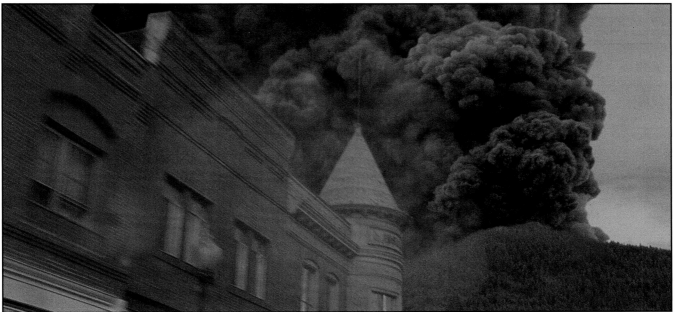

FOLLOWING PAGES
7-8 The huge 'miniature' for *Dante's Peak* is prepared.

7

8

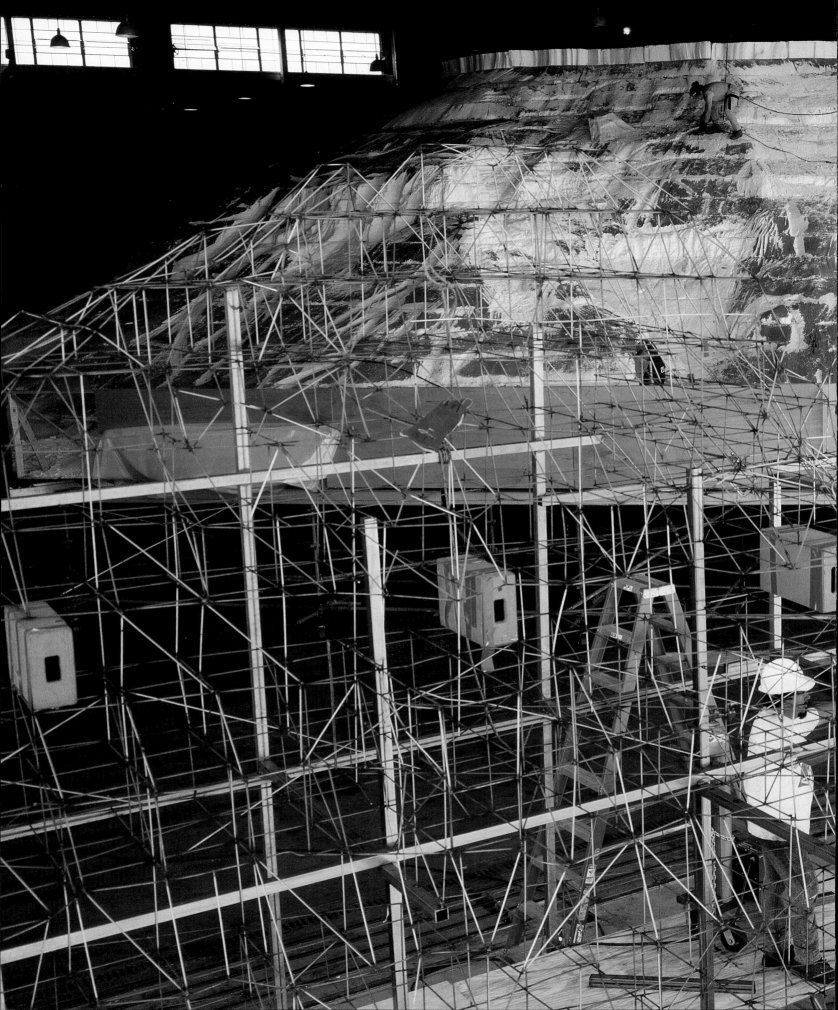

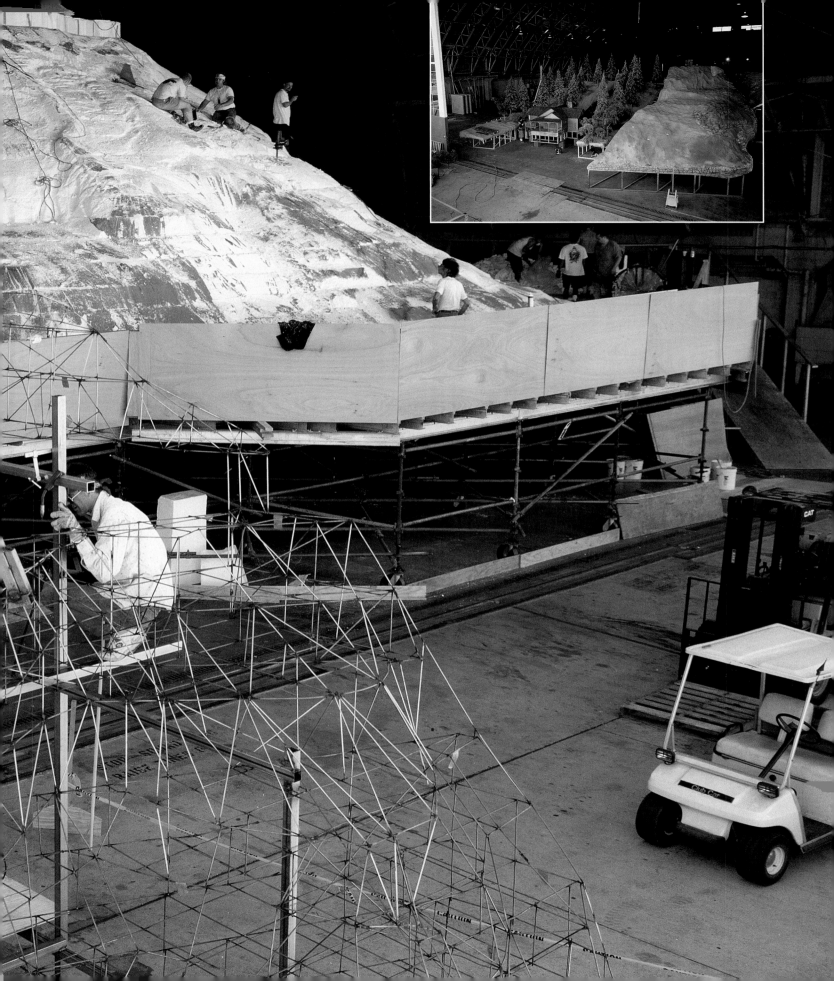

A padded screen, illuminated from within, casts an appropriate glow so that CG lava can be added later.

Background interior details and additional practical and CG flame elements are composited into the shot, along with CG lava to replace the mat.

An illuminated pad bursts through the back wall of a mountain cabin.

The CG lava incorporated a fractal routine to melt, solidify and remelt the black crust, constantly cracking it into random shapes.

MOLTEN ROCK

In the earlier chapter on motion control, we saw how Donaldson's jerky, hand-held camera technique gave *Dante's Peak* a raw, edgy sense of panic, and how Digital Domain's motion-tracking software was able to lock the CG lava effects onto those sequences later. However, it wasn't enough merely to create convincing CG lava flows and then composite them onto the live action, and the reason is simple. Lava glows like super-hot liquid coal. It lights up its surroundings. What's more, the quality of the light changes second by second as the lava folds over itself and dark crust forms over the glowing morass, then breaks, then forms again. To pre-empt this difficulty, a stream of lights, covered by translucent red filter sheets, was set up on location, along the supposed flow path of the lava. When switched on, the lights cast a fiery red glow onto the rocks on either side of the path. The set-up gave the impression of a series of red-glowing blow-up mattresses strung up a hillside as part of a bizarre Christmas fiesta.

At first, the plan was to control individual lights under the red sheets and create a sort of Mexican wave of travelling illumination, over which appropriate CG lava effects could be superimposed. In a classic demonstration of successful integration between live action and post-production effects work, 3-D digital-effects supervisor David Isyomin was on hand to rethink this proposal. 'Of course we had to make the practical lighting appear to move in step with the lava, but if we were going to solve this on location, we didn't want to string up the lights and then be locked into their exact on-off patterns, because we might want to vary the speed of the CG lava flow that we'd be creating later on. The solution was to shoot two live-action plates, one with all the lights switched on,

and one with them all off. Back at Digital Domain, we created mattes that could sweep along the lava path, switching the lights on and off as needed, to make it look like the CG lava was lighting up the surroundings as it went.' It was as if the CG crew were able to reach into the real-world environment of the location and alter it. Portable green screens took this apparent interaction even further.

The script called for a surge of traffic to try to escape the town when the folly of staying at home becomes all too clear. A section of elevated freeway running through the town was supposed to collapse because of severe earth tremors caused by the volcano's awakening. Vehicles fleeing one disaster are caught up in another as the freeway collapses. Pat McClung was in luck: 'Fortunately, Wallace really did have a freeway running through it, raised about 30 feet off the ground. For

shots taken from inside cars of the other cars outside, we built short sections of ramp that could take the weight of ten or twelve additional vehicles, and those sections could be made to collapse.'

But that was the extent of the effects crew's authority to disturb Wallace's road map. They could hardly be allowed to destroy a real freeway. Instead, for wide shots showing the overall extent of the catastrophe, Grant McCune Design was hired to build an exact quarter-scale replica of Wallace's share of the freeway, along with quarter-scale trucks and cars. Miniature-photography expert Les Bernstein then shot McCune's model in the studio against a green screen. Sections of the model were rigged with specially weakened 'shear pins' to control its collapse, and Bernstein speeded up his camera so that, on viewing at the normal 24 frames per second, the

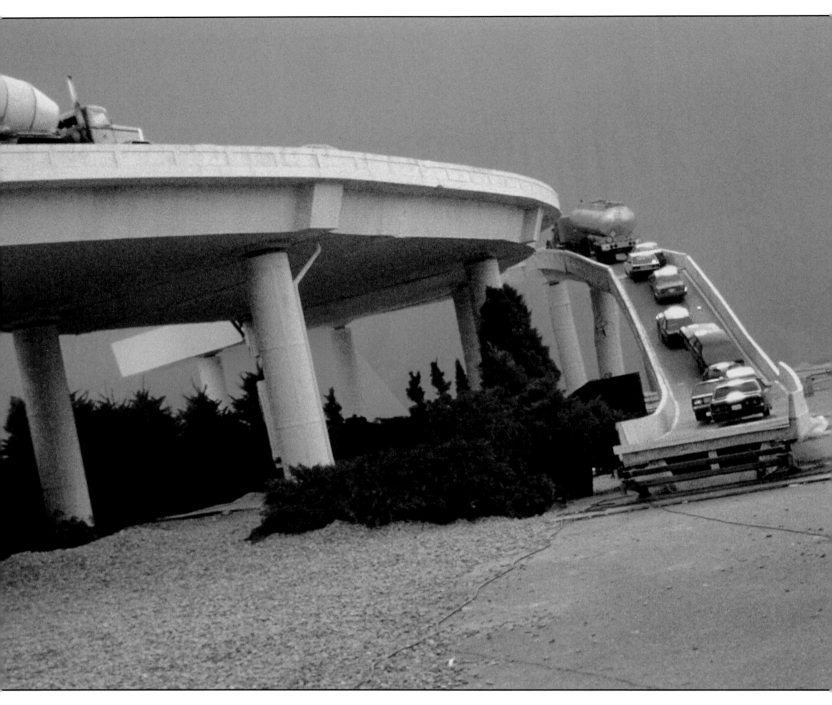

model would appear to collapse slowly and ponderously, in keeping with gigantic chunks of reinforced concrete suddenly not being quite so reinforced anymore.

Meanwhile, out on location, the full-scale foreground action of cars fleeing onto the real road was filmed. In the background there was a large sheet of green-screen material, suspended by metal scaffolding. Real cars and actors could do whatever was necessary in front of the screen (which was too many feet away from them to create any green-spill problems). Literally, the techniques of a green-screen studio had

been taken on location.

Back at Digital Domain, the motion-tracking software grabbed onto a relevant set of reference points in the constantly moving frame of the scene: the edges and corners of a building to the right, a freeway entrance signpost to the left, and so on. The model shot was then inserted into the blank green-screen area. Full-scale live action and miniature photography were seamlessly combined, but only because the company's effects supervisors were on hand from the start of filming *Dante's Peak* to help plan the shots far in advance.

9

10

PREVIOUS PAGES
9-10 Real cars were shot under red lighting, then composited with CG lava and flames.

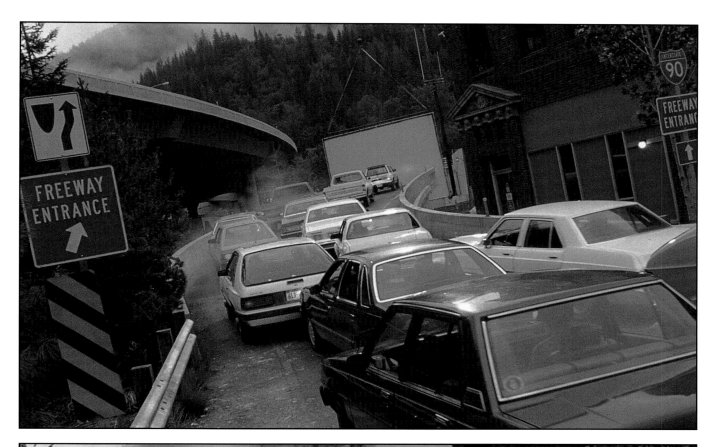

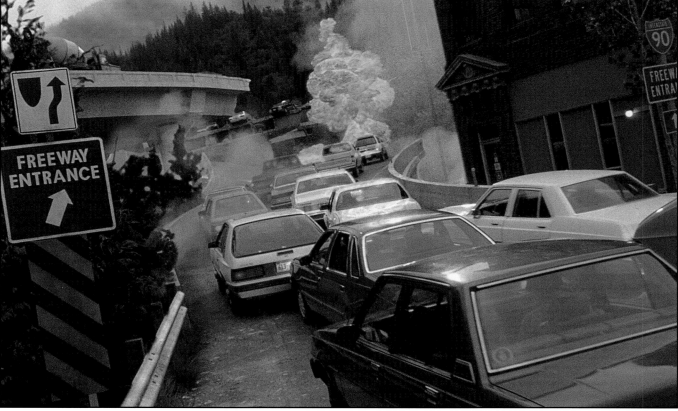

11–13 A miniature freeway ramp, with cars to scale, was shot in the studio. A green screen on location facilitated the composite.

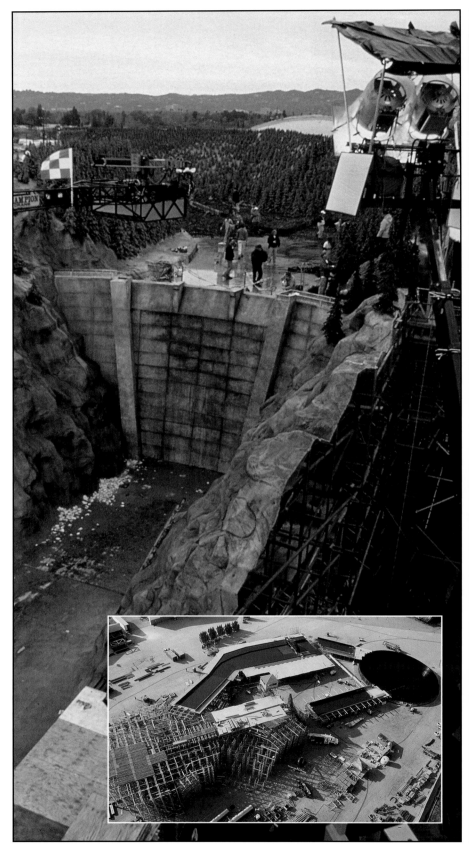

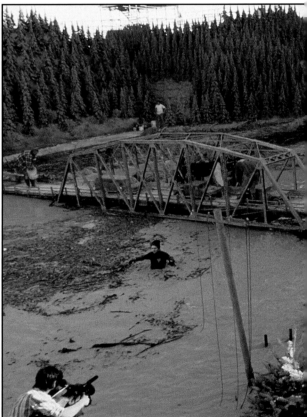

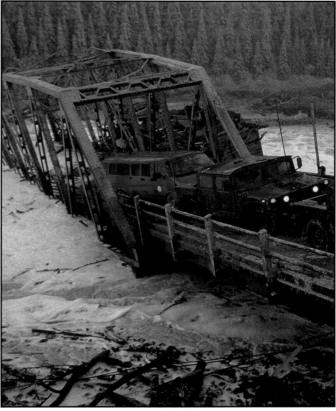

ROUGH WATER

Dante's Peak explodes, an entire mountainside of snow melts within hours, the local dam bursts, the river floods, and cars on the bridge are swept away. This effect called for a 650,000-gallon tank of water to be constructed (by Dean Miller) at the Van Nuys facility, with sluices that could feed into 1/3-scale models of the dam and the stretch of river crossed by the bridge. The two floods, dam and bridge, were shot separately, but it made sense for them both to be fed from the same tank, at the rate of 150,000 gallons per minute. After each take, all the water was collected in a run-off tank at the other end and pumped back into the main holding tank for another shoot.

Alan Faucher's team built a landscape of hillsides dotted with 10,000 miniature synthetic trees. The 30-foot bridge model was weakened with soft lead spars at key points that would twist realistically at 1/3 scale, like steel girders being hit by thousands of tons of water.

This set-up had to be vast, because real water does not scale down well for miniature work. Foam, raging torrents and white water cannot be created in small tanks. The other option, going digital, would have been impractical (at least, in the given time frame and budget) because of the many interacting elements: the cars, the bridge, many floating trees and logs, plus the dam debris, all interacting with the water.

Shooting could only take place just before sunrise, or just after sunset, while the sun was below the horizon. Bright daylight would not have matched the overcast conditions supposedly caused by huge clouds of volcanic ash in the sky.

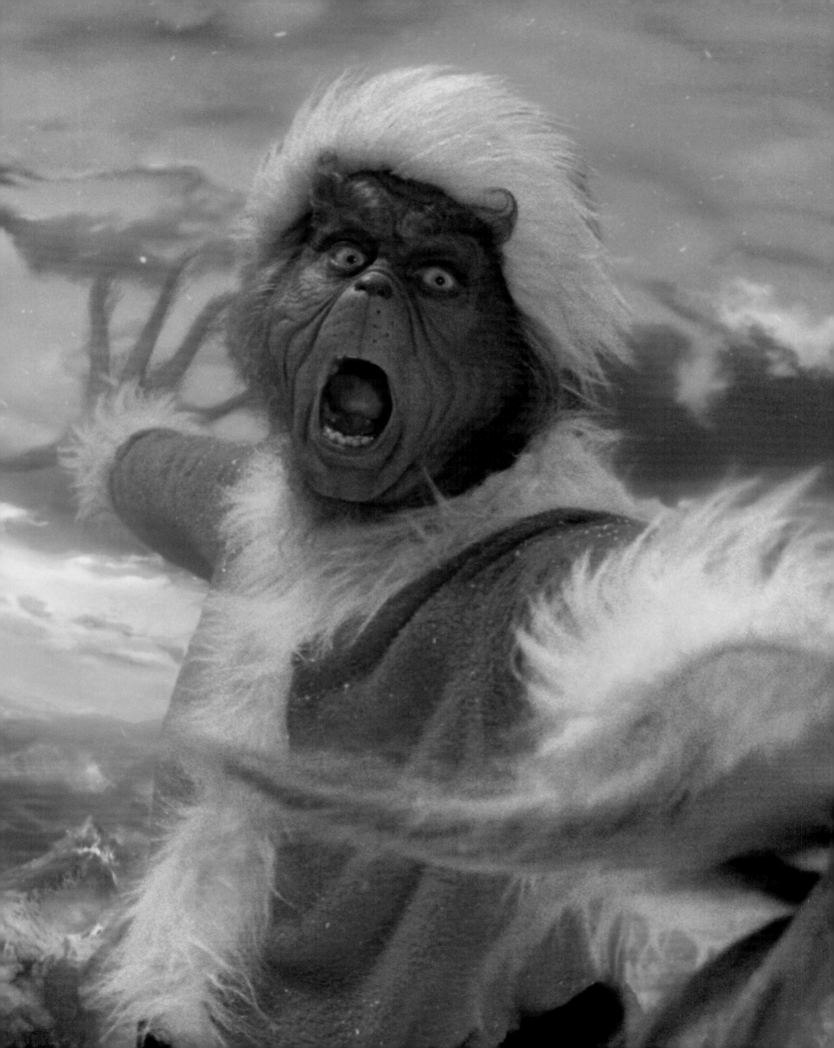

GREEN DEMON

In 2000, Digital Domain worked on another movie featuring a snowcapped mountain with a dark force buried within it – a dark green force of mischief and malcontent. Director Ron Howard chose as his subject one of America's all-time favourite children's books, *How The Grinch Stole Christmas*, originally conceived and drawn by Dr Seuss 40 years ago and perennially popular ever since.

The plot of the film is simple enough, and charming. In the snowy mountain town of 'Whoville', elf-like 'Who' people live a charmed life of fun and frolics, and the film catches up with them just as they're preparing for a great Christmas 'Who-bilation', with feasting and singing, and huge bundles of giftwrapped presents ready to be delivered to all and sundry.

Alas, one slightly odd Who, a green furry creature known as The Grinch because of his sour nature, has exiled himself to a cave deep inside nearby Mount Crumpit. Long, long ago he was teased for his strange appearance, and at that same fateful time, he was disappointed in his love for a little girl, Martha May Whovier. Now he lives only for one thing: revenge. He plans, literally, to *steal* all the Christmas trappings and gifts from Whoville while the folk are all asleep on Christmas Eve. Disguising himself in a Santa Claus outfit, and dressing his sceptical canine companion as a single-antlered reindeer, he sets off in a rickety motorized sleigh that's half rocket, half curmudgeonly pile of junk.

After the Grinch has returned to Mount Crumpit with the stolen presents, he looks forward to going outdoors on Christmas morning so that he can gaze over a miserable Whoville and enjoy the faint but still discernible cries of despair drifting on the wind as the townsfolk awaken to a cheerless dawn. Instead, he hears them singing and celebrating loud and clear, as though nothing has happened, and he realizes there's something about the Christmas spirit that can't be spoiled just because he's incinerated the big Christmas tree in the town square and made off with everyone's presents. In a flash of understanding, his mood lifts, his heart swells, and he determines to put back what he's stolen.

The energetic comic actor Jim Carrey played the Grinch: his second appearance in green after *The Mask*. Make-up supervisor Rik Baker devised a Grinch headpiece that allowed Carrey's distinctive physical humour and facial expressions to shine through from within the funny-grotesque costume – an important consideration given that Universal Studios had paid more than $20 million for Carrey, a proven box-office draw, and at first weren't too keen on the prospect of concealing his face behind Baker's elaborate prosthetics. Ron Howard was more concerned at a practical level: could Carrey be expected to act through the dense layers of his costume? Looking at a test shot, he reckoned that, just for starters, the eyebrows on the mask moved in too exaggerated a style, and audiences would be distracted by this cartoonish excess. But Carrey had merely been furrowing his own eyebrows. The prosthetics stayed. It was a decision that required great commitment from the actor, who found the confinement, the heat, and the weight of his fur suit and latex mask unbearable. Sometimes he would rush off to his make-up trailer clawing at his face, like a man terrorized by a cloud of bees. He persevered bravely throughout 92 days of on-set photography, and his

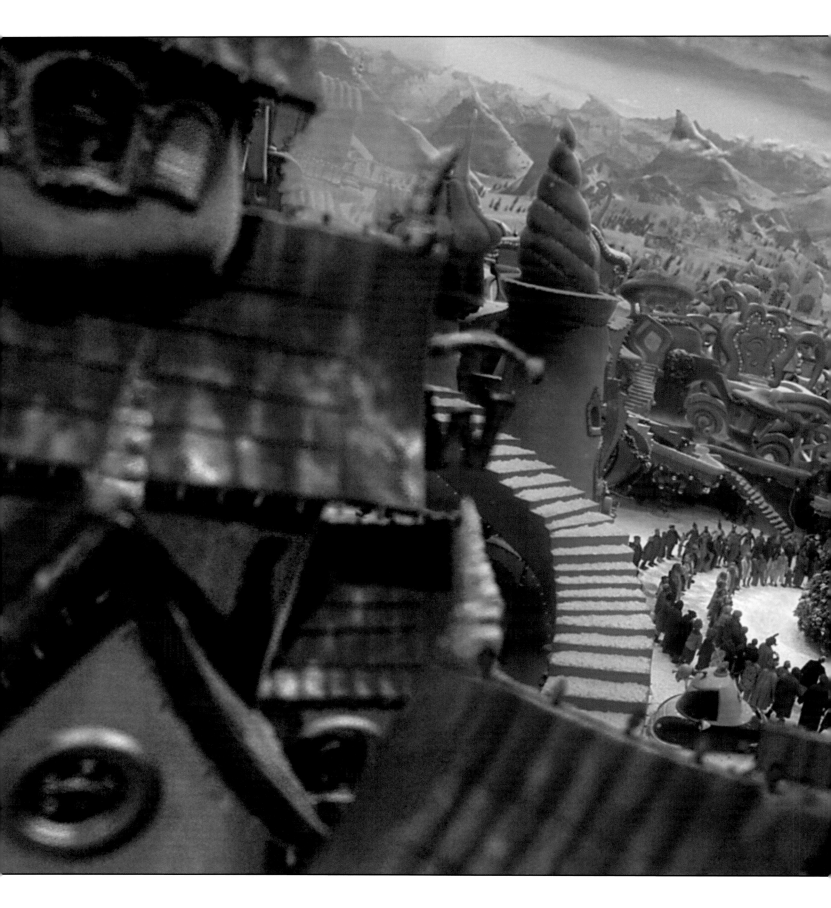

14

PREVIOUS PAGES
14 The Grinch in a characteristically tetchy pose.

15 A circle of mainly CG Whos in a mainly CG town celebrate Christmas.

15

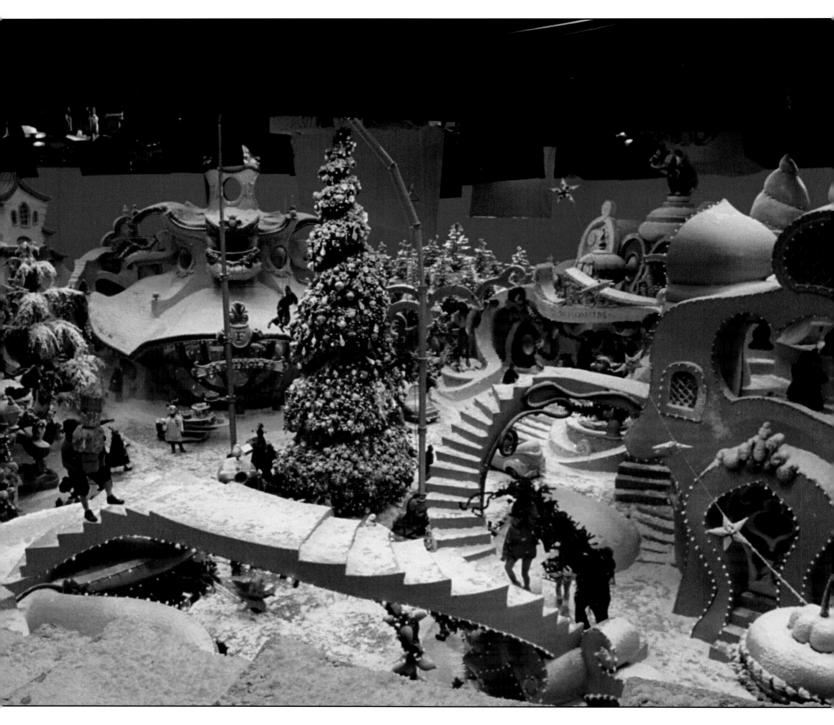

performance really did 'shine through'.

Baker also created a make-up regime for the Whos, with perky noses and elf-like facial features that were sufficiently human to allow actors to express themselves while still looking distinctly 'Seussian'. An entire second sound stage was occupied full-time by 60 make-up stations, dressing upwards of 100 Whos every morning. It was the largest makeup and prosthetics challenge since the 1968 film *Planet of the Apes*, and by a neat coincidence, Rik Baker's next assignment after *The Grinch* was to produce the ape costumes for Tim Burton's remake.

Retaining the unique, zany mood of Dr Seuss's original drawings was essential if the movie was going to be accepted by American audiences already acclimatized over three generations to the style of the original book. This was a substantial challenge for production designer Michael Corenblith, who had to build the principal Whoville set as a three-dimensional real-life rendition of Seuss's two-dimensional

16 The full-size live-action set of Whoville was surprisingly small in comparison to what appears on screen.

17 The Whoville set after the addition of CG extensions, CG terrain backgrounds and CG characters. Which characters are real, and which ones CG?

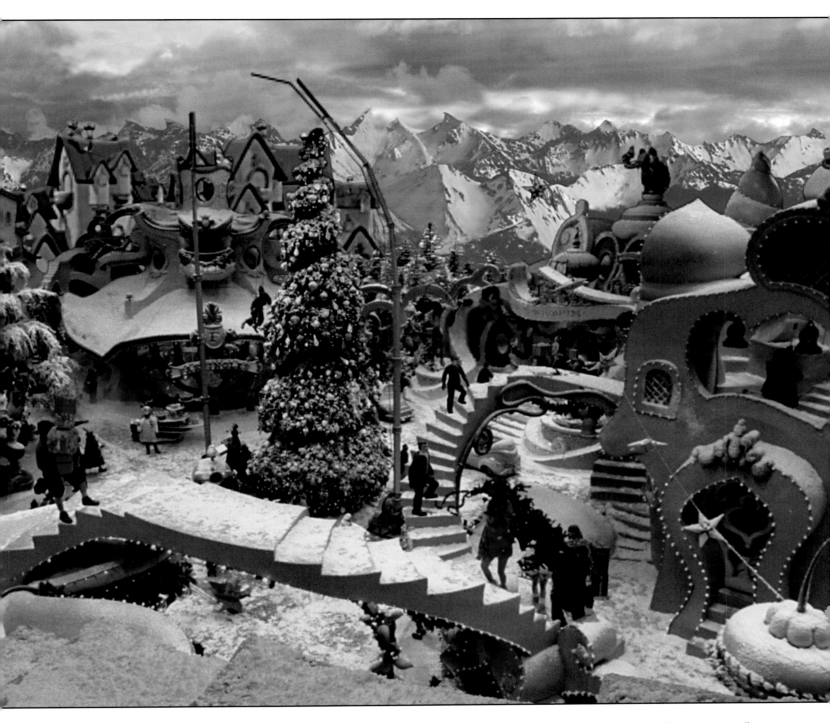

cartoons. Apart from the physical sets, lighting played an integral part in creating the right environment. Because this was a fantasy world, shooting on location wasn't appropriate. A huge sound studio on the Universal lot was commandeered, and the kernel of Whoville was assembled at full size.

But even the hugest studio building won't accommodate an entire town. Less than a dozen separate buildings, representing the very heart of the community, could be accommodated as life-size sets. How to create the wide views of the 'suburbs', the swooping aerial shots, the surrounding mountainous landscape? For a while, Howard thought he might shoot tight on his actors and the small cluster of complete buildings that the sound stage could accommodate, and then pull wide for those shots where additional CG elements would be needed to flesh out, as it were, the broader scenery. This didn't seem entirely satisfactory. In fact, Brian Grazer (Howard's long-time production partner) had a terrible dream one night that the entire movie was on the verge of

becoming 'stagey', like a one-set theatrical play inappropriately transferred to the screen. Digital Domain's senior vice-president Nancy Bernstein had already been hugely influential in setting up the *Grinch* visual-effects deal, and now she and visual-effects supervisor Kevin Mack asked Ron Howard to be very trusting and take a risk: shoot as wide as he liked all the time on set, and move the camera in any direction, regardless of the incompleteness of the physical surroundings. Bernstein guaranteed that CG set extensions would fill in the gaps, including more than 30 additional buildings. There would be no need for painted backdrops, and no need for the camera to pull in tight if Howard didn't really want it to. This *was* a gamble, but Howard agreed that wide-angle photography suited the mood of the film much better. What's more, he decided on a camera style with a subtle weaving movement even in scenes that might appear, at first glance, to be locked-off shots. A slight, almost drunken, drift of viewpoint throughout *The Grinch* enhances the sense that we are in a strange otherworld, but it's never obvious enough to be intrusive. It's a subliminal effect that nevertheless required the CG artists to motion track every frame throughout most of the movie.

Once these decisions had been made (and well ahead of the start of principal photography), virtual set extension expert Vernon Wilbert and his team adopted the mindset of town planners: here would be the dormitory suburb seen in the distance, here the downtown entertainment centre, and here, the gas station and utilities district. In an echo of Mark Forker's warning to CG modellers not to build everything as if brand-new, Corenblith wanted some buildings to look as though they'd been in place for a long time, while others were to appear more recently constructed. Constant cross-referring between Digital Domain staff and Corenblith's art department enabled a range of CG architecture to be designed to match perfectly the mood and texture of the on-set buildings.

The problem for everyone, CG and practical set builders alike, was that the Seussian world, which is so lively and entrancing on the printed page, was hard to translate into three dimensions. None of the walls are flat. Strange staircases and bendy bridges swirl off in odd directions, and there are no sharp corners. Somewhat to their surprise, Wilbert's team found themselves modelling houses out of curvaceous NURB patches.

18 The Grinch incinerates an L-systems tree.

19– Whoville, showing blue-screen additions, and a number of CG characters included in the scene.
20 Note the temporarily unrendered unicyclist on the left.

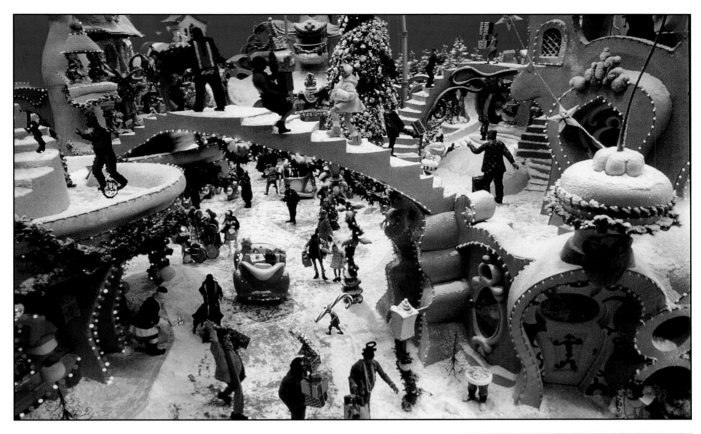

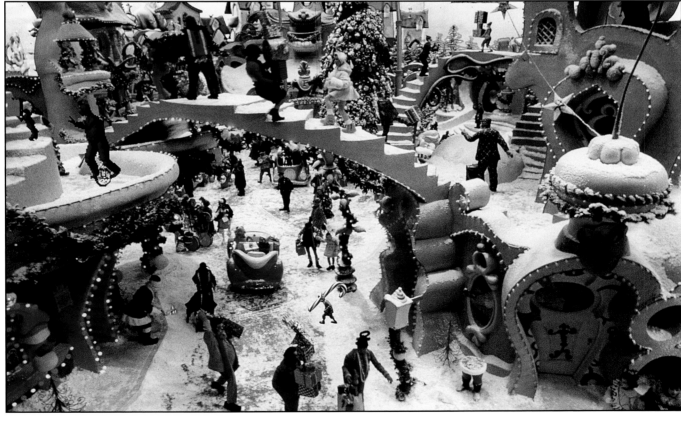

FOLLOWING PAGES

21 One of the many multi-plane skies digitally created by Martha
Snow Mack and Shannan Burkley.

21

22–
25
Mount Crumpit, with its exaggerated peak. Mountainous terrain for *The Grinch* was created by constantly swapping data between several different types of software. A basic mesh landscape was created in Maya from NURB patches. Houdini software then applied procedural routines to deliver natural-looking jagged rock surfaces, and RenderMan shaders added colour and texture, while an adapted virtual-lighting routine simulated the snow.

PROCEDURAL SNOW

The surrounding mountainous terrain was built using a complex combination of geometry interfacing with procedural shaders. In an earlier chapter, Kevin Mack told us that 'shading and rendering are indistinguishable, in some cases, from the underlying geometry of the model'. Referring to the *Grinch* landscape, Butler says much the same thing: 'The shader became impossible to separate from the topology.'

Vernon Wilbert describes how the landscape was constructed. 'We took a NURB surface and obtained the overall contours of the terrain. Then we swapped out the NURB for a polygonal mesh so that we could get some harder kinks and crags in there. But so far, we're dealing with a model that looks "manufactured", and we needed to get a much more natural feel. We took the whole thing and put it into a procedural software program that applied random, fractal, chaotic deformations to the geometry. Then the shader team took over.'

The colours and rock textures for such a dauntingly complicated surface couldn't possibly be derived from conventional 'maps'. Procedural shaders had to be written. Snow was a particular problem, because no one was quite sure what rules a snow shader should follow. Snow couldn't be wavy like water, and it couldn't be dune-ish like desert sand, and it couldn't be sharp-edged like rock, and it couldn't simply fall straight down from the sky to make neat, flat layers, so how *should* it behave? Shader team leader Johnny Gibson realized that 'we could "shine" snow onto the surfaces just as though it were a light'.

On any mountain, snow will lie more deeply on the slopes where the wind is strongest. Also, flat rock terraces will be more heavily covered in snow than slopes, and the steepest rock sides will barely be touched, because the snow will fall off as soon as it hits them. These directional qualities are not unlike the behaviour of light. The virtual-lighting kit was instructed to bathe the mountain in a fairly hard illumination, but instead of rendering those areas merely as 'brighter' than others, the shader was instructed to map snow in depths that varied according to the 'brightness' levels. Adjustments to the rules in the virtual-lighting set-up enabled the physics of snow drift and settling to be emulated with startling success.

Mount Crumpit itself didn't obey quite such realistic rules. It was conceived as a ludicrously high peak topped by a summit that leaned to one side, like the tip of Scrooge's nightcap.

All of the landscape, including the lower slopes of Mount Crumpit, required many thousands of trees, but it was not practical to grow each one procedurally in L-systems, down to the last branch. Instead, simple approximations were created that were nothing more than trunks surrounded by conical shells. Branches were painted on two-dimensionally with texture maps, while opacity maps created gaps through which background landscape details could be seen. A library of 14 trees provided all the variation that was needed (rather like the instanced dendrite in *Fight Club's* brain sequence).

The sky was an important fantasy character in its own right, echoing the Grinch's capricious moods. Martha Snow Mack and Shannan Burkley created digital matte paintings that made two-dimensional weather effects appear three-dimensional. Clouds were painted onto a large pan and tile environment, so that the appropriate area of sky would come into view whenever the virtual camera's point of view was altered.

FOLLOWING PAGES
26 The final shot of Mount Crumpit with all the CG elements composited into place.

26

The trick is that many separate layers of cloud could be super-imposed in different positions relative to each other, to give the impression of foreground clouds moving in front of more distant ones. Unlike the ever-shifting and genuinely three-dimensional perspectives of CG foreground scenery, which needed to be recalculated and rendered anew for every frame of footage, the essentially 'flat' sky elements needed only a single render, and could be called up ready-made at any time during compositing. When the virtual camera's point of view shifted across the sky, a plug-in to the compositing software automatically simulated realistic lens curvatures at the edge of the frame, enhancing yet further the sense of depth perspective.

It comes as no surprise to hear Kevin Mack say, 'This movie completely dissolved the boundaries between working in two dimensions, three dimensions, and matte painting.'

PICTURING THE INVISIBLE

Meanwhile, at the Universal live-action studio, the majority of shots took in light fixtures, rigging, and vast areas of blank blue screen. Matthew Butler was Digital Domain's CG supervisor for the project. 'The sets were bounded almost 360 degrees around by blue screen, and we had to take them out of that by extending the architecture of Whoville, the surrounding terrain, and, of course, the sky, and a huge Mount Crumpit lurking in the background. It was a total environment, seemingly with no bounds.'

On set, previsualization software enabled Howard and his camera crew to see, on a video monitor, how the final composition would look. Although by no means rendered, low-resolution versions of the CG set extensions and mountain backdrop were prepared in advance of principal photography, and temporarily composited with a video image feed from the Panavision camera. Whenever the camera was moved, the CG elements shifted appropriately on the monitor. After a while, despite the blank screens surrounding them, everyone on set soon 'knew' whereabouts Mount Crumpit loomed over the town, or which direction was supposed to be north and which south.

Mack was also pleased with the tight correlation between his effects team and director of photography Don Peterman's studio lighting riggers. 'This movie was shot entirely under stage lights, but the scenario is that most of the action takes place outdoors, under a sky. It's quite a shock when you realize that.' Digital manipulation of the highlight and shadow ranges delivered a flat wintery look to the film that would not have been easy to achieve in the studio without risking underexposure.

Again, precise planning and integration was vital, as Butler explains. 'We had excellent communication for *The Grinch*, because Kevin Mack was out on set all day. His information was then passed very accurately to all the other people who needed to know.' For instance, as live-action photography got under way, the tricky subject of snow came up yet again, raising important issues of time, money and personal safety.

Falling snow is often and easily faked in a film set, and *The Grinch* featured plenty of it, but Mack, Butler, effects producer Julian Levi and compositing supervisor Bryan Grill decided against using the conventional method for shots that involved blue screens. 'When there are additional elements to be

27 Jim Carrey in full cry on a small set representing the entrance to his mountain lair. Everything else (including the gloomiest and coldest weather) was added later.

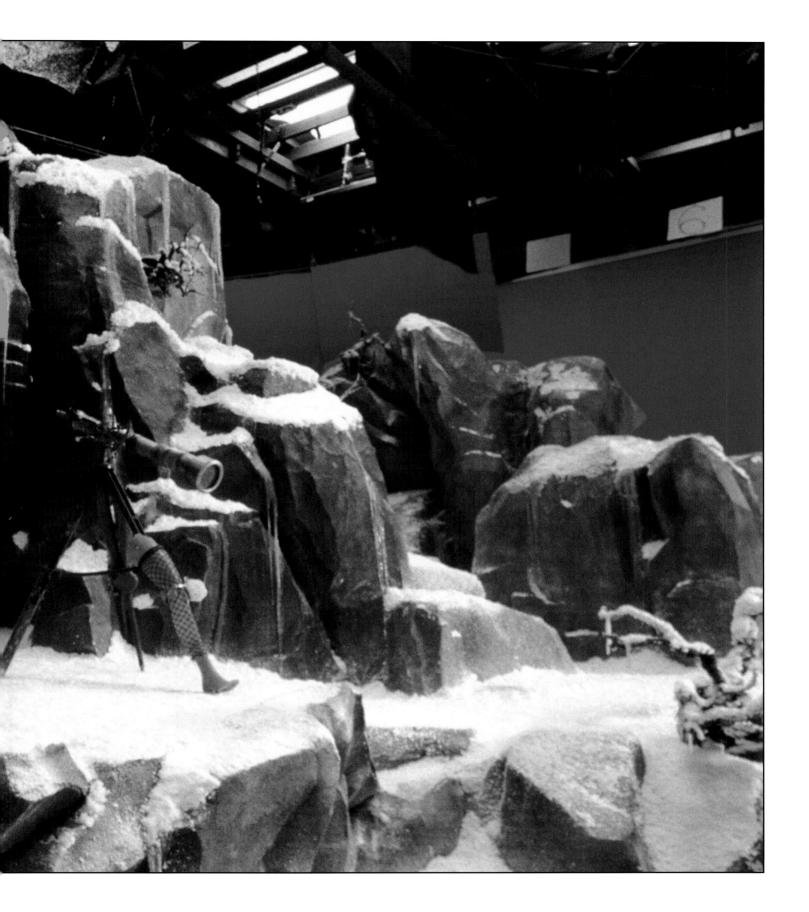

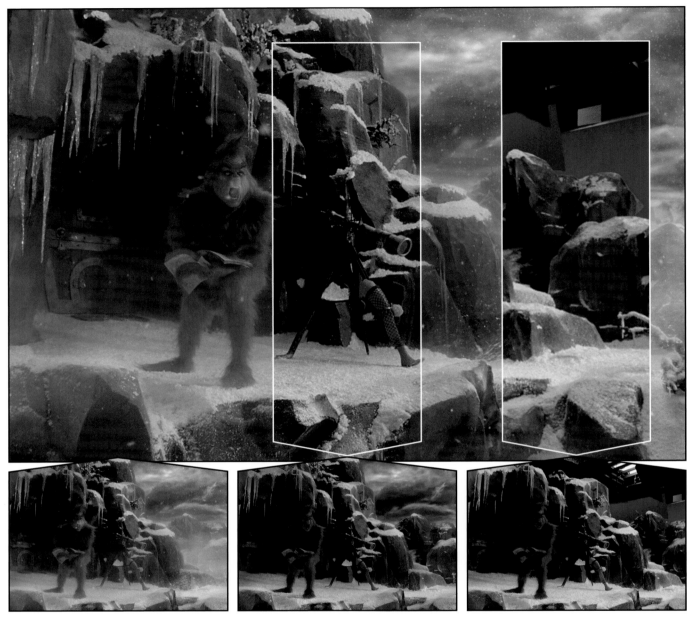

FINISHED SHOT
With CG extensions, the effect is complete. The scene also includes CG weather effects and CG distortions applied to the Grinch's fur, to create the visual impression of blustering wind.

LIVE ACTION AND BLUE SCREEN COMP
Live-action footage is combined with CG clouds to create the final pre-weather shot.

BASE SHOT
Live action of the Grinch is shot on set using compensated lighting and blue screens. The background is clearly visible so that CG clouds can be dropped in later.

composited later, you have to be careful about using practical snow falling on the set itself,' says Butler. 'If you don't have clear sight of your blue screen, you can't get a matte, and even painting out stray cables and rigging becomes a nightmare. So, wherever possible, we opted for adding snow and weather effects digitally. We built terrain maps of the scene so that the snow in particle systems would settle in the right place, or extinguish at the right point. It was better than rotoscoping through a blizzard. That's just one of countless decisions we needed to work out in advance with Ron [Howard] and his

studio team, otherwise we might have got into all kinds of trouble later.'

The drawbacks of fan-generated wind were not so obvious until shooting began. Jim Carrey was wearing larger-than-average contact lenses to give his eyes a sickly yellow cast. The slightest hint of dust, the merest whisper of a breeze, and they became irritated, causing the actor considerable distress. Mack promised that his team could solve the problem later, implying the presence of wind ruffling through the Grinch's unkempt fur by CG and during compositing, and without

28

28 The Grinch tries to ruin the Whos' party by setting fire to their communal Christmas tree.

FOLLOWING PAGES
29 With help from particle systems, leaves and branch tendrils
shrivel into soot, then fall to the ground.

29

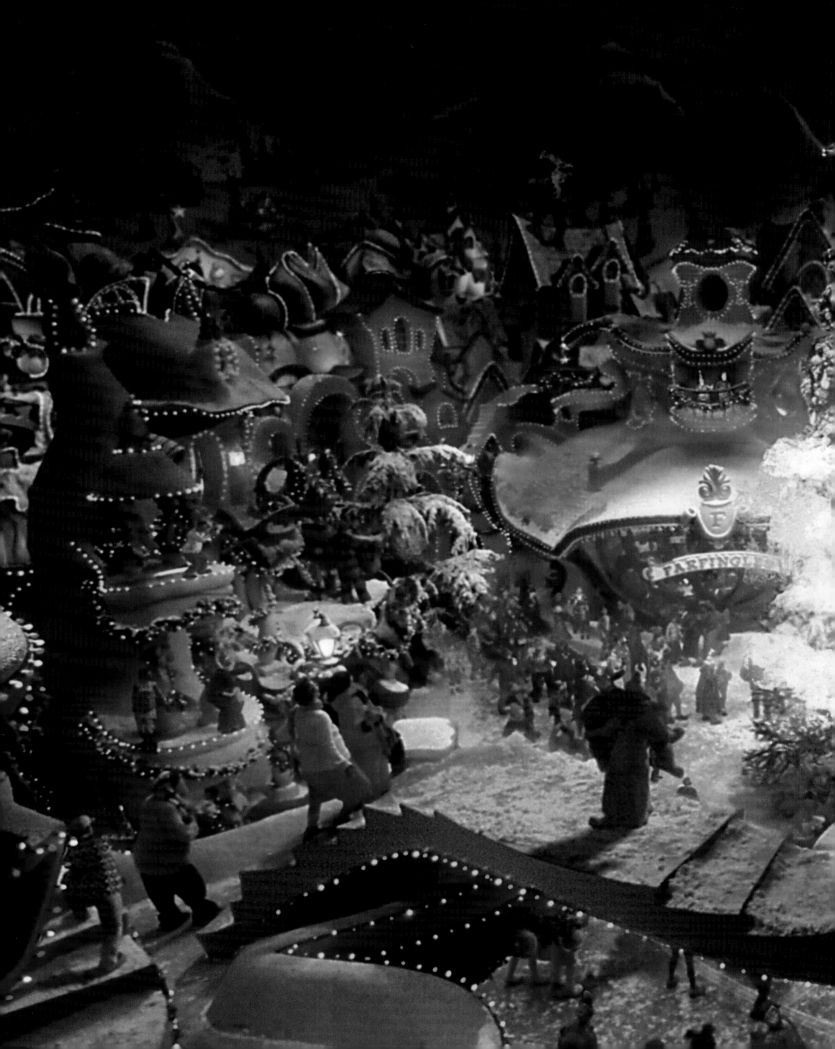

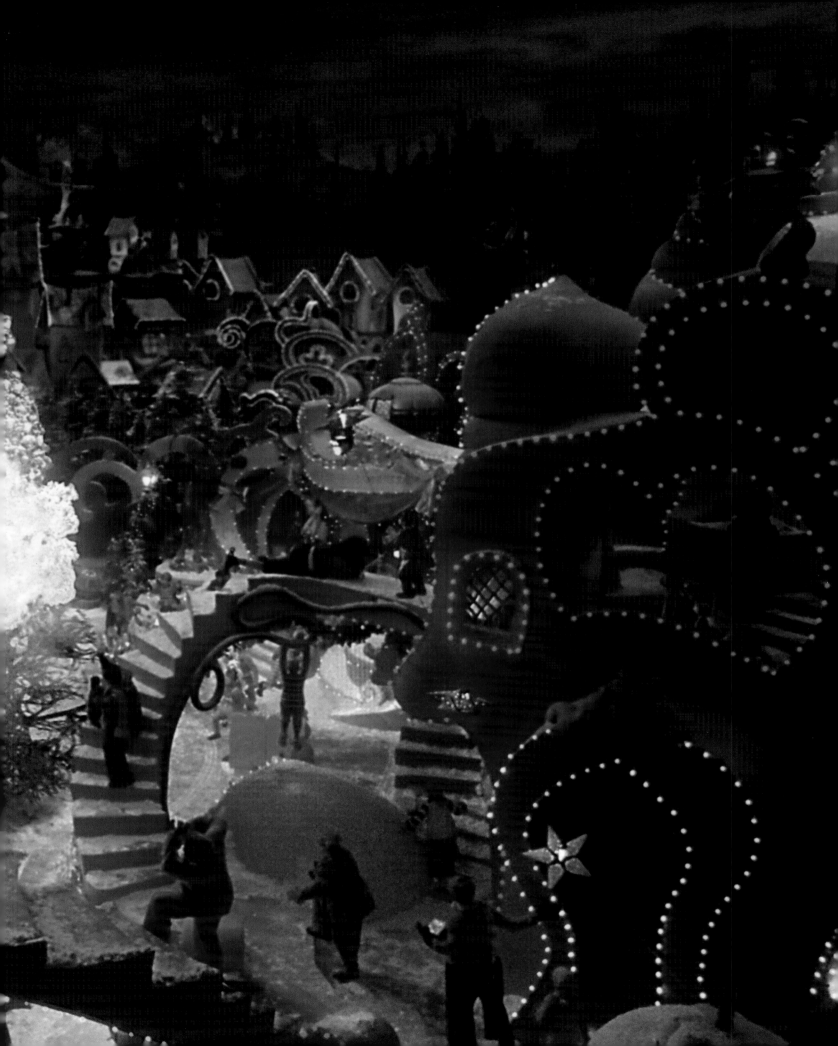

recourse to fans and blowers. Compositing supervisor Bryan Grill explains how this was achieved. 'You can't see air itself. You can only see the effect that it has on dust and smoke, snow, the waving of tree branches, and fur. If you can simulate those movements visually, then you don't actually need the air current. The "wind" blowing on the Grinch was a procedure acting on CG enhancements to his fur.'

There remained plenty of real fur at the edges of the costume that had to be matted out for compositing the backgrounds. 'Our main character is jumping about in front of a blue screen during about 200 shots, and he has long stringy hair. That's the compositing challenge of a lifetime,' says Grill.

As the list of CG solutions grew and grew, some of the people on set wondered if it was all too much to pull off. At one point, *Grinch* executive producer Todd Hallowell stared disbelievingly at the huge expanse of blue screen, where no mountain could be seen. He looked up at the studio ceiling in which no sky was evident, and from which no snow could ever fall. Then, turning his attention to the distant suburbs of Whoville that were nothing more than wireframe rumours on a video monitor, he turned to Kevin Mack and asked, 'Are you sure about all this? I hope you know what you're doing.' Mack assured him that he did.

GRINCH GAGS

Not every effect for *The Grinch* was derived from complex computer imaging. In movie-making, a 'gag' is a visual illusion so simple it's almost laughable: hardly a 'special effect' at all, more a cheeky camera angle or a prank with mirrors. The word 'gag' is probably derived from pre-cinema vaudeville routines and magic shows. (British movie technicians call gags 'trick' shots. Same difference, as they say.) The great thing about gags is that they seem to deliver much more, on screen, than their simple origins would suggest. In Kubrick's *2001: A Space Odyssey*, for instance, famous gags included making a space hostess appear to walk upside down simply by tumbling the set and camera around her. In other scenes, astronauts seemed to float along corridors and towards the audience as if weightless, but the corridor sets were built vertically, and the camera was actually pointing up at the performers so that the steel wires suspending them from the top of the sets were invisible.

In *The Grinch*, there is an equally wonderful gag. Keen to show that her Christmas decorations are far and away better than anyone else's, the grown-up Martha May Whovier, played by Christine Baranski, fires a fairy-light 'machine gun' at the outside walls of her house, and as if by magic a string of lights and electric flex is stapled onto the roof gables and around the window frames and front door, until the entire house is ablaze with glowing electric decorations. At first glance, this looks like a very smart CG effect. But it's a gag. The lights were on the house already, and Baranski's machine gun was stripping them down, not spraying them on. After shooting, the sequence was simply played backwards. A similar gag was employed in the scene where the Grinch vacuums everyone's presents into his gigantic swag sack.

30

30 An aerial shot of the burning tree.

INTO THE THIRD DIMENSION

When Jim Cameron made *The Terminator* in 1984, it was perceived as an imaginative but essentially low-budget science-fiction thriller.

A few years later, he was spending $100 million on the sequel, *T-2: Judgement Day* (1991). As Cameron moved on to *True Lies*, the *Terminator* adventure seemed at last to have finished, having already lasted longer than anyone ever expected.

In 1992, theme-park specialists Landmark Entertainment met with MCA/Universal executives to discuss an idea: could the *Terminator* concept form the basis for some kind of stunt show? With attractions based on *Jaws* and *Ghostbusters* already in their portfolio, Landmark was optimistic about this new venture – until they started analysing the movies. As concept designer Adam Bezark recalls, 'The original action scenes were just too fantastic because, in *Judgement Day* especially, they involved a lot of morphing. How could we possibly incorporate morphs into a live-action show?'

Very quickly, 3-D photography came into the mix. The idea was to combine live theatre-style action on a foreground stage with a mix of filmed and computer-generated 3-D images in (or rather, appearing to emerge from) the background. Now the prospective budget began to worry MCA/Universal. Landmark president Gary Goddard knew that his best hope was to win Cameron's support. 'Whatever we came up with, we knew it would have to be something that Jim could get excited about. We'd really have to push the edges of the technical envelope.'

Cameron was intrigued by the idea, and volunteered to take an active role. But he had a couple of provisos: first, the narrative and dramatic tension of the whole piece would have to stand up regardless of the whizz-bang 3-D elements, and second, it would be no good using stand-in actors for the filmed portions of the show. Arnold Schwarzenegger, Linda Hamilton, Edward Furlong and Robert Patrick would have to reprise their original roles. This was yet another budget consideration. By now, Digital Domain had taken a lead role in the project, with Scott Ross as producer. *T2-3D* was destined to become a $60 million attraction: a 20-minute show barely less expensive than the movie that had inspired it.

In *Terminator 2*, a second terminator, again played by Schwarzenegger, is reprogrammed by the adult Connor and sent back in time to protect his younger self against a 'liquid metal' terminator played by Robert Patrick (in conjunction with Industrial Light and Magic's CG morph effects). The *T2-3D* storyline called for the 'good' terminator to join up with the teenage Connor once more and ride a Harley Davidson

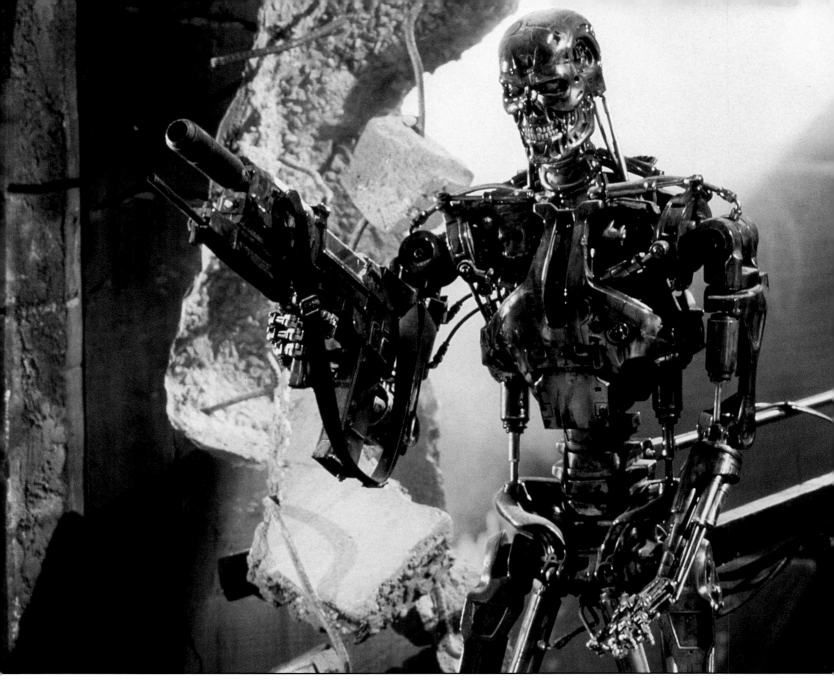

motorbike through a time warp into the year 2029. Never mind that Schwarzenegger valiantly melted himself down at the end of *Judgement Day*; a subplot takes care of that. We are once more in the nightmare world controlled by the Skynet supercomputer with its attendant cohorts of endo-skeleton warriors and flying Hunter-Killers. Humans are all but wiped out. Los Angeles lies in ruins. Schwarzenegger must penetrate Skynet's main building and destroy the central processor, which is guarded by the most lethal Terminator of all.

To no one's great surprise, *T2-3D* took four years to develop, both financially and technically. In March 1995, MCA/Universal finally gave the green light. Cameron supervised the project but split his workload with John Bruno, who handled the live-action scenes, and Stan Winston, who recreated his menacing

Terminator endoskeletons and animated them with puppet-eers. Chuck Comisky supervised the visual effects, and quite apart from the administrative load of the company's prod-uction role, Digital Domain's artists were given the task of creating the complex CG elements, with Karen Goulekas, Judith Crow and Neville Spiteri taking on key roles, Amy Jupiter as CG producer, and Mark Forker compositing.

STEREO VISION
The principle of 3-D photography, often used before, is to shoot with two cameras in parallel to mimic the stereoscopic vision of a pair of human eyes. In the movie theatre, twin projectors throw images from both cameras onto the screen simultaneously. Each projector features a polarizing filter in front of the lens. To the naked eye, the effect on screen is

1 A menacing *Terminator* endoskeleton is mounted on a hydraulic crane to provide some suitably dynamic movement.

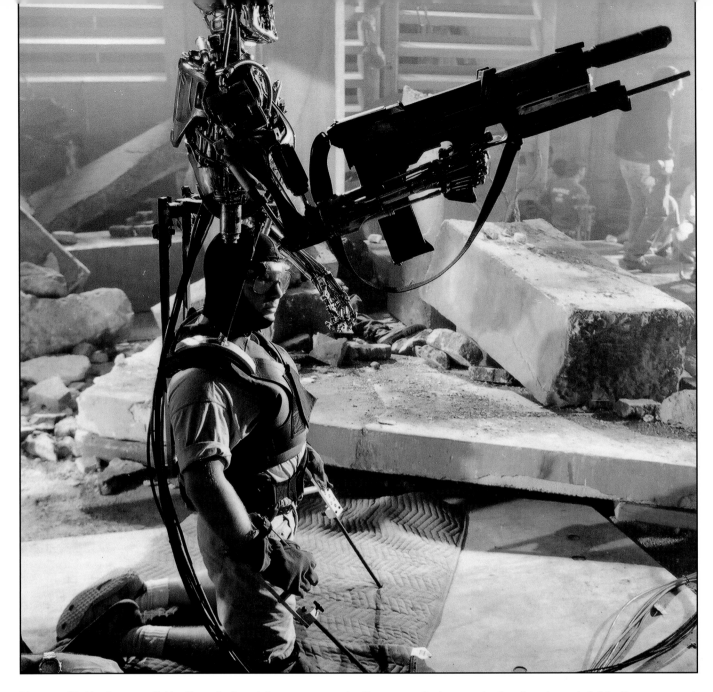

blurry, with the images distinctly out of register – very much like the results one sees when colour-magazine pictures have not been printed properly. However, when everyone in the audience wears polarized eyeglasses, the effect is magically transformed.

Polaroid filters are essentially fine grids of parallel lines, which only allow light to pass at a certain angle through the clear gaps between the lines. In the 3-D eyeglasses, one filter permits vertical waves of light to pass through, while the other lets through only horizontal waves. In turn, each of the projectors transmits only vertical or horizontal light waves, dictated by the orientation of polarizers in front of the lenses. Each eye sees only images from the appropriate projector. Light coming out of the projectors at intermediate angles is, to a great extent, blocked by the polarizers, and inevitably

the overall image looks far less bright than normal. Accordingly, the projectors' light intensity needs to be more powerful to compensate.

When 3-D presentations cause eyestrain for their audience (as they often do), it is because the original photography has not been sufficiently subtle. A pair of locked-off cameras doesn't really correspond with human stereo vision, because our eyes are constantly adjusting their angle of view. We only stare directly forwards when we are looking at the far horizon. When you try to focus on a butterfly hovering near the bottom of your garden, your eyes are gazing ahead in parallel. As the butterfly draws nearer and settles on the tip of your nose, your twin lines of vision converge until they are turned inwards to such an extent that you are almost cross-eyed. Between the far horizon and the tip of your nose, there is always some

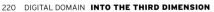

2 For close-up work, a T-800 endoskeleton was strapped to the upper torso of a puppeteer.

3 Stan Winston makes final adjustments to one of his most famous creations, while Jim Cameron and John Bruno plan the shot.

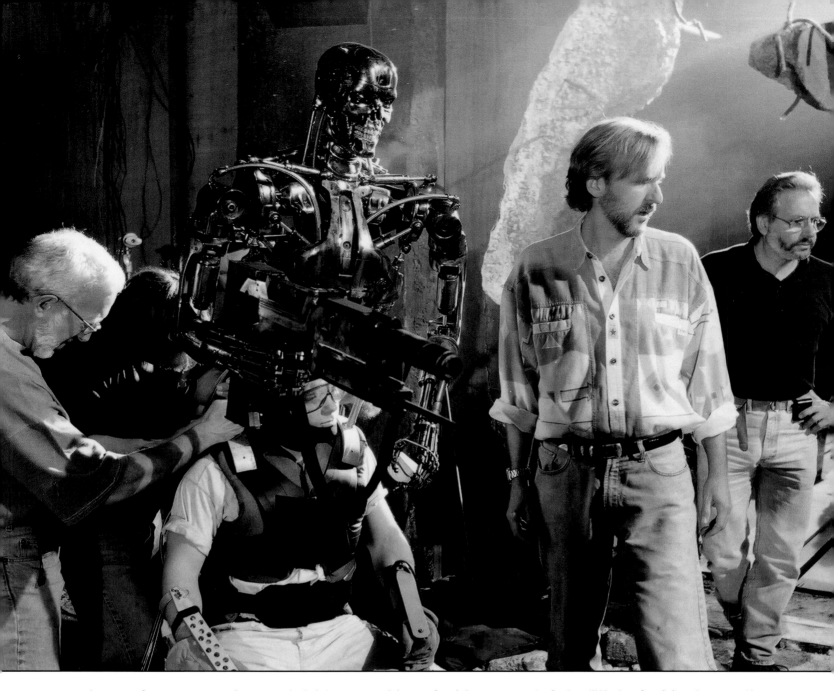

degree of convergence incorporated into your vision. Meanwhile, the lenses in your eyeballs constantly change shape to maintain focus.

A good 3-D camera system must replicate this convergence and follow-focus moment by moment. In old-fashioned systems incorporating a pair of cameras side by side, the width of the camera boxes was simply too great to bring the lens barrels close enough to match human eyes. As for convergence, it could only be achieved, clumsily, by moving each camera on its mounting. Quite frankly, film-makers didn't always bother with convergence because of the calculations and great care involved in the set-ups. Moviegoers often came away from screenings with headaches.

Ken Jones, an expert on 3-D photography, acted as a consultant for *T2-3D* on sabbatical from NASA. 'It can be a pretty forgiving process. In fact, a little *too* forgiving, because the viewer's brain is very good at unscrambling the depth cues when things are a little bit wrong. A lot of the eyestrain in 3-D comes from misphotographed imagery, where the cameras aren't lined up properly, or the left and right frames are shot with slightly different focal-length lenses. Get things exactly right and it's magical how much better everything looks.'

Flicker is another concern. Since the left and right eye images are on separate films, the separate flickers may not coincide properly, and the audience might become aware of it. The solution is to shoot (and project) everything at 30 frames per second, rather than the usual 24 frames. At this frame rate, the human brain cannot register the flicker. But there's a price for this, as Russell Carpenter explains. 'Shooting at that rate cuts down on the available shutter speed, and you

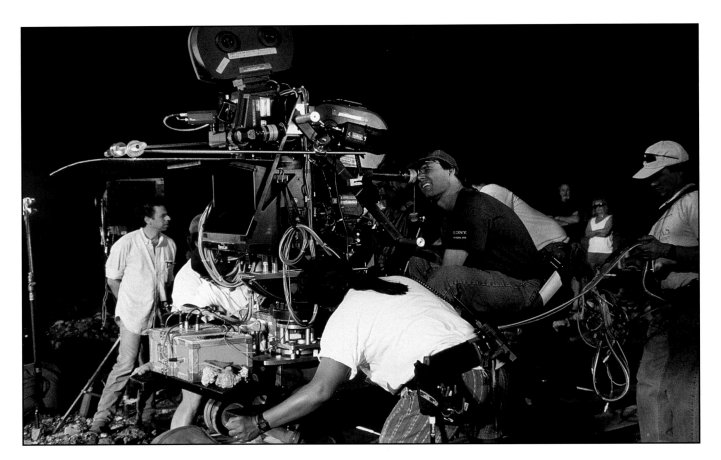

lose a quarter of the light. And you're using 65mm film rather than 35mm to get that extra image quality. Again, you need more light to hold focus in the larger format.'

From a financial point of view, there are other problems to consider. The film stock and processing costs are alarming at 30 frames per second, because each camera burns up 25 per cent more film per second than normal.

The photographic hardware also incorporates excesses of scale. At first glance, the *T2-3D* camera rig certainly seemed monstrous, with the cameras mounted in a bizarre L-shape, as if they'd been involved in an accident. But this design kept the heavy drive mechanisms and film magazines from interfering with each other and ensured that the fronts of the lenses were as close together as human eyes. A compact system of mirrors and prisms known as a **beam splitter** straightened out the two cameras' L-shaped view of the world. Precise convergence, controlled by software, only required minute shifts in the angles between the camera lenses and the beam splitter. Just as well, because the system weighed upwards of 450 pounds: somewhere around the bulk of a refrigerator. This wouldn't have mattered for static scenes, but Cameron and Bruno wanted to move the rig at speed. Bruno says, 'We spent two days in Florida and took in all the theme-park attractions. They were all set up as ride simulators or 3-D gimmicks, but none of them were really proper films. We also noticed that all the 3-D stuff was shot with locked-off cameras. Jim wanted *T2-3D* to be like a chase sequence out of a real *Terminator* movie.'

INTO THE APOCALYPSE

A chase would need a *setting* rather than a set. Bruno, along with effects supervisor Chuck Comisky, flew to an abandoned Kaiser Steel facility near Eagle Mountain, deep in the heart of the Californian desert, and found, as Bruno recalls, 'a wonderful collection of derelict buildings, smashed structures and abandoned machinery, all compressed into a mile-square site. It was almost as if it had leapt by magic off the pages of our storyboards. The owners of the site said they were going to demolish everything, and we said, "Hey, don't bother. We'd be delighted to do that for you." And they gave us free reign to destroy, burn or blow up whatever we wanted.'

Production designer John Muto was in his element. 'We dressed the set with over a hundred smashed cars and trucks from a wrecking yard. A bunch of guys with forklift trucks and big steam shovels smashed them up and dumped them around the place, wherever we needed. We had tons of rubble and concrete strewn across a million-square-foot set. I wanted to get a bombed-out feel, but not completely flattened, like Hiroshima. More like London after the Blitz.'

Unusually for a set, even on the most elaborate Hollywood backlot, there was effectively no limit to the shooting area. The desert stretched for miles all around, the mountains to the west made a great backdrop, and the cameras could point in any direction. However, the light levels fell away quickly across such a vast expanse. In addition to the most powerful studio lamps on offer from conventional suppliers, Carpenter organized banks of Musco floodlights, normally used for night-

4 The bulky stereoscopic shooting rig.

5 Schwarzenegger and Furlong ride their Harley Davidson motorbike through the debris, as Roy Arbogast's pyrotechnic charges ignite in the background.

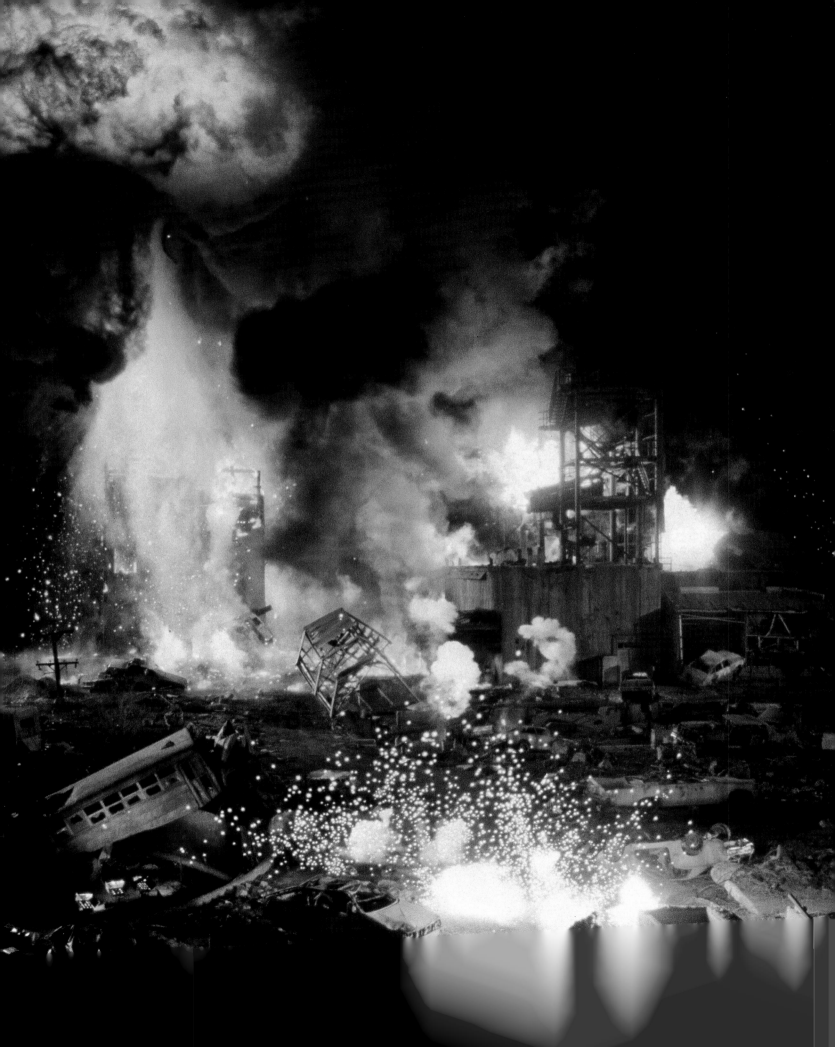

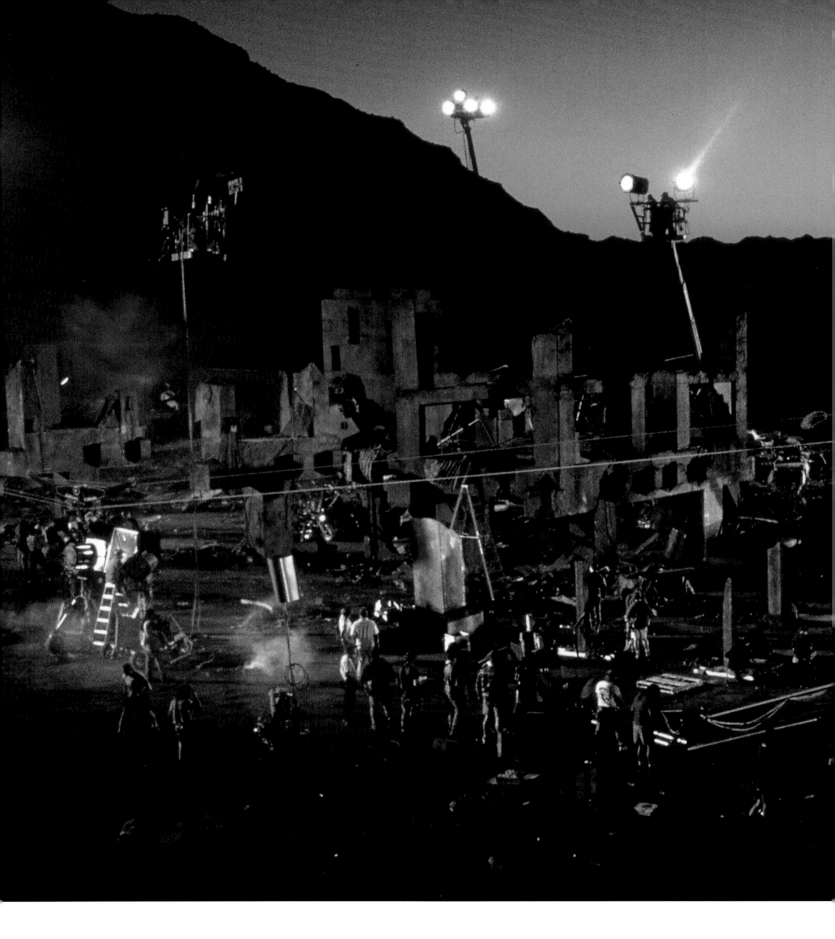

6

6 The huge Eagle Mountain shooting set provided the *T2-3D* team with a suitably vast arena in which to create a post-apocalyptic wasteland.

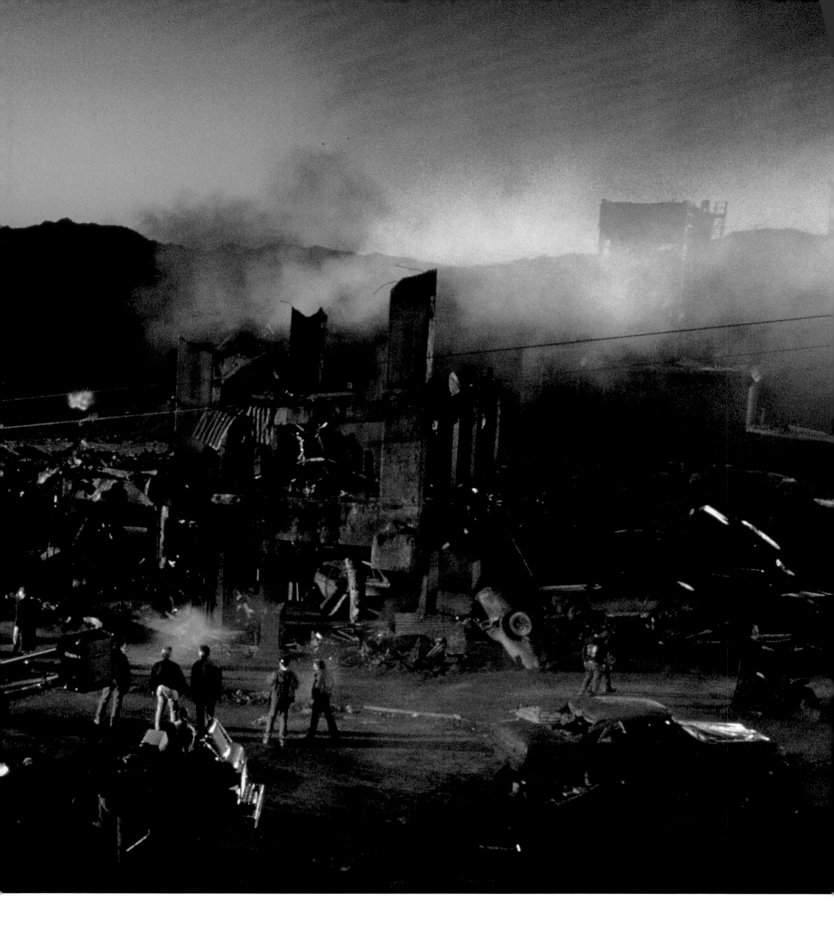

time football games, and Night Sun lights capable of illuminating an area the size of four city blocks. In the desert dusk, the set glowed like an inferno when everything was switched on. At one point, Jim Cameron quipped, 'People in the neighbouring town are probably going to get up and go to work. They'll think it's morning.' The 'neighbouring town' of Blythe was 40 miles away.

Now the challenge was to move the camera across this chaotic wasteland as smoothly as possible. (The 3-D effect wouldn't be comfortable for audiences if the viewpoint kept jumping about.) Hydraulic cranes and lifts were more than capable of moving the 3-D rig in sweeping arcs, but the greater challenge was to follow Schwarzenegger and Furlong on their Harley Davidson as they swooped at speed through

7 The Cablecam enabled the 3-D camera to 'fly' over rough terrain and follow the speeding bike across the set.

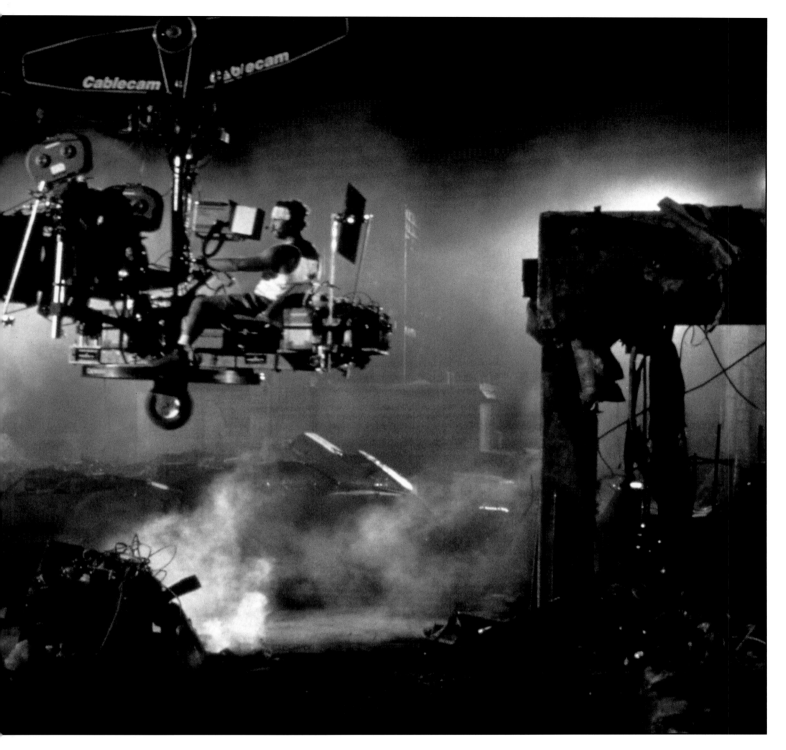

the set. A normal camera truck wouldn't have worked because the rubble-strewn ground was far too rough. A low-flying helicopter seemed the obvious solution until it became clear that the 3-D system was too heavy to bolt onto its airframe.

The answer turned out to be the Cablecam, an elaborate system in which the rig was suspended on steel cables stretched between two towers 1000 feet apart. Cablecam could fly over the ground at speeds upwards of 50 miles per hour. Normally it took two or three operators to run the 3-D rig, but Cablecam could only support the weight of one operator because the equipment load was so much heavier than Cablecam's normal design limits. The rig had to be adapted to run with remote-controlled help from the ground. Other than that, it worked wonderfully.

The T-Meg wireframe is an amalgam of NURB patches unified into a single surface that can be stretched and pulled to create the legs, pincers and other frightening features. The final rendering of its shiny surface required complex interaction with environment and reflection maps derived from the separate CG models of the Skynet interior.

Imagine the ray-tracing complexities of a CG model that sometimes reflects parts of itself – for instance, when one tentacle crosses over another.

CG IN 3-D

The real star of the show is the T-1,000,000, the ultimate Terminator. Called the T-Meg for short, it disguises itself as a metal security cage wrapped around the main Skynet computer. When roused by a security breach, it unfurls and becomes a huge spider-like monster with lethally spiked legs and jaws.

Using Softimage, animation director Daniel Robichaud constructed the T-Meg as a complex amalgam of NURB patches, ultimately creating one smooth surface with undulating features. In order to maintain the illusion of a liquid-metal entity, Robichaud needed to avoid any apparent seams between the substructures and the main body, but the model was sufficiently complex that it still appeared to have separately shaped components, like legs, eyes, and vicious pincers. During T-Meg's dramatic shape changes, the morph routines swept smoothly across its entire surface.

Robichaud also modelled the hard-edged metallic cage around the main Skynet computer, again from a single surface folded and curved into the right shape. At first glance, there seems little resemblance between this mechanistic cage and the sinuous creature that it eventually becomes, but they are basically the same topological object. The fact that the curves in the cage are in the form of fairly sharp edges doesn't matter. The edges are really just kinks in a single surface, rather than sharply angled joins between different surfaces. All that mattered was that the cage and its struts had the same total number of corners as there were tips on the T-Meg's vicious spikes and prongs. These were, quite literally, points of reference around which the overall surface could morph. The audience sees the cage transforming itself into the spider-like T-Meg in one smooth shot, with no cuts.

The dramatic interior of the Skynet pyramid was also a CG construct. A design team led by Darren Gifford came up with a virtual set in which walls floated, objects were suspended from the ceiling, and cold, misty shafts of light punctured the seemingly infinite chasm of semi-darkness in the background. Judith Crow took charge of controlling all the separate elements. 'There were thousands of computer files, and when we composited them, we had about 50 separate layers for the foreground, the midground and the background. If we'd tried to render everything as a single model, it would have been absolutely unmanageable.'

Skynet, T-Meg and all other CG elements had to be modelled twice, with shifts in perspective appropriate for the right and left eyes. Virtual camera convergences also had to be calculated for CG in the same way as for the live-action sequences. All this meant literally doubling up on the render times.

In fact, *six* 3-D views of Skynet's interior had to be rendered for the climactic moments of the show. During a convenient moment of darkness precipitated by the Skynet pyramid doors apparently slamming shut, two new 3-D screens rise stealthily into position on either side of the main central screen, wrapping the audience in a 180-degree vista. The divisions between the screens in the theatre are cleverly disguised so that they appear to be columns within the Skynet interior. The T-Meg then scuttles from screen to screen as though trying to sneak around the side of the audience. All the while, stage actors doubling in the Schwarzenegger and Furlong roles climb the dividing columns and try to battle the creature. Their live actions have to integrate precisely with its movements.

CUTTING FOR STEREO

Scenes containing 3-D elements like the T-Meg couldn't be cut or edited in the conventional way, as director of photography Russell Carpenter explains: 'If you have a 3-D object in the foreground and you make a cut to another scene, then that object instantly disappears as if it's vaporizing in front of your eyes. If you then cut to something in the distance, it feels as if someone's snapped a rubber band on your eyeball. It's very jarring, so you have to think very carefully about where to put your cuts.' The key is to allow 3-D objects to move out of frame naturalistically, as an integral part of the action, before cutting to a different shot once the 3-D objects are safely out of view. For the CG animators especially, this isn't as straightforward as it sounds. 'Take that tentacle from the T-Meg that reaches right into the audience,' says Carpenter. 'A difference of a tenth of a degree in the modelling of that thing would have nudged it out of frame and broken the illusion.'

Another subtle consideration is that the audience is always focusing on the huge screens at the front of the theatre, even when the 3-D elements appear to be just inches way from their faces. As the two separate images on screen converge or diverge laterally, so the watcher's eyes converge and de-converge, but they must be 'cheated' into staying at the same long-distance focus throughout. 'You have to provide apparent depth cues on screen, while leaving the actual lens focus of the eyes unaffected,' says Carpenter. 'You can't have elements rushing out of the screen too rapidly, because then you create a kind of visual whiplash.'

BEYOND THE SCREEN

The *T2-3D* show begins even before the members of the audience have taken their seats. As they wait in the foyer, they are surrounded by video screens showing a glossy presentation from Cyberdyne, a modern-day corporation that seems to have taken over the world, from phones to medicines, transport to defence. As the honeyed corporate tones announce that everyone will feel that much happier and more secure when they put their trust in Cyberdyne's products, Linda Hamilton and her resistance group hack into the broadcast, telling everyone to beware. She and her companions are going to destroy this particular Cyberdyne building for the good of the world. Everyone had better get out.

At this point, a real person, a PR girl, steps onto the balcony overlooking the foyer. The video presentation gets back to normal, and the PR girl tells the audiences not to worry about that minor interruption – it's all being dealt with, and everyone is quite safe. What they're about to see is a wonderful new range of combat robots from Cyberdyne, designed, of course, to enhance national security and well-being. Safety goggles must be worn to protect the eyes against stray laser blasts from the robots' powerful weaponry. This is just a gag to make sure that everyone knows how to put on their Polaroid spectacles correctly, but the audience already senses that this whole thing is turning into an *experience*, and not just a passive movie short. All the while, the girl is thoroughly patronising and offensive.

8 The T-Meg wireframe is an amalgam of NURB patches unified into a single surface that can be stretched and pulled to create the legs, pincers and other frightening features.

9 The fully rendered T-Meg in its Skynet lair. The interior was composited from many layers of architecture, spinning rays of light, moving elevators and eerie crystalline components that seem to float, unsupported, in the cavernous space.

10 The T-Meg is solidified after being caught in a stream of liquid nitrogen from a cooling system.

10

11 The T-Meg shatters into pieces. All the fragments were created procedurally.

11

In the auditorium itself, a squad of full-size T-70 cyborg endoskeletons, wielding huge laser rifles, rise on platforms surrounding the audience. Suddenly, in a blaze of gunfire, Hamilton and Furlong descend from SWAT-style ropes onto the stage, and a ferocious exchange of shots between them and the cyborgs begins. Laser blasts swoop over the audience. Much to everyone's delight, the smarmy PR girl gets blown away as well.

Then the embossed Cyberdyne logo above the stage begins to change shape. The head of the liquid-metal T-1000 cyborg (last seen in the movie *Terminator 2: Judgement Day*) reaches right out to menace the audience. In the nick of time, Schwarzenegger arrives out of a momentary 'time portal' connecting today's world with the future. He rumbles across the stage on his Harley Davidson, picks up Furlong, then aims

directly for the screen, to ride at breakneck speed through the shattered 2029 landscape and towards the Skynet stronghold.

In reality, nothing is as it seems. Lookalike actors in appropriate costume appear on stage, miming to prerecorded speech from the real stars; the Cyberdyne logo is actually a projected part of the film presentation; the T-1000 is the first of many 3-D CG effects; and the bike escapes through a precisely cut door in the screen, under cover of stage smoke and explosions. After all that, the audience is watching the prerecorded 3-D film. The transitions are all 'sleight of hand', but conducted with great technical precision.

So, what's going on here? Is this a movie, or a stage show, or a magic act? Are the audience just spectators, or are they participants?

12 Finishing touches are applied to a Hunter-Killer drone. When a CG version is superimposed at an appropriate moment, the drone appears to zoom out of the screen to inspect the audience at extremely close range.

13 James Brown studded with performance-capture dots.

THE GODFATHER OF SOUL

The Experience Music Project (EMP) is just as startling as *T2-3D*. This visitor complex, developed in Seattle by Microsoft co-founder Paul Allen and his sister Jody Patton, and encompassed in a superb new building designed by architect Frank Gehry, is dedicated to 'the celebration and exploration of creativity and innovation as expressed through American popular music'. That might sound rather dry, but the actual 'experience' on offer is extraordinary. EMP is a blend of museum, movie theatre and theme-park ride. Digital Domain spent three years developing and producing the ride component, *Funk Blast* – a journey in which visitors are seated in a 'motion base' simulator that can roll, pitch and yaw in lockstep with apparent visual movement cues from high-definition footage projected onto a huge screen from 65mm film, running at 30 frames per second (just as in *T2-3D*, to reduce flicker). This filmed component takes place on a busy neon-lit street, somewhere around 1971.

The ride is essentially a quest for the 'Essence of Funk'. Lenny Kravitz does it. Michael Jackson does it. Prince did it before he became 'The Artist Formerly Known As', and then he kept on doing it. But who did it *first*? None other than the Godfather of Soul, Mr James Brown.

Playing himself in inimitable style, Brown leaps out of a billboard poster to help two lost souls get in touch with their 'inner funk'. In an extraordinary scene, he encounters a young version of himself giving an all-singing, all-dancing performance of his rabble-rousing 1971 hit 'Sex Machine'. This isn't a trick with archive; it's a brand-new performance.

Director Ray Giarratana and effects supervisor André Bustanoby took on an ambitious challenge. Basically, a CG animation of James Brown's face *as he looked 30 years ago* needed to be mapped onto the head of Tony Wilson, a young dancer personally selected by Brown, who could mimic his original dancing style during live-action photography on set. The CG face had to move fluidly with the dancer, all the while lip-synching with the music. And it had to be expressive, in keeping with Brown's extraordinary passion and energy. Today he still sings up a storm, belying his senior-citizen status, but 30 years ago he was more like a hurricane.

The first task was to capture as much information as possible about Brown's head: the shape of his skull; the layout of his muscles; the way his lips, eyes and mouth moved when he sang. 'We used almost every possible device for getting our data,' says Bustanoby. 'Make-up supervisor Todd Masters took a plaster cast of his face. We scanned him with a laser. We covered him with performance-capture markers. The difficulty was that, at this stage, we had no idea where the camera's viewpoint was going to end up in the final sequences. We wanted Ray [Giarattana] to be able to direct the shoot on set with any lens, from any angle, and we'd deal with the consequences later. So we had to get every scrap of information that we could think of, just in case.'

The next hurdle was to take the data from today's James Brown and somehow smooth away the wrinkles of a long life lived hard and fast. ('I know what you're trying to do. You're trying to clone me!' he said to Bustanoby.) To donate the necessary anatomical data, he had to sit with his head held in a surgical vice normally used to ensure accuracy in brain

14 James Brown confined behind a cage of scanner machinery.

15– Brown's face digitized and smoothed out to take away 30 years.
18

surgery. The slightest movement would have ruined the task at hand: the complete scientific mapping of his face in repose, down to the last fraction of a millimetre, the last pore of skin. Sculptor Todd Masters then made a clay cast of Brown's face as it would have appeared 30 years ago, cross-referring between the latest scans and photos taken in the early 1970s. This beautiful sculpture was then scanned into the computer as a template. Bustanoby was appreciative. 'Todd's artistry helped us define muscular flow and surface skin tensions that the laser scan simply couldn't read. People are inclined to undervalue traditional modelling media today, but it can bring so much to the digital arena.'

Next, Brown's characteristic facial expressions had to be analysed, so that the as-yet-unborn CG facial construct could be imbued with some semblance of life. In the performance-capture studio, Brown sang portions of 'Sex Machine' with his customary panache, despite the fact that his face was covered in 54 white reflector dots and surrounded by an intimidating cage of metal scaffolding, from which locked-off cameras recorded his face from every angle. Later, the reflectors would help control equivalent markers in the CG model.

Bustanoby was a little abashed at having to confine James Brown in so many ways. 'We need to get rid of all that machinery, get out of the laboratory environment we're in, and into the real world. We had this great mover sitting in a chair so we could record his head, and instead of being up on stage, projecting to an audience, he was in a little darkened room, surrounded by wires and cameras and technology. And that's not at all how a performer like James Brown really works. He was just fantastically patient with it all, but he shouldn't have to have adapted to us. We should have been able to adapt to *him*, and until we can do that, performance capture still has some way to go.'

Despite everyone's best efforts, performance data alone was not sufficient. As Brown himself pointed out, 'I can't lip-synch. When I perform, I am a conduit from God. It just flows through me.' In short, every performance he makes is unique. Therefore, rather than slavishly mimicking his facial expressions from the capture data, the youthful CG head would have to be teased and manipulated into generating its own performance in time with the unalterable 30-year-old recording of 'Sex Machine' that features in *Funk Blast*.

Lead CG modeller Beau Cameron and technical director Caleb Owens assembled the final CG head as a subdivison surface mesh. NURBs were overlaid at key points, but these were single lines only, not patches. This union of spline-based and polygonal modelling allowed the face to be distorted in certain areas, while leaving others largely untouched. The splines changed their shapes according to cues from the performance-capture data, and their weight then tugged appropriately at the mesh face. However, because the at best vague lip-synch didn't tie in all that often with the recording of the song, a good deal of keyframing was also required. Additional slider controls attached to the splines enabled facial expressions to be adjusted manually.

It was not necessary to render the interior anatomical details in exact form, HARD-style, but merely as ellipsoid shapes over which the surface skin would stretch. The shape of bones, muscles and sinews under the skin was implicit

19 The live-action set for *Funk Blast*.

19

20– Tony Wilson before and after his eerie transformation into James Brown.
21

rather than literally modelled. The subdivision approach allowed animators to manipulate the CG face at low resolution for speed and convenience, in the knowledge that a smooth model would emerge during the render. Bump, displacement and texture maps were derived from photos of James Brown's skin, then reworked to smooth out all those years of hard living.

FITTING THE FACE

Next came the motion-tracking data. The live-action stage had already been thoroughly surveyed by laser theodolite, so that Tony Wilson's dance performance could be tracked in three-dimensional space with near-perfect accuracy. His face was marked up with white dots, so that when the CG face was mapped onto his, the dots could be matched up with their equivalent CG points. And then the illusion was complete: a brand-new never-before-seen performance from the Godfather of Soul in the youthful prime of his career. However, as Bustanoby points out, 'the tracking had some extremely tough moves to work out, like when Tony does a complete 360-degree somersault. That needed a lot of reaching in there and fixing.' Compositing supervisor David Stern and his team also worked immensely hard to smooth the boundaries between the CG face and Tony Wilson's real neck.

Last and by no means least, High Dynamic Range (HDR) data from a spherical light probe was crucial to ensuring a naturalistic blend between the virtual lighting on the CG face and the real surroundings of the set. As the director of the show, including the elaborate live-action scenes, Giarratana certainly appreciated the technique. 'You pay a very expensive director of photography and his crew to light the huge set, and the results are beautiful, with countless kicker lights, spotlights, fill lights, reflectors, and all kinds of craftsmanship that comes from their long experience of, essentially, painting a scene with lights. So then what are you going to do? Put a CG element in there, with someone on a computer *guessing* where the lights should be? You really want to take what the director of photography came up with in the first place, and stick with that.'

It's not just lights but the entire environment of colours, soft shadows, muted reflections and other subtleties within the live-action set that HDR captures. 'It's the lighting map, the environment map, and everything else all rolled into one. To put it simply, all the information about what impinges on the surface of the CG and alters its appearance can be fed into the shader from HDR.'

Bustanoby sees a shift of attitude implicit in HDR. 'Until now, computer imaging has been all about synthesizing the look and behaviour of the real world, and that has all the disadvantages of synthesized music: it doesn't come across as natural. And it's from the world of music that a new paradigm is gradually encroaching into CG. Don't synthesize, but sample from reality. Just as you'd sample a violin to get its textures really right if you wanted to get that sound into an electronic keyboard, so we are learning to sample real lighting, real reflections, real characteristics, into our CG.'

THE EYE OF THE STORM

Tokyo DisneySea, a major new theme park at Tokyo Disney Resort, opened to the public on 4 September 2001. One of the showcase attractions, *StormRider*, takes its audience on an exhilarating flight through the eye of a colossally powerful storm. At Walt Disney Imagineering, Tom Fitzgerald (executive vice-president and senior creative executive) produced the show with Marianne Ray McLean (producer, visual effects), who also directed background-plate photography in the stunning aerial opening shots. Digital Domain effects producer Denise Ballantyne worked on the project for over two years, with a team of up to 30 digital artists.

The scenario calls for 'passengers' to fly in a futuristic craft that diffuses storms by firing torpedo-like devices, called fuses, directly into the eye of the storm. The mission takes a turn for the worse, literally, when a fuse is struck by lightning and doubles back on the craft. Visual-effects supervisor Mark Forker takes up the story: 'There are 122 seats in the passenger compartment, and the whole thing is mounted on what's called a "motion base", similar to the machinery that makes an aircraft cockpit simulator pitch and roll. Except this is the largest number of people in the world ever to be seated in something like this at one time. The film show that we've made, on high-resolution 65mm, is projected onto a huge curved screen in front of the audience, and the design of the compartment makes it seem like the view from the cockpit windows. It's very encompassing, and when the "fuse" hits the plane, the whole thing rumbles and shakes, and the audience really gets the feeling that it's happening to them.'

Motion-base rides are common enough, but the challenge here was twofold: first, to scale the whole thing for the large audiences that Disney wished to accommodate, and second, to deliver a type of ride whose novelty and ambition would be obvious. There have been ski-slope rides, dinosaur rides and fantasy space rides, but a trip through the eye of a storm promised a new thrill. Digital Domain's task was to create the mother and father of all storms and send the audience right through its heart.

The CG load was enormous and varied. Traditional mesh and texture-map modelling was used to create vehicles that appear to be floating or flying in the sky ahead, along with a huge floating city, towards which the increasingly endangered sightseeing plane is supposed to be heading. Wispy clouds at the top of the storm were created with particle systems and volumetric shaders, along with vapour trails from the aircraft ahead, but as Forker points out, 'it would have been a nightmare to create the whole sky environment as a single digital entity. That would have taken up our entire render-farm capability. We could have ended up shutting the place down.'

The solution, as Forker explains, was to divide the clouds into separate regions – with, literally, a twist: 'For the sequences that take place inside the storm's centre, we needed to be in a believable CG environment for a long time, and that's difficult to pull off convincingly. The storm clouds needed the right kind of densities and depth perception cues for lighting and self-shadowing. For most of the large-scale storm structures, the clouds were created from true computations of cloud volumes, based on the proper physics of real clouds. But after that, they were output as texture maps. These were applied

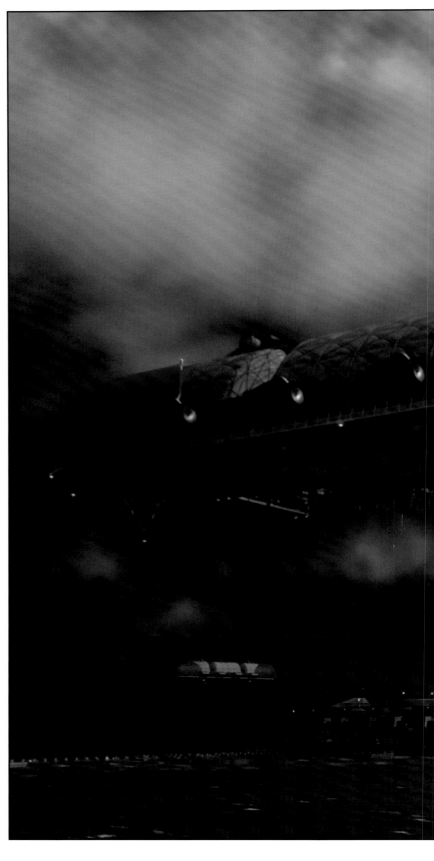

22 In Tokyo DisneySea's *StormRider*, a vast floating airship escapes the storm that the audience is about to experience.

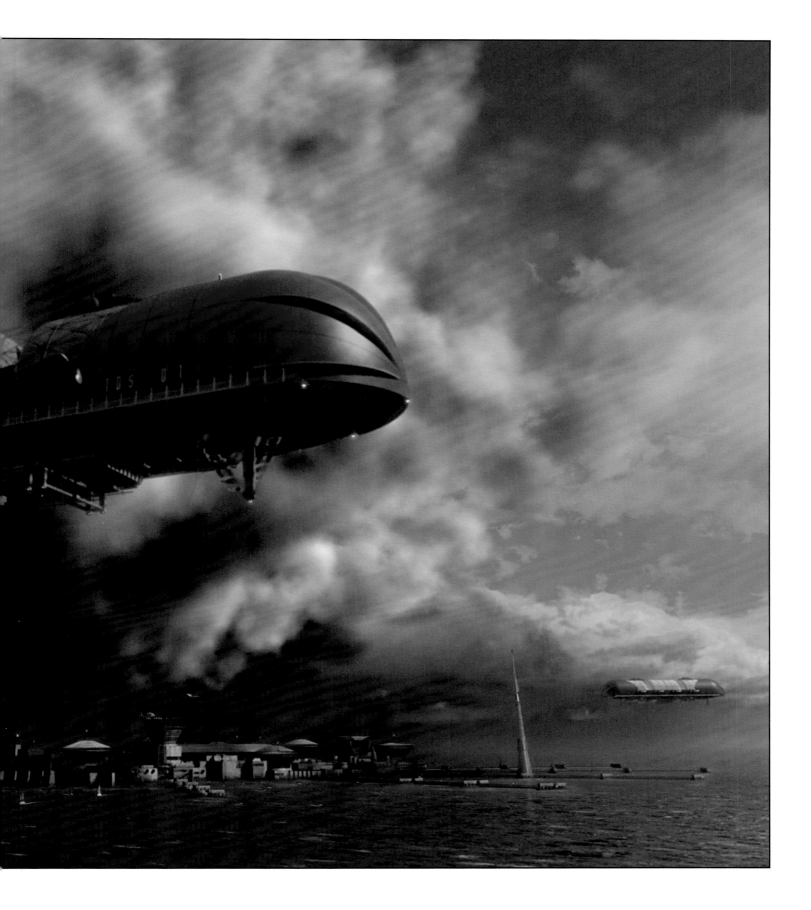

onto six tall, concentrically spinning cylindrical grids, which fitted inside one another and spun at different rates. There were four wispy layers in front of these grids to add more dynamic realism to the foreground. We needed to fly through the walls of this storm, so we needed to pass through the grids, and all the while the detail needed to hold up. The impression is of a deep and complex storm with true volume and perspective, but it was created relatively quickly.'

'Photo-realistic water is definitely one of the toughest challenges,' says Forker. 'That really struck me in the *Titanic* days, when I happened to be driving every day along the Pacific Coast Highway. No matter what day it was, the water looked completely different every time. The haze would be different or the spectral reflections from the sun, or the colour, the type of waves. People don't realize how complicated water can be. Large-scale folds and ripples and variations in the flatness or waviness of the overall water surface are caused by undercurrents, or by sandbars on the seabed, or warm water hitting a cold zone. Any number of factors mean that even calm water, with regular waves, is never really as "regular" as you'd think.'

StormRider, *T2-3D* and other theme-park projects under development at Digital Domain point the way to one particular aspect of special effects in the future: total, all-encompassing visual and physical sensory experiences that allow audiences to venture into incredible worlds far beyond their normal lives – if only for 15 minutes at a time. Meanwhile, the conventional movie, with its human drama and conventional narrative played out over two leisurely hours, shows no signs of being replaced by these other media – it's merely supplemented by them. Experiments with interactive TV, virtual-reality head-sets, holographic displays and all kinds of extraordinary new technologies have shown that the public enjoy sensory novelties up to a point, but the instinct for sitting around the camp fire, so to speak, while a skilled storyteller casts a spell on us is innate in human beings. We need to be told stories and to be liberated, for a while, from the tedious responsibility of governing our own thoughts and actions. Movies aren't called 'escapist' for nothing.

As widescreen TVs and home DVD players flood the market, it might seem that we don't actually have to visit movie theatres any more, but a widely predicted trend away from theatre-going hasn't quite worked out as the market analysts had expected. Yes, home movie rentals are on the increase, but many of those renting videos will have already caught the film at a theatre. Sharing a movie with loved ones, as well as with crowds of strangers, is an essential part of the experience. People like to confirm that when they are laughing or crying, everyone in the seats around them is experiencing the same emotional response. That's how a collection of individuals becomes an audience.

Movies and movie theatres are here to stay, because they fulfil an ancient human need for narrative. It's just the actual strips of film that may be on the way out.

23 Concentric cylinders of clouds create the three-dimensional 'eye of the storm' into which *StormRider*'s audience is plunged.

DIGITAL TOTALITY

The overwhelming trend from now on will be towards electronic production of movies from beginning to end. Imaging supervisor Michael Kanfer says, 'Although there's a huge vested business interest behind the way things have been for years, with film, chemical processing, and all that goes with it, once you've seen what's possible with the latest high-definition digital cameras, you know that everything is about to change. But at the moment, every director of photography out there with an Academy Award on the mantelpiece is used to working with film, and maybe only 5 per cent of them have touched high-def digital. If anything, it's not some complete overnight revolution in technology that's remarkable right now, so much as the fact that we have tools that can combine elements from analogue video, digital video, computer graphics and conventional film all in the same image. Whatever tool is appropriate for the various small pieces of the jigsaw puzzle, you can be sure of fitting everything together. That never used to be the case. But soon, all the imaging requirements will be combined in the same digital tool set, and we won't have to worry about the jigsaw anymore.'

Price Pethel identifies a logjam at the theatrical end of the process, as well as in the production side. 'Digital projection can save on the cost of all those release prints, transporting the heavy film cans to the theatres and so on. Movies could be transmitted from a satellite, or through cable, so nothing physical actually has to be delivered to the theatres. Niche-marketed art films that aren't going to attract huge audiences could be beamed in for a short "art-house" run, without any great difficulty or cost. As for the major movies, with so many screens available at a multiplex, they could delay the start of each one by 20 minutes, so that whatever time you show up, you get to see the movie. You don't arrive to find that you have two hours to kill before you can take your seat.'

Hardware is now becoming available to make digital projection possible at screen resolutions to match conventional film. Pethel says, 'The hot ticket right now is a device developed by Texas Instruments called the DLP – the digital light projector. It's a mirror array on the surface of a chip, with each mirror the size of a pixel. Each one has a tiny piezo-electric element, basically combined into the design of the chip. Every time you send a current through the piezo-electric node, the corresponding mirror flips from a full reflective angle to a completely non-reflective angle. They can flip back and forth very much faster than 24 times per second.'

Three separate mirror arrays respond directly to RGB data, combining their light via a prism into a single full-colour beam for projection. Rather than 'scanning' lines across an image as in a TV monitor, complete frames are loaded into the DLP's memory and projected whole. A brief moment of darkness separates one frame from another, just as in a normal movie projector, and the resulting images still flash across the screen 24 times per second, leaving audiences with the impression that they are watching a conventional movie.

According to Kanfer, 'The 24-frame standard will be with us for a while yet. It's too ingrained into the industry. That frame rate will also preserve the ability to shoot on conventional film stock, even if most of the projections end up digital. There remain some photographic characteristics inherent in film

which even the best digital cameras cannot match, but this is bound to change in the future.'

The costs of shooting and processing thousands of feet of film are prohibitive for young film-makers. Digital technology will allow them to shoot a two-hour film with just a few hundred dollars' worth of digital tapes. Pethel is enthusiastic about total digital production. 'You can do an hour-long TV show on digital or video inside a month, but you can't do that for a movie. Why not? Because of the latency. The term "latent image" describes when you've shot a piece of film, and it's there, but you haven't processed it yet. From a practical point of view, you're working with a minimum 12-hour latency, because that's the time it takes to get the film to the lab, have them process it, and get it back to you so that you can see the results and make a decision. You're on set and you need to see, right there and then, that the shot is working, but you can't. Sound artists and music producers work on a mixing desk, so why can't we mix the visual images in the same way? Very soon, we'll be able to.'

And when these possibilities are realized, one company in particular will be ready to take a lead role in the new, all-digital age of film-making.

ACKNOWLEDGEMENTS

I would like to thank Scott Ross, Nancy Bernstein, Ed Ulbrich and Brad Call for their consistent support and hospitality. Despite their tremendous workloads on matters far more important than me, they offered their time and support and allowed me incredible access throughout all areas of Digital Domain. I hope that their trust in me has proved worthwhile.

A very special thanks to Bob Hoffman, Director of Publicity at Digital Domain until March 2001, who nursed this project from initial idea all the way to fruition. Without Bob's patient support, this book would not have been possible.

Thanks also to Tim Clayton for assembling a huge amount of background data for me, and for helping in the picture selection process.

Everyone, without exception, showed me the greatest hospitality at Digital Domain. The following people provided me with extended interviews and demonstrations of procedures and granted me access to documentation: Roy Arbogast, Shannan Burkley, Beau Cameron, Russell Carpenter, Ray Giarratana, Bryan Grill, André Bustanoby, John Bruno, Matthew Butler, Stephane Couture, Judith Crow, Sean Cunningham, Leslie Ekker, Alan Faucher, Mark Forker, Johnny Gibson, Karen Goulekas, Caleb Howard, David Isyomin, Ken Jones, Mike Kanfer, Michael Karp, Rob Legato, Andy MacDonald, Kevin Mack, Martha Snow Mack, Pat McClung, Erik Nash, Mike O'Neil, Donald Pennington, Price Pethel, David Prescott, Fred Raimondi, Daniel Robichaud, Doug Roble, Randall Rosa, Mark Stetson, George Stevens and Vernon Wilbert. Finally, thanks to Kris Rich and Jeff Kalmus for the hard work they put into sourcing and preparing the images for the book.

Don and Estelle Shay at *Cinefex* were tremendously supportive. Their excellent magazine is a valuable and authoritative source of information about special effects in contemporary cinema.

My thanks also to Dave Kent at the Kobal Collection in London.